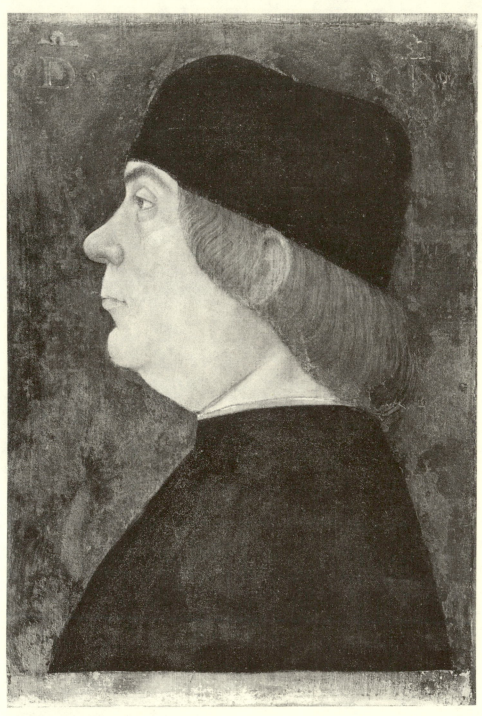

Baldassare Estense, *Portrait of Tito Vespasiano Strozzi*,
Private Collection, Venice.

Fifteenth-Century
North Italian Painting and Drawing

an annotated bibliography

A
Reference Publication in
ART HISTORY

Marilyn Aronberg Lavin, Editor

Fifteenth-Century
North Italian Painting and Drawing

an annotated bibliography

CHARLES M. ROSENBERG

REFERENCE PUBLICATIONS
IN
ART HISTORY

G. K. Hall & Co, 70 Lincoln Street, Boston, Massachusetts

Library of Congress Cataloging in Publication Data

Rosenberg, Charles M.
 Fifteenth-century North Italian painting and drawing.

 (Reference publication in art history)
 Includes index.
 1. Art, Italian—Italy, Northern—Bibliography.
 2. Art, Renaissance—Italy, Northern—Bibliography.
 I. Title. II. Title: 15th century North Italian painting and drawing. III. Series.
 Z5961.I8R67 1986 [N6949.N67] 016.7595'1 86-4729
 ISBN 0-8161-8555-7

This publication is printed on permanent/durable acid-free paper
MANUFACTURED IN THE UNITED STATES OF AMERICA

Contents

Contents

Contents

The Author

Charles M. Rosenberg is an associate professor and director of Art Historical Studies at the University of Notre Dame. He did his undergraduate work at Swarthmore College and took his Master's degree and Doctorate at the University of Michigan, writing a dissertation on art in Ferrara during the reign of Borso d'Este, 1450-71. Rosenberg has published articles dealing with fifteenth- and sixteenth-century Ferrarese art and patronage in a number of journals including Acta, Renaissance Quarterly, and Art Bulletin. In addition, he has written and lectured on cubism, Raphael, Leonardo, Michelangelo, and the patronage of Federigo da Montefeltro. Rosenberg has been the recipient of grants from the Samuel H. Kress Foundation, the National Endowment for the Humanities, the American Council of Learned Societies, and the Harvard Center for Renaissance Studies, the Villa I Tatti.

Preface

The selection of artists covered in this bibliography was
governed by two primary criteria. First, these artists were born
in the North Italian provinces of Emilia-Romagna, Liguria, Lombardy,
or Piedmont (including the Valle d'Aosta). Second, these artists
were either born between 1400 and 1500 or produced the majority of
their work during this period. Literature on anonymous works of art
is included only if there is general agreement that they were pro-
duced by artists fitting these criteria. Within these parameters a
few exceptions have been allowed. A small number of artists born
outside the region, most notably Ludovico Brea, are included because
a significant portion of their work was produced for local patrons.
On the other hand, certain artists from the region are excluded
(e.g., Luini, Solario, Sodoma, Gaudenzio, Mazzolino, and Garofalo),
because their work more fully reflects the stylistic concerns and
trends of the cinquecento.

All of the articles, monographs, and manuscripts included in
this bibliography have been consulted directly except those marked
with an asterisk (*). If the citation is from a secondary source,
that source is indicated in the body of the entry. Works that upon
inspection proved either trivial or redundant have been omitted,
particularly if an article was a republication of an author's pre-
vious work in another form or different periodical. Similarly, most
books that are principally picture-books with no new images or
significant commentary have not been cited. Although some sources
that proved inaccessible were omitted, others were included because
of their apparent significance.

Museum catalog entries for both drawings and paintings have
been limited to the most important collections in the major urban
centers of Northern Italy and to large collections outside of Italy.
Early guidebooks have been included in the bibliography, whereas
later examples have been excluded, unless they contain truly sig-
nificant new information.

The bibliography is divided into five main sections, and the
entries within each section are arranged chronologically. The first

part is a general category that includes sources containing material about artists or works from two or more of the four northern provinces. Each of the remaining four major sections is devoted to one of the four relevant provinces: Emilia-Romagna, Liguria, Lombardy, and the Piedmont.

Within each of these major geographical divisions there are three subgroups. The first is a general category citing studies that include observations about works by a number of artists from the region or anonymous works from less important urban centers. The second subdivision is organized by city. This category, in turn, is divided into as many as four subdivisions. The first subdivision includes general works dealing with art either located in the city or produced by artists working in the city. For example, the Ferrara city category has a subdivision entitled "Ferrara: General." This is the subdivision in which to seek general information concerning the development or character of fifteenth-century Ferrarese art, Ferrarese patronage, significant exhibitions and catalogs, monographs, and articles on Ferrarese painting and drawing. The second subdivision lists guidebooks; the third details significant collections and museums; and the fourth deals with major monuments. Not every city will include all of these different subdivisions. For example, although there are entries under all four types of categories for the city of Ferrara, there are no subcategories for Mantua and Rimini.

The third division for each province is devoted to individual artists. With very few exceptions, these are arranged alphabetically, according to the spelling appearing in Thieme-Becker's <u>Allgemeines</u> <u>lexikon</u> <u>der</u> <u>bildenden</u> <u>Kunstler</u>. Citations under each artist are arranged chronologically. Articles and monographs are listed together.

In general, works have not been cited more than once. In certain cases, however, as when an article treats two or three artists equally, particularly artists from different geographical areas, an exception has been made. In such cases, articles may be cited under each of the individual artists, with the notes reflecting the particular relevance of the information for each of the specific individuals. The other case in which a work may be cited more than once is when single chapters or sections in a book represent virtual monographs or extended statements about individual artists. Notable examples of such multiple citations are Adolfo Venturi's <u>Storia dell'arte italiana</u> (e.g., ERA63, ERA99, ERA345, LI11) and Francesco Malaguzzi Valeri's <u>Pittori lombardi del quattrocento</u> (e.g., LA27, LA115, LA347, LA366).

Entries have been kept as terse and objective as possible. Most indicate which major artists are discussed within the work and whether the publication concerns documentary, stylistic, and/or attributional material. In the case of newly discovered or attributed works, a brief description of the objects' contents and location

usually accompanies the citation. Annotations may also include information regarding the usefulness of a publication, the main thrust of the author's stylistic observations, significant dates, and whether the provenance of works cited is provided.

It has not always been practical to list every artist discussed in a particular work. For example, since Gustave Gruyer's book L'art ferrarais a l'époque des princes d'Este (ERC48) included information on all of the major and minor fifteenth-century Ferrarese artists, a truly exhaustive entry would have to include the names of more than thirty individuals. Such an entry would be cumbersome and not particularly useful. Instead, most of the artists discussed in any detail in a publication have been listed in the Index of Artists. For this reason, the index represents the most complete guide to any particular individual in the bibliography and should be consulted after the reader has examined the artist section.

I should like to conclude this preface by acknowledging the editorial assistance and support of my wife, Carol, and my indefatigable assistant, Kay-Pro II.

Introduction

The historiography of North Italian early Renaissance painting did not come into its own until the seventeenth century. Admittedly, some early Renaissance poets celebrated individual North Italian artists and/or paintings (G8). Giorgio Vasari included scattered biographical references to fifteenth-century North Italian painters in his Vite (e.g., ERA90, ERA142, ERA182, ERA255), and Giovan Paolo Lomazzo mentioned a few Lombard painters and their special talents in his Trattato dell'arte della pittura (L01) and Idea del tempio della pittura (L02). But the first truly extensive studies of North Italian painting and painters were not undertaken until the seventeenth century.

For Emilia-Romagna in general and Bologna in particular, it was Carlo Malvasia's Felsina pittrice: Vite dei pittori bolognesi, published in 1678 (ERC4), that represented the first large-scale attempt to chronicle the artistic history of Northern Italy. The form of the Felsina was to some extent modeled on Vasari's Vite, and its intent was also similar. As the Aretine had written his Lives to enhance the reputation of his Tuscan predecessors and compatriots, so Malvasia wrote to enhance the reputation of his Bolognese and Emilian predecessors and contemporaries. Because North Italian art had suffered such historiographic neglect in the sixteenth century, Malvasia had to depend heavily on the fragments available in the works of Vasari, the writings of Filippo Baldinucci (e.g., ERA257), and such sketchy early Bolognese sources as Giovanni Antonio Filoteo's Il Viridario (ERC1), Pietro Lamo's Graticola di Bologna (ERC18), Ovidio Montalbani's Minervalia bononiense (ERC2), and Antonio Masini's Bologna perlustrata (ERC3) for most of his information. Nonetheless, Malvasia contributed some original material, most notably in his Life of Francia. Unfortunately, the restricted number of sources available to Malvasia, coupled with his chauvanistic bias, makes the Felesina of limited value in studying the fifteenth century in general, and non-Bolognese Emilians in particular.

For Modena, Lodovico Vedriani's Raccolta de' pittori. . . . (ERC144), first published in 1662, represented another early attempt

to assemble a collection of artists' biographies. Because of the scarcity of material, this work, too, includes very little solid information about the fifteenth century.

In the eighteenth century, local historians began to evince an interest in compiling information about their civic and/or regional artistic heritages. In Modena, this work was undertaken by the great literary historian Girolamo Tiraboschi, whose Notizie de' pittori . . . natii negli stati del S. Duca di Modena (ERC145), included as an appendix to the sixth volume of his monumental Biblioteca modenese . . ., was an attempt to bring together a variety of literary and documentary materials relevant to local artists. In Ferrara, it was Girolamo Baruffaldi who first assembled biographies of the principal Ferrarese artists. His work dates from the very end of the seventeenth century and first two decades of the eighteenth, but was not published until 1844 (ERC34). Baruffaldi's somewhat anecdotal Vite was expanded later in the eighteenth century by the archival investigations of Giuseppe Scalabrini, whose invaluable summaries and transcriptions of documents concerning ecclesiastical patronage still remain in manuscript form in the Biblioteca ariostea in Ferrara (ERC29-31); and Cesare Cittadella (ERC32), who borrowed heavily from Baruffaldi's writings but also supplemented them with observations about surviving works and their locations.

The mining of archival material in Ferrara and Modena, the seat of the Archivio estense, became even more intense in the nineteenth and early twentieth centuries as Giuseppe Campori, Luigi Napoleone Cittadella, and Adolfo Venturi began their studies. Cittadella's collections of documentary citations are wide-ranging, but one of his two principal publications is devoted entirely to documentation concerning Ferrarese artists. This work remains a fundamental source for civic and notarial documents (ERC37). Both Campori's and Venturi's work centered around the patronage of the Este. Campori organized his studies by media, discussing the work of painters (ERC41), miniaturists (ERC38-39), architects, and sculptors who worked for the Este, and supporting his observations with significant documentary illustrations. Campori's work, only recently assembled and reprinted by Arnaldo Forni, first appeared in individual articles published in the local provincial journal. By contrast, Adolfo Venturi, one of the most perceptive and informative art historians of his time, not only discussed the Ferrarese school of painting in his monumental Storia dell'arte italiana, but also published a series of articles devoted to art in Ferrara in the fifteenth century before the reign of Borso d'Este (ERC40), under Borso (ERC42), and under Ercole I (ERC46). In addition, Venturi published numerous articles concerning individual artists and monuments in Ferrara, Modena, and Reggio (e.g., ERC44, ERC122, ERC147, ERC168, ERA15, ERA32, ERA92, ERA291-93, ERA338-39), basing his visual observations on a strong first-hand knowledge of the documentary material. Two other significant late nineteenth- and early twentieth-century sources should also be noted: Gustave Gruyer's two-volume work on Ferrarese art during the time of Este family rule, published

at the very end of the century (ERC48), and Hermann Hermann's mono-
graphic article, published in 1900, on manuscript illumination done
for the Este from Nicolò III to Alfonso I d'Este (ERC50). Hermann's
study includes a very rich documentary appendix.

In Bologna, during the latter half of the eighteenth century,
Marcello Oretti collected information about Bolognese and Emilian
artists from a vast variety of sources. His notebooks in the
Biblioteca dell'Archiginnasio (ERC5-6, ERC19-20) contain not only
transcriptions from the communal and notarial archives, but also
descriptions of collections in Bologna and other Emilian and
Romagnole cities, descriptions that include very important attri-
butions. The publication of these notebooks would be a very useful
project.

In Liguria, the early historiography is extremely thin. In the
seventeenth century, following the same pattern as Malvasia in
Bologna, Raffaele Soprani wrote Le vite de' pittori . . . genovesi e
de' forestieri che in Genova operarono (LIC1). This collection,
amplified in the eighteenth century by Carlo Ratti, the author of a
significant guide to art in Liguria in his own right (LI1), unfortu-
nately contains very little information about fifteenth-century
Ligurian artists, for at this time it appears that French and
Lombard influences and artists prevailed and no truly vital indig-
enous Ligurian school existed. This impression is reinforced by the
work of nineteenth-century artist and historian Federico Alzieri,
whose invaluable three-volume work on artists in Liguria through the
sixteenth century, Notizie dei professori dei disegno in Liguria
dalle origini al secolo XVI (LI4), likewise devotes most of its
discussion of the fifteenth century to Lombard and French artists
working in the region. It is not until the early twentieth century,
in the documentary studies of Giuseppe Bres, Notizie intorno ai
pittori nicesi. . . . (LI6) and Questioni d'arte regionale. . . .
Altre notizie inedite sui pittori nicesi (LI8), and Tommaso Bensa,
La peinture en Basse-Provence, à Nice et en Ligurie (LI7), works that
concentrate on the interaction of the school of Nice and Ligurian
art, that sources provide significant insights into regional artists
and their work. Five other nineteenth- and early twentieth-century
historians—Santo Varni, Marcello Staglieno, Archille Neri, Francesco
Podesta, and Orlando Grosso—actively searched the Genoese and
Ligurian archives for references to regional artists from all
periods. Only Varni, Staglieno (LI2 and LIC4), and Grosso (LI10),
however, published portions of their findings. The work of the
other two archivists remains in note form, some at the Biblioteca
Berio and some at the Società di storia patria in Genoa (LI10).

The study of the development of Lombard art and the collection
of pertinent biographical and documentary material progressed much
as it had in Emilia-Romagna and Liguria until the nineteenth cen-
tury. As noted earlier, Lomazzo's Trattato (LO1) and Idea (LO2)
include significant early references to the work of such Lombard
artists as Foppa, Zenale, and Bramantino. Lomazzo, however, bent on

developing a theory of artistic practice, did not provide much biographical or even attributional material in his treatises. True biographical collections focusing on individual cities only began to appear in the seventeenth and eighteenth centuries. In Bergamo, Francesco Maria Tassi's biographical work was published in 1793 (LC1). In Brescia, Don Stefano Fenaroli assembled a Dizionario degli artisti bresciani at the end of the nineteenth century (LC8), based in part on an early eighteenth-century guidebook by Giul'Antonio Averoldo (LC15). Artist/historian Giovanni Battista Zaist published his Notizie istoriche de' pittori, scultori ed architetti cremonesi in 1774 (LC21), the same year in which Alessandro Lamo's Discorso. . . . concerning Cremonese art also appeared (LC20). Both men depended at least in part on Antonio Campo's late sixteenth-century guidebook to Cremona, which listed artists who worked in that city (LC32). In the late nineteenth century, Bartolomeo de Soresina Vidoni also summarized the history of Cremonese art, bringing together material from a wide range of sixteenth- through eighteenth-century sources (LC22).

Mantuan art was documented by Pasquale and Luigi Coddè in the first half of the nineteenth century in their "dictionary" of brief biographies of Mantuan artists (LC37). Between 1857 and 1859, Carlo D'Arco's better-known three-volume collection of documentary notes, Delle arti e degli artefici di Mantova . . ., appeared (LC38). D'Arco's discussion of the fifteenth century was naturally dominated by a consideration of Gonzaga patronage, including Andrea Mantegna's work for the family and Isabella d'Este's commissions. The patronage of the Gonzaga and the contributions and influence of Mantegna (an artist unfortunately outside the parameters of this bibliography) have continued to dominate the study of fifteenth-century Mantuan painting in the studies of Charles Yriarte (ERA94) and Alessandro Luzio (LC39) in the early portion of the twentieth century and up to the present day.

Milan, as one of the two principal centers of Visconti and Sforza power in Lombardy, has naturally received the lion's share of attention in that region. An alphabetical list of pictores memorabilies was included as part of Salvatore Vitale's Theatrum triumphale Mediolanesis . . ., published in the early seventeenth century (LC42). Agostino Sant'Agostino's L'immortalità e gloria del pennello . . ., a guidebook to Milanese painting, appeared in 1671 (LC67). During the following century, Antonio Francesco Albuzzi collected references to Milanese artists (although his work was not published until 1948-55) (LC43), and Carlo Torre (Il ritratto di Milano, 1714) (LC69) and Serviliano Latuada (Descrizione di Milano, 1737-38) (LC70) published important guides to the city and its art. Between 1859 and 1869, Girolamo Calvi published a three-volume documentary work devoted to artists working in Milan during the reign of the Visconti and Sforza, Notizie sulla vita e sulle opere dei principali architetti, scultori e pittori che fiorirono in Milan durante il governo dei Visconti e degli Sforza (LC45). The third volume of Calvi's study is devoted entirely to Leonardo and, as

such, represents an early appreciation of the impact of the Tuscan's presence on the development of Lombard art at the end of the fifteenth century. This same theme underlies Luigi Malvezzi's Le glorie dell'arte lombarda, published in 1882 (L03). Malvezzi's book, an example of typical nineteenth-century campanilismo, is, however, much more concerned with defining the nature of Lombard art before Leonardo and imparting to it some independent value.

One of the most important landmarks in the study of fifteenth-century Lombard art was the founding of the journal Archivio storico lombardo in 1873. This publication became the principal forum for a wide variety of historical articles, a number of which were devoted to the documentation of Lombard art. Articles and notes by historians Michele Caffi (e.g., LC48-49, LC109), Giuseppe Mongeri (LC51), Emilio Motta (LC54, LC113), Gerolamo Biscaro (LC57, LC59), and others appeared throughout the late nineteenth and early twentieth centuries, establishing an important documentary foundation for the study of Lombard painting. The same sort of interest in documentation also underlies Luca Beltrami's study of the building and decoration of the castello in Milan under the Visconti and Sforza (LC87).

In addition to the work of the historians noted above, three other publications dating from the first two decades of the twentieth century are of critical importance for the historiography of Lombard art. The first of these is Francesco Malaguzzi Valeri's Pittori lombardi del quattrocento, published in 1902 (L06). The work consists of eight chapters, each devoted to an individual artist or group of related artists. Malaguzzi Valeri carefully blended biography, stylistic analysis, and documentation. He carried this same methodology over into the volume dedicated to the visual arts in his four-volume history of culture and politics at the court of Lodovico il Moro, La corte di Lodovico il Moro. Volume three, Gli artisti lombardi, appeared in 1917 (L016). Meanwhile, Pietro Toesca had published his classic study of early Lombard painting, La pittura e la miniatura nella Lombardia. Dai più antichi monumenti alla metà del quattrocento (1912) (L014). Toesca's book was one of the earliest serious attempts to define the character of Lombard art without judging it by Tuscan standards.

Pavia did not enjoy the same attention to its monuments and artists in the seventeenth and eighteenth centuries as did the other major Lombard centers. Documentation of the art of that city was neglected until the nineteenth century, and even then, it centered primarily on the Visconti and Sforza foundations, most notably the castello and Certosa. In the sixth volume of his Notizie appartenenti alla storia della sua patria, published in 1838 (LC94), Giuseppe Robolini included a survey of artists working in the Certosa and elsewhere in the city during the last half of the fifteenth century. Later, Carlo Magenta published two extensive studies, the first devoted to the castello (1883) (LC110), and the second to the Certosa (1897) (LC112). Finally, in 1937 and 1949,

Rodolfo Maiocchi published a two-volume collection of Pavian documentary material, the Codice diplomatico-artistico di Pavia dall'anno 1330 all'anno 1550 (LC100). An invaluable research tool for the history of art in Pavia, Maiocchi's monument to archivistic scholarship was made even more useful in 1966, when an index compiled by Renata Cipriani (LC106) finally appeared.

In general, Piedmont suffered from the same sort of benign neglect as Liguria. The first systematic documentation of art in Piedmont was carried out by Giuseppe Vernazza (1745-1822). An indefatigable archivist, Vernazza scoured the Savoyard, notarial, ecclesiastical, and familial archives throughout the region, ferreting out information concerning artists from the fourteenth through the eighteenth centuries. Unfortunately, though Vernazza was assiduous about collecting information, he was not nearly so conscientious about publishing it. The vast majority of his notes remain in manuscript form in the Accademia delle scienze and Biblioteca reale in Turin (e.g., P1). Gianni Carlo Sciolla is currently preparing a preliminary inventory of the Accademia's Vernazza schede that concern the fifteenth century.

In the nineteenth century, some brief studies of individual Piedmontese schools of artists were published, including Giovanni Antonio de Giorgi's Notizie sui celebri pittori e su altri artisti alessandrini (1836) (PC1) and Giuseppe Colombo's Documenti e notizie intorno gli artisti vercellesi (1883) (PC27). Also of significance for the history of Piedmontese art was the introduction of the Atti della Società piemontese di archeologia e belle arti in 1875. This provincial journal became the forum for specialized archeological and art historical articles regarding Piedmont, just as the Archivio storico lombardo had for Lombardy.

No discussion of the early art history of Piedmont would be complete without including the work of another late nineteenth- and early twentieth-century archival scholar, Alessandro Baudi di Vesme. Baudi di Vesme was more conscientious than Vernazza about publishing his findings, particularly in relation to the most important of the fifteenth-century Piedmontese artists, Martino Spanzotti. He also assembled an invaluable bibliography that appeared in the Atti del X Congresso internazionale di storia dell'arte in Rome--1912, published belatedly in 1922 (P14). Many of his findings, however, remained in note form in Turin until very recently, when the four-volume Schede Vesme appeared. References to fifteenth-century Piedmontese and Ligurian artists and collections appear in the fourth volume of this work (P60).

The significance of art produced outside the Tusco-Romano and Venetian traditions was recognized in the earliest of the general surveys of Italian art, Pellegrino Antonio Orlandi's Abecedario pittorico, first published in 1706 (G2), and Luigi Lanzi's Storia pittorica della Italia, 1795-96 (G3). Orlandi includes biographies of artists from Emilia-Romagna, Lombardy, and even Piedmont, but

they are very brief and not always terribly reliable. More inter-
esting is his bibliography, citing very early manuscript sources,
some of which have been lost. Lanzi's Storia includes sections on
the Emilian, Lombard, Genoese, and Piedmontese schools, but his
biographical material is also very slight, particularly in regard to
fifteenth-century North Italian artists, and his critical evalua-
tions of these local schools reveal the author's Tuscan bias.

The Tuscan prejudices of Giorgio Vasari were recognized by some
of his later editors and attempts were made to redress the imbal-
ance. Guglielmo della Valle published sections on Lombard and
Piedmontese art as supplements in his late eighteenth-century edi-
tion of Vasari's Vite (1793-94). These additions included his own
Notizie dell'artefici piemontesi (P2) and Venanzio de Pagave's notes
on the Lombard artists Foppa (LA168) and Bramantino (LA310). In
what has become the standard edition of the Vite, Gaetano Milanese
also expanded on Vasari's sparse comments about North Italian art-
ists, drawing on the various published sources that were available
to him by the end of the nineteenth century (1878-85).

The end of that century also saw a significant new development
in the world of Italian art history. In 1880, physician/connoisseur
Giovanni Morelli published the first of a series of studies con-
cerned with the attribution of works of art in various Italian and
German museums (G5-7). Morelli's now familiar method of attributing
paintings on the basis of an artist's unconscious manner of render-
ing anatomical details represented an attempt to give the art of
connoisseurship a scientific, objective basis. A number of North
Italian works, particularly from the Ferrarese and Milanese schools,
figured prominently in his studies of the Doria-Pamfili, Munich,
Dresden, and Berlin galleries. Perhaps as a result of his desire to
be scientific, Morelli refrained from offering critical judgments
about the paintings he analyzed. Such was not the case with another
prolific art historian, Bernard Berenson. Berenson, also writing at
the end of the nineteenth century and beginning of the twentieth,
was influenced by the Morellian method. He, however, based his
attributions not only on an analysis of details, but also on a
strongly asserted visual sensitivity to individual style. Through-
out his career, Berenson was concerned not only with investigating
problems of attribution and connoisseurship, but also with identi-
fying regional stylistic characteristics. In his view, the stylis-
tic touchstones for the Florentines were a sense of form and tactile
values. For the North Italians, particularly the Ferrarese and
Milanese of the late fourteenth and fifteenth centuries, the charac-
teristic stylistic qualities were an emphasis on illustration and a
tendency toward a certain decorativeness (G9). Inherent in this
analysis was a critical bias, a bias about which Berenson was quite
candid. In his view, Florentine painting represented an ideal; any
alternative visualization of the world was inferior. Thus, Berenson
perpetuated a Vasarian view of the history of art, a view that
devalued the achievements of the North Italians except to the extent
that they were able to absorb and mimic Tuscan attitudes.

The character and development of the various North Italian
schools of painting were chronicled with much greater objectivity by
Joseph Archer Crowe and Giovanni Battista Cavalcaselle, in their
three-volume History of Painting in North Italy (G13), and by Adolfo
Venturi, in the third volume of his Storia dell'arte italiana.
Crowe and Cavalcaselle blended a dependence on traditional sources
and archival materials with an independent stylistic analysis.
Their work remains an important source of information, particularly
concerning the location and condition of objects in the early por-
tion of this century. Venturi devoted considerable space to each of
the provincial schools, writing virtual monographs on such artists
as Cossa (ERA64), Costa (ERA99), and Francia (ERA273) within this
broader framework. Because of the breadth of his knowledge and the
quality of his eye, Venturi's Storia still remains a very useful
resource.

To some extent Morelli, Berenson, Crowe and Cavalcaselle, and
Adolfo Venturi prefigured the direction that the study of fifteenth-
century North Italian painting would take in the twentieth century.
If the nineteenth century was characterized by a concern with docu-
mentation and archival study, the twentieth century has, until
recently, been primarily concerned with the delineation of regional
and individual styles, a definition of the stylistic relationships
among regions and artists, and the attribution of previously unknown
or unattributed works to specific artists or schools. The emphasis
in regard to fifteenth-century North Italian art has, in short, been
principally on questions of style.

This tendency was manifested in and encouraged by the emergence
of several important monographs at the turn of the century. Among
the artists of Emilia-Romagna, Francesco Raibolini (Francia) and
Melozzo da Forlì were the subjects of late nineteenth- and early
twentieth-century monographs. In 1901, George Charles Williamson
published a curiously moralistic biography of Francia (ERA265),
emphasizing the honesty of sentiment in the artist's work. Another,
less didactic, biography was published by Giuseppe Lipparini in 1913
(ERA270). Both works addressed the problems of attribution and
style. The principal pre-1930 monographs devoted to Melozzo were
written by German art historian August Schmarsow and Finnish scholar
Onni Okkonen. Schmarsow's studies, Melozzo von Forlì: Ein Beitrag
zur Kunst- und Kulturgeschichte Italiens in 15. Jahrhunderts (1886)
(ERA186) and Joos van Gent und Melozzo da Forlì in Rom und Urbino
(1912) (ERA198), attempted not only to define the oeuvre of Melozzo
but also to place his work into the more general cultural context of
aristocratic and papal patronage and to define the artist's rela-
tionship to Northern European painting. Unfortunately, this work is
marred by some quite untenable attributions, particularly as regards
the panels done for the Studio dei ritratti in Urbino. Okkonen's
monograph, Melozzo da Forlì und seine schule (1910) (ERA195), is
primarily biographical and stylistic in character and more directly
concerned with the work of Melozzo per se. The final portion of

Okkonen's study is devoted to the definition and assessment of Melozzo's school, including the work of Marco Palmezzano.

In 1938, due to the impetus of a major exhibition of the work of Melozzo and other fifteenth-century Romagnole painters (ERA211), a very brief-lived periodical entitled Melozzo da Forlì was founded in Forlì, devoted to the work of those artists. In the same year, Rezio Buscaroli published a fundamental study entitled Melozzo da Forlì nei documenti, nelle testamonianze dei contemporanei e nella bibliografia (ERA212), which summarized the current state of Melozzo scholarship. In 1955, Buscaroli published Melozzo e il melozzismo (ERA222), in which he attempted to define the formal characteristics of Melozzo's art and to follow its evolution not only in the work of Romagnole artists from the later fifteenth and sixteenth centuries, but on into the twentieth century as well.

In Lombardy, one of the most significant examples of this new monographic interest is the marvelous study of Vincenzo Foppa by Constance Jocelyn ffoulkes and Rodolfo Maiocchi (LA175). Published in 1909, this book remains a model of scholarly documentation and analysis. Subsequent studies of Foppa such as Fernanda Wittgens's stylistically oriented monograph of 1949 (LA184) might differ with ffoulkes and Maiocchi's conclusions, but they have always had to take them under consideration. Another Lombard artist, Bartolomeo Suardi, better known as Bramantino, received the careful attention of Wilhelm Suida at the beginning of the century. Suida's two-part article, which appeared in the Jahrbuch der Kunsthistorischen Sammlungen des allerhöchsten Kaiserhauses between 1905 and 1907 (LA313-14), cited all of the then-known facts concerning Bramantino's life and artistic activity, summarized earlier opinions concerning his work, and offered a coherent vision of the artist's oeuvre and stylistic development. Suida's articles not only confronted the question of what constituted Bramantino's particular style and artistic contribution but also examined the impact of Leonardo on Lombard art. Therefore, the significance of Suida's discussion extended well beyond the work of a single artist. These articles formed the basis for Suida's much later monograph on Bramante and Bramantino (1953) (LA331), a work designed to elucidate the relationship between these two important masters.

Fifteenth-century Ligurian and Piedmontese artists did not receive the same monographic attention at the beginning of the twentieth century as their Lombard and Emilia-Romagnole contemporaries. In general, the attitude seems to have prevailed that the art and artists in these two regions were not only dependent on external influences, most notably French and Lombard, but were also more provincial in character.

In the 1930s, under the influence of the rising sense of nationalism that characterized the Fascist era, three very significant local North Italian exhibitions were held. These shows assembled significant examples of the visual arts of a city or regional school

with the political purpose of demonstrating the depth and glory of
the Italian cultural heritage. The exhibitions offered art histo-
rians a rare opportunity to make comparisons and to define regional
and individual stylistic characteristics. Among these exhibitions
was the above-mentioned show assembled in Forlì in 1938, devoted to
Melozzo and the Romagnole school (ERA211). Other exhibitions were
held in Ferrara in 1933, in honor of the four-hundredth anniversary
of the death of Lodovico Ariosto (ERC65), and in Turin in 1939
(P25). The exhibition in Ferrara, principally devoted to works of
the fifteenth and sixteenth centuries, spawned the first comprehen-
sive attempt to define the nature of Ferrarese quattrocento art:
Roberto Longhi's Officina ferrarese. Longhi based his discussion of
Ferrarese art on a critique of the exhibition and its attributions.
He did not, however, limit his statements to works that were dis-
played in Ferrara, but rather drew on a broad range of comparative
material, much of which he illustrated in the Officina. Longhi
revised his observations throughout a long, productive career, pub-
lishing an Ampliamenti in 1940 and a Nuovi ampliamenti in 1956 as
part of his Opere complete (ERC82). These additional remarks were
also profusely illustrated and, like the original Officina, were
principally concerned with defining the oeuvre of an almost encyclo-
pedic array of fifteenth- and sixteenth-century Ferrarese artists.
Adolfo Venturi (ERC67) and Curt Weigelt (ERC68) also used the oppor-
tunity of the 1933 exhibition to make new observations and attribu-
tions concerning Ferrarese art and artists.

The Piedmontese exhibition, held in the Palazzo Carignano in
1939, was devoted to Gothic and Renaissance art in the province,
Gotico e rinascimento in Piemonte, and was accompanied by an ex-
tremely significant catalog edited by Vittorio Viale (P25). In
addition to its very complete entries for each of the exhibited
objects, this catalog includes a biography of each of the artists
discussed, a review of major works, and a discussion of what the
author saw as the major problems associated with each artist's
oeuvre. Viale was among the first to state the independent nature
of Piedmontese art in very strong and certain terms, claiming, for
example, that Giovanni Martino Spanzotti's art had indigenous
Piedmontese roots. This exhibition generated a number of reviews,
including one by Noemi Gabrielli (P23), a scholar who became one of
the most prolific writers on Piedmontese problems (e.g., P28, P32,
P35, P37). Soon afterward, in 1942, Anna Maria Brizio published a
general review of painting in the province entitled La pittura in
Piemonte dall'eta romanica al cinquecento (P26). This work is
particularly useful for its introductory historiographic essay and
its bibliography.

Major exhibitions of Lombard art were held throughout the
twentieth century. An exhibition dedicated to Milanese art was held
at the Burlington Fine Arts Club in London in 1908, but perhaps more
significant in terms of helping to define the nature of Lombard
painting was the one held at the Circolo d'arte e d'alta cultura in
Milan in 1923. Paolo D'Ancona's review of this exhibition (L017)

opened a lively discussion of the unique character of Lombard art as
intrinsically more emotional than contemporary Tuscan works. After
World War II, an exhibition of Lombard art objects from 500 B.C. to
1800 A.D. was held in Zurich between 1948 and 1949. The catalog for
this show, written by Constantino Baroni and Gian Alberto
dell'Acqua, was published as an independent book in 1952 (L027).
Because the variety of objects included in this exhibition ranged
from liturgical vestments to paintings and sculptures, the particu-
lar value of this volume for the study of fifteenth-century Lombard
painting is somewhat limited. More important, perhaps, is
Constantino Baroni and Sergio Samek-Ludovici's La pittura lombarda
del quattrocento, which also appeared in 1952 (L027). This study,
though somewhat controversial in its conclusions, contains a very
useful opening historiographic essay. In the spring of 1958, a
third exhibition of Lombard art was held in Milan in the Palazzo
reale. This show, devoted to Arte lombarda dai Visconti agli
Sforza, included material that falls more directly within the param-
eters of this bibliography than the 1948 exhibition (L043). The
catalog for the 1958 exhibition includes a brief introduction by
Roberto Longhi, an historian who demonstrated a profound interest in
Lombard art throughout his long career, making notable contributions
to the literature on the Bembi (LA41, LA52), Carlo Braccesco
(LA107), and later Lombard artists.

The 1958 exhibition also inspired a number of evaluative arti-
cles, including a major piece by Longhi himself that appeared in
Paragone in 1958 (L041) and reviews by Anna Maria Brizio (L040),
Atillo Podestà (L044), and Wilhelm Suida (L051). Most recently, in
1982-83, a multifaceted exhibition was held in Milan in honor of the
five-hundredth anniversary of Leonardo's first visit to that city.
That part of the exhibition most significant in terms of this bib-
liography was the portion held at the Museo Poldi-Pezzoli, dedicated
to the works of Bernardo Zenale and examples of indigenous fifteenth-
century Lombard art. The catalog, Zenale e Leonardo: Tradizione e
rinnovamento della pittura Lombarda (LA379), is valuable for the
detailed information it provides about the objects exhibited, its
sophisticated discussion of the problems of style and attribution in
Lombard painting, particularly in regard to Zenale, and its exten-
sive bibliography and documentation.

In Liguria, a seminal survey exhibition was held in the Palazzo
reale in Genoa in 1946. The avowed purpose of this show was to put
on display a large number of objects that had been placed in storage
during the war. The first part of this show, dedicated to Pittura
antica in Liguria dal trecento al cinquecento, was accompanied by a
catalog edited by Antonio Morassi (LT14). The text perpetuates the
notion of Ligurian painting as highly derivative. The book is
useful for its biographies and bibliography, though it does not
illustrate all of the works displayed in the exhibition. Morassi
based his Capolavori della pittura a Genova (LIC7), published in
1951, on the material gathered for the 1946 exhibition.

The subsequent historiography of fifteenth-century North Italian painting is rather diverse. Particular artists and artistic problems in each region have attracted the attention of historians throughout the second and third quarters of this century. Regarding the artists of Emilia-Romagna, major monographs have been written about Francesco del Cossa (ERA75, ERA78, ERA80), Lorenzo Costa (ERA114-15), Melozzo da Forlì (ERA212, ERA222), Marco Palmezzano (ERA250), Ercole de' Roberti (ERA312, ERA317), Cosmè Tura (ERA353, ERA357-59, ERA361), and Marco Zoppo (ERA392, ERA396), though many of these studies date back twenty years or more.

The decorations in the Palazzo Schifanoia have also received considerable attention. Since the frescoes in the Sala dei mesi were uncovered in 1840, the authorship and iconography of this large cycle of secular wall-paintings have been the subject of a lively debate (ERC116-36), particularly in recent years. Though Francesco del Cossa has been universally acknowledged as the painter of three of the fields in the Sala on the basis of documentary and stylistic evidence, the role of other Ferrarese artists such as Cosmè Tura, Ercole de' Roberti, and Baldassare Estense has remained a matter of controversy.

The sources for the contents of the cycle were first proposed by Aby Warburg in 1922 in his classic article on Italian art and astrology (ERC124). His conclusions have been generally, though not universally, accepted. Werner Gundersheimer's publication of Sabadino degli Arienti's descriptions of the fresco cycles in the Este villas of Belfiore and Belriguardo has expanded the Schifanoia inquiry to include the broader question of courtly mural decorations (ERC90).

No single fifteenth-century Ligurian artist has been the subject of monographic treatment, and the region as a whole remains probably the least investigated of the four discussed in this bibliography.

Piedmontese artists Macrino d'Alba (PA42), Giovanni Martino Spanzotti (PA69, PA72), and the Jacquerio (PA28-9) have each been the subject of a monographic study. In addition, there has been a growing interest on the part of a number of historians, including Geronimo Raineri (e.g., P49, P53, PA4, PA6-7) and Marco Piccat (e.g., P54, P56, P58), in publishing more remote fresco cycles in Piedmont. These studies have been concerned with defining popular regional styles and local schools of painting. They have also investigated subject matter and its diffusion within the region. The frescoes, with their palimpsestic structures and frequent combination of texts and images, invite an extended study of fifteenth-century popular visual culture and the relationship between texts and images beyond the world of manuscript illumination.

Lombard artists, like their Emilian counterparts, have continued to enjoy substantial scholarly attention, though there is still much

to be done. The founding of Arte lombarda in 1955 certainly pro-
vided an impetus for this interest. Belbello da Pavia has been the
focus of a number of monographic studies, including those by Antonio
Cadei (LA23), Sergio Samek-Ludovici (LA18), and Millard Meiss and
Edith Kirsch (LA22). Though Bonifacio Bembo was the subject of a
tesi di laurea by Gabriella Ferri in 1954-55 (LA39) and was dis-
cussed in book-length studies devoted to the Visconti tarocchi by
Gertrude Moakley in 1966 (LA51), and Samek-Ludovici in 1969 (LA53),
he has not been the focus of a recent monograph. This is curious,
considering the Bembi's prominence at the Visconti and Sforza courts
and their central place as exemplars of the late Gothic courtly
style in Lombardy.

Though the work of Taddeo Crivelli, another court artist, was
discussed by Campori (ERC38), Venturi (ERC42), and Hermann (ERC50)
in the context of Este patronage and was the subject of a slim,
primarily documentary study by Giulio Bertoni in 1925 (LA164),
Crivelli and his principal collaborator on the Bible of Borso
d'Este, Franco de' Russi, are artists who deserve further attention.
In fact, the history of mid- and late fifteenth-century North
Italian manuscript illumination—its patronage, workshop organ-
ization, and diffusion—are all topics that warrant additional
study.

Vincenzo Foppa has remained a center of interest since the
ffoulkes and Maiocchi and Wittgens monographs. Subsequent studies
have focused on the artist's role as a designer of stained glass in
Pavia (LA191-2), his work at Santa Maria di Castello in Savona
(LA194), his contributions to the development of perspective in
Northern Italy (LA199), the history of the Orzinuovi standard
(LA201), and, most recently, the iconography of the Portinari Chapel
in Sant'Eustorgio, Milan (LA202-3).

Ambrogio da Fossano, better known as Bergognone, has also been
the focus of a great deal of scholarly attention, including three
somewhat disappointing monographs, one by Nietta Aprà in 1945
(LA220), another by Franco Mazzini in 1948 (LA222), and a third by
Jolanda Poracchia in 1963 (LA228). The fascination with this artist
derives in part from the major role he played in the decoration of
the Certosa of Pavia and in part from his status as a transitional
artist who illustrates the wedding of indigenous Lombard stylistic
concerns with the powerful influence of Leonardo. This last issue,
the relationship between Leonardo and Lombard painting, has also
fueled a continuing interest in Ambrogio de Predis, who at one time
was believed to be the mysterious Master of the Pala sforzesca.
Continuing speculation about the identity of this anonymous master,
as well as specific riddles of attribution and dating, have moti-
vated further studies of this important figure (LA263-67).

Finally, Bernardo Zenale, an exemplar of pre-Leonardesque
Lombard attitudes towards space and three-dimensional form, has been
the subject of two recent studies. The first of these, written by

Giovanna Carlevaro, filled an entire issue of <u>Arte lombarda</u> (LA378). The second was the catalog previously noted for the exhibition <u>Zenale e Leonardo</u> (LA379). The appearance of these studies seems to signal a resurgence of interest in the indigenous roots of Lombard art.

Finally, no discussion of the historiography of fifteenth-century North Italian art would be complete without mentioning the work of Carlo Ludovico Ragghianti and Mario Salmi. Both of these historians, like Adolfo Venturi, made wide-ranging and significant contributions to the general study of North Italian art.

Abbreviations

Throughout the bibliography the abbreviation "Thieme-Becker" refers to Thieme, Ulrich, and Felix Becker, <u>Allgemeines lexikon der bilden kunstler</u>.

The following abbreviations have been used in numbering the entries:

G:	General Bibliography
ER:	Emilia-Romagna: General
ERC:	Emilia-Romagna: Cities
ERA:	Emilia-Romagna: Artists
LI:	Liguria: General
LIC:	Liguria: Cities
LIA:	Liguria: Artists
LO:	Lombardy: General
LC:	Lombardy: Cities
LA:	Lombardy: Artists
P:	Piedmont: General
PC:	Piedmont: Cities
PA:	Piedmont: Artists

General Bibliography

G1 VITRUVIUS, POLLIO. De architectura libri dece tr: De
 latino in vulgare, affigurati: Commentati . . . da Cesare
 Cesariano. Como: G. da Ponte, 1521. Reprint. London:
 Benjamin Blom, 1968, 384 pp.
 In list of best contemporary artists (fol. 48v) names
 Boltraffio, Zenale, and Bramantino. Also cites fresco in the
 Castello di Giovia, Milan.

G2 ORLANDI, PELLEGRINO ANTONIO. Abecedario pittorico.
 Bologna: Constantino Pisarri sotto le Scuole, 1706, 436 pp.
 Alphabetically arranged. Brief biographies of artists
 including Piedmontese, Lombard, and Emilian-Romagnole. Very
 interesting for bibliography of books on art.

G3 LANZI, LUIGI ANTONIO. Storia pittorica della Italia dal
 risorgimento delle belle arti fin presso al fino del XVIII
 secolo. 3 vols. Florence: Sansoni, 1968-74, 687 pp., 452
 pp., and 550 pp.
 First edition: 6 parts in 2 vols., 1795-96.
 English translation: The History of Painting in Italy
 from the Period of the Revival of the Fine Arts to the End of
 the Eighteenth Century. Translated by Thomas Roscoe. 6 vols.
 London: W. Simpkin & R. Marshall, 1828.
 Modenese and Lombard artists in vol. 2. Bolognese,
 Romagnole, Ferrarese, Genoese, and Piedmontese in vol. 3.
 Brief biographies and attributions.

G4 MORELLI, JACOPO. Notizia d'opere di Disegno nella prima
 metà del secolo XVI esistenti in Padova, Cremona, Milano,
 Pavia, Bergamo, Crema e Venezia scritta da un anonimo di
 quel tempo. Bassano: n.p., 1800, 272 pp.
 Description of frescoes and easel paintings in the listed
 cities by Marco Antonio Michiel (f. 1552), from the mid-
 sixteenth century. Also known as the Anonimo Morelliano.
 Important for early attributions. Index.

1

General Bibliography

G5　MORELLI, GIOVANNI [Ivan Lermolieff]. Kunstkritische Studien
über italienische Malerei. Vol. 2, Galerien zu München und
Dresden. Leipzig: F.A. Brockhaus, 1891, 393 pp., 41 b&w
illus.
First edition: In Die Werke italienischer Meister in den
Galerien von München, Dresden und Berlin. Leipzig: Seeman,
1880.
English translation: Italian Painters: Critical Studies
of Their Works. Translated by Constance Jocelyn ffoulkes.
Vol. 2, The Galleries of Munich and Dresden. London: John
Murray, 1907, 334 pp., 45 b&w illus. and text illus.
Ferrarese, Bolognese, and Lombard schools of painting in
Munich (pp. 98-121) and Dresden (pp. 163-220 and 334-36).
Discusses works by Cossa, Roberti, "Ercole Grandi," Boltraffio,
and Bernardino dei Conti.

G6　MORELLI, GIOVANNI [Ivan Lermolieff]. Kunstkritische Studien
über italienische Malerei. Vol. 3, Die Galerie zu Berlin.
Leipzig: F.A. Brockhaus, 1893, 394 pp., 66 b&w illus.
First edition: As part of Die Werke italienischer
Meister in den Galerien von München, Dresden und Berlin.
Leipzig: Seeman, 1880.
English translation: Italian Masters in German Gal-
leries: A Critical Essay on the Italian Pictures in the Gal-
leries of Munich-Dresden-Berlin. Translated by Mrs. Louise M.
Richter. London: George Bell & Sons, 1883, 449 pp. (Munich,
pp. 1-99; Dresden, pp. 100-226; Berlin, pp. 227-444).
Attributions for Lombard school, including Zenale,
Butinone, Bergognone, Bernardino dei Conti, and Boltraffio (pp.
104-52); Melozzo and Marco Palmezzano (pp. 48-50); Ferrarese,
differentiating Tura and Costa (pp. 51-60); Bolognese
(pp. 61-68).

G7　MORELLI, GIOVANNI [Ivan Lermolieff]. Kunstkritische Studien
über italienische Malerei. Vol. 1, Die Galerien Borghese
und Doria Pamfili in Rom. Leipzig: F.A. Brockhaus, 1890,
443 pp., 62 b&w illus.
English translation: Italian Painters: Critical Studies
of Their Works. Translated by Constance Jocelyn ffoulkes.
With an Introduction by A.H. Layard. Vol. 1, The Borghese and
Doria-Pamfili Galleries. London: John Murray, 1900, 358 pp.,
text illus.
Most significant for methodology. Important for knowl-
edge of collections and attributions in the late nineteenth
century. Discusses Emilian and Lombard schools.

G8　COLASANTI, ARDUINO. "Gli artisti nella poesia del
rinascimento. Fonti." Repertorium für Kunstwissenshaft 27
(1904):193-220.
Lists sources where contemporary artists are mentioned in
fifteenth- and sixteenth-century poetry. Includes works and

reputations of Boltraffio, Cossa, "Ercole Grandi" and de'
Roberti, Zoppo, Francia, Bramantino, and Tura.

G9 BERENSON, BERNARD. Italian Painters of the Renaissance.
 Vol. 4, The North Italian Painters. Cleveland and New York:
 World Publishing Co., 1957, pp. 223-325.
 First printed separately as: North Italian Painters of
 the Renaissance. New York and London: G.P. Putnam's Sons,
 1907, 341 pp., 1 b&w illus.
 Includes sections on the Ferrarese school and the
 Milanese both before and after Leonardo. Shows a definite
 Tuscan bias in his evaluation. Sees Squarcione as root for
 Tura. Cossa dependent on Tura and Piero. Decline in Roberti.
 Long section on Monza frescoes of the Zavattari. Also signifi-
 cance of Foppa for the Milanese school. Basic characteristic
 of Northern painting is artists' quality as "illustrators."
 First edition includes checklist of artists and works, as well
 as index by location.

G10 FRY, ROGER E. "The Painters of North Italy." Burlington
 Magazine 12 (1907-8):347-49.
 Review of Berenson's The North Italian Painters. Takes
 issue with Berenson's characterization of North Italian paint-
 ers as illustrators. Feels an oversimplification of the
 system.

G11 HOLYROD, Sir CHARLES. The National Gallery, London: The
 North Italian Schools. London: George Newnes, 1907, xli
 pp., 48 b&w illus.
 Cursory introduction with description of schools and
 works, then checklist of works with artists, dates, and
 National Gallery number. Includes works by Foppa, Cossa, Tura,
 Francia, Roberti, Ambrogio de Predis, Bono da Ferrara, Giovanni
 Oriolo, Zoppo, Boltraffio, Bergognone, and Macrino d'Alba.

G12 RICCI, CORRADO. Art in Northern Italy. London: William
 Heinemann, 1911, 372 pp., 590 b&w and 1 color illus.
 General survey of North Italian art arranged by region
 with numerous illustrations. Extensive bibliography. Pub-
 lished in U.S. simultaneously by Charles Scribner's Sons.

G13 CROWE, J[OSEPH] A[RCHER], and G[IOVANNI] B[ATTISTA]
 CAVALCASELLE. A History of Painting in North Italy, Venice
 Padua, Vicenza, Verona, Ferrara, Milan, Friuli, Brescia,
 from the Fourteenth to the Sixteenth Century. Edited by
 Tancred Borenius. Vol. 2. London: John Murray, 1912, 458
 pp., numerous b&w illus. Reprint. New York: AMS Press,
 1976.
 Remains essential source of information about North
 Italian painting. Vol. 2 contains schools relevant to this
 bibliography (see Milan, Ferrara, and Emilia-Romagna for

General Bibliography

pages). Occasionally publishes original documents and lists of
attributed works in notes. Index at end of vol. 3.

G14 BORENIUS, TANCRED. "Professor Venturi on Quattrocento
 Painting." Burlington Magazine 29 (1916):161-64, 1
 b&w illus.
 Review of Adolfo Venturi's Storia dell'arte italiana.
 Critical of attributions to Tura, Cossa, and Ercole de'
 Roberti. Also publishes a Salvator Mundi that he attributes
 to Zoppo in the collection of F.E. Sidney.

G15 SCHLOSSER MAGNINO, JULIUS. La letteratura artistica.
 Florence: La nuova Italia, 1977, 792 pp.
 Original edition: Schlosser, Julius von. Die Kunst-
 literatur. Vienna: Kunstverlag Anton Schroll & Co., 1924.
 History of the literature of art. Includes citations and
 summaries of all of the major early sources through the eight-
 eenth century.

G16 van MARLE, RAIMOND. The Development of the Italian Schools
 of Painting. Vol. 7, Late Gothic Painting in North Italy.
 The Hague: Martinus Nijhoff, 1926, 438 pp., 275 b&w illus.
 Chap. 1 considers the roots of the International style
 and the relationships between North and South. Chap. 2 con-
 siders the phenomenon particularly in Lombardy, Piedmont, and
 Emilia. Reviews, among others, the Besozzi, Francesco
 de'Veris, and the Zavattari. Particularly useful for illus-
 trations. Artist index at end.

G17 BERCKEN, ERICH v.d. Malerei der Renaissance in Italien:
 Die Malerei der Fruh- und Hochrenaissance in Oberitalien.
 Wildpark-Potsdam: Akademische Verlagsgesellschaft Athenaion
 M.B.H., 1927, 274 pp., 13 color and 276 b&w illus.
 General survey of the development of painting in Northern
 Italy, including Piedmont, Liguria, Emilia, Lombardy, and the
 Veneto, from the late fourteenth through the sixteenth cen-
 turies. Bibliography and indexes.

G18 PARKER, K[ENNETH] T. North Italian Drawings of the
 Quattrocento. Drawings of the Great Masters. New York:
 Robert McBride, 1927, 36 pp., 72 collotype illus.
 Illustrates and briefly discusses drawings from provinces
 of Lombardy, Emilia, and the Veneto. Works by major artists
 such as Zoppo, Tura, Cossa, Bergognone, Zenale, Bramantino,
 Boltraffio, and others.

G19 VENTURI, ADOLFO. Studi dal vero attraverso le raccolte
 artistiche d'Europa. Milan: U. Hoepli, 1927, 415 pp., 285
 b&w illus.
 Series of studies of works in private collections and
 public galleries throughout Europe. Arranged by school. In
 Emilian and Romagnole: Melozzo, Angolo degli Erri (St. Vincent

Ferrer panels in Vienna), Tura, Cossa, Roberti, Costa, Zoppo, and Francia. In Lombard, works of Zenale, Bergognone, Boltraffio, and Bramantino.

G20 KIEL, HANNA. "Oberitalienische Porträts der Sammlung Trivulzio." Pantheon 7 (1930):440-48, 6 b&w and 1 color illus.
 Portraits from fifteenth and sixteenth centuries including works attributed to Bernardino dei Conti, Zanetto Bugatto, Baldassare Estense, and Ambrogio de Predis.

G21 VENTURI, ADOLFO. North Italian Painting of the Quattrocento: Lombardy, Piedmont, Liguria. Florence and New York: Pantheon and Harcourt, Brace, [1931], 115 pp., 80 collotype illus.
 General overview of fifteenth-century painting in Lombardy, Piedmont, and Liguria. Bibliography. German and Italian translations published at the same time. See also Emilia.

G22 VENTURI, ADOLFO. Pitture italiane in America. Milan: U. Hoepli, 1931, unpaged, 438 b&w and 1 color illus.
 Important mainly for the illustrations. Very brief biographies. Index in the back.

G22A van MARLE, RAIMOND. "La pittura all'esposizione d'arte antica italiana di Amsterdam." Bollettino d'arte 28 (1934-35):445-59, 10 b&w illus.
 Review of exhibition of North Italian paintings in Amsterdam from Dutch public and private collections. Illustrates works by or attributed to Francesco Zaganelli, Marco Zoppo, Francesco del Cossa, Foppa, Lorenzo Costa, Butinone, Bramantino, Ambrogio de Predis, and Bergognone.

G23 BUDINIS, CORNELIO. Gli artisti in Ungheria: L'opera del genio italiano all'estero. Rome: La libreria dello stato, 1936, 190 pp., 183 b&w illus.
 "L'epoca di Mattia Corvino," pp. 39-64, includes brief notices about the activities of Guglielmo Giraldi, Francesco da Castello, Cattaneo, and the Master of the Missal of Bona Sforza, in Hungary at the court of Matthew Corvinus.

G24 SUIDA, WILHELM. "Italian Miniature Painting from the Rodolphe Kann Collection." Art in America 35 (1947):19-33, 9 b&w illus.
 Attributes works to Cristoforo de Predis (Pliny, Natural History); Antonio da Monza (Chorale); anonymous Lombard and Ferrarese artists, the latter showing the influence of Roberti; and Giraldi.

G25 POPHAM, ARTHUR E., and JOHANNES WILDE. The Italian Drawings at Windsor Castle. Vol. 3, The Italian Drawings of the XV

and XVI Centuries in the Collection of His Majesty the King
at Windsor Castle. London: Phaidon, 1949, 390 pp., 402 b&w
illus.
 Individual entries with description, measurements, prove-
nance, bibliography, and related or similar works for drawings
by Butinone, Cossa, Costa, Francia, Giovan Francesco Maineri,
Marmitta, Palmezzano, Ambrogio de Predis, Roberti, Tura, and
Zoppo.

G26 POPHAM, ARTHUR E., and PHILIP POUNCEY. Italian Drawings in
 the Department of Prints and Drawings in the British Museum:
 The Fourteenth and Fifteenth Centuries. 2 vols. London:
 British Museum, 1950, 230 pp., 286 b&w illus.
 Includes entries on drawings by Butinone, Cossa, Costa,
 Francia, Giovan Francesco Maineri, Marmitta, Palmezzano, Ercole
 de' Roberti, Ambrogio de Predis, and Zoppo. Description of the
 drawing and links to other works by artist.

G27 BERTINI, ALDO. I disegni italiani della Biblioteca reale di
 Torino. Rome: Istituto poligrafico dello stato, 1958, 87
 pp., 700 b&w illus.
 Physical description and attributions. Works by Butinone,
 Giovan Francesco Maineri, Zoppo, Bramantino, Boltraffio, and
 Lombard and Ferrarese schools.

G28 RUSSOLI, FRANCO. La raccolta Berenson. With a "Presenta-
 tion" by Nicky Mariani. Milan: Officine grafiche ricordi,
 1962, unpaged, 102 b&w and color illus.
 Catalog of Berenson Collection. Attributions, brief
 bibliography, index. Works by Bergognone, Antonio de
 Crevalcore, Foppa, Roberti, Scaletti, G.B. Utili, and Michele
 da Matteo.

G29 ZOEGE von MANTEUFFEL, CLAUS. Italienische Zeichnungen vom 14.
 bis zum 18. Jahrhundert. Bibliothek der Meisterzeichnungen,
 vol. 3. Hamburg: Hoffman & Campe, 1966, 143 pp., 87 color
 illus.
 Drawings by Zoppo, Cossa, Roberti, Francia, and Boltraffio.
 Mainly of value for the plates.

G30 BERENSON, BERNARD. Italian Pictures of the Renaissance:
 Central Italian and North Italian Schools. 3 vols. London
 and New York: Phaidon, 1968, 533 pp., 1711 b&w illus.
 First volume is checklist of works alphabetically by
 artist. Topographical index of locations in back. Iconography
 of work and date. Vols. 2 and 3 are plates. Checklist is
 revised from 1907 book on North Italian painting by Berenson
 (G9).

G31 SHAPLEY, FERN RUSK. Paintings from the Samuel H. Kress
 Collection: Italian School XV-XVI Century. 2 vols. London

and New York: Phaidon, 1968, 435 and 459 pp., 450 and 444
b&w and color illus.
Entries on Belbello, Tura, Baldassare d'Este, Cossa,
Roberti, and Zoppo in vol. 1. Entries on Foppa, Nicolò da
Varallo, Francia, Costa, Giovan Francesco Maineri, Butinone,
Zenale, Bramantino, Bergognone, and Macrono d'Alba in vol. 2.
Literature and provenance.

G32 KOSCHATZKY, WALTER, KONRAD OBERHUBER, and ECKHART KALB, eds.
Italian Drawings in the Albertina. Greenwich, Conn.: New
York Graphic Society, 1971, 322 pp., 100 color illus.
Includes drawings accompanied by brief biography and
bibliography by Michelino da Besozzo, Ercole de' Roberti,
Lorenzo Costa, Francia, and Bramantino.

G33 LONDON. NATIONAL GALLERY. Illustrated General Catalogue.
London: National Gallery, 1973, 842 pp., numerous b&w illus.
Measurements, title, and provenance for all of the works.
Every work illustrated with a small black and white photo.
Works arranged alphabetically by artist. Includes paintings by
the Master of the Pala sforzesca, Bergognone, Foppa, Macrino,
Boltraffio, Tura, Cossa, Costa, Bono da Ferrara, and others.

G34 SHAW, JAMES BYAM. Drawings by Old Masters at Christ Church,
Oxford. Vol. 1, Catalogue. 445 pp., 139 b&w illus. Vol.
2, Plates. 890 b&w illus. Oxford: Clarendon Press, 1976.
Drawings by the following artists cited in the catalog,
with provenance, measurements, and bibliography: Costa, no.
861-63; Bramantino, no. 1060; and Boltraffio, no. 1062.

G35 ZERI, FEDERICO. Italian Paintings in the Walters Art
Gallery. Vol. 1. Baltimore: Trustees of the Walters
Gallery, 1976, 312 pp., 202 b&w illus.
Entries for works by Baldassare Carrari, Cristoforo
Caselli (Temperello), Filippo Mazzola, Zenale, Antonio della
Corna, Master of the Pala sforzesca, Foppa, G.B. Bertucci,
Francesco Zagnelli, Roberti, Costa, Zoppo, Michele di Matteo,
Francesco da Rimini, and Francia. Very complete entries, at-
tribution history, subject matter, condition, bibliography.
Every work illustrated.

G36 CANOVA, GIORDANA MARIANI. Miniature dell'Italia
settentrionale nella Fondazione Giorgio Cini. Vincenza:
Neri Pozza, 1978, xxii + 104 pp., 255 b&w and 8 color illus.
outside the text.
Catalog of collection including much comparative mate-
rial. Individual entries include bibliography, provenance,
approximate date, and stylistic environment. By school.

G37 PARIS. LOUVRE. Catalogue sommaire illustré des peintures
du Musée du Louvre. Vol. 2, Italie, Espagne, Allemagne,

7

General Bibliography

Grande-Bretagne et divers. Paris: Reunion des musées nationaux, 1981, 411 pp., numerous b&w illus.
Italy, pp. 139-338, with artist index. Small illustrations, provenance, and attributional history. Works by the following artists: Bergognone, Bernardino dei Conti, Boccaccino, Boltraffio, Braccesco, Costa, Lorenzo Fasolo, Francia, Marimitta, Marco d'Oggiono, Michele di Matteo Lambertini, Palmezzano, Roberti, Tura, Zenale, and Zoppo.

G38 SHEARMAN, JOHN. The Early Italian Pictures in the Collection of Her Majesty the Queen. Cambridge, Eng.: Cambridge University Press, 1983, 301 pp., 274 b&w illus.
Catalog entries including condition report, iconography, attributions, and provenance on works by the following artists: Bergognone (cat. 40-42); Costa (cat. 77-78): Francia (cat. 95-98); Marco Palmezzano (cat. 180-81); and Francesco and Bernardino Zaganelli (cat. 327).

G39 KAFTAL, GEORGE. Iconography of the Saints in the Painting of North West Italy. Florence: Sansoni, 1985, xx + 430 pp., 958 b&w illus.
Iconographic index of saints and their attributes for Lombardy, Piedmont, Savoy, and Liguria. Includes index of painters and schools. Also bibliographic index.

Emilia-Romagna

GENERAL

ER1 ORETTI, MARCELLO. Pitture dello Stato ecclesiastico.
 Bologna, Biblioteca communale dell'Archiginnasio, MS. B.
 291., 1778, 358 fols.
 Includes sections on Forlì, with notices of Melozzo and
 Palmezzano; Ferrara and territories, ff. 110-28; and Romagna,
 ff. 173-211. Depends heavily on secondary sources.

ER2 FILIPPINI, FRANCESCO. Studi di storia dell'arte. Bologna,
 Biblioteca communale dell'Archiginnasio, Fondi speciali,
 Carte di Francesco Filippini, Cartelle i-vii.
 Collected articles and notes of Filippini, one of the
 great historians of the art of Emilia-Romagna. Includes
 notices on Francia, Melozzo, Giovan Francesco Maineri, Ercole
 de' Roberti, Cossa, Lianori, Zoppo, and Costa.

ER3 FRIZZONI, GUSTAVE. "La Galerie Layard." Gazette des
 beaux-arts, 3d ser. 15 (1896):455-76, 5 b&w illus.
 Paintings from the Costabili Collection, Ferrara, pur-
 chased by Layard, include Primavera from the studiolo of
 Belfiore, attrributed to Tura; Costa, Adoration of the Child;
 "Ercole Grandi," two Old Testament subjects including a Gather-
 ing of Manna. Also notes Bramantino, Adoration of the Magi.

ER4 KRISTELLER, PAUL. Andrea Mantegna. London, New York and
 Bombay: Longmans, Green, & Co., 1901, pp. 69-81, figs.
 11-14.
 Includes discussion of the role of Ansuino da Forlì and
 Bono da Ferrara in the decorations of the Ovetari Chapel,
 Church of the Eremetani, Padua. Also discusses relationship
 between Mantegna and Melozzo.

ER5 TOESCA, PIETRO. "Di un pittore emiliano del rinascimento."
 L'arte 10 (1907):18-24, 3 b&w illus.
 Assigns three panels, one in the Wallace Collection in
 London and one in Faenza, to an anonymous Emilian artist.

9

General

ER6 RICCI, CORRADO. "Emilia: The Painting of the 14th and 15th
 Centuries." In Art in Northern Italy. London: William
 Heinemann, 1911, pp. 302-19, numerous b&w illus.
 Brief biography and sketch of major works of the princi-
 pal artists in Emilia-Romagna. Bibliography.

ER7 CROWE, J[OSEPH] A[RCHER], and G[IOVANNI] B[ATTISTA]
 CAVALCASELLE. "Painters of Parma and Romagna." In A
 History of Painting in North Italy. Edited by Tancred
 Borenius. Vol. 2. London: John Murray, 1912, pp. 295-315,
 4 b&w illus.
 Cursory sketch of schools of Parma and Romagna. Notices
 of Bernardino Loschi, Filippo Mazzola, Cristoforo Casella,
 Alessandro Araldi, and Nicolò Rondinello.

ER8 VENTURI, ADOLFO. La storia dell'arte italiana. Vol. 7, La
 pittura del quattrocento. Pt. 3. Milan: U. Hoepli, 1914,
 pp. 849-1128, 219 b&w illus.
 Chapter on the diffusion of Ferrarese art in Emilia-
 Romagna. Specific discussion of works of Francia, Scaletti,
 Agnolo and Bartolomeo degli Erri, Bianchi-Ferrari, Giovan
 Francesco Maineri, and Araldi.

ER9 VENTURI, ADOLFO. North Italian Painting of the
 Quattrocento: Emilia. Florence and Paris: Pantheon/
 Pegasus Press, 1931, ix + 105 pp., 80 collotype illus.
 Two principal early influences: Pisanello leads to popu-
 lar art of Bartolomeo Grossi and Jacopo Loschi in Parma, and
 Tuscan influence via Piero visible in Ferrara in work of Bono
 and Galasso. Piero also influenced Ansuino da Forlì and the
 Lendinara. In Bologna main influences Marco Zoppo and Paduan
 art. Three main figures in Ferrara: Tura, a combination of
 Tuscan and German influence, leads to Costa; Cossa; and Roberti.

ER10 FIOCCO, GIUSEPPE. "Porträts aus der Emilia." Pantheon 10
 (1932):337-43, 9 b&w illus.
 Publishes a number of male and group portraits that he
 attributes to Tura, Francia, Antonio della Corna, and Antonio
 di Bartolomeo Maineri.

ER11 SALMI, MARIO. "La miniatura emiliana." In Tesori delle
 biblioteche d'Italia. Edited by Domenico Fava. Emilia-
 Romagna. Milan: U. Hoepli, 1932, pp. 267-374, 3 color and
 418 b&w illus.
 History of manuscript illumination in Emilia in fifteenth
 century (pp. 321-74). Discussion of individual artists and
 projects. Special attention to Ferrarese school. Increase in
 Lombard influence under Ercole I. Following artists discussed:
 Giorgio d'Alemagna, Benedetto degli Erri, Taddeo Crivelli,
 Franco de' Russi, Marco dell'Avogaro, Guglielmo Giraldi, Fra
 Evangelista da Reggio, Jacopo Filippo Medici called l'Argenta,
 Andrea delle Vieze, and Martino da Modena. Index of proper names.

ER12 BUSCAROLI, REZIO. La pittura romagnola del quattrocento.
 Faenza: Fratelli Lega, 1931, xiv & 469 pp., 136 b&w illus.
 Sections on all major Romagnole artists. Biographies,
 attributions, and bibliography.

ER13 RIGONI, ERICE. "Il pittore Nicolò Pizolo." Arte Veneta 2
 (1948):141-47.
 Includes documentation on the Ovetari Chapel, Church of
 the Eremetani, Padua, relevant to the work of Ansuino da Forlì
 and Bono da Ferrara.

ER14 RUHMER, EBERHARD. "Jacob Bean: Les dessins italien de la
 collection Bonnat (1960)." Pantheon 20 (1962):186-88, 7 b&w
 illus.
 Includes fifteenth-century drawings by artists from
 Romagna.

ER15 QUINTAVALLE, ARTURO CARLO. "I freschi di Vignola e la
 pittura emiliana del primo quattrocento." Arte antica e
 moderna 20 (1962):439-47, 20 b&w illus.
 Illustrations of frescoes in the Castle of Vignola, ca.
 1420, by an anonymous Emilian artist, circle of Belbello, and
 artists working at the court of Milan.

ER16 BOTTARI, STEFANO. "La pittura in Romagna nel tempo di
 Caterina Sforza." Atti e memorie della Deputazione di
 storia patria per la provincia di Romagna 15-16
 (1963-65):236-43, 2 b&w illus.
 Principally of interest for Melozzo information.

ER17 TOURING CLUB ITALIANO. Guida d'Italia: Emilia-Romagna.
 Milan: Touring Club italiano, 1971, 787 + 47 pp., 9
 maps and 17 city plans.
 Comprehensive guide to the region. Index by artist and
 location.

ER18 TEMPESTI, ANNA FORLANI, and ANNA MARIA PETRIOLI TOFANI. I
 grandi disegni italiani degli Uffizi di Firenze. Milan:
 Silvana editoriale d'arte, 1973, 306 pp., 100 color and 51
 b&w illus.
 Includes discussion and illustration of the following
 works: Costa, Coronation of the Virgin, 178E; Tura, St. John
 the Evangelist, 2068F; Roberti, Five Figures 103F; and Orpheus
 (normally attributed to Cossa, here to an anonymous fifteenth-
 century Ferrarese), 1394F.

ER19 FIOCCO, GUISEPPE. The Frescoes of Mantegna in the Eremetani
 Church, Padua. London: Phaidon, 1978, 117 pp., 25 color
 and 17 b&w illus.
 Brief discussion of the role of Ansuino da Forlì and Bono
 da Ferrara in the Ovetari Chapel decorations. Includes se-
 lected bibliography on the chapel at the end.

General

ER20 DREYER, PETER. I grandi disegni italiani del
 Kupferstichkabinett di Berlino. Milan: Silvana, 1979,
 277 pp., 80 color and 6 b&w illus.
 Includes discussion and illustration of Francia, St.
 Sebastian, KdZ5221; and Tura, Allegory, KdZ5051.

ER21 BOSCHETTO, ANTONIO, and MARIA GRAZIA VACCARI. Maestri
 emiliani del quattro e cinquecento. Biblioteca di disegni,
 vol. 11. Florence: Istituto Alinari, 1980, 29 pp., 40
 color illus.
 Includes drawings by Giovan Francesco Maineri, Francesco
 Marmitta, and Francia.

ER22 GRIGORIEVA, I., J. KUZNETSOV, and I. NOVOSELSKAJA. Disegni
 dell'europa occidentale dall'Ermitage di Leningrado.
 Gabinetto disegni e stampe degli Uffizi, 57. Florence: Leo
 S. Olschki, 1982, 95 pp., 100 b&w illus.
 Drawings by Baldassare Estense, Portrait of a Man;
 Francia, Sacrifice of Bacchus, end of fifteenth century; and
 Ercole de' Roberti, Group of Este Princes, ca. 1492.

 CITIES

 BOLOGNA

 General

ERC1 FILOTEO, GIOVANNI ANTONIO. Il Viridario. Bologna:
 Hieronymo di Plato, 1513, 197 pp.
 Rare early source that on page 188 mentions Crevalcore,
 Bittino da Forlì, and "il dopio [sic] Hercule," which has been
 taken to refer to Ercole de' Roberti and "Ercole Grandi."

ERC2 MONTALBANI, OVIDIO. Minervalia bononiense civium anademata,
 seu biblioteca boneniensis cui acessit antiquiorum pictorum
 et sculptorum bonon. brevis catalogus collectore Jo. Antonio
 Bumaldo (pseudo). Bologna: Benacci, 1641, 264 pp.
 On pp. 238-64, a brief guide to the major artists and
 their works in Bologna, with dates. Some dependence on the
 Viridario (ERC1). Includes mention of Galasso, Lippo Dalmasio,
 Lambertini, the "two Ercoles," Antonio Crevalcore, Costa, and
 Francia.

ERC3 MASINI, ANTONIO di PAOLO. Bologna perlustrata. 3 vols in
 2. Bologna: Erede di Vittorio Benacci, 1666, 752 pp., 216
 pp., and 332 pp. with 1 map.
 First edition: 1650, enlarged in 1666.
 Vol. 1, Tavola de' pittori, scultori et altri artefici
 della scuola di Bologna, pp. 612-40, lists date, name, object
 or activity with page references to the general chronological

history of Bologna. Also includes notices of various churches where objects are displayed.

ERC4 MALVASIA, CARLO CESARE. Felsina pittrice: Vite dei pittori bolognesi. 2 vols. Bologna: Erede di Domenico Barbieri, 1678, 582 and 608 pp. Reprint. Bologna: Edizioni Alfa, 1971, 2 vols. in 1, vi + 621 pp.
 Collection of biographies, chronologically arranged. Argues for indigenous Bolognese school. Place of Lippo Dalmasio as teacher, list of works. Also mentions, in fifteenth century, Lianori, Lambertini, "Ercole da Bologna," Caterina dei Vegri, and Marco Zoppo. Life of Francia, pp. 38-50, Costa, pp. 58-60.

ERC5 ORETTI, MARCELLO. Tavola dei pittori, scultori, architetti Bolognesi . . . descritti secondo il tempo che fiorono. Bologna, Biblioteca comunale dell'Archiginnasio, MS. B. 406., 18th century.
 Collection of notices culled from a variety of sources including Masini, Malvasia, and the Viridario, by century. Includes main works in Bologna. Fifteenth century ff. 3-6.

ERC6 ORETTI, MARCELLO. Notizie de professori del disegno cioé pittori, scultori ed architetti bolognesi e de forestieri de sua scuola. Vol. 1. Bologna, Biblioteca comunale dell'Archiginnasio, MS. B 123., 18th century, 516 fols.
 A thirteen-volume compendium of information of which the first volume includes the fifteenth century and volume thirteen (B. 135) is a general index. Includes matricola of the painters' guild ff. 20a-g.

ERC7 BOLOGNINI-AMORINI, ANTONIO. Vite de' pittori e architetti bolognesi. 5 vols. in 2. Bologna: Tipi Governativa alla Volpe, 1841-43, 34 pp., 167 pp., 202 pp., 115 pp., and 405 pp.
 Vol. 1 argues for an indigenous Bolognese school. Among fifteenth-century artists, Pietro Lianori, Michele Lambertini, Zoppo, and Ripanda. Vol. 2 continues argument, in opposition to Baldinucci. Lives of Francia (pp. 42-65) and Lorenzo Costa (pp. 69-77).

ERC8 VENTURI, ADOLFO. "La mostra d'arte antica a Bologna." Rassegna emiliana di storia, letteratura ed arte 1 (1888-89):428-33.
 Discusses painting by Marco Zoppo from the Collegio degli Spagnuoli in Bologna, as well as works by Francia and Tura.

ERC9 VENTURI, ADOLFO. "La pittura bolognese nel secolo XV." Archivio storico dell'arte 3 (1890):281-95, 7 b&w illus.
 General survey of fifteenth-century Bolognese art.

Cities

ERC10 MALAGUZZI VALERI, FRANCESCO. "Architetti, scultori,
 pittori, miniatori e orefici ricordati in atti guidiziari di
 Bologna." Archivio storico dell'arte 7 (1894):370-71.
 Includes documents concerning Lorenzo Costa.

ERC11 MALAGUZZI VALERI, FRANCESCO. "La miniatura in Bologna dal
 XIII al XVIII secolo." Archivio storico italiano, 5th ser.
 18 (1896):242-315.
 Pp. 270-315 include information on the fifteenth century
 and later. Documentation particularly on Taddeo Crivelli,
 Martino da Modena, Tommaso Basso, Domenico Pagliarlo and their
 work on the choirbooks for San Petronio, and on Gerardo
 Ghisilieri, who also worked for the Este. Numberous minor
 miniaturists.

ERC12 MALAGUZZI VALERI, FRANCESCO. "I pittori ufficiali a
 Bologna." Rassegna bibliografica dell'arte italiana 1
 (1898):1-3.
 Documents concerning official painters for Bologna for
 decorative projects. Tommaso di Alberto Garelli (1465-88).
 Also mentions minor artists Giovanni and Alessandro de Orazio.
 Documents in the Mandati, Comunale, Archivio di stato, Bologna.

ERC13 RUBBIANI, ALFONSO. "Il Castello di Giovanni II Bentivoglio
 a Ponte Poledrano." Atti e memorie della reale Deputazione
 di storia patria per le provincie di Romagna, 4th ser. 3
 (1906):145-234.
 Includes description of the decorations of the apartments
 and chapel. Paintings by Lorenzo Costa.

ERC14 GEREVICH, TIBERIO. "Sull'origine del rinascimento pittorico
 in Bologna." Rassegna d'arte 7 (1907):177-84, 7 b&w illus.
 Third part of three-part article. First source of in-
 fluence indigenous, Jacopo de Paolo, led to Michele di Matteo
 Lambertini, Pietro Lianori, and Marco Zoppo, in ruggedness.
 After mid-century primary forces Ferrarese, Galasso, Roberti,
 Cossa, and Costa. Considers Costa as synthesis in new formal
 harmony.

ERC15 ZUCCHINI, GIULIO. Bologna. Italia artistica, 76. Bergamo:
 Istituto italiano d'arti grafiche, 1914, 172 pp., 170 b&w
 illus.
 Historical overview of art in Bologna. Fifteenth century
 covered on pp. 95-104. Francia and Costa among those discussed.

ERC16 FRATI, LODOVICO. "Miniatori bolognese del quattrocento."
 L'arte 22 (1919):121-23.
 Cites documents naming Taddeo Crivelli, Tommaso di Cesare
 Basso da Modena, Gabriele de' Cipelli, Bartolomeo del Tintore,
 Domenico Pagliarolo, Giovanni di Biagio, Nicolò di Marescotti,
 and Antonio di Giacomo degli Arienti.

ERC17 CUPPINI, GIAMPIERO, and ANNA MARIA MATTEUCCI. Ville del
 bolognese. Bologna: Zanichelli, 1969, xv + 398 pp.,
 numerous b&w and color illus.
 Publishes late fifteenth-century fresco in the Castello
 di Ponte Poledrano. The frescoes illustrate the story of bread
 in ten episodes: 1) clearing the land; 2) plowing and sowing;
 3) maturation of the grain; 4) gathering the grain; 5) thresh-
 ing; 6) transporting the grain to the mill; 7) the mill; 8)
 making bread; 9) baking bread; 10) three knights serving a meal
 to three ladies. Artist in the circle of Ferrarese art.

 Guidebooks

ERC18 LAMO, PIETRO. Graticola di Bologna, ossia descrizione della
 pitture, sculture e architetture di detta città fatta l'anno
 1560. Bologna: Guidi dall'Ancona, 1844, 50 pp.
 Early descriptive guidebook organized by structure.

ERC19 ORETTI, MARCELLO. La pitture nelle chiese della città di
 Bologna. Bologna, Biblioteca comunale dell'Archiginnasio,
 MS. B. 30., 1767, 410 fols.
 Descriptions of paintings in churches, also oratories and
 homes in Bologna in mid-eighteenth century. Includes the fate
 of the works. Index of churches mentioned, but not by artist.

ERC20 ORETTI, MARCELLO. Le pitture che si ammirano nelli palazzi
 e case de' nobili della città di Bologna e di altri edifici
 in detta città. Notizie raccolte da varrij autori e da
 molti inventori fatti dà valorosi cognitori della pittura,
 e dalli archivi. Bologna, Biblioteca comunale
 dell'Archiginnasio, MS. B. 104, 18th century, 249 fols.
 Invaluable source for inventories of private collections
 in the eighteenth century and earlier. Index of locations, but
 no index by artist or work.

ERC21 ZUCCHINI, GUIDO. "Catalogo critico delle guide di Bologna."
 L'Archiginnasio 46-47 (1951-52):135-68.
 Critical discussion of guidebooks to Bologna from Lamo
 (1560) to 1950. Includes description of the contents of the
 guidebooks and various editions.

ERC22 VARESE, RAINERI. "Una guida inedita del seicento
 bolognese." Critica d'arte 103 (1969):25-38; 104 (1969):
 31-42, 16 b&w illus.
 Guide of Francesco Cavazzoni, Pitture e sculture ed altre
 cose notabili che sono a Bologna e dove si trovano, 1603, in
 Bologna, Biblioteca comunale dell'Archiginnasio, MS. B. 1343.
 Compares with Lamo (ERC18); in places more complete, but gen-
 erally more spare and less meticulous.

Cities

Collections and Museums

ERC23 MAUCERI, ENRICO. La regia Pinacoteca di Bologna. Bologna:
La libreria dello stato, 1935, 216 pp., 28 b&w illus.
Very cursory guide to the collection in the Pinacoteca.
Description, size, provenance when known. Works by Cossa,
Foppa, Lippo Dalmasio, Roberti, Francia, and Palmezzano.

ERC24 EMILIANI, ANDREA. La Pinacoteca nazionale di Bologna.
Preface by Cesare Gnudi. Bologna: Cappelli, 1967, 493 pp.,
349 b&w and color illlus.
Updated guide to the Pinacoteca. General history of the
museum. Eightheenth-century inventories of the collection.
Some longer entries with provenance, condition of the work, and
stylistic observations. Works by Francia, Giovan Francesco
Maineri, Panetti, Coltellini, Roberti, Cossa, Zoppo, and Pietro
Lianori.

FAENZA

ERC25 GIORDANI, GAETANO. Memorie MSS^e intorno alla vita ed alle
opere de pittori, scultori, architetti ecc. di Faenza.
Bologna, Biblioteca comunale dell'Archiginnasio, MS. B.
1803, 1827, 388 fols.
Index in front and chronological list of Faentine
artists. Very few fifteenth century. Only one with any real
information is Giovanni Battista Bertucci; includes family
tree.

ERC26 VALGIMIGLI, GIAN MARCELLO. Dei pittori e degli artisti
faentini de secolo XV e XVI. Faenza: P. Conti, 1871, 186
pp. Reprint. Bologna: Forni, 1976.
Includes documents, shortened form, and inscriptions
pertaining to Bittino da Faenza, Gian Francesco Scaletti,
Giovanni da Oriolo, and Andrea Utili.

ERC27 GRIGONI, CARLO. La pittura faentina dalle origini alla metà
del cinquecento. Faenza: Lega, 1935, 750 pp., 37 b&w
illus.
Organized chronologically. Biographies of artists. Rich
source of documents. Entries for Marco Palmezzano, Utili,
Scaletti, and Bartolo Coda, as well as minor masters. Index.

FERRARA

General

ERC28 MARESTI, ALFONSO. Teatro genealogico et istorico delle
antiche et illustri famiglie di Ferrara. 2 vols. Ferrara:
1678-81. Reprint. Bologna: Forni, 1973, 2 vol. in 1.

Biographical sketches in alphabetical order by family of
major families of Ferrara. Includes some information about
patronage. Not totally reliable.

ERC29 SCALABRINI, GIUSEPPE ANTENORE. Memorie della Cattedrale di
Ferrara. 2 vols. Ferrara, Biblioteca ariostea, Cl. I,
447., 18th century, 336 and 446 fols.
Includes documents, which have subsequently been lost,
about objects done for the cathedral, including manuscripts by
Giraldi. Also Tura documents.

ERC30 SCALABRINI, GIUSEPPE ANTENORE. Le rendite e le spese della
sacrista della Metropolitana di Ferrara. Ferrara, Biblioteca
ariostea, Cl. I, 456., 18th century, 323 fols.
Notices from the sacristy account books from 1404-1699.
The originals have been lost.

ERC31 SCALABRINI, GIUSEPPE ANTENORE. Vite de pittori e scultori
Ferrarese . . . scritte dal dottor. Girolamo Baruffaldi
. . . e notate ed abbreviate dal . . . can. Giuseppe
Antenore Scalabrini. Ferrara, Biblioteca ariostea, Cl. I,
129., 18th century, 99 fols.
Late seventeenth-century collection of biographies, in-
cluding Galasso, Tura, Cossa, and Roberti.

ERC32 CITADELLA, CESARE. Catalogo istorico de' pittori e scultori
ferraresi e delle opere loro. 4 vols. Ferrara:
F. Pomatelli, 1782, 198 pp., 246 pp., 328 pp., and 346 pp.
Chronologically organized biographies. Vol. 1 includes
figures from fifteenth century. Antonio Alberti, mentions
works destroyed in 1780 in Paradiso, Tura, Jacopo Filippo
Medici called L'Argenta, Giraldi, Caterina dei Vegri, Ettore
Bonacossi, Melozzo da Forlì, Costa and Ercole de' Roberti.

ERC33 UGHI, LUIGI. Dizionario storico degli uomini illustri
ferraresi, nella pietà, nelle arti e nelle scienze colle
loro opere o fatti principali. 2 vols. Ferrara: Eredi di
Giuseppe Rinaldi, 1804, 231 and 231 pp. Reprint. Bologna:
Forni, 1969, 2 vols. in 1.
Alphabetical biographies based on seventeenth-century
sources, Cittadella (ERC32), Guarini (ERC105), etc. Includes
biographies of Antonio Alberti, Galasso, Baldassare Estense,
Tura, "Ercole Grandi" (Roberti), Fino Marsigli, and Costa.

ERC34 BARUFFALDI, GIROLAMO. Vite de' pittori e scultori
ferraresi. 2 vols. Ferrara: Domenico Taddei, 1844-46, 471
and 611 pp.
Lives of Ferrarese artists written in the early eight-
eenth century. Fifteenth-century artists in vol. 1. Makes use
of earlier sources [Vasari, Malvasia (ERC4), Guarini (ERC105)],
inscriptions, and observations. Notes by Crespi elaborate the
text with other opinions.

Cities

ERC35 ANTONELLI, GIUSEPPE. "Documenti risguardanti i libri corali
 che conservansi nel Duomo di Ferrara." In Memorie originali
 italiane risguardanti le belle arti, by Michelangelo Gualandi.
 6th series. Bologna: Sassi nelle spaderie, 1845, pp. 153-63.
 Documents from the lost account books of the Cathedral of
 Ferrara concerning choirbooks by Guglielmo Giraldi, Jacopo
 Filippo Medici called l'Argenta, Fra Evangelista da Reggio, and
 Andrea delle Vieze.

ERC36 LADERCHI, Conte CAMILLO. La pittura ferrarese. Ferrara:
 Servadio, 1856, 186 pp.
 Early history of Ferrarese painting, includes articles on
 Galasso Galassi, Tura, Cossa, and Ercole de' Roberti.

ERC37 CITTADELLA, LUIGI NAPOLEONE. Notizie amministrative,
 storiche, artistiche relative a Ferrara. 2 vols in 1.
 Ferrara: Taddei, 1868. Reprint. Bologna: Forni, 1969.
 Fundamental documentary source for Ferrarese art with
 entries by monument and in vol. 2 by artist.

ERC38 CAMPORI, GIUSEPPE. "I miniatori estense." Atti e memorie
 della reale Deputazione di storia patria per le provincie
 modenesi e parmensi 6 (1872):245-74.
 Fundamental early study on the miniaturists at the Este
 court. Documents.

ERC39 CAMPORI, GIUSEPPE. "Le carte da giuoco dipinte per gli
 Estense nel secolo XV." Atti e memorie della Deputazione di
 storia patria per le provincie modenesi e parmensi 7
 (1874):123-32.
 Documents concerning Jacopo di Sagramoro and Giovanni di
 Lazaro Cagnolo.

ERC40 VENTURI, ADOLFO. "I primordi del rinascimento artistico a
 Ferrara." Rivista storica italiana 1 (1884):591-631.
 Art in Ferrara during the reigns of Nicolò III and
 Leonello d'Este. Visits of Pisanello, Jacopo Bellini,
 Mantegna, and Roger van der Weyden. Work of Galasso and Angelo
 da Siena, called Maccagnino. Decorations in the studiolo in
 Belfiore. Guglielmo Giraldi and Marco dell'Avogaro working for
 Leonello.

ERC41 CAMPORI, GIUSEPPE. "I pittori degli Estensi nel secolo XV."
 Atti e memorie della reale Deputazione di storia patria per
 le provincie modenesi e parmensi 3d ser. 3 (1885):525-604.
 Discusses the artists who worked for the Este in Ferrara
 up through the end of the fifteenth century. Arranged chrono-
 logically with a gathering of selected documents at the end of
 the article.

ERC42 VENTURI, ADOLFO. "L'arte ferrarese nel periodo di Borso
 d'Este." Rivista storica italiana 2 (1885):689-749.

General survey of the patronage of Borso d'Este (1450-
71). Documents and letters cited in the footnotes. Considers
all of the arts, not only painting.

ERC43 VENTURI, ADOLFO. "Relazioni artistiche tra le corti di
 Milano e Ferrara nel secolo XV." Archivio storico lombardo
 12 (1885):225-280.
 All of the arts, including painting and drawing, though
 largest section on sculptor Amadio da Milano. Documents pri-
 marily from the Sforza and Este archives. Concerns particu-
 larly Baldassare Estense.

ERC44 VENTURI, ADOLFO. "Beiträge zur Geschichte der
 ferraresischen Kunst." Jahrbuch der Königlich preussischen
 Kunstsammlungen 8 (1887):71-88, 1 b&w illus.
 Pt. 1 is historiographic through mid-nineteenth century.
 Notes a number of errors in L.N. Cittadella's (ERC37) docu-
 ments. Pt. 2 concerned with Death of Virgin in Lombardi Col-
 lection, Ferrara: identifies it as work done for the nunnery
 of the Mortara by Baldassare Estense.

ERC45 HARCK, FRITZ von. "Opere di maestri ferraresi in raccolte
 private a Berlino." Archivio storico dell'arte 1
 (1888):102-6, 6 b&w illus.
 Beckerath, Kauffmann, and Wesendock collections. Works
 by Domenico Panetti, Lorenzo Costa, Cosmè Tura, and Ercole de'
 Roberti.

ERC46 VENTURI, ADOLFO. "L'arte ferrarese nel periodo d'Ercole
 d'Este." Atti e memorie della reale Deputazione di storia
 patria per le provincie di Romagna, 3d ser. 6 (1888):91-119,
 350-422; 7 (1889):368-412.
 Artistic patronage of Ercole I d'Este. Discussion of all
 of the principal Ferrarese artists of the last quarter of the
 century. Documents and letters.

ERC47 LONDON. BURLINGTON FINE ARTS CLUB. Exhibition of Pictures,
 Drawings and Photographs of Works of the School of Ferrara-
 Bologna, 1440-1540. Catalogue. Historical preface by
 Adolfo Venturi. Introduction by R.H. Benson. London:
 Burlington Fine Arts Club, 1894, 22 b&w illus.
 Exhibition of sixty-five works of the Ferrarese and
 Bolognese school including objects by Tura, Roberti, Zoppo,
 Costa, and Francia.

ERC48 GRUYER, GUSTAVE. L'art ferrarais a l'epoque des princes
 d'Este. 2 vols. Paris: Lib. Plon, 1897, 493 and 673 pp.
 General survey of Ferrarese art and patronage by artist
 and medium. Includes review of attributions of frescoes in
 Palazzo Schifanoia, vol. 1, pp. 423-68.

Cities

ERC49 HERMANIN, FEDERICO. "Le miniature ferraresi della
 Biblioteca vaticana." L'arte 3 (1900):341-73, 13 b&w illus.
 Identifies miniatures by Guglielmo Giraldi, Franco de'
 Russi, and Vicepalladio.

ERC50 HERMANN, HERMANN JULIUS. "Zur Geschichte der
 Miniaturmalerei am Hofe der Este in Ferrara." Jahrbuch der
 Kunsthistorischen Sammlungen des allerhöchsten Kaiserhauses
 21 (1900):117-272, 106 b&w illus.
 Monographic history of manuscript illumination in Ferrara
 under the Estes through Alfonso I, with special attention to
 the fifteenth century. Numerous documents.

ERC51 BERTONI, GIULIO. La biblioteca estense e la coltura
 ferrarese ai tempi del Duca Ercole I (1471-1505). Turin:
 Ermanno Loescher, 1903, 307 pp.
 Notices of painters and miniaturists scattered throughout
 to illustrate particular elements of late-quattrocento
 Ferrarese culture. Primarily interested in the sorts of books
 obtained. Very complete index.

ERC52 VENTURI, ADOLFO. "Le opere de' pittori ferraresi del '400
 secondo il catalogo di Bernard Berenson." L'arte 11
 (1908):419-32, 8 b&w illus.
 Critical review of Berenson's (G9) attributions.

ERC53 ANCONA, PAOLO D'. "La miniatura ferrarese nel fondo
 Urbinate della Vaticana." L'arte 13 (1910):353-61, 6 b&w
 illus.
 Cites works by Giraldi and Franco de' Russi.

ERC54 GARDNER, EDMUND G. The Painters of the School of Ferrara.
 London and New York: Duckworth and Charles Scribner's Sons,
 1911, 267 + xv pp., 36 b&w illus.
 Broad overview of development of painting in Ferrara
 under the Estes. Depends on published documents. Specific
 discussions of Tura, Cossa, Baldassare Estense, Ercole de'
 Roberti, Marco Zoppo, Costa, Francia, and Francesco Bianchi-
 Ferrari. Checklist of works at end.

ERC55 CROWE, J[OSEPH] A[RCHER], and G[IOVANNI] B[ATTISTA]
 CAVALCASELLE. "The Ferrarese." In A History of Painting in
 North Italy. Edited by Tancred Borenius. Vol. 2. London:
 John Murray, 1912, pp. 221-68, 7 b&w illus.
 Survey of Ferrarese painting from Galasso Galassi to
 Michele Coltellini. Includes sections on Tura, Cossa,
 Baldassare Estense, Roberti, and Costa. Also discussion of
 Schifanoia frescoes.

ERC56 VENTURI, ADOLFO. "La pittura a Ferrara." In Storia
 dell'arte italiana. Vol. 7, La pittura del quattrocento.
 Pt. 3. Milan: Hoepli, 1914, pp. 493-847, figs. 386-682.

Detailed survey of the Ferrarese school of painting and its main stylistic characteristics. Attributions on basis of documents when available, but usually on the basis of style. Has sections on all of the major artists working in Ferrara including Galasso, Lorenzo and Cristoforo da Lendinara, Tura, Cicognara, Giraldi, Franco de' Russi, Cossa, and Baldassare Estense. Problem of confusion of Ercole de' Roberti and "Ercole Grandi" persists.

ERC57 BERENSON, BERNARD. "Un plateau de mariage ferrarais au Musée de Boston." Gazette des beaux-arts, 4th ser. 13 (1917):447-66, 17 b&w illus.
 Takes issue with Siren's (Burlington Magazine, 1917) attribution of a marriage platter with Solomon and Sheba and a Putto to Baccatis da Camerino. Attributes it instead to fifteenth-century anonymous Ferrarese artist. Characterizes Ferrarese art in the fifteenth century in the course of the analysis with special attention to Tura and Cossa.

ERC58 FAVA, DOMENICO. La Biblioteca estense nel suo sviluppo storico, con il catalogo della mostra permanente. Modena: G.T. Vincenzi & nipote, 1925, 389 pp., 10 b&w illus.
 Description of the history of the library, catalog of the works from the Estense on display. Very complete index at end.

ERC59 VENTURI, ADOLFO. "L'arte ferrarese del rinascimento." L'arte 28 (1925):90-109, 19 b&w illus.
 Includes illustrations and comments on Galasso Galassi, Cosmè Tura, Francesco del Cossa, Ercole de' Roberti, Antonio Cicognara, and Lorenzo Costa.

ERC60 MESSORI-RONCAGLI, MARIA TERESA. "Borso e la Bibbia di Borso." Academie e biblioteche d'Italia 1 (1927/28):24-37, 5 b&w illus.
 Discusses the history of the Bible and how it relates to the general patronage of Borso. Notes the principal illumina-tors: Taddeo Crivelli, Franco de' Russi, and Marco dell'Avogaro

ERC61 MAYER, AUGUST L. "Das Ferraresische Bildnis des Meisters A.F. im Museum Correr." Pantheon 4 (1929):536-38, 1 color and 2 b&w illus.
 Disagrees with identification of artist of Portrait signed "A.F." in the Museo Correr, Venice, as Ansuino da Forlì. Says unknown Ferrarese artist working earlier than Ercole de' Roberti but with some similarities to his style.

ERC62 PIGLER, ANDREAS. "Ein Ferraresisches Bildnis." Pantheon 8 (1931):484-86, 2 b&w illus.
 Portrait of a Man in the collection of J.C. Beers, Budapest, identified as Costanzo Sforza on basis of medal. By unknown Ferrarese who did the work signed "A.F." in Correr. Dates ca. 1475. Says "A.F.P." may stand for Alexandri Filius Pisaurensis.

Cities

ERC63 WITTGENS, FERNANDA. "Illuminated Manuscripts at the
 Ambrosiana." Burlington Magazine 63 (1933):57-64, 8 b&w
 illus.
 Includes notice of the Aulo Gellio by Giraldi and a later
 Offices of the Virgin showing the influence of the Franco de'
 Russi.

ERC64 COLASANTI, ARDUINO. "Frammenti di un cassone ferrarese."
 Bollettino d'arte, 3d ser. 27 (1933):94-103, 4 b&w illus.
 Publishes three panels: Woman with Sleeping Youth,
 Berghoff Collection, Paris; Young Man Greeting an Older Man,
 Fogg Museum, Cambridge, Mass.: and, Arrested Execution of a
 Youth, Drey Collection, Munich. Fogg panel bore attribution to
 Scaletti. Places in orbit of Roberti and Agnolo degli Erri.
 Relates to panel with the life of Saint Benedict in the Brera.

ERC65 FERRARA, CITY OF. Esposizione della pittura ferrarese del
 rinascimento: May-October, 1933. Ferrara: n.p., 1933, 88
 pp., 32 b&w illus.
 Catalog of the exhibition of Ferrarese art that led to
 the total reevaluation of the school. Brief biographies of the
 artists. See reviews ERC66-68 and Longhi, ERC82.

ERC66 VENTURI, ADOLFO. "The Ariosto Exhibition at Ferrara."
 Burlington Magazine 62 (1933):232-37, 5 b&w illus.
 Capsule review of the exhibition and the development of
 Ferrarese art in fifteenth and early sixteenth centuries.

ERC67 VENTURI, ADOLFO. "L'esposizione della pittura ferrarese del
 rinascimento per il centenario ariostesco." L'arte 36
 (1933):367-90, 9 b&w illus.
 Review of the 1933 show in Ferrara.

ERC68 WEIGELT, CURT H. "Die Ausstellung Ferraresischer Malerei
 der Renaissance." Pantheon 12 (1933):211-18, 8 b&w illus.
 Review of the 1933 exhibition in Ferrara. Overview of
 development of fifteenth- and early sixteenth-century Ferrarese
 art.

ERC69 FAVA, DOMENICO. "Com'è nata la Bibbia di Borso?" Accademie
 e biblioteche 8 (1934):327-42, 1 b&w illus.
 Begins with general consideration of illumination in
 Ferrara, then particulars of the commission and style of the
 miniaturists of Bible of Borso d'Este, Taddeo Crivelli, Franco
 de' Russi, and Marco dell'Avogaro.

ERC70 FIOCCO, GIUSEPPE. "Tre disegni dell'esposizione ferrarese
 del rinascimento." L'arte 37 (1934):230-45, 9 b&w illus.
 Reattributes two drawings, Nativity and Sacra
 conversazione, from Tura to Zoppo, and a Study of a Nude from
 Ercole de' Roberti to Carpaccio.

ERC71 "Glorie di Ferrara a Parigi, Venezia e Parma." <u>Rivista di</u>
 <u>Ferrara</u> 3 (1935):267-76, 10 b&w illus.
 Includes illustrations of works by Tura, Cossa, Roberti,
 and Costa.

ERC72 <u>La Bibbia di Borso d'Este: Riprodotta integralmente, per</u>
 <u>mandato di Giovanni Treccani con documenti e studio storico</u>
 <u>artistico di Adolfo Venturi</u>. 2 vols. Milan: Treccani,
 1937.
 Facsimile edition of the <u>Bible of Borso d'Este</u>, fully
 illustrated in black and white with a few color plates. In-
 cludes contracts and payments for the Bible. Documents con-
 cerning Crivelli, Franco de' Russi, Fino Marsigli, Marco
 dell'Avogaro, Giorgio d'Alemagna, and Malatesta Romano.

ERC73 FAVA, DOMENICO. "Il Breviario di Ercole I d'Este."
 <u>Accademie e biblioteche d'Italia</u> 13 (1939):415-18, 4 b&w
 illus.
 Description of the breviary. Four illuminations cut out
 and sold. Dates between 1502-4. Four main miniaturists:
 Andrea delle Vieze, Matteo da Milano, Tommaso da Modena, and
 Cesare delle Vieze.

ERC74 BEENKEN, H[ERMAN THEODOR]. "Angelo del Maccagnino und das
 Studio von Belfiore." <u>Jahrbuch der Königlich preussischen</u>
 <u>Kunstsammlungen</u> 61 (1940):147-62.
 Role of Angelo del Maccagnino in creation of the Muses
 for the <u>studiolo</u> in Belfiore. Role of Galasso and Tura also.

ERC75 SORRENTINO, A[NTONIO]. "Ferrara, S. Antonio Vecchio:
 Restauro di affreschi." <u>Bollettino d'arte</u>, 4th ser. 33
 (1948):365-67, 6 b&w illus.
 Frescoes connected with Antonio Alberti and Jacopo
 Soncino called Sagramoro. Records inscriptions as late as
 1451.

ERC76 NICOLSON, BENEDICT. <u>The Painters of Ferrara: Cosmè Tura,</u>
 <u>Francesco del Cossa, Ercole de' Roberti and others</u>. Master
 Painters. London: Paul Elek, 1950, 20 pp., 24 b&w and 12
 color illus.
 Very brief pamphlet with short biographies of the major
 fifteenth-century Ferrarese artists. Brief bibliography.

ERC77 FAVA, DOMENICO. "La miniatura ferrarese e i suoi
 capolavori." In <u>Studi riminesi e bibliografici in onore di</u>
 <u>Carlo Lucchesi</u>. Edited by Società di studi romagnoli, Città
 di Rimini. Faenza: F.lli Lega, 1952, pp. 53-89, 3 b&w
 illus.
 Overview of the history of Ferrarese illumination in the
 fifteenth century, noting the major works of Belbello, Giorgio
 d'Alemagna, Taddeo Crivelli, Franco de' Russi, Marco
 dell'Avogaro, Guglielmo Giraldi, Martino da Modena, and others.

Cities

ERC78 HASSALL, W.O. "XVth-Century Ferrarese illumination at
 Holkham Hall, Norfolk." Connoisseur 133 (1954):18-24, 5 b&w
 and 1 color illus.
 Boccaccio, Decameron, MS. 531, ii, iii, by Taddeo
 Crivelli for Teofilo Calcagnini; an Ambrose, MS. 123, iv,
 anonymous Ferrarese; St. Bernard, MS. 151, v, vii, anonymous
 Ferrarese; and Miscellanea including Dictys, MS. 364, i, anon-
 ymous Ferrarese.

ERC79 PADOVANI, CORRADO. La critica d'arte e la pittura
 ferrarese. Rovigo: S.T.E.R., 1954, 636 pp., no
 illustrations.
 Overview of the literature of Ferrarese art from six-
 teenth through the twentieth century. Includes sections on
 early historiography; collections with listing of items; exhi-
 bitions; and special problems, particularly the decorations of
 the studiolo of Belfiore and the Palazzo Schifanoia. Large and
 very useful bibliography included in the text notes.

ERC80 BARGELLESI, GIACOMO. Notizie di opere d'arte ferrarese.
 Rovigo: S.T.E.R., 1955, 142 pp., 42 b&w illus.
 Includes studies on Antonio Alberti da Ferrara, Cosmè
 Tura, Francesco del Cossa, Andrea Delitto, school of Ferrara
 fresco, Antonio da Crevalcore, Giovan Francesco Maineri,
 Lazzaro Grimaldi, Antonio Aleotti, and Michele Coltellini by
 one of the foremost scholars of Ferrarese art.

ERC81 BOVERO, ANNA. "Ferrarese miniatures at Turin." Burlington
 Magazine 99 (1956):261-65, 18 b&w illus.
 Attributes miniatures from a Pliny Naturalis Historia in
 Turin, which survived the 1904 fire, to Galasso or his circle.
 Done for the Gonzaga. Two hands. Date 1460-70.

ERC82 LONGHI, ROBERTO. Edizione delle opere complete di Roberto
 Longhi. Vol. 5, Officina ferrarese (1934). Seguita dagli
 ampliamenti 1940 e dai nuovi ampliamenti 1940-55. Florence:
 Sansoni, 1956, 270 pp., 456 b&w and 16 color illus.
 Discussion of the 1933 exhibition with many reattribu-
 tions, and citation and illustration of supplementary examples.
 Later amplifications include rethinking some of his own attri-
 butions and citation of new examples. Fundamental source for
 Ferrarese art.

ERC82A CALVESI, MAURIZIO. "Nuovi affreschi ferraresi nell'
 Oratorio della Concezione." Bolletino d'arte 43 (1958):141-
 56, 309-28, 43 b&w illus.
 Publishes fragments of late fifteenth- and early
 sixteenth- century fresco cycle in the Oratory of the Concep-
 tion, now in the Pinacoteca Nazionale Ferrara, by Baldassare
 Estense, Coltellini, Boccaccio Boccaccino, Lorenzo Costa, and
 Domenico Panetti. Pala Strozzi originally part of the
 decorations.

ERC83 SALMI, MARIO. "Arte e cultura artistica nella pittura del
 primo rinascimento a Ferrara." Rinascimento 9 (1958):123-
 39, 36 b&w illus.
 Particularly interested in the influence of Piero della
 Francesca on Giraldi, Cristoforo da Lendinara, Galasso, and
 Tura.

ERC84 SALMI, MARIO. "Echi della pittura nella miniatura ferrarese
 del rinascimento." Commentari 9 (1958):88-98, 11 b&w illus.
 Influence of Piero della Francesca, Tura, and Cossa on
 work of Giraldi in the choirbooks of the Certosa and other
 illuminated manuscripts.

ERC85 SALMI, MARIO. Pittura e miniatura a Ferrara nel primo
 rinascimento. Ferrara: Cassa di risparmio di Ferrara,
 1961, 56 pp., 52 b&w and 20 color illus.
 General survey of art in Ferrara during the reigns of
 Nicolò III, Leonello, Borso, and Ercole I d'Este.

ERC86 BAXANDALL, MICHAEL. "A Dialogue on Art from the Court of
 Leonello d'Este." Journal of Warburg and Courtauld Insti-
 tutes 26 (1963):304-26, 8 b&w illus.
 Significant for the cultural climate of artistic patron-
 age at court of Leonello. Section on art from Angelo
 Decembrio's fifteenth-century dialogue De politia litteraria,
 Pars LXVIII.

ERC87 BARGELLESI, GIACOMO. "Alcuni disegni in relazione ad opere
 d'arte Ferrarese." In Arte in Europa: Scritti di storia
 dell'arte in onore di Edoardo Arslan. Vol. 1. Milan:
 n.p., 1966, pp. 481-88, 2 b&w illus.
 Publishes drawing, Arione on a Dolphin, in the Museo
 Bonnat, Bayonne. Connects with same subject in Milanese pri-
 vate collection, formerly at Chatsworth. Not by same hand,
 though Bean in Bonnat catalog attributes to same artist.
 Longhi had related to early phase of Costa, disagrees says
 related to early Roberti.

ERC88 ZANINI, WALTER. "La diffusion de la peinture ferraraise en
 Lombardie dans la seconde moitié du XVe siecle." Gazette
 des beaux-arts, 6th ser. 69 (1967):307-18, 14 b&w illus.
 Sketches exchanges between Ferrara and Milan because of
 ties between Este and Sforza. Flow of influence of Tura,
 Cossa, and Roberti north to Lombardy, seen in Zenale, Butinone,
 Nicolò da Varallo, Birago, and Bramantino.

ERC89 BISOGNI, FABIO. "Contributo per un problema ferrarese."
 Paragone 265 (1972):69-79, 11 b&w illus.
 Discusses series of panels dedicated to life of Saint
 Jerome, probably for the Gesuati, anonymous Ferrarese ca. 1450,
 in Brera, Correr, and private collection.

Cities

ERC90 GUNDERSHEIMER, WERNER L. Art and Life at the Court of
 Ercole d'Este: The "De triumphis religionis" of Giovanni
 Sabadino degli Arienti. Geneva: Libreria Droz, 1972.
 Included within the discussion of the virtue of Magnifi-
 cence by Sabadino are descriptions of the decorations in
 Belriguardo and Belfiore.

ERC91 GUNDERSHEIMER, WERNER L. "Courtly Style in the Visual
 Arts." In Ferrara: The Style of a Renaissance Despotism.
 Princeton, N.J.: Princeton University Press, 1973,
 pp. 229-71.
 Reviews the major artists and styles in Ferrara from the
 time of Nicolò III through Ercole I. Suggests the pursuit of a
 courtly style similar to manuscript illumination as preferred
 type.

ERC92 ROSENBERG, CHARLES M. "Art in Ferrara during the Reign of
 Borso d'Este (1450-71): A Study in Court Patronage." Ph.D.
 Dissertation, University of Michigan, Ann Arbor, 1974, 284
 pp., 66 b&w illus.
 Chapters on the decorations in the Sala dei mesi and its
 iconography and on the Bible of Borso d'Este, with special
 attention to motivations and use. General survey of patronage
 under Borso.

ERC93 VASCO, SANDRA. "Le tavolette di S. Bernardino a Perugia. I
 committenti: Qualche ipotesi e precisazione." Commentari
 25, no. 1 (1974):64-68, 6 b&w illus.
 Elements of Este iconography in the three panels illus-
 trating miracles of St. Bernard, Pinacoteca, Perugia. Says may
 have been commissioned by Borso d'Este on his trip through
 Perugia in 1471, or by Ercole I d'Este between 1471 and 1473.

ERC94 EÖRSI, ANNA. "Lo studiolo di Leonello d'Este e il programma
 di Guarino da Verona." Acta Historiae Artium Academiae
 Scientiarum Hungaricae 21 (1975):15-52.
 Follows Baxandall's association of the program in the
 studiolo of Belfiore with Guarino. Attributions of the paint-
 ings particularly to Michele Pannonio.

ERC95 PADOVANI, SERENA. "Materiale per la storia della pittura
 ferrarese nel primo quattrocento." Antichità viva 13, no. 5
 (1975):3-21, 41 b&w illus.
 Patronage of Nicolò III d'Este. Attributions particu-
 larly to the Master of Roncaiette and Giovanni di Francia.
 Also works by Master G.Z.

ERC96 PIROMALLI, ANTONIO. La cultura a Ferrara al tempo di
 Ludovico Ariosto. Rome: Bulzoni, 1975, 213 pp.
 Marxist interpretation of the courtly culture in later
 fifteenth and sixteenth centuries. Interprets art as expres-
 sion of the cultural values of the court.

ERC97 RAGGHIANTI, CARLO LUDOVICO. "Un altro disegno cavalleresco
 ferrarese." Bollettino annuale dei musei ferraresi 5-6
 (1975-76):9-10, 2 b&w illus.
 Draws attention to correspondence between two men in
 courtly costume in the British Museum, n. 305, and a drawing of
 man in similar dress on horseback in the Lugt Collection, Paris.

ERC98 ZAMBONI, SILLA. Pittori di Ercole I d'Este: Giovan
 Francesco Maineri, Lazzaro Grimaldi, Domenico Panetti,
 Michele Coltellini. Milan: Silvana editoriale d'arte,
 1975, 277 pp., 56 b&w and 32 color illus.
 General survey of artistic culture under Ercole with
 special attention to development of public piety as reflected
 in painting. Individual catalogs of the work of Maineri,
 Grimaldi, Panetti, and Coltellini. Extensive bibliography.

ERC99 ZANINI, WALTER. "Opere che gravitano intorno allo studio di
 Belfiore." Bollettino annuale dei musei ferraresi 5-6
 (1975-6):16-23, 11 b&w illus.
 Cosmopolitan nature of artists working on the studiolo in
 Belfiore. Ferrarese artists, like Galasso, non-Italians like
 Pannonio, Maccagnino, and Alfonso di Spagna.

ERC100 BOSKOVITS, MIKLOS. "Ferrarese Painting about 1450: Some
 New Arguments." Burlington Magazine 120 (1978):370-85, 32
 b&w illus.
 Discussion of paintings from the studiolo of Belfiore.
 Gives Poldi Pezzoli Muse to Tura. Reconsiders chronology and
 attributions to Tura. Other attributions to Giorgio
 d'Alemagna, Taddeo Crivelli, and Michele Pannonio.

ERC101 CANOVA, GIORDANA MARIANI. "Una illustre serie liturgica
 riconstruita: I corali del Bessarione già all'Annunziata di
 Cesena." Saggi e memorie di storia dell'arte 11 (1978):7-
 20, 38 b&w illus.
 Reconstructs series of choirbooks donated by Cardinal
 Bessarion to the Church of the Annunziata in Cesena. Six
 hands, all Ferrarese, circle of Giraldi and Jacopo Filippo
 Medici called l'Argenta. Dates 1455-65.

ERC102 MEZZETTI, AMALIA, and EMANUELE MATTALIANO. Indice ragionate
 delle "Vite de' pittori e scultori Ferrarese" di Gerolamo
 Baruffaldi. 2 vols. Ferrara: Cassa di risparmio di
 Ferrara, 1980-81, 305 pp., 189 b&w illus., 8 color illus.,
 and 349 pp., 332 b&w illus.
 Index to Baruffaldi, with notices as to where specific
 extant works mentioned can be found.

ERC102A ROSENBERG, CHARLES M. "The Bible of Borso d'Este: Inspira-
 tion and Use." In Cultura figurativa ferrarese tra XV e XVI
 secolo, by Deputazione provinciale ferrarese di storia patria.
 Arte e storia, vol. 1. Venice: Corbo e Fiore, 1981, pp.
 54-74, 10 b&w illus.

Cities

Brief review of the history of the production of the
Bible of Borso d'Este. Suggests that Crivelli and Russi used
the Bible of Nicolo III, illuminated by Belbello, as a model
for Genesis illustrations. Function of the Bible as symbol of
magnificence and piety.

ERC103 LOMBARDI, P. TEODOSIO. "I corali del Museo del Duomo." In
La Cattedrale di Ferrara. Accademia delle scienze di
Ferrara. Ferrara: Belriguardo, 1982, pp. 351-411, 12 b&w
illus.
Survey of the history of the choirbooks done for the
cathedral between 1473 and 1535. Also includes notations of
religious volumes in Franciscan and Este collection. Publishes
Scalabrini's previously unpublished transcriptions from the
account books of the cathedral concerning the choirbooks.

ERC104 ROSENBERG, CHARLES M. "Courtly Decorations and the Decorum
of Interior Space." In La Corte e lo spazio: Ferrara
estense. Edited by Giuseppe Papagano and Amedeo Quondam.
Vol. 2. Rome: Bulzoni, 1982, pp. 529-44, 3 b&w illus. in
vol. 3.
Sets the decorations in the Schifanoia, Belriguardo, and
Belfiore into context of the theories of decoration as ex-
pressed in the treatises of Alberti and Filarete.

ERC104A LONDON, MATTHIESEN FINE ART LTD. From Borso to Cesare
d'Este. The School of Ferrara: 1450-1628. An Exhibition
in Aid of the Courtauld Institute of Art Trust Appeal. June
1-August 14, 1984. London: Matthiesen Fine Art, 1984, 138
pp., 79 b&w and color illus.
Catalog of exhibition. Introductory historical essays by
a variety of scholars. Catalog entries with provenance and
short bibliography. All works illustrated. Includes
Baldassare Estense, Francesco del Cossa, Lorenzo Costa, Michele
Pannonio, Roberti, Tura, Zoppo, and others.

Guidebooks

ERC105 GUARINI, MARC'ANTONIO. Compendio historico dell'origine,
accrescimento e prerogative delle chiese e luoghi pij della
città e diocesi de Ferrara. Ferrara: Heredi di Vittorio
Baldini, 1621, 475 + viii pp.
Organized by church. Citations of paintings and tombs.
No index.

ERC106 BARUFFALDI, GIROLAMO. Descrizione delle pitture e sculture
che adornano le chiese et oratori della città di Ferrara,
opera postumna di Carlo Brisighella data nuovamente in luce
& accresciuta con copiosa giunta delle nuove pitture e
sculture mutate, rinovate o accresciute . . . dall'anno 1704
fino alli giorni correnti. . . . Ferrara, Biblioteca
ariostea, Cl. I, 429., 18th century, 410 fols.

Brisighella died in 1710. Includes additional comments
about the fate of some pictures cited in the margins, probably
by Cesare Barotti. List of artists cited.

ERC107 SCALABRINI, GIUSEPPE ANTENORE. Descrizione della S. Chiesa
metropolitana di Ferrara . . . sino al presente anno 1766.
Ferrara, Biblioteca ariostea, Cl. I, 26., 18th century,
fols. 730.
Copies of documents and descriptions. Tura organ wings.

ERC108 BAROTTI, CESARE. Pitture e scolture che si trovano nelle
chiese, luoghi pubblici, e sobborghi della città di Ferrara.
Ferrara: Giuseppe Rinaldi, 1770, 224 pp., 1 plan. Reprint.
Bologna: A. Forni, 1977.
Guidebook that begins with a very brief history of
Ferrarese painting mentioning Tura, Galasso, "Ercole Grandi
da Ferrara," and Ettore Bonacossi. Index of names at end.

ERC109 SCALABRINI, GIUSEPPE ANTENORE. Memorie istoriche delle
chiese di Ferrara e de' suoi Borghi munite ed illustrate con
antichi inediti monumenti che ponno servire all'istoria
sacra della suddetta città. 2 vols. in 1. Ferrara: Per
Carlo Coatti, 1773, 424 + 129 + 11 pp.
History of churches and other significant structures and
zones in Ferrara. Index by church. Entries include informa-
tion about works of art in the churches, but on a somewhat
unpredictable basis.

ERC110 FRIZZI, ANTONIO. Guida del forestiere per la città di
Ferrara. Ferrara: F. Pomatelli, 1787, 178 pp., 1 map.
Guide to the city by zone. Includes attributions for the
works of art found in churches and public buildings, including
Panetti, Tura, and Costa. No index.

ERC111 AVVENTI, FRANCESCO. Il servitore di piazza: Guida per
Ferrara. Ferrara: 1838, 12 b&w illus. and 1 map.
Guide to the city by zone with attributions. No index.

ERC112 AGNELLI, GIUSEPPE. Ferrara e Pomposa. Italia artistica, 2.
Bergamo: Istituto italiano d'arti grafiche, 124 pp., 138
b&w illus.
Chronological history of Ferrara and works of art. Last
section devoted to Pomposa, Abbazia. Very general. Late
nineteenth-century photographs.

Collections and Museums

ERC113 LADERCHI, CAMILLO. Descrizione della quadreria Costabili.
Ferrara: Negri alla Pace, 1838, 2 pts. in 1 vol., 50 + 20 pp.
Includes paintings by Galasso Galassi, Antonio Alberti,
Tura, Francesco del Cossa, Bono da Ferrara, Baldassare Estense,

Cities

Antonio Aleotti d'Argenta, Lorenzo Costa, Domenico Panetti, and
Giovan Francesco Maineri. See also ERC115.

ERC114 FERRARA. PINACOTECA NAZIONALE. La Pinacoteca nazionale di
 Ferrara. Edited by Eugenio Riccomini. Ferrara: 1969, 54
 pp., 9 b&w illus.
 Brief guide to the collection and its history. Index.

ERC115 BENINI, LAURA. "Descrizione della quadreria Costabili."
 Bollettino annuale dei musei ferraresi 7 (1977):79-96.
 Index of Costabili Collection, with current bibliography
 and location of the works cited in the nineteenth-century
 inventory.

 Monuments

 Palazzo Schifanoia

ERC116 AVVENTI, FRANCESCO. Descrizione dei dipinti di Cosimo Turra
 (sic) ultimamente scoperti nel Palazzo di Schifanoia in
 Ferrara nell'anno 1840. Bologna: Marsigli, 1840, 30 pp.
 Two contracts for the land of the Schifanoia and a de-
 scription of the frescoes in 1840.

ERC117 BOZOLI, GIOVANNI MARIA. Importante scoperta d'un antico
 dipinto in Ferrara: Relazione artistica. Rovigo: Minelli,
 1840, 44 pp.
 Reports discovery of the Schifanoia frescoes. Attributes
 them to Lorenzo Costa.

ERC118 LADERCHI, CAMILLO. Sopra i dipinti del Palazzo di
 Schifanoia. Bologna: Dalla Volpe (Nozze Rimainaldi-
 Guiccidi), 1840, 49 pp.
 One of the earliest descriptions of the newly uncovered
 Sala dei mesi frescoes. Attributes the frescoes to Tura and
 Francesco del Cossa.

ERC119 BARUFFALDI, GIROLAMO. Vite de' pittori e scultori ferraresi.
 Vol. 1. Ferrara: Domenico Taddei, 1844, pp. 85-91.
 Description of the frescoes in the Schifanoia appended to
 end of the life of Tura. Fields of March, April, May, June,
 July, August, and September, fragments on remaining walls.

ERC120 GRUYER, GUSTAVE. "Le Palais de Schifanoja à Ferrarè."
 Revue des deux monde (August 1883):613-41.
 Description of the frescoes. Attributions to Tura,
 Cossa, and anonymous artists.

ERC121 HARCK, FRITZ von. "Die Fresken des Palazzo Schifanoia in
 Ferrara." Jahrbuch der Königlich preussischen Kunstsammlungen
 5 (1884):99-127.
 Survey of previous attributions. Attributions to Tura,
 Roberti, and Cossa.

ERC122 VENTURI, ADOLFO. "Gli affreschi del Palazzo Schifanoia
 secondo recenti pubblicazioni e nuove ricerche." Atti e
 memorie della reale Deputazione di storia patria per le
 provincie di Romagna, 3d ser. 3 (1885):381-417.
 Review of literature to 1885. Documents concerning the
 work of Baldassare Estense in the Schifanoia.

ERC123 PARDI, GIUSEPPE. "La suppellettile dei palazzi estensi in
 Ferrara nel 1436." Atti e memorie della Deputazione
 ferrarese di storia patria 19 (1908):1-183.
 Este inventory of 1436. Palazzo Schifanoia on p. 176.

ERC124 WARBURG, ABY. "Italienische Kunst und internazionale
 Astrologie in Palazzo Schifanoia zu Ferrara." In Gesammelte
 Schriften. Edited by Gertrude Bing. Vol. 2. Leipzig and
 Berlin: B.G. Teubner, 1932, pp. 465-81.
 Originally published in 1922. First comprehensive inter-
 pretation of the astrological elements in the Schifanoia fres-
 coes, tracing sources to Manilius and Arabian sources.
 Suggests Pellegrino Prisciano as author of the program.

ERC125 RIGHINI, GIULIO. "L'enigma di Schifanoia." Atti e memorie
 della Deputazione di storia patria per l'Emilia e la
 Romagna. Sezione di Ferrara 2 (1943):67-82, 6 b&w illus.
 Recapitulation of Warburg with a critique.

ERC126 BARGELLESI, GIACOMO. Palazzo Schifanoia: Gli affreschi nel
 "Salone dei mesi" in Ferrara. Bergamo: Istituto italiano
 d'arti grafiche, 1945, 22 pp., 40 b&w illus.
 Folding plan of the frescoes. Summary of previous opin-
 ions. Assigns paintings to Tura and Cossa.

ERC127 ANCONA, PAOLO D'. I mesi di Schifanoia in Ferrara: Con una
 notizia critica sul recente restauro di Cesare Gnudi. Milan:
 Edizione del millione, 1954, 120 pp., 2 b&w illus., 42 color
 illus.
 English translation: The Schifanoia Months at Ferrara.
 With a critical notice on the recent restoration by Cesare
 Gnudi. Milan: Edizione del milione, 1954, 100 pp., 2 b&w
 illus., 42 color illus.
 Bibliography. Assigns frescoes to Cossa, Tura, and
 Roberti. Reports on the condition of the frescoes.

ERC128 SALMI, MARIO. "Schifanoia e la miniatura ferrarese."
 Commentari 12 (1961):38-51, 27 b&w illus.
 Draws stylistic parallels between work of miniaturists
 Taddeo Crivelli, Antonio Cicognara, and Guglielmo Giraldi, and
 other Ferrarese artists like Galasso, Cossa, Ercole de'
 Roberti, and the Master of the "Occhi Spalancati."

ERC129 MERCIER, ANDRÉ. "L'organisation de l'espace dans les
 fresques du Palais Schifanoia à Ferraré." L'information
 d'histoire de l'art 13 (1968):82-84.

Cities

Considers spatial anomalies (combination of three-dimensional and flat elements) as conscious device of Cossa. Roberti in September field supposedly refining technique.

ERC130 VARESE, RAINERI. "Novità a Schifanoia." Critica d'arte 113
 (1970):47-62, 16 b&w illus.
 Publishes earliest figurative frescoes in second floor
 salone, now part of the attic. Cavalresque theme. Also pub-
 lishes 1436 inventory. Remnants of Borsian facade.

ERC131 LEVEY, MICHAEL. "Courts of Earth." In Painting at Court.
 New York: New York University Press, 1971, pp. 45-80, b&w
 illus. 41-58, color plate III.
 Interprets frescoes as idealistic vision of Borso's
 rulership.

ERC132 Affreschi ferraresi restaurati ed acquisizioni per la
 Pinacoteca nazionale di Ferrara. Bologna: Soprintendenza
 alle gallerie di Bologna, 1972, 108 pp., 14 b&w illus.
 Includes comments by Cesare Gnudi about restorations of
 north wall in the Palazzo Schifanoia.

ERC133 ROSENBERG, CHARLES M. "Notes on the Borsian Addition to the
 Palazzo Schifanoia." Bollettino annuale dei musei ferraresi
 3 (1973):32-42, 6 b&w illus.
 Chronology of construction of Borsian addition to the
 palace and the iconography of the architectural sections of the
 decorations in the Sala dei mesi.

ERC133A ZORZI, LODOVICO. "Ferrara: il sipario ducale." Il teatro
 e la città: Saggi sulla scena italiana. Turin: Einaudi,
 1977, pp. 50-59, 3 color and 15 b&w illus.
 Discusses the mode of spatial visualization and placement
 of figures in the frescoes in the Sala dei mesi in relation to
 Pellegrino Prisciani's Spectacula and the revival of classical
 theater in Ferrara in the later fifteenth century.

ERC134 VARESE, RANIERI. Il Palazzo di Schifanoia. Bologna:
 Grafica editoriale s.r.l., 1980, 96 pp., 43 color illus.
 General guidebook to the palazzo and its collection in
 Italian, English, German, and French.

ERC135 VARESE, RAINIERI. "Proposte per Schifanoia." In La corte e
 lo spazio: Ferrara estense. Edited by Giuseppe Papagno and
 Amedeo Quondam. Vol. 2. Rome: Bulzoni, 1982, pp. 545-62,
 illus. in vol. 3.
 Discussion of the facade of the palace as a backdrop for
 public entertainments, and discussion of point of view and
 perspective in the Sala dei mesi.

ERC135a MACIOCE, STEFANIA. "La 'Borsiade' di Tito Vespasiano Strozzi
 e la 'Sala dei Mesi' de Palazzo Schifanoia." Annuario

dell'Istituto di storia dell'arte. Universita degli studi
di Roma 'La Sapienza.' Facoltà di lettere e filosofia, n.s.
2 (1982-83):3-14, 6 b&w illus.
 Draws parallels between themes in Tito Strozzi's Borsiade
and the frescoes in the Sala dei mesi. Given Strozzi's posi-
tion at the court, suggests that he may have contributed to
the program.

ERC136 MACIOCE, STEFANIA. "Palazzo Schifanoia: Una proposta
 iconologica per il "Settembre" nella Sala dei mesi." Storia
 dell'arte 48 (1983):75-99, 15 b&w illus.
 Review of literature on the Schifanoia, both iconographic
and attributional. Suggests identification of the figure in
the September field as Maia. Connects particularly with
Boccaccio.

 FORLÌ

ERC137 MARCHESI BUONACCORSI, GIORGIO VIVANO. Vitae virorum
 illustrium foroliviensium. Forlì: Pauli Sylvae, 1726,
 496 pp.
 Lives of Melozzo da Forlì (pp. 249-52) and Marco
Palmezzano (p. 257).

ERC138 GIORDANI, GAETANO. Memorie Mss^e intorno alle vite ed alle
 opere de' pittori, scultori, architetti ecc. di Forlì.
 Bologna, Biblioteca communale dell'Archiginnasio, Ms. B.
 1813., 1828, 501 fols.
 Collection of lives and notes about Forliese artists
including Ansuino, Melozzo, and Marco Palmezzano. Useful as a
compendium of sources and as indication of the location of
works in early nineteenth century.

ERC139 CASALI, GIOVANNI. Guida per la città di Forlì. Forlì:
 Tip. Casali, 1838, 111 + xxii pp.
 Organized by monument; alphabetical index at end, with
artists. Biographical notes in footnotes. Includes Melozzo,
Palmezzano, and Francia.

ERC140 CALZINI, EGIDIO. "L'arte in Forlì al tempo di Pino III
 Ordelaffi." Atti e memorie della reale Deputazione di
 storia patria per le provincie di Romagna, 3d ser. 12
 (1895):125-48.
 Cites an altarpiece done for San Francesco in 1465 by
Melozzo da Forlì and Marco Palmezzano.

ERC141 SANTARELLI, ANTONIO. "Galleria e Museo di Forlì." Le
 gallerie nazionale italiane 3 (1895-96):141-59.
 Includes notices of Melozzo and Marco Palmezzano.

Cities

ERC142 MAMBELLI, ANTONIO. <u>Uomini</u> <u>e</u> <u>famiglie</u> <u>illustri</u> <u>Forliuesi</u>.
 Forlì: Camera di commercio, industria artigianato e
 agricoltura, 1978, 277 pp.
 Includes bibliography for artists discussed: Baldassare
 Carrari, Ansuino da Forlì, Leone Cobelli, Melozzo da Forlì,
 Giovanni Merlini, and Marco Palmezzano. Very brief biographies.

IMOLA

ERC143 GIORDANI, GAETANO. <u>Memorie</u> <u>Ms</u><u>e</u> <u>intorno</u> <u>alle</u> <u>vite</u> <u>ed</u> <u>alle</u>
 <u>opere</u> <u>de'</u> <u>pittori,</u> <u>scultori,</u> <u>architetti</u> <u>ecc.</u> <u>d'Imola</u>.
 Bologna: Biblioteca communale dell'Archiginnasio, MS. B.
 1809., 1826.
 Primarily eighteenth and early nineteenth century. Only
 fifteenth-century figure is a Guidaccio da Imola, ca. 1470,
 from a painting in Forlì, fol. 119.

MODENA

General

ERC144 VEDRIANI, D. LODOVICO. <u>Raccolta</u> <u>de'</u> <u>pittori,</u> <u>scultori,</u> <u>ed</u>
 <u>architetti</u> <u>modenesi</u> <u>più</u> <u>celebri</u>. Modena: Lo Soliani, 1662,
 152 pp. Reprint. Bologna: A. Forni, 1970 (Italia gens, 16).
 Organized chronologically with index at the end. Modest
 notices concerning the Lendinari, Francesco Bianchi-Ferrari,
 and Francesco Maria Castaldi.

ERC145 TIRABOSCHI, GIROLAMO. <u>Biblioteca</u> <u>modenese</u>. Vol. 6, <u>Notizie</u>
 <u>dei</u> <u>pittori,</u> <u>scultori,</u> <u>incisori</u> <u>e</u> <u>architetti</u> <u>nati</u> <u>negli</u>
 <u>stati</u> <u>del</u> . . . <u>Duca</u> <u>di</u> <u>Modena</u>. Pts. 1-2. Modena: Società
 tipografica, 1786, 343 and 272 pp.
 Alphabetical with a citation of the source of information.

ERC146 BORGHI, CARLO. "Sulla scuola modenese di tarsia." <u>Atti</u> <u>e</u>
 <u>memorie</u> <u>della</u> <u>Deputazione</u> <u>di</u> <u>storia</u> <u>patria</u> <u>per</u> <u>le</u> <u>provincie</u>
 <u>modenesi</u> <u>e</u> <u>parmensi</u> 5 (1870):55-63.
 Primarily the work of Cristoforo and Lorenzo da Lendinara.

ERC147 VENTURI, ADOLFO. "La pittura modenese nel secolo XV."
 <u>Archivio</u> <u>storico</u> <u>dell'arte</u> 3 (1890):379-96, 9 b&w illus.
 Brief documentary notes about several minor Modenese
 painters with particular attention to degli Erri.

ERC148 NANNINI, MARCO CESARE. "Guida dell'arte pittorica modenese
 dalle origini al Bianchi Ferrari." <u>Atti</u> <u>e</u> <u>memorie</u> <u>della</u>
 <u>Deputazione</u> <u>di</u> <u>storia</u> <u>patria</u> <u>per</u> <u>le</u> <u>antiche</u> <u>provincie</u>
 <u>modenesi</u>, 7th ser. 4 (1952):80-97.
 Brings together brief notices of all Modenesi painters
 until the end of the fifteenth century.

Guidebooks

ERC149 LAZARELLI, D. MAURO ALESSANDRO. Pitture delle chiese di
 Modena. Modena: Biblioteca estense. Ital. 997,
 alpha.R.9.16., 1714, 166 fols.
 Includes an index by church but none by artist. Primar-
ily post-1500.

ERC150 PAGANI, GIOVANNI FILBERTO. Le pitture e sculture di Modena.
 Modena: Soliani, 1770, 219 pp.
 Arranged by church and by palace. Listing of holdings in
Grandducale apartments of Francesco III d'Este. Mentions draw-
ings by Ercole da Ferrara. No artist index at end.

Collections and Museums

ERC151 TARABINI, FERDINANDO CASTELLANI. Cenni storici e
 descrittivi intorno alle pitture della reale Galleria
 estense. Modena: Regio-Ducale Camera, 1854, 191 pp.
 Index by artist at end. Descriptions of all the works.

ERC152 PALLUCHINI, RODOLFO. I dipinti della Galleria estense di
 Modena. Rome: Cosmopolita, 1945, 308 pp., 238 b&w illus.
 Photo source. Bibliography. History of the objects.
Arranged by school.

PARMA

General

ERC153 GRAPALDO, FRANCESCO MARIA. De partibus aedium. Parma:
 Ugoletus, 1506 (1st ed. 1494), 157 fols.
 Mentions works by Francesco Marmitta and Temperello
(Cristoforo Casella) on 125r.

ERC154 AFFÒ, IRENO. Notizie intorno ad artisti parmigiani.
 Biblioteca palatina, Parma, Parmense 1599, 18th century,
 521 fols.
 A miscellany. Arranged alphabetically, with documents;
includes notices of Biffi, Loschi, and Marmitta. At the end,
corrections to various guides to Parma.

ERC155 BAISTROCCHI, ROMUALDO. Notizie dei pittori che lavorano in
 Parma raccolte dal P. Romualdo Baistrocchi. Biblioteca
 palatina, Parma, Parmense 1106, Notizie intorno alle belle
 arti parmigiane, 19th century, fols. 74-151.
 Chronological. With notices of Araldi, Casella, Francia,
and Filippo Mazzola.

ERC156 BAISTROCCHI, ROMUALDO. Spoglie de' conti del Monastero di
 S. Giovanni Evangelisti. Biblioteca palatina, Parma,
 Parmense 1106, Notizie intorno alle belle arti parmigiane,
 19th century, fols. 1-24.

Cities

Includes documents concerning Jacopo dei Loschi,
Cristoforo Casella, and Giacomo Antonio da Reggio.

ERC157 BERTOLUZZI, GIUSEPPE, et al. Cenni intorno ad artisti
specialmente parmigiani raccolti dal Bertoluzzi e da altri.
Biblioteca palatina, Parma, Parmense 1106, Notizie intorno
alle belle arti parmigiane, 1830, fols. 288-320.
Extensive documentation of Araldi; mention also of
Battista Biffi and Casella.

Guidebooks

ERC158 RUTA, CLEMENTE. Guida a forastieri più eccellenti pitture
che sono nelle chiese di Parma. Parma: Gozzi, 1739, 84 pp.
Organized by church. Index of artists at end. No
fifteenth-century artists listed.

ERC159 AFFÒ, IRENO. Il Parmigiano: Servitore di Piazza overo
dialoghi di Frombola. Parma: Carmignani, 1794.
Mentions work by Bartolomeo Grossi and Jacopo Loschi for
S. Francesco and S. Giovanni Evangelista, also Cristoforo
Casella called Temperello, Francesco Marmitta, and Francia.

ERC160 BAISTROCCHI, ROMUALDO. Guida per forastieri a riconscere le
opere più insigni di pittura, scultura ed architecttura
esistenti in Parma. Biblioteca palatina, Parma, Parmense
1106, Notizie intorno alle belle arti parmigiane, 19th cen-
tury, fols. 25-72.
Mentions works by Francia from the Annunziata, by
Alessandro Araldi in the cathedral and in Sta. Maria del
Carmine, and by Filippo Mazzola and Bernardino Canozio da
Lendinara in the baptistry.

ERC161 TESTI, LAUDEDEO. Parma. Italia artistica, 19. Bergamo:
Istituto italiano grafiche d'arti, 1905, 134 pp., 130 b&w
illus.
Sec. 1 is history of Parma. Sec. 2 devoted to Parma in
the figurative arts; entries for Bartolomeo Grossi, Jacopo
Loschi, Cristoforo Casella called Temperello, Araldi, Giovan
Francesco Maineri, and the Canozii. Sec. 3 guide by monument,
including the Palatina.

ERC162 MINISTERO DELL'EDUCAZIONE NAZIONALE. DIREZIONE GENERALE
ANTICHITÀ E BELLE ARTI. Inventario degli oggetti d'arte
d'Italia. Vol. 3, Provincia di Parma. Rome: Libreria
dello stato, 1931, 326 pp., numerous b&w illus.
Inventory of works of art (painting, sculpture, minor
arts) throughout area of Parma. Arranged alphabetically by
city. Artist index. Includes attributions for the works and
bibliography.

ERC163 BERTOLUZZI, GIUSEPPE. "Pitture che si vedono eseguite su
varie case della città." Parma nell'arte 1 (1969):71-4.

Section of <u>Nuovissima guida per osservare le pitture sia
ad olio che a fresco esistenti attualmente nelle chiese di
Parma</u>, 1830. Mentions a <u>Pietà</u> on the exterior of Monastery of
San Paolo by Araldi.

PIACENZA

ERC164 AMBIVERI, LUIGI. <u>Gli artisti piacentini: Cronaca
 ragionata</u>. Piacenza: Tip Francesco Solari, 1879, 254 pp.
 Reprint. Bologna: Forni, 1976.
 Biographies of artists from Piacenza arranged chronolog-
 ically. Dependent on eighteenth-century sources. Limited
 number of fifteenth century including Bartolomeo da Groppallo,
 Giovanni de Palatio, Giovanni da Medio Fontana, and Giorgio de
 Muzano.

*ERC165 FIORI, GIACOMO. "Documenti biografici di pittori piacentini
 dalla fine '400 al 1700." <u>Archivio storico per le provincie
 parmenesi</u> 24 (1972):171-206.
 Cited in <u>Repetoire d'art et d'archéologie</u>, n.s. 11
 (1975):146, no. 2328.

RAVENNA

ERC166 BERNICOLI, SILVIO. "Arte e artisti in Ravenna." <u>Felix
 Ravenna</u> (1912):194-207, 217-43.
 Ravennate painters (and artists working in Ravenna) from
 the thirteenth through the fifteenth centuries, including
 Bittino da Faenza, Michino Lamberdani da Ravenna, Ercole de'
 Roberti, and Nicolò Rondinelli. Considers Baldassare Carrari
 and Francesco and Bernardino Zaganelli in section on sixteenth
 century.

ERC167 GRIGONI, CARLO. "Nota su l'arte e gli artisti in Ravenna."
 <u>Felix Ravenna</u> (1913):355-65.
 Painters of the fifteenth and sixteenth centuries, in-
 cluding information about Baldassare Carrari (and Nicolò
 Rondinelli.)

REGGIO-EMILIA

ERC168 VENTURI, GIOVANNI BATTISTA. "Notizie di artisti reggiani
 non ricordati dal Tiraboschi." <u>Atti e memorie delle RR.
 Deputazioni di storia patria per le provincie di modenesi e
 parmensi</u>, 3d ser. 2 (1884):29-46.
 Expands on work of Tiraboschi, <u>Biblioteca modenese</u>
 (ERC145). Organized by century. Includes the following
 fifteenth-century artists: Pietro Fasolo, Marc'Antonio
 Girondi, and Jacopo and Bartolomeo Maineri.

ERC169 MALAGUZZI VALERI, FRANCESCO. <u>Notizie di artisti reggiani
 (1300-1600)</u>. Reggio-Emilia: 1892, 145 pp. Reprint.
 Bologna: A. Forni, 1975.

Cities

Organized by century. Fifteenth century pp. 11-32. Main
painters are members of Maineri family. Publishes documents.

ERC170 MALAGUZZI VALERI, FRANCESCO. "La pittura reggiana nel
quattrocento." Rassegna d'arte 3 (1903):145-52, 10 b&w
illus.
Survey of artists working in Reggio and from Reggio.
Documentary citations. Mentions Baldassare Estense, the
Maineri, Francesco Caprioli, Bernardino Orsi, and Lazzaro
Grimaldi.

ERC171 BERTI, GIUSEPPE. "Aspetti e momenti dell'arte figurativa a
Reggio Emilia nel secolo XV." Atti e memorie della
Deputazione di storia patria per le antiche provincie
modenesi, 10th ser. 11 (1976):111-26, 3 b&w illus.
Disputes the notion of the primitive nature of the fig-
urative school in Reggio-Emilia. Publishes series of frescoes
in Bismantova from the first half of the century.

RIMINI

ERC172 MARCHESELLI, CARLO FRANCESCO. Pitture delle chiese di
Rimini (1754); and with ORETTI, MARCELLO, Pitture nella
città di Rimini (1777). Edited by Pier Giorgio Pasini.
Fonti e studi per la storia di Bologna e delle provincie
emiliane e romagnoli, no. 4. Bologna: Alfa, 1972, 287 pp.,
10 b&w illus. in the text + 193 b&w and 20 color illus.
Primarily a source on sixteenth-century and later objects.

ARTISTS

ALBERTI, ANTONIO

ERA1 BALDINUCCI, FILIPPO. Notizie dei professori del disegno da
Cimabue in qua. Edited by F. Ranalli. Vol. 1. Florence:
Eurografica, 1974, p. 333.
First published: Florence: Santi Franchi, 1681.
Brief life of Antonio. Reiterates statement of Vasari
that he was pupil of Agnolo Gaddi. Notes work in Città di
Castello and San Francesco, Urbino.

ERA2 BARUFFALDI, GIACOMO. Vite de' pittori e scultori ferraresi.
Vol. 1. Ferrara: Domenico Taddei, 1844, pp. 58-62.
Follows Vasari naming as pupil of Agnolo Gaddi. Work in
San Francesco, Urbino, and Città di Castello. Nothing remain-
ing in Ferrara. Notes work in Palazzo Paradiso, Ferrara,
depiction of the Council of Ferrara/Florence 1438. Other
works in footnotes.

ERA3 SCATANA, ERCOLE. "Documenti." Rassegna bibliografica
dell'arte italiana 1 (1898):196-97.

Payment for two standards from the Confraternity of Saint
Anthony Abbot, Urbino, 10 July 1438, to Antonio da Ferrara.

ERA4 SCATANA, ERCOLE. "Di Antonio di Guido Alberti da Ferrara."
 Rassegna bibliografica dell'arte italiana 9 (1906):56-63.
 Review of published material and biography. Document of
 1423 indicates already married. Dead by 1465.

ERA5 CALZINI, E[GIDIO]. "Antonio da Ferrara." In Thieme-Becker.
 Vol. 1. Leipzig: Seeman, 1907, pp. 589-90.

ERA6 COLETTI, LUIGI. "Gli affreschi della 'Sagra' di Carpi e
 Antonio Alberti." Bollettino d'arte 30 (1936):189-201, 17
 b&w illus.
 Connects frescoes in the chapels of SS. Martin and
 Catherine, Church of the Cemetery, Talamello, with Alberti.
 Rejects attribution to Serafino da Serafini.

ERA7 BOTTARI, STEFANO. "Gli affreschi della Cappella di Santa
 Caterina nella 'Sagra' di Carpi." Arte lombarda 3, no. 2
 (1958):65-70, 8 b&w illus.
 Argues that it is earlier than adjacent St. Martin
 Chapel. Dates first decade of fifteenth century. Disagrees
 with Coletti (ERA6). Not by Alberti, rather possibly by
 Giovanni da Modena.

ERA8 PADOVANI, SERENA. "Pittori della corte estense nel primo
 quattrocento." Paragone 26, no. 299 (1975):25-53, 35 b&w
 illus.
 Particular attention to Alberti, attributions and trav-
 els. General sketch of art in period of Nicolò III and
 Leonello. Also information on anonymous masters from Carpi.

ERA9 FONTANA, WALTER. "I miracoli del Santo e le storie del
 Battista di Antonio Alberti da Ferrara." Notizie da Palazzo
 Albani 7, no. 1 (1978):22-37, 16 b&w illus.
 Attributes two scenes of the Miracles of St. Anthony of
 Padua, San Francesco, Cagli, which he dates to early fifteenth
 century, to Alberti. Also attributes last scenes of life of
 St. John on left wall of Oratory of San Giovanni, Urbino, to
 Alberti.

ERA10 FONTANA, WALTER. "Tre tavole ignorate di Antonio Alberti di
 Ferrara." Notizie da Palazzo Albani 8, no. 2 (1979):8-26,
 22 b&w illus.
 Three works are Madonna della Misericordia, Cagli; St.
 Albertino at Eremo di Fonte Avellana; and Madonna del pianto,
 St. Angelo, Vado. Attributions on the basis of style.

ANSUINO DA FORLÌ

ERA11 MUÑOZ, A[NTONINO]. "Ansuino da Forlì." In Thieme-Becker.
 Vol. 1. Leipzig: Seeman, 1907, p. 545.

Artists

ERA12 CALZINI, EGIDIO. "Marco Palmezzano e le sue opere."
 Archivio storico dell'arte 7 (1894):185-200, 8 b&w illus.
 In discussion of background of Palmezzano, discusses work
 of Ansuino, pp. 190-96.

ERA13 CIPRIANI, RENATA. "Ansuino da Forlì." In Dizionario
 biografico italiano. Vol. 3. Rome: Istituto della
 enciclopedia italiana, 1961, pp. 426-27.
 Reviews the attribution of destroyed frescoes in Padua
 and other works and attributions. Characterizes style.
 Bibliography.

BALDASSARE ESTENSE

ERA14 BARUFFALDI, GIACOMO. Vite de' pittori e scultori ferraresi.
 Vol. 1. Florence: Domenico Taddei, 1844, pp. 92-95.
 Identifies as a disciple of Tura on basis of style. Work
 in Sta. Maria degli Angeli and Sta. Maria della Consolazione.
 Relationship to the aborted project for equestrian statue of
 Ercole I.

ERA15 VENTURI, ADOLFO. "Di chi fosse figlio il pittore Baldassare
 d'Este?" Archivio storico dell'arte 1 (1888):42-43.
 Document of 1489 suggesting Baldassare was the illegiti-
 mate son of Nicolò III d'Este.

ERA16 MOTTA, EMILIO. "Il pittore Baldassare da Reggio (1461-71)."
 Archivio storico lombardo, 2d ser. 6 (1889):403-9.
 Documents Baldassare Estense's work for the Milanese court.

ERA17 "Ancora del pittore Baldassare da Reggio." Archivio storico
 lombardo, 2d ser. 7 (1890):999-1000.
 Note from the Annali della Fabrica del Duomo in Milan, 4
 April 1461, payment for painting a crucifix to Baldassare.

ERA18 VENTURI, ADOLFO. "Baldassare Estense." In Thieme-Becker.
 Vol. 2. Leipzig: Seeman, 1908, pp. 387-9.

ERA19 COOK, HERBERT. "Baldassare d'Este." Burlington Magazine 19
 (1911):228-33, 3 b&w illus.
 A number of attributions, some quite suspect. Useful for
 tracing provenance.

ERA20 GRAFF, WALTER. "Ein Familienbildnis des Baldassare Estense
 in der Alten Pinakothek." Münchner Jahrbuch der bildender
 Kunst 7 (1912):207-24, 7 b&w illus.
 Publishes the Sacrati Family Portrait with attribution to
 Baldassare.

ERA21 VENTURI, ADOLFO. Storia dell'arte italiana. Vol. 7, La
 pittura del quattrocento. Pt. 3. Milan: Hoepli, 1914, pp.
 712-23, 6 b&w illus.
 Review of factual data. Attributions.

ERA22 COOK, HERBERT. "Further Light on Baldassare d'Este."
 Burlington Magazine 27 (1915):98-104, 7 b&w illus.
 Further attributions: Sacrati Family, Munich; Concert,
 National Gallery, London; Man with a Ring, Thyssen Collection,
 Lugano; Portrait of a Musician, Dublin; Portrait of Giovanni
 Bentivoglio and His Wife, National Gallery, Washington; and
 Portrait of an Unknown Man, Museo Correr, Venice. Most attri-
 butions generally not acceptable.

ERA23 GRONAU, GEORG. "Ein Bildnispaar im Kestner Museum zu
 Hannover." In Italienische Studien: Paul Schubring zum 60
 Geburtstag gewidmet. Leipzig: Hiersmann, 1929, pp. 63-73,
 4 b&w illus.
 Baldassare Estense's Portraits of Galeotto I Pico and
 Bianca Maria d'Este.

ERA24 DOBROKLONSKY, M. "Notes on Drawings: ?Baldassare d'Este."
 Old Master Drawings 7 (1932):41, 1 b&w illus.
 Drawing in the Hermitage Head of a Man. Draws parallels
 with Portrait of Borso d'Este. Possibly Baldassare. Other
 possibility is Zenale.

ERA25 MEISS, MILLARD. "Five Ferrarese Panels." Burlington
 Magazine 93 (1951):69-71, 5 b&w illus.
 Attributes five Dominican Saints formerly on display in
 the Provinzialmuseum, Bonn, to "Vicino da Ferrara" whom Longhi
 (ERC88) identifies with Baldassare.

ERA26 SHAPLEY, FERN RUSK. "Baldassare d'Este and a Portrait of
 Francesco II Gonzaga." In Studies in the History of Art
 Dedicated to William E. Suida on His Eightieth Birthday.
 London: Phaidon, 1959, pp. 124-26, 6 b&w illus.
 Attributes a profile portrait of Francesco II Gonzaga in
 the National Gallery, Washington, to Baldassare Estense.
 Places between Portrait of Borso d'Este, 1471, and Portrait of
 Tito Strozzi, 1493.

ERA27 ARSLAN, EDOARDO. "Baldassare d'Este." In Dizionario
 biografico italiano. Vol. 5. Rome: Istituto della
 enciclopedia italiana, 1963, pp. 444-45.
 Biography. Relates style more to the generation of Tura
 and Cossa than to Roberti. Bibliography.

ERA28 NIRONI, VITTORIO. "Una medaglia del reggiano Baldassare
 Estense nell'Archivio di Stato di Reggio-Emilia." Atti e
 memorie della Deputazione di storia patria per le antiche
 provincie modenesi, 10th ser. 12 (1977):89-94.
 Review of biographical data on Baldassare including bap-
 tismal documents and a will.

ERA28A BENATI, DANIELE. "Per il problema di 'Vicino da Ferrara'
 (alias Baldassare d'Este?)." Paragone 33, no. 393 (1982):
 3-26, 26 b&w illus.

Artists

Disputes Longhi's (ERC88) identification of the artist "Vicino da Ferrara" as Baldassare d'Este on the basis of different dating and stylistic assumptions. Suggests new chronology for the work of "Vicino." Raises issue of exactly what Baldassare did in the Schifanoia.

ERA29 BERNASCONI, ENRICA. "Il restauro della 'Morte della Vergine' di Baldassare d'Este." Paragone 34, no. 401-3 (1983):56-59, 2 b&w illus.
Restoration report on the Death of the Virgin by Baldassare in the Pinacoteca ambrosiana, Milan.

BIANCHI FERRARI, FRANCESCO

ERA30 PEDERZINI, ANTONIO CAVAZZONI. Intorno al vero autore di un dipinto attribuito al Francia. Modena: 1864.
Attribution of an Annunciation in the Galleria estense to Francesco Bianchi Ferrari.

ERA31 VENTURI, ADOLFO. "Francesco Bianchi Ferrari." Rassegna emiliana di storia, letteratura ed arte 1 (1888):133-43.
Detects influence of Tura and Ferrarese in Bianchi Ferrari. Disputes certain attributions of Morelli and Crowe and Cavalcaselle. Summary of attributions. Documents.

ERA32 VENTURI, ADOLFO. "Il Maestro del Correggio." L'arte 1 (1898):279-303, 17 b&w illus.
Documents concerning Bianchi Ferrari and his relationship with Correggio.

ERA33 VENTURI, ADOLFO. "Bianchi Ferrari, Francesco." In Thieme-Becker. Vol. 3. Leipzig: Seeman, 1909, pp. 586-87.

ERA34 VENTURI, ADOLFO. "Note su alcuni quadri del Museo nazionale di Napoli." L'arte 32 (1929):203-9, 5 b&w illus.
Attributes Christ in the Tomb with the Symbols of the Passion to Bianchi Ferrari.

ERA35 VENTURI, ADOLFO. "Un'opera di Francesco Bianchi Ferrari." L'arte 33 (1930):41-45, 1 b&w illus.
Attributes Crucifixion in collection of Baron Alberto Fassini, Rome.

ERA36 NANNINI, MARCO. "Contributo allo studio del Bianchi Ferrari." Atti e memorie della Deputazione di storia patria per le antiche provincie modenesi, 8th ser. 3 (1950):19-25.
Discusses landscapes by Bianchi Ferrari and his work as a sculptor.

ERA37 GRASSI, EMY. "Profilo storico del pittore modenese Francesco Bianchi Ferrari (1448/60-1510)." Parma nell'arte 2, no. 2 (1970):63-82, 2 b&w illus.

Reconstructs career with special attention to documents in the archives of the Cathedral, Modena. Particular analysis of Crucifixion and Annunciation in the Galleria estense. Relationship to Correggio.

BITTINO DA FAENZA

ERA38 FILIPPINI, FRANCESCO. "Gli affreschi nell'abside della Chiesa di Sant'Agostino e un ritratto di Dante." Bollettino d'arte ser. 2 no. 1 (1921):3-22, 21 b&w illus.
Frescoes in Sant'Agostino in Rimini with the life of Saint John uncovered. Attributes them to Bittino da Faenza.

ERA39 CORBARA, ANTONIO. "Note sulla pittura del rinascimento in Romagna. Un inedito Bitino (sic) da Faenza ed altre pitture Romagnole." Melozzo da Forlì 2 (January 1938):67-69, 4 b&w illus.
Attributes oval Madonna and Child in Sta. Maria dell'Angelo, Faenza, to Bittino. Possibly also fragments of a fresco with Madonna and Child in S. Nicolò, Castrocaro.

BONO DA FERRARA

ERA40 BARUFFALDI, GIACOMO. Vite de' pittori e scultori ferraresi. Vol. 2. Ferrara: Domenico Taddei, 1846, pp. 560-61.
Brief biography of Bono from secondary sources.

ERA41 BORENIUS, TANCRED. "Bono da Ferrara." Burlington Magazine 35 (1919):178-79, 1 b&w illus.
Basic biography. Notes painting of two castles near Ferrara in 1450 and 1452. Working in Siena 1442-61. Attributes SS. John the Baptist and Prodochimus in the collection of Henry Harris to Bono. Suggests influence of Tura.

ERA42 VENTURI, ADOLFO. "Del quadro attribuito a Bono da Ferrara nella Galleria nazionale di Londra." L'arte 25 (1922):105-8, 2 b&w illus.
Figure of Saint Jerome.

ERA43 COCKE, R[ICHARD]. "Piero della Francesca and the Development of Italian Landscape Painting." Burlington Magazine 122 (1980):627-31, 4 b&w illus.
Influence of Piero on the art of Bono da Ferrara.

CARRARI, BALDASSARE

ERA44 GRIGONI, CARLO. "Baldassare Carrari il giovane, pittore forliuese." Arte e storia 15 (1896):91-93.
Brief bibliography on artist. Documents for two works: Baptismal chapel in S. Mercuriale, Forlì, 20 April 1498; and altarpiece with St. Apollinare for the Church of S. Apollinare in Longana (Ravenna), 23 January 1520.

Artists

ERA45 GRIGONI, CARLO. "Documenti." Rassegna bibliografica
 dell'arte italiana 1 (1898):237-41.
 Genealogy and various notarial documents concerning
 Baldassare Carrari il Giovane. Dead by 1519. Documents con-
 cerning panel painted before 1498, and for panels for the
 Church of the Batuti Verdi, Forlì, 1513.

*ERA46 BUSCAROLI, REZIO. "Baldassare Carrari da Forlì." Forum
 livii 3 (1928):11f.
 Cited in Montanari (ERA47). State of knowledge about art-
 ist in 1928. Intermediary between school of Ravenna and Forlì.

ERA47 MONTANARI, LUIGI. "Un quadro di B. Carrari il giovane nella
 Chiesa arcipretale di San Apollinare in Longana presso
 Ravenna." Studi romagnoli 7 (1956):175-82, 3 b&w illus.
 Painting of SS. Apollinare, Sebastian, and Roch. Active
 last decade of fifteenth through first of sixteenth centuries.
 Painter "di moda" in Ravenna and Forlì. Died before 23 January
 1520. Shows knowledge of work of Nicolò Rondinelli. The patron
 of the painting was the rector of the Church of S. Apollinare.

 CATTANEO, GIOVANNI ANTONIO

ERA48 BERKOVITS, ILONA. "Una miniatura della Biblioteca Corvina."
 Acta Historiae Artium Academiae Scientiarum Hungaricae 7
 (1960-61):79-90, 4 b&w and 1 color illus.
 Forty-five miniatures in a Graduale in the National Li-
 brary "Szechenyi" in Budapest, Clmae 424. Attributes the illu-
 minations to the Dominican Cattaneo, who was at Corvinus's court.

 CICOGNARA, ANTONIO

ERA49 NEBBIA, UGO. "Cicognara, Antonio." In Thieme-Becker. Vol.
 6. Leipzig: Seeman, 1912, pp. 572-3.

ERA50 SALMI, MARIO. "Intorno al Cicognara." Bollettino d'arte,
 2d ser. 6 (1926-27):217-23, 7 b&w illus.
 Touchstone is altarpiece in Cologna Collection, Milan,
 dated 1490, shows influence of Tura. Attributes Psalter in
 Arezzo to follower of Cicognara.

ERA51 HENDY, PHILIP. "Antonio Cicognara." Art in America 19
 (1930-31):48-56, 6 b&w illus.
 Adds four panels to his oeuvre: Annunciation, Wallace
 Collection, London; Women before Tomb, Gardner Collection,
 Boston; Triumph of St. Ursula, Musée Jacquemart-André, Paris;
 and Virgin and Child, Museum of Fine Arts, Boston.

ERA52 RUHMER, EBERHARD. "Nachträge zu Antonio Cicognara."
 Pantheon 18 (1960):254-59, 6 b&w illus.
 Attributes miniature to Cicgonara. Exchange between
 Ferrara and Cremona.

COSSA, FRANCESCO DEL

ERA53 FRIZZONI, GUSTAV. "Zur Wiederherstellung einer
 altferraresischen Altarwerkes." Zeitschrit für bildende
 Kunst 23 (1888):299-302, 2 b&w illus.
 Locating the remnants of the Altarpiece of St. Vincent of
 Ferrer, from S. Petronio, Bologna, in the Vatican and London.

ERA54 FRIZZONI, GUSTAVE. "Die Verkundigung von Francesco del
 Cossa in der Dresdener Galerie." Zeitschrift für bildende
 Kunst 24 (1889):163-64, 1 b&w illus.
 Agrees with Morelli's attribution of the Annunciation to
 Cossa. Traces other attributions.

ERA55 MARUTTI, O. "Una tela attributo al Cossa in S. Giovanni in
 Monte a Bologna." Archivio storico dell'arte 2 (1889):171.
 Says that Virgin and Child, S. Giovanni al Monte,
 Bologna, bears inscription that dates it to 1492 (i.e., after
 the death of Cossa).

ERA56 FRIZZONI, GUSTAVE. "I nuovi acquisiti della Pinacoteca di
 Brera (Francesco Cossa e Galeazzo Campi)." Arte e storia 12
 (1893):123-25.
 A St. Peter and St. John the Baptist.

ERA57 BODE, WILHELM von. "Der Herbst vom Francesco Cossa in der
 Berliner Galerie." Jahrbuch der Könglich preussischen
 Kunstsammlungen 16 (1895):88-90, 1 b&w illus.
 Attributes Autumn from Belfiore studiolo to Cossa.
 Attributions on Morellian basis. Strong analysis of color.

ERA58 FRATI, LUDOVICO. "La morte di Francesco del Cossa." L'arte
 3 (1900):300-302.
 Documents Cossa's death to 1477.

ERA59 VENTURI, ADOLFO. "Due quadri di Francesco del Cossa nella
 raccolta Spiridion a Parigi." L'arte 9 (1906):139-40, 2 b&w
 illus.
 SS. Liberale and Lucy, now in the National Gallery,
 Washington.

ERA60 BERNATH, M[ORTON] H. "Cossa, Francesco del." In Thieme-
 Becker. Vol. 7. Leipzig: Seeman, 1912, pp. 507-10.

ERA61 FIOCCO, GIUSEPPE. "A proposto di un cassone nuziale del
 Palazzo Pitti." L'arte 16 (1913):18, 1 b&w illus.
 Assigns the marriage chest to Cossa on the basis of a
 comparison with the Schifanoia frescoes.

ERA62 BRECK, JOSEPH. "A Crucifixion by Francesco del Cossa." Art
 in America 2 (1914):314-17, 1 b&w illus.
 First publication of the Crucifixion tondo in the Lehman
 Collection from the Costabili Collection, Ferrara.

Artists

ERA63 PERKINS, J. MASON. "La Crocefissione di Francesco del
 Cossa." L'arte 17 (1914):222-23, 1 b&w illus.
 Tondo Crucifixion in the Lehman Collection.

ERA64 VENTURI, ADOLFO. Storia dell'arte italiana. Vol. 7, La
 pittura del quattrocento. Pt. 3. Milan: U. Hoepli, 1914,
 pp. 586-656, 48 b&w illus.
 Influences, Piero and Tura. Biography and documented
 works. Attributions, including stained glass. Discussion of
 work in the Schifanoia. Extensive discussion of triptych with
 miracles of St. Vincent of Ferrer.

ERA65 RICCI, CORRADO. "Tarsie disegnate dal Cossa." Bollettino
 d'arte 9 (1915):262-63, 3 b&w illus.
 St. Ambrose and St. Petronius from the choir stalls,
 S. Petronio, Bologna, done between 1468-77. Payment in 1473 to
 Cossa for the designs.

ERA66 ZUCCHINI, GUIDO. "Le vetrate di San Giovanni in Monte di
 Bologna." Bollettino d'arte 11 (1917):82-90, 3 b&w illus.
 Attributes Madonna and Child and the Stemma Gozzadini
 from a window on the facade to school of Cossa, and Evangelist
 to Ercole de' Roberti.

ERA67 BERENSON, BERNARD. "A Ferrarese Marriage-Salver in the
 Boston Museum of Fine Arts." In Essays in the Study of
 Sienese Painting. New York: F. Fairchild Sherman, 1918,
 pp. 57-80, 19 b&w illus.
 Correcting attribution of marriage salver with Solomon
 and Sheba to Matteo di Giovanni. Says instead close to Cossa.
 Discusses ties and stylistic parallels between the Sienese and
 Ferrarese styles.

ERA68 MAYER, AUGUST L. "Two Unknown Panels by Cossa." Burlington
 Magazine 57 (1930):311, 1 b&w illus.
 SS. Elizabeth and Catherine, formerly in the collection
 of Lord Wemyss, Gosford Hall, now in Heinemann Gallery, Munich.
 Dates ca. 1467-70 as part of larger altarpiece.

ERA69 VENTURI, ADOLFO. "Eine Madonna von Francesco del Cossa."
 Pantheon 5 (1930):249-50, 1 color illus.
 Attributes Madonna and Child formerly in private collec-
 tion in Rome, to Cossa.

ERA70 GIGLIOLI, ODOARDO. "Disegni inedite di Francesco del Cossa
 e di Amico Aspertini." Bollettino d'arte 27 (1934):455-59,
 12 b&w illus.
 Drawing of Orpheus in Uffizi.

ERA71 NEPPI, ALBERTO. "Alla mostra della pitture ferrarese del
 rinascimento. Rettifiche di attribuzioni relative al Tura,
 al Cossa, all'Ortolano e al Garofalo." Rivista di Ferrara
 2, no. 4 (1934):189-91, 14 b&w illus.

Attributes St. Jerome in the Palazzo comunale, Ferrara,
to Tura rather than Cossa.

ERA72 NEPPI, ALBERTO. "Cimelli della mostra ferrarese del
 rinascimento: Disegni del Tura, Cossa, Roberti." Rivista
 di Ferrara 2, no. 8 (1934):376-77, 10 b&w illus.
 Includes illustration of Orpheus by Cossa.

ERA73 ZUCCHINI, GUIDO. "Avanzi di un affresco di Francesco del
 Cossa." Il Comune di Bologna 21, no. 8 (1934):16-18, 3 b&w
 illus.
 Attributes architectural decorations in the Casa dello
 studente in Bologna, via Zamboni 25, to Cossa.

ERA74 BODMER, HEINRICH. "Francesco Cossa." Pantheon 28
 (1941):230-36, 7 b&w illus.
 Using Schifanoia frescoes as touchstone, defines place of
 Cossa in the Griffoni Altarpiece, Bologna. Characterization of
 style.

ERA75 ORTOLANI, SERGIO. Cosmè Tura, Francesco del Cossa, Ercole
 de' Roberti. Milan: U. Hoepli, 1941, 225 pp., 200 b&w illus.
 Attributions to Cossa on pp. 83-138. Stylistic development.

ERA76 MEISS, MILLARD. "Five Ferrarese Panels." Burlington
 Magazine 93 (1951):69-71, 10 b&w illus.
 Attributes Portrait of Young Man (El tempo consuma) in
 Musée Bensançon to Cossa, ca. 1470. Possible connection with
 Scipione d'Este.

ERA77 CHIAPPINI, LUCIANO. "Appunti sul pittore Francesco del
 Cossa e la sua famiglia." Atti e memorie della Deputazione
 provinciale ferrarese di storia patria, n.s. 14 (1955):
 105-20.
 Documents and genealogy.

ERA78 NEPPI, ALBERTO. Francesco del Cossa. Milan: Silvana,
 1958. 46 pp., 48 b&w and 21 color illus.
 Monograph with emphasis on stylistic development. Recon-
 structs work prior to the Schifanoia. Analysis of Schifanoia
 frescoes, only April and March. Attributions.

ERA79 NEUMEYER, ALFRED. "Francesco del Cossa: Mann mit Strick."
 In Glanz des Schoenen, Gesprachen mit Bildern. Heidelberg:
 L. Schneider, 1959, pp. 35-39, 1 b&w illus.
 Aesthetic evaluation of decan with cord from the
 Schifanoia. Recapitulation of Warburg's argument concerning
 astrology in the Sala dei mesi.

ERA80 RUHMER, EBERHARD. Francesco del Cossa. Munich:
 F. Bruckmann, 1959, 100 pp., 103 b&w and 9 color illus.
 Catalogue raisonné.

Artists

ERA81 N.d.R. "La Madonna dei mercanti di Francesco del Cossa."
 Acropoli 1 (1960-61):149-53, 4 color illus.
 Illustrates the Madonna dei mercanti after restorations,
 with details of the Annunciation above. Brief summary of
 Cossa's life and activities.

ERA82 SALMI, MARIO. "Cossa, Francesco." In Encyclopedia of World
 Art. Vol. 4. New York, London and Toronto: McGraw Hill,
 1962, cols. 1-8, 2 color and 9 b&w illus.
 Biography. Schifanoia frescoes as touchstone for style
 and attributions. Influence of Pisanello, Tura, and Piero
 della Francesca. Basically agrees with Ortolani's attribu-
 tions. Roberti collaborator in predella of St. Vincent Ferrer
 Altarpiece.

ERA83 RUHMER, EBERHARD. "Ein Madonnenbild nach Francesco del
 Cossa." Pantheon 22 (1964):73-80, 13 b&w illus.
 Madonna and Child in a private collection in southern
 Germany, closer to Ercole de' Roberti.

ERA84 MELLER, PETER. "Drawings by Francesco Cossa in the Uffizi."
 Master Drawings 3 (1965):3-20, 35 b&w illus.
 Attributes eight drawings of men dancing (Morris
 dancers), formerly attributed to Quentin Massys, to Cossa.
 Uffizi 2321F-2328F.

ERA85 MOLAJOLI, ROSEMARIA, ed. L'opera completa di Cosmè Tura e i
 grandi pittori ferraresi del suo tempo: Francesco Cossa e
 Ercole de' Roberti. Classici dell'arte, no. 73. Milan:
 Rizzoli, 1974, 104 pp., 164 b&w and 64 color illus.
 Overview of criticism on each of the artists surveyed.
 Entries on each of the works include attributional history and
 date. Palazzo Schifanoia discussed on pp. 100-102.

ERA86 ROSENBERG CHARLES M. Francesco del Cossa's Letter Recon-
 sidered." Bollettino annuale dei musei ferraresi 5/6
 (1975-76):11-16, 3 b&w illus.
 Considers implications of Cossa's letter of 25 March
 1470, for what it indicates about methods of payment, workshop
 practice, and patronage of the Schifanoia frescoes.

ERA87 ETTLINGER, HELEN. "The Virgin Snail." Journal of the
 Warburg and Courtauld Institutes 41 (1978):316, 2 b&w illus.
 Iconographic explanation of snail as symbol of virginity
 (Franz von Retz, Defensorum inviolate virginitatis Mariae,
 1460) in foreground of the destroyed Annunciation by Cossa,
 formerly in the Dresden.

ERA88 GENTILI, AUGUSTO. "Mito cristiano e storia ferrarese nel
 Polittico Grifino." In La corte e lo spazio: Ferrara
 estense. Edited by Giuseppe Papagano and Amedeo Quondam.
 Vol. 2. Rome: Bulzoni, 1982, pp. 563-76, illus. in vol 3.

Concentrates on the iconography of miracles of Saint
Vincent Ferrer in the predella by Ercole de' Roberti under the
supervision of Cossa. Identifies backgrounds with Ferrara.

ERA89 CONTI, ALESSANDRO. "Due disegni del quattrocento." In
 Scritti di storia dell'arte in onore di Federico Zeri.
 Milan: Electa, 1984, pp. 179-82, 4 b&w illus.
 Drawing of Saint Michael from Cod. min. 46, Bologna,
 Archivio di stato. Codex has text of Sabadino degli Arienti's
 Gynevera, which dates from 1483. On basis of armor and style,
 close to Cossa, dates to 1480s.

COSTA, LORENZO

ERA90 VASARI, GIORGIO. Le vite de' più eccellenti pittori,
 scultori ed architettori. . . . Annotated by Gaetano
 Milanesi. Vol. 3. Florence: Sansoni, 1973, pp. 131-40.
 Compilation of 1550 and 1568 editions. Reprint of 1906
 edition.
 Biography. Story of early attraction of Florence. Os-
 cillation between Ferrara and Bologna. Works listed.

ERA91 BARUFFALDI, GIACOMO. Vite de' pittori e scultori ferraresi.
 Vol. 1. Ferrara: Domenico Taddei, 1844, pp. 102-25.
 Error in naming master, following Vasari, training in
 Florence; next master Francia. Notes works, including portrait
 of Alfonso I, in collection of Nicolò Baruffaldi. Works in
 Ferrara, Bologna, and Mantua. Pupils.

ERA92 VENTURI, ADOLFO. "Lorenzo Costa." Archivio storico
 dell'arte 1 (1888):241-56, 6 b&w illus.
 Summary of works and attributions.

ERA93 VENTURI, ADOLFO. "Raccomandazione aprò di Lorenzo Costa e
 de' suoi fratelli." Archivio storico dell'arte 1 (1888):328.
 Document of 1519.

ERA94 YRIARTE, CHARLES. "Isabella d'Este et les artistes de son
 temps: Relations d'Isabelle avec Lorenzo Costa et Francia."
 Gazette des beaux-arts, 3d ser. 15 (1896):330-46, 3 b&w illus.
 Correspondence between Isabella and agents concerning
 portraits and paintings for her studiolo summarized.

ERA95 JACOBSEN, EMIL. "Lorenzo Costa und Francesco Francia."
 Jahrbuch der Königlich preussichen Kunstsammlungen 20
 (1899):159-73, 6 b&w illus.
 Consideration of the interaction between Costa and
 Francia. Does not consider Francia the teacher of Costa,
 though may have learned goldsmith and die-cutting from Francia.
 General review of Costa's work. Sees Venetian influence.

Artists

ERA96 BERTI, UGO. "Un restauro importante a Bologna (Cappella San
 Sebastiano in San Petronio)." Rassegna d'arte 2 (1902):72-
 75, 5 b&w illus.
 Documents concerning the early history of the Chapel of
 St. Sebastian, San Petronio, Bologna. Attributes S. Sebastian
 to an anonymous Ferrarese and the Annunciation to Costa.

ERA97 DUNCAN, ELLEN. "The National Gallery of Ireland."
 Burlington Magazine 10 (1906-7):8, 1 b&w illus.
 Illustration of Costa's Holy Family with St. Joseph.

ERA98 GEREVICH T[IBERIO]. "Costa, Lorenzo." In Thieme-Becker.
 Vol. 7. Leipzig: Seeman, 1912, pp. 522-30.

ERA99 VENTURI, ADOLFO. Storia dell'arte italiana. Vol. 7, La
 pittura del quattrocento. Pt. 3. Milan: U. Hoepli, 1914,
 pp. 752-847, 70 b&w illus.
 Considers Costa pupil of Tura. Monographic discussion of
 work. Factual data and attributions. Influence of Ercole de'
 Roberti.

ERA100 VENTURI, ADOLFO. "Capolavori primitivi inediti del Francia
 a Vienna e del Costa a Reggio Emilia." L'arte 24
 (1921):185-88, 3 b&w illus.
 St. Sebastian, collection of Count Cassoli, Reggio-Emilia.

ERA101 GRONAU, GEORG. "Frauenbildnisse des Mantuaner Hofes von
 Lorenzo Costa." Pantheon 1 (1928):235-41, 6 b&w illus.
 Identifies portraits in Hampton Court and American pri-
 vate collection as Eleonora Gonzaga. Relationship to portraits
 of Isabella d'Este. Suggests that ideal vision governs
 portraits.

ERA102 VENTURI, ADOLFO. "Opere d'arte ignote o misconosciute."
 L'arte 32 (1929):7-14, 8 b&w illus.
 Attributes Portrait of a Woman with the Attributes of the
 Magdalen in Dowdeswell Collection, London, to Costa, ca. 1506.

ERA103 OZZOLA, LEANDRO. "Perugino oder Costa?" Pantheon 5
 (1930):164-65, 3 b&w illus.
 Attributes Portrait of a Young Boy in the Uffizi (no.
 1454) to Costa.

ERA104 VENTURI, ADOLFO. "Ignoto capolavoro di Lorenzo Costa."
 L'arte 33 (1930):552-55, 1 b&w illus.
 Attributes Venus with a Cornucopia of Flowers, collection
 of Count Giuseppe Scarselli, Bologna, to Costa.

ERA105 ZUCCHINI, GUIDO. "Una tavola di Lorenzo Costa." Il Comune
 di Bologna 21, no. 9 (1934):12-13, 3 b&w illus.
 Attributes Madonna and Child with Saints in the sacristy,
 Sta. Trinità, Bologna, to Costa.

ERA106 ZUCCHINI, GUIDO. "Una tela del Costa." Il Comune di
 Bologna 21, no. 10 (1934):55-56, 2 b&w illus.
 Attributes Assumption of the Virgin, apse of Abbazia di
 Monteveglio (Bologna), to Costa. Attributed traditionally to
 Francesco Giusti da Fagnano.

ERA107 HADELN, DETLEV von. "Das Bentivoglio-Konzert von Lorenzo
 Costa." Pantheon 14 (1934):338-40, 1 b&w illus.
 Group portrait with identifying inscriptions of members
 of the Bentivoglio family and court, ca. 1493. Swiss private
 collection. Strange pastiche.

ERA108 BUCARELLI, PALMA. "Due opere inedite di Lorenzo Costa in
 Roma." Bollettino d'arte, 3d ser. 27 (1934):322-26, 4 b&w
 illus.
 Proves no artist named "Ercole Grandi," then attributes
 Portrait of Young Woman, in the Capitoline Gallery, Rome, to
 Costa on the basis of a comparison with Nude Venus, Scarselli
 Collection, Bologna. Also attributes Annunciation, collection
 of Marchese A. Dusnet, Rome (ca. 1501), and Portrait of a Young
 Woman (unlikely), collection of Eugenio Ruspoli, Rome (ca.
 1506), to Costa.

ERA109 BODMER, HEINRICH. "Lorenzo Costa." Pantheon 26 (1940):141-
 45, 6 b&w illus.
 Attributions and description of his style.

ERA110 ZERI, FEDERICO. "Il terzo pannello degli 'Argonauti' di
 Lorenzo Costa." Propozioni 2 (1948):170-72, 1 b&w illus.
 Publishes third panel from story of Jason and the
 Argonauts in the Musée des arts decoratifs, Paris. Banquet
 scene whose specific reference is unclear. Assigns whole cycle
 to Costa.

ERA111 ARCANGELI, FRANCESCO. "Una 'Maddalena' di Lorenzo Costa."
 Paragone 57 (1954):48-51, 1 b&w illus.
 Identifies Mary Magdalene, private collection, datable
 1505-10, as by Costa.

ERA112 RUHMER, EBERHARD. "Ein unveröffentlichen Lorenzo Costa."
 Pantheon 19 (1961):141-47, 6 b&w illus.
 Virgin from an Annunciation in a private collection.
 Dates to ca. 1500.

*ERA113 SCERBACEVA, MARIA I. "Lorenzo Kosta i zenskij portet ego
 naboty" (Lorenzo Costa and his portrait of woman in the
 Hermitage). Trudy Gosudarstvennogo Ermitaza 6 (1961):182-
 200, 20 b&w illus.
 Cited in Repetoire d'art et d'archeologie 65 (1961):276,
 no. 6183. Attributes portrait of Emilia Pia da Montefeltro to
 Costa on stylistic basis through comparison with paintings in
 Hampton Court and Frankfurt.

Artists

ERA114 BROWN, CLIFFORD MALCOLM. "Lorenzo Costa." Ph.D. disserta-
tion, Columbia University, 1966, 612 pp., numerous b&w illus.
 Catalogue raisonné. Special attention to the iconography
of the Bentivoglio Chapel.

ERA115 VARESE, RANIERI. Lorenzo Costa. Milan: Silvana, 1967, 256
pp., 64 b&w illus., 16 color illus.
 Critical essay, biographical data, catalogue raisonné,
and bibliography.

ERA116 TOESCA, ILARIA. "Il Costa di San Nicola in Carcere (Roma)."
Paragone 225 (1968):43-46, 7 b&w illus.
 Ascension in San Nicola in Carcere, ca. 1503. After
restoration connects with a painting of same subject noted as
being in Sta. Maria della Mascarella, Bologna, in 1785.

ERA117 BROWN, CLIFFORD MALCOLM. "Comus, Dieu des fêtes: Allegorie
de Mantegna et de Costa pour le studiolo d'Isabella d'Este-
Gonzague." Revue du Louvre Musées de France 19 (1969):31-
38, 3 b&w illus.
 Notes that Calandra saw a Comus begun by Mantegna. Sug-
gests that Louvre Comus by Costa is the Mantegna finished after
his death.

ERA118 HOURS, MADELEINE. "Étude comparative des radiographies
d'oeuvres de Costa et de Mantegna faites au laboratoire de
recherche des Musées de France." Revue du Louvre Musées de
France 19 (1969):39-42, 4 b&w illus.
 Concludes on basis of laboratory analysis that Louvre
Comus did not undergo any major changes during composition.
Hand quite different from Mantegna, therefore was not begun by
him.

ERA119 VENTUROLI, PAOLO. "Lorenzo Costa." Storia dell'arte 1-2
(1969):161-68.
 Review of recent literature on Costa.

ERA120 BROWN, CLIFFORD, and ANNA MARIA LORENZONI. "Lorenzo Costa
in Mantua--Five Autograph Letters." L'arte, n.s. 3, nos.
11-12 (1970):102-16, 4 b&w illus.
 Letters from Mantuan archives relating to personal mat-
ters and Holy Family done for Isabella d'Este before trip to
France, and two versions of Venus in Budapest and Bologna.

ERA121 SHAW, JAMES BYAM. Old Master Drawings from Christ Church,
Oxford. A Loan Exhibition. Catalogue. N.p.:International
Exhibitions Foundation, 1972.
 Entry number 22 is a Lorenzo Costa Christ in the House of
Simon the Pharisee. Dates to after 1500.

ERA122 BROWN, CLIFFORD. "Un tableau perdu de Lorenzo Costa et la
collection de Florimond Robertet." Revue de l'art 52
(1981):24-8, 5 b&w illus.

Veronica with the Sudarium sent to France for collection
of Robertet subsequently lost. Relationship between the French
and the court of the Gonzaga.

ERA123　TOSETTI GRANDI, PAOLA. "Lorenzo Costa in San Giacomo
　　　　Maggiore a Bologna: Una proposta e la valutazione di una
　　　　fonte." Prospettiva 24 (1981):37-40, 4 b&w illus.
　　　　　　Attributes four tondi in the vaults of the nave of S.
　　　　Giacomo Maggiore, Bologna, to Costa on basis of style. One
　　　　bears date of 21 December(?) 1499 which coincides with
　　　　chroniclers' statements about building of the church.

ERA124　BOLOGNA, FERDINANDO. "Aggiunte a Lorenzo Costa." In
　　　　Scritti di storia dell'arte in onore di Federico Zeri.
　　　　Milan: Electa, 1984, pp. 263-75, 7 b&w illus.
　　　　　　Publishes Adoration of the Child, private collection.
　　　　Sources of iconography and composition in Perugino. Suggests
　　　　Madonna may be portrait of Isabella d'Este. Two other Costas:
　　　　St. John the Baptist, formerly in Madrid private collection,
　　　　and Lamentation in the collection of Grasses Hernandez,
　　　　Barcelona.

COSTANZO DA FERRARA

ERA125　VENTURI, ADOLFO. "Costanzo medaglista e pittore." Archivio
　　　　storico dell'arte 4 (1891):374-75.
　　　　　　Publishes letter of Battista Bendidio from 1485 identi-
　　　　fying Costanza as in Naples, and having been in Constantinople.

ERA126　ANDALORO, MARIA. "Costanzo da Ferrara: Gli anni a
　　　　Constantinopoli alla corte di Maometto II." Storia
　　　　dell'arte 38-40 (1980):185-212, 29 b&w illus.
　　　　　　Medal of Mohammed II 1480-81. Sent to Sultan by
　　　　Ferdinando d'Aragon. Reprints Bendidio letter. Notes letter
　　　　of 1524 that refers to Costanzo as "lombardo," another refer-
　　　　ence as Costanzo di Mosé. Attributions to Costanza: Mohammed
　　　　II miniature in Topkapi Museum, Istanbul, H2153, 145b; minia-
　　　　ture in Gardner Museum, Boston; double portrait in Swiss pri-
　　　　vate collection; and group of eight drawings of Persian figures
　　　　in British Museum, Louvre, Frankfurt, and Fogg Museum, Cambridge,
　　　　Mass. Relates stylistically to Baldassare Estense.

CREVALCORE, ANTONIO LEONELLI DA

ERA127　COLETTI, LUIGI. "Über Antonio da Crevalcore." Belvedere 13
　　　　(1928):9-11, 1 b&w illus.
　　　　　　Only autograph work by Crevalcore Holy Family with Young
　　　　St. John, Berlin, 1493. On basis of comparison attributes Holy
　　　　Family with the Baptist, Spiridon collection, Paris, and Este
　　　　Family Portrait, Munich. Sees Ferrarese influence in work.

ERA128　"Leonelli da Crevalcore, Antonio." In Thieme-Becker. Vol.
　　　　23. Leipzig: Seeman, 1929, p. 82.

Artists

ERA129 BARGELLESI, GIACOMO. "Alla mostra della pittura ferrarese
 del rinascimento: Due ritratti in cerca d'autore." Rivista
 di Ferrara 2 (1934):4-8.
 Assigns a number of pictures in the exhibition to Antonio
 da Crevalcore. Also attributes the Sacrati Family Portrait in
 Munich; Portrait of a Man in the Correr, Venice; and Portrait
 of Constantine Sforza in the Beer Collection, Budapest to
 Crevalcore.

ERA130 ZERI, FEDERICO. "An Addition to Antonio da Crevalcore."
 Burlington Magazine 108 (1966):422-25, 2 b&w illus.
 Attributes half-length St. Francis of Assisi in Princeton
 and St. Catherine in Berenson Collection to Crevalcore. Both
 before 1493. Reviews other attributions and sketches chronology.

ERA131 MUNDY, E. JAMES. "Franciscus alter Christus: The Interces-
 sory Function of a Late Quattrocento Panel." Record of the
 Art Museum Princeton University 36, no. 2 (1977):4-15, 11
 b&w illus.
 Iconographic analysis of panel by Crevalcore of half-
 length St. Francis. Image of saint based on intercessory and
 Imago Pietatis representations of Christ.

 DITRALDI, GIACOMO FILIPPO

ERA132 MALAGUZZI VALERI, FRANCESCO. "Giacomo Filippo Ditraldi
 ferrarese dipinge la Chiesa di S. Salvatore in Bologna."
 Archivio storico dell'arte 7 (1894):366-67.
 Documents for frescoes 1474-75.

ERA133 "Ditraldi, Giacomo Filippo di Paolo." In Thieme-Becker.
 Vol. 9. Leipzig: Seeman, 1913, p. 333.

 DEGLI ERRI, AGNOLO, BARTOLOMEO, AND BENEDETTO

ERA134 VENTURI, ADOLFO. "Unbekannte oder vergessene Kunstler der
 Emilia." Jahrbuch der Königlich preussichen Kunstsammlungen
 11 (1890):183-94.
 Documents about the Erri (pp. 183-88). Gives Madonna and
 Child with Saints polyptych in the Galleria estense, Modena, to
 Bartolomeo and Agnolo degli Erri.

ERA135 VENTURI, ADOLFO. "I pittori degli Erri o del R." Archivio
 storico dell'arte 7 (1894):132-43.
 Documents concerning Agnolo, Bartolomeo, and Benedetto
 degli Erri.

ERA136 V.A.C. "Erri, degli." In Thieme-Becker. Vol. 11.
 Leipzig: Seeman, 1915, pp. 13-14.

ERA137 VICINI, EMILIO P. "Benedetto degli Erri, pittore e plastico
 del secolo XV." Atti e memorie della reale Accademia di

scienza, lettere ed arti di Modena. Sezione di lettere, 4th
ser. 1 (1926):15-29.
 Documents and genealogy of Erri family.

ERA138 VICINI, EMILIO P. "Nota sul pittore Bartolomeo degli Erri."
 Atti e memorie della reale Deputazione di storia patria per
 le provincie modenesi, 7th ser. 7 (1932):123-26.
 Document of 1467 for ancona for San Domenico, Ferrara.

ERA139 CHIODI, ALBERTO MARIA. "Bartolommeo degli Erri e i
 polittici domenicani." Commentari 2 (1951):17-25,
 7 b&w illus.
 Identifies image of Saint Vincent of Ferrer, Seminario
 arcivescovile, Modena, as part of polyptych from S. Domenico,
 Modena. After 1475. Other parts in Oxford and Vienna. Docu-
 mentary information and early sources. See also Cossa.

 FORTI, JACOPO

ERA140 ZUCCHINI, GUIDO. "Un ritratto di Jacopo Forti." Il Comune
 di Bologna 21, no. 2 (1934):61-62, 2 b&w illus.
 Portrait of Ludovico Forti, 1483, collection of Count
 Bosdari, Bologna. Rejects attribution of Madonna and Child
 with SS. Francis and Jerome in S. Francesco, Bologna.

 FUSAIO, FRANCESCO DI PIETRO DA FAENZA

ERA141 GRIGIONI, CARLO. "Il pittore Francesco da Faenza
 collaboratore di Andrea del Castagno a Venezia." L'arte
 25 (1922):7-9.
 Documents him working with Castagno in 1452.

 GALASSI, GALASSO

ERA142 VASARI, GIORGIO. Le vite de' più eccellenti pittori,
 scultori ed architettori. . . . Annotated by Gaetano
 Milanesi. Vol. 3. Florence: Sansoni, 1973, pp. 89-92.
 Compilation of 1550 and 1568 editions. Reprint of 1906
 ed.
 Life of Galasso only in 1550 edition. Dependence on
 Piero della Francesco. Learned oil painting in Venice. Work
 in Bologna.

ERA143 BARUFFALDI, GIACOMO. Vite de' pittori e scultori ferraresi.
 Vol. 1. Ferrara: Domenico Taddei, 1844, pp. 47-57.
 Notes work of Galasso in Bologna cited by Leandro Alberti
 and Malvasia, most lost or covered over by time of Baruffaldi.
 Suggests Piero della Francesca as model. Says Galasso worked
 with Piero in Ferrara. Credits with knowledge of oil painting.

ERA144 VENTURI, ADOLFO. "Galazzo Ferrarese." Pantheon 16
 (1935):338-42, 5 b&w illus.

Artists

Biography of Galasso. Attributes <u>Autumn</u> in Berlin and two Muses in Budapest to Galasso. Two seated allegorical figures in the Strozzi Collection to Angelo Maccagnino.

GIRALDI, GUGLIELMO (DEL MAGRO)

ERA145 VENTURI, ADOLFO. "Guglielmo del Magro, miniatore minia per Cecilia Gonzaga un officiolo; Amadio da Milano, orefice, ne orna la legatura." <u>Archivio storico dell'arte</u> 2 (1889):86. Document of 1469.

ERA146 LIEBAERT, P[AUL]. "Un'opera sconosciuta di Guglielmo Giraldi." <u>L'arte</u> 14 (1911):401-6, 6 b&w illus.
Illuminations in the <u>Commentaria Aulu Gelli</u> in the Ambrosiana.

ERA147 BAER, L[EO]. "Giraldi, Guglielmo." In Thieme-Becker. Vol. 14. Leipzig: Seeman, 1921, pp. 155-56.

ERA148 BATTISTI, EUGENIO. "Due codici miniati del quattrocento." <u>Commentari</u> 6 (1955):18-26, 6 b&w illus.
Attributes a <u>Plautus</u> originally for Mantua now in Madrid (ms. V. 22.5) to Giraldi.

ERA149 BONICATTI, MAURIZIO. "Contributo al Giraldi." <u>Commentari</u> 8 (1957):195-210, 11 b&w illus.
Discusses work of Giraldi and two collaborators in <u>Divine Comedy</u>, Biblioteca apostolica vaticana, Urb. lat. 365. Summary of works by Giraldi.

ERA150 BONICATTI, MAURIZIO. "Nuovo contributo a Bartolommeo della Gatta ed a Guglielmo Giraldi." <u>Commentari</u> 9 (1958):259-69, 12 b&w illus.
Notes presence of Giraldi at Urbino court in 1480s. Suggests collaboration of Giraldi and Bartolommeo in <u>Virgil</u>, Biblioteca apostolica vaticana, Urb. lat. 350, for Federigo da Montefeltro.

ERA151 HENZE, ANTON. "Das Konzilevangliar (1475-82)." <u>Hochland</u> 56 (1963-64):375-76, 4 b&w illus.
Four Evangelists in an <u>Evangelarium</u> done in a Ferrarese scriptorium for Federigo da Montelfeltro. Attributes three to Guglielmo Giraldi and one to Franco de' Russi.

LAMBERTINI, MICHELE DI MATTEO DA BOLOGNA

ERA152 FILIPPINI, FRANCESCO. "Michele di Matteo da Bologna." <u>Cronache d'arte</u> (1924):183-93, 9 b&w illus.
Distinguishes from Michele da Panzano. Also does not agree with Malvasia identification of Michele di Matteo as Lambertini. Documents and citations. Touchstone for his work

is a polyptych in Venice, Accademia, no. 24. Compares with style of Jacopo di Paolo, his mentor.

LENDINARA, LORENZO AND CRISTOFORO CANOZIO DA

ERA153 BORGHI, CARLO. "Sulla scuola Modenese di tarsia." Atti e memorie della Deputazione di storia patria per le provincie modenesi e parmensi 5 (1870):55-63.
 Discusses the place of Lorenzo and Cristoforo da Lendinara in the development of intarsia decorations in Modena and Ferrara. Incorrectly identifies their family name as Genesini.

ERA154 FIOCCO, GIUSEPPE. "Lorenzo e Cristoforo da Lendinara e la loro scuola." L'arte 16 (1913):273-88, 321-40, 17 b&w illus.
 Discusses both their intarsia work and paintings. Attributes Madonna and Child in Modena and Aristotle in Ferrara to the artists. Correctly identifies their family name as Canozio.

ERA155 CROWE, J[OSEPH] A[RCHER], and G[IOVANNI] B[ATTISTA] CAVALCASELLE. A History of Painting in North Italy. Edited by Tancred Borenius. Vol. 2. London: John Murray, 1912, pp. 72-76, 1 b&w illus.
 Brief biographies with attributions for the two brothers in section that discusses the Squarcionesques.

ERA156 VENTURI, ADOLFO. "Un quadretto supposto di Lorenzo da Lendinara." L'arte 26 (1923):18-19, 1 b&w illus.
 Portrait of Beato Lorenzo Giustiani, Accademia Carrara, Bergamo. Still considers problematic.

ERA157 FIOCCO, G[IUSEPPE]. "Lendinara." In Thieme-Becker. Vol. 23. Leipzig: Seeman, 1929, pp. 48-49.

ERA158 ORSI, MARIO D'. "Dipinti ignorati di Cristoforo da Lendinara in Puglia." Le arti 1 (1938-9):500-504, 7 b&w illus.
 Publishes seven paintings that are attributed to Cristoforo. Six in Sta. Maria degli Angeli, Cassano Murge (Standing Saints, Madonna and Child, Dead Christ) and one in S. Andrea, Barletta (Madonna and Child).

ERA159 QUINTAVALLE, ARTURO CARLO. Cristoforo da Lendinara. Parma: Ente provinciale turismo, Rotary club, 1959, 117 pp., 68 plates, 80 b&w illus.
 Generally a recapitulation of the significance of the Lendinari, and particularly Cristoforo, for painting in Parma and Modena in the later fifteenth century as discussed in his articles in Critica d'arte (ERA160). Documents. Bibliography. Attributions.

Artists

ERA160 QUINTAVALLE, ARTURO CARLO. "Cristoforo da Lendinara:
 Problemi di storiografia artistica." Critica d'arte 35
 (1959):335-55, 22 b&w illus.; 36 (1959):399-408. 9 b&w
 illus.; 37 (1960):113-25, 9 b&w illus.
 Raises question as to whether intarsia workers are origi-
 nators of designs or translators. Suggests originality.
 Traces career with documents. Attributes choir stalls,
 Cathedral, Parma, to Cristoforo. Influence of Tuscan art
 on intarsia in Sacrista dei Consorziati, Cathedral, Parma.

 LIANORI, PIETRO

ERA161 KREPLIN, B.C. "Lianori, Pietro." In Thieme-Becker. Vol.
 23. Leipzig: Seeman, 1929, p. 182.

ERA162 ZUCCHINI, GUIDO. "Opere di Pietro Lianori." Il Comune di
 Bologna 21, no. 12 (1934):33-39, 5 b&w illus.
 Review of earlier attributions to Lianori; attributes
 Madonna and Child with Saints, formerly in the Collection
 Podio, Bologna, and SS. Francis and Petronio in the Palazzo
 Garagrani, Bologna, to Lianori.

 MAINERI, BARTOLOMEO, GIACOMO, AND GIOVAN FRANCESCO

ERA163 VENTURI, ADOLFO. "Gian Francesco de' Maineri, pittore."
 Archivio storico dell'arte 1 (1888):88-89.
 Documents from 1492-1502.

ERA164 VENTURI, ADOLFO. "Antonio di Bartolomeo Maineri, pittore
 reggiano, prigione." Archivio storico dell'arte 2
 (1889):36.
 Document of 1482.

ERA165 VENTURI, ADOLFO. "Testamento di Giovanni di Bartolomeo
 Maineri, pittore reggiano." Archivio storico dell'arte 2
 (1889):37-38.
 Will of 1497.

ERA166 MALAGUZZI VALERI, FRANCESCO. "Altre notizie sui pittori
 Maineri." Archivio storico dell'arte 4 (1891):372-74.
 Documents about Giacomo, Bartolomeo, and Giovanni
 Maineri.

ERA167 MALAGUZZI VALERI, FRANCESCO. "La facciata della Chiesa
 della Madonna di Galliera in Bologna." Archivio storico
 dell'arte 6 (1893):41-42.
 Contract for the facade of the Church of the Madonna di
 Galliera, Bologna, 1486, Giovan Francesco.

ERA168 CAVAZZA, FRANCESCO. "Finestroni e capelle in San Petronio
 di Bologna: Restauri recente e documenti antichi."
 Rassegna d'arte 5 (1905):161-66, 8 b&w illus.

Report of recent restorations in Church of S. Petronio.
Reference to Zoppo altar. Payment in the archives of the
Fabbriceria of S. Petronio, 1470, for painting vaults and walls
of Chapel of Santa Brigida. Originally, 1459, to Bartolomeo
and Giacomo Maineri shifted to Tomaso Garelli. Gian Francesco
da Rimini originally associated with Maineri, f. 1470.

ERA169　VENTURI, ADOLFO. "Gian Francesco de' Maineri da Parma,
pittore e miniatore." L'arte 10 (1907):33-40, 7 b&w illus.
Repetition of successful formula. Identifies four images
of the Madonna and Child and three of Christ with the Cross as
by Maineri.

ERA170　VENTURI, ADOLFO. Storia dell'arte italiana. Vol. 7, La
pittura del quattrocento. Pt. 3. Milan: U. Hoepli, 1914,
pp. 1104-20, 11 b&w illus.
Biography of Giovan Francesco Maineri. Reconstruction of
work. Influence of Ercole de' Roberti. Repetition of themes.

ERA171　PELICELLI, N[ESTOR]. "Maineri, Gian Francesco." In Thieme-
Becker. Vol. 23. Leipzig: Seeman, 1929, p. 577.

ERA172　POUNCEY, PHILIP. "Ercole's Grandi's Masterpiece."
Burlington Magazine 70 (1937):161-68, 16 b&w illus.
Reattributes altarpiece made up of Madonna and Child with
SS. William and John the Baptist in the National Gallery,
London, and Pietà in the Massari-Zavaglia Collection,
Ferrara, to Giovan Francesco de' Maineri, with repainting by
Lorenzo Costa, on the basis of X rays. Formerly attributed to
Costa or "Ercole Grandi." Identifies the altarpiece with the
high altar of the Oratorio della Concezione, Ferrara, 1498-99.

MARMITTA, FRANCESCO

ERA173　TOESCA, PIETRO. "Di un miniatore e pittore emiliano:
Francesco Marmitta." L'arte, n.s. 17 (1948):35-40,
9 b&w illus.
Sees influence of Ercole de' Roberti in Petrarch minia-
ture (Kassel, Ms. poet. 40,6.) and Missal of Cardinal Domenico
della Rovere, Turin. Bolognese and Ferrarese continues in
Officiolo Durazzo, Palazzo Bianco, Genoa, and Pala S. Quintino,
Louvre.

ERA174　POUNCEY, PHILIP. "Drawings by Francesco Marmitta." Omaggio
a Pietro Toesca. Proporzioni: Studi di storia dell'arte a
cura di Roberto Longhi 3 (1950):111-13, 9 b&w illus.
Attributes Madonna and Child, Entombment of Christ, and a
Procession, all in the British Museum, to Marmitta. Agrees
with Toesca's attribution of Virgin and Child between SS.
Quentin and Benedict, Louvre, to Marmitta.

Artists

ERA175 LEVI d'ANCONA, MIRELLA. "Un libro d'oro di Francesco
 Marmitta da Parma e Martino de Modena al Museo Correr."
 Bolletino del Museo civico veneziano 1, no. 2 (1966):18-35,
 11 b&w illus.
 Book of Hours for the Garzoni family in Venice, ca. 1471.
 Eleven miniatures with one in the Wildenstein Collection in New
 York.

 MARTINO DI GIORGIO D'ALEMAGNA DA MODENA

ERA176 DANEU LATTANZI, ANGELA. "Un breviario della Biblioteca
 nazionale di Palermo miniato da Martino da Modena."
 Academie e biblioteche d'Italia 13, no. 6 (1939):552-59, 8
 b&w illus.
 Attributes miniatures in MS. I.B. 21 to Martino on basis
 of comparison with Giorgio d'Alemagna. Says manuscript has
 terminus post quem of 1447. Dates ca. 1470. Says Neapolitan
 breviary, notes ties of Ercole and Eleonora d'Aragon with
 Naples. Notes missal, 2165, in the Trivulziana also by
 Martino.

 MASTER OF SANT'APOLLINARE

ERA177 RAGGHIANTI, CARLO LUDOVICO. "Il Maestro di Sant'Apollinare."
 Bollettino annuale dei musei ferraresi 2 (1972):9-30, 15 b&w
 illus.
 Defining oeuvre of the "Master of S. Apollinare" active
 in Ferrara in the 1440s. Works in the Rocca di Vignola, the
 Convent of S. Apollinare, Ferrara, and Musée des arts
 decoratif, Paris.

ERA178 RAGGHIANTI, CARLO LUDOVICO. "Il Maestro di S. Apollinare."
 Critica d'arte 133 (1974):25-30, 18 b&w illus.; 135
 (1974):35-50, 16 b&w illus.
 Attributes frescoes in Rocca Boncompagni Ludovisi in
 Vignola (Modena) to the "Master of S. Apollinare."

ERA179 RAGGHIANTI, CARLO LUDOVICO. "Ferrara, 1432." Critica
 d'arte 138 (1974):v-vi, 1 b&w illus.
 Aragonese duel in Ferrara, February 1432, connected with
 ex-voto of Cavaliere Coane, Musée des arts decoratif, Paris, by
 "Master of S. Apollinare."

 MASTER OF SAN PIER DAMIANO

ERA180 TAMBURI, A. "Ricerche in Romagna: Il Maestro di San Pier
 Damiano." Paragone 367 (1980):47-60, 13 b&w illus.
 Four fragments from 1440 to 1460.

MELOZZO DA FORLÌ

ERA181 PACIOLI, LUCA. De divina proportione. Fontes ambrosiani,
31. Milan: Biblioteca ambrosiana, 1955, 247 pp., 53 color
and 1 b&w illus.
 First edition: Venice: 1509.
 Notes Melozzo's abilities as artist in challenge to
produce image of a marble columnar structure for Girolamo
Riario, pp. 111–12.

ERA182 VASARI, GIORGIO. Le vite de' più eccellenti pittori,
scultori ed architettori. . . . Annotated by Gaetano
Milanesi. Vol. 3. Florence: Sansoni, 1973, pp. 51–52 and
64–68.
 Compilation of 1550 and 1568 editions. Reprint of 1906
edition.
 Mentions works by Melozzo in SS. Apostoli in Rome in Life
of Benozzo Gozzoli. Milanesi expands with notices from biogra-
phies by Melchiorri (ERA184), Girolamo Reggiani, and chronicles.

ERA183 MARCHESI, SIGISMONDO. Supplemento istorico dell'antica
città di Forlì in cui si descrive la provincia di Romagna.
Forlì: Selva, 1678. Reprint. Bologna: A. Forni, 1968,
959 pp.
 Hanging of Melozzo's father, pp. 544–45.

ERA183A GRIGONI, CARLO. "Il Cristo Benedicente di Melozzo da
Forlì." Forum livii 2 (1927):22–25, 1 b&w illus.
 Publishes Christ Blessing, Gualino Collection, Turin.
Attributed by Lionello Venturi. Says it's early, 1456–59.
Draws parallel with painting of Saint Mark from Rome. Also
publishes documents from Forliese archives from 1464 to 1478
concerning Melozzo's brother Francesco.

ERA184 MELCHIORRI, GIUSEPPE. Notizie intorno alla vita e alle
opere in Roma di Melozzo da Forlì. Rome: 1835.
 Addresses made in Forlì in 1934. Summary of biographical
information. History of frescoes from SS. Apostoli, Rome, and
The Founding of the Vatican Library. List of paintings attrib-
uted to Melozzo in Forlì.

ERA185 MÜNTZ, EUGENE. "Les peintures de Melozzo da Forlì, à la
Bibliothèque du Vatican." Gazette des beaux-arts, 2d ser. 2
(1875):369–74, 2 b&w illus.
 Publishes documents from account books of Platina con-
cerning Melozzo's work in the library. Also documents on
Antoniazzo Romano and Ghirlandaio.

ERA186 SCHMARSOW, AUGUST. Melozzo von Forlì: Ein Beiträg zur
Kunst- und Kulturgeschichte Italiens in 15. Jahrhundert.
Berlin and Stuttgart: Verlag von W. Spemann, 1886, vi + 404
pp., 27 b&w illus.

Artists

Career of Melozzo in the context of fifteenth-century
Italian art and culture. Issue of his work in the Vatican and
at court of Urbino.

ERA187 SCHMARSOW, AUGUST. "Ottaviano Ubaldini in Melozzo's Bild
 und Giovanni Santi's Versen." Jahrbuch der Königlich
 Preussichen Kunstsammlungen 8 (1887):67-70.
 Identifies the figure kneeling before Astronomy in the
 Berlin panel from the Montefeltro cycle as Ottaviano Ubaldini,
 mentioned in Santi's rhymed chronicle. Also identifies Astron-
 omy as based on Patasilea Baglione.

ERA188 JANITSCHEK, HEBERT. Review of August Schmarsow's Melozzo da
 Forlì. Repertorium für Kunstwissenschaft 11 (1888):196-200.
 Critical review of ERA186.

ERA189 GRIGONI, CARLO. "La famiglia degli Ambrogi." Bollettino
 della Società fra gli amici dell'arte per la provincia di
 Forlì 1 (1895):57-58.
 Genealogy of Ambrogi family.

ERA190 GRIGONI, CARLO. "Documenti." Rassegna bibliografica
 dell'arte italiana 1 (1898):4-5
 Will of mother of Melozzo dated 11 December 1487. Docu-
 ment concerning distribution of goods places Melozzo in Rome on
 9 May 1489.

ERA191 GRIGONI, CARLO. "Documenti." Rassegna bibliografica
 dell'arte italiana 2 (1899):114-15.
 Minor addition to the genealogy of Melozzo previously
 published in Grigoni ERA189.

ERA192 VENTURI, ADOLFO. "Un quadro di Melozzo da Forlì nella
 Galleria nazionale a Palazzo Corsini." L'arte 7 (1904):310-
 12, 3 b&w illus.
 Saint Sebastian with Donors originally from Sta. Maria
 della Pace.

ERA193 SCHEGEL, LISA de. "Per un quadro di Melozzo da Forlì."
 L'arte 12 (1909):307-15, 5 b&w illus.
 Attributes St. Sebastian with Donors from Sta. Maria
 della Pace, Rome, to Melozzo. Previously attributed to
 Antoniazzo Romano.

ERA194 SCHMARSOW, AUGUST. "Melozzo-Entdeckungen in Rom."
 Monatshefte für Kunstwissenschaft 2 (1909):497-503.
 Critical review of various attributions to Melozzo of
 works in Rome including Annunciation in Pantheon; St. Sebastian
 with Kneeling Donors from Sta. Maria della Pace; and two panel
 Annunciation. Rejects all of them; attributes Pantheon panel
 to Antoniazzo Romano.

ERA195 OKKONEN, ONNI. Melozzo da Forlì und seine schule. Helsinki:
 Suomalaisen Kirjallisuuden Seuran Kirhapainon Osakeyhtio,
 1910, 155 pp., 32 b&w illus.
 Documents and bibliography. Also mention of work of
 Marco Palmezzano.

ERA196 SCHEGEL, LISA de. "Dell'Annunciazione di Melozzo da Forlì
 nel Pantheon." L'arte 13 (1910):139-43, 3 b&w illus.
 Disputes Schmarsow's attribution to Antoniazzo Romano.

ERA197 SCHEGEL, LISA de. "L'affresco di Melozzo da Forlì nel
 monumento Coca a Santa Maria sopra Minerva." L'arte 13
 (1910):222-24.
 Enthroned Christ with Angels and Kneeling Donor.
 Schmarsow attributes the fresco to Bartolomeo della Gatta.

ERA198 SCHMARSOW, AUGUST. Joos van Gent und Melozzo da Forlì in Rom
 und Urbino. Leipzig: B.G. Teubner, 1912, 214 pp., 28 b&w
 illus.
 Relationship of Melozzo to Northern painting, particu-
 larly Joos van Ghent. Attributes Portrait of Federigo da
 Montefeltro and Guidobaldo to Melozzo. Locations of studiolo
 portraits and Liberal Arts. Discussion of work in Rome and
 Loreto. Question of attribution of Volte santo in Città di
 Castello.

ERA199 VENTURI, ADOLFO. Storia dell'arte italiana. Vol. 7, La
 pittura del quattrocento. Pt. 2. Milan: U. Hoepli, 1913,
 pp. 1-63, 54 b&w illus.
 Biography of Melozzo. Bibliography. Attributions. In-
 fluence of Piero della Francesca. Influence of the Ascension
 from SS. Apostoli. Summary of erroneous attributions. Does
 not see his participation in the studiolo cycle, Urbino.

ERA200 CROWE, J[OSEPH] A[RCHER], and G[IOVANNI] B[ATTISTA]
 CAVALCASELLE. "Melozzo and Palmezzano." In A History of
 Painting in Italy: Umbria, Florence and Siena, from the
 Second to the Sixteenth Century. Edited by Tancred
 Borenius. Vol. 5, Umbrian and Sienese Masters of the
 Fifteenth Century. London: John Murray, 1914, pp. 33-62,
 3 b&w illus.
 Attributions to Melozzo. Concentrates on his work in
 Umbria, particularly Urbino.

ERC201 PHILLIPS, CLAUDE. "Two Angels by Melozzo da Forlì?"
 Burlington Magazine 25 (1914):273-80, 2 b&w illus.
 Two angels with censors and crowns purchased by Philips
 attributed to Melozzo.

ERA202 HAENDCKE, BERTHOLD. "Der franzosisch-niederlaendische
 Einfluss auf die italienische Kunst von ca. 1250 bis ca.
 1500 und der Italiens auf die franzosisch-deutsche Malerei

Artists

ca. 1350 bis ca. 1400." Repertorium für Kunstwissenschaft 38
(1916):28-92.
Relates work of Melozzo to Netherlandish influences.

ERA203 VENTURI, ADOLFO. "Un primitivo: Melozzo da Forlì." L'arte
29 (1926):49-51, 1 b&w and 1 color illus.
Madonna and Child in Benson Collection, London, attrib-
uted to Melozzo with early influence of Piero.

ERA204 VENTURI, LIONELLO. "Ein 'Humanist' von Melozzo?" Pantheon
1 (1928):82-88, 1 b&w illus.
Attributes Portrait of a Humanist in the collection of M.
von Nemes, Munich, to Melozzo. Possibly for court of Urbino,
1476-81. Possible identification as Giovanni Pontano.

ERA205 VENTURI, LIONELLO. "Contributi a Melozzo da Forlì." L'arte
33 (1930):289-91, 1 b&w illus.
Discusses Annunciation in Gardner Museum, Boston.

ERA206 GRONAU, [GEORG]. "Melozzo da Forlì." In Thieme-Becker.
Vol. 24. Leipzig: Seeman, 1930, pp. 370-72.

ERA207 NICODEMI, GIORGIO. Melozzo da Forlì. I grandi maestri del
colore. Bergamo: Istituto italiano d'arti grafiche, 1935,
27 pp., 8 color illus.
Brief biographical introduction. Large color plates with
brief descriptions.

ERA208 PASINI, ADAMO. "Melozzo nei documenti di archivio." Atti e
memoire della reale Deputazione di storia patria per
l'Emilia e la Romagna 3 (1937-38):121-36.
Various legal documents.

ERA209 PASINI, ADAMO. "Documenti riguardano Melozzo e la sua
famiglia." Melozzo da Forlì 1 (October 1937):75-77.
Various legal documents not concerning works of art from
the Archivio notarile, Forlì. One document about Melozzo,
others about wife and father.

ERA210 BIAGETTI, BIAGIO. "L'affresco di Sisto IV e il Platina."
Melozzo da Forlì 5 (October 1938):227-29, 1 b&w illus.
Review of the payment history of the fresco. Raises
question of collaboration with Antoniazzo and Ghirlandaio.
Illustrates the dayworks in the fresco.

ERA211 BUSCAROLI, REZIO. "La mostra di Melozzo e del quattrocento
romagnole." Melozzo da Forlì 4 (July 1938):170-206.
Review of the 1938 exhibition, includes general overview
of the development of Romagnole art. Checklist of works in the
exhibition in the back of the issue.

ERA212 BUSCAROLI, REZIO. Melozzo da Forlì nei documenti, nelle
 testamonianze dei contemporanei e nella bibliografia. Rome:
 Reale Accademia d'Italia, 1938, 256 pp., 64 b&w illus.
 Traces notices of Melozzo from the sixteenth to the
 nineteenth century with quotations. Index. Catalog.
 Bibliography.

ERA213 FILIPPINI, FRANCESCO. "Melozzo e gli Sforza." Melozzo da
 Forlì 2 (January 1938):58-66, 8 b&w illus.; 3 (April
 1938):114-25, 12 b&w illus.
 Traces ties from very early on with the Sforza family.
 Initially through Cotignola, later in Rome. Some quite un-
 likely attributions, particularly of profile portraits, to
 Melozzo. Some discussion also of Palmezzano.

ERA214 FILIPPINI, FRANCESCO. "Il ritratto di Melozzo." Melozzo da
 Forlì 5 (October 1938):229-31, 3 b&w illus.
 Corrects rendering of fresco by Palmezzano in S. Biagio,
 Forlì, done by Girolamo Reggiani (1834). Publishes majolica
 tile with portrait of Melozzo in the Victoria and Albert
 Museum.

ERA215 FIOCCO, GIUSEPPE. "Un disegno giovanile di Melozzo."
 Melozzo da Forlì 5 (October 1938):246-47, 1 b&w illus.
 Publishes a red chalk drawing heightened with white in
 the Palazzo comunale, Bologna. Depicts a philosopher. From
 the Noli Collection.

ERA216 FORLI. PALAZZO DEI MUSEI. Mostra di Melozzo e del
 quattrocento romagnolo. Bologna: Stabilimenti poligrafici
 editori de "Il Resto del Carlino," 1938, xx + 167 + 7 pp.,
 116 b&w illus.
 Exhibition setting Melozzo into context of fifteenth
 century. Works by Palmezzano, Lattanzio da Rimini, Baldassare
 Carrari, and Bernardino and Francesco Zaganelli. For each
 artist brief biography, attributions, and bibliography. All
 works in exhibition illustrated.

ERA217 LANYI, JENO. "Un autoritratto di Melozzo da Forlì."
 Critica d'arte 3 (1938):97-103, 7 b&w illus.
 Drawing no. 473, Berlin, Kunstkabinett. Confirms
 eighteenth-century attribution.

ERA218 OERTEL, ROBERT. "Die Melozzo Ausstellung in Forlì."
 Pantheon 22 (1938):354-55, 1 b&w illus.
 Review of 1938 exhibition. Questions identification of
 Berruguette's work.

ERA219 CALOSSO, A[CHILLE] B[ERTINI]. "Gli affreschi di Melozzo
 nella Chiesa di Santa Maria Nova al foro romano." Melozzo
 da Forlì 7 (April 1939):358-65.

Artists

 Works in the vaults and walls mentioned in Giulio
Mancini's seventeenth-century Viaggio di Rome. Heavily re-
painted Church Fathers as the vault figures referred to. Res-
toration done in 1867-80.

ERA220 ZOCCA, EMMA. "Un probabile Melozzo." L'arte 43 (1940):87-
 89, 1 b&w illus.
 Redeemer in the Church of San Salvatore in Lauro, Rome.

ERA221 SUIDA, WILLIAM E. [WILHELM]. "Mantegna and Melozzo." Art
 in America 34 (1946):57-72, 12 b&w illus.
 Reviews attributions to Melozzo. Shows parallels with
 work of Mantegna. Publishes fragment of Lute-playing Angel in
 New York private collection, pre-Vatican work. Similar
 Mantegnesque influence in two small panels of angels in
 Washington, National Gallery.

ERA222 BUSCAROLI, REZIO. Melozzo e il melozzismo. Bologna:
 Athena, 1955, 191 pp., 91 b&w illus.
 Bibliography. Notices on Palmezzano, Giovanni del Sega,
 Lorenzo da Viterbo, Ansuino da Forlì, and Guidaccio da Imola.

ERA223 BERTELLI, CARLO. "L'affresco per Juan Diaz de Coca alla
 Minerva (Roma)." Paragone 221 (1968):40-48, 3 b&w illus.
 Fresco of ca. 1477, possibly designed by Melozzo but
 executed by another artist.

ERA224 RUHMER, EBERHARD. "Melozzo als zeichner." In Festschrift
 für Ulrich Middeldorf. Berlin: Walter de Gruyter & Co.,
 1968, pp. 201-5, 7 b&w illus.
 Few drawings attributable to Melozzo. Head of Young
 Bearded Man, British Museum, London. Agrees with Schmarsow's
 attribution of Head of a Man in Uffizi, and Musical Angels,
 British Museum. New attribution Lamentation in Budapest.

 MERLINI, GIOVANNI DI MAESTRO PEDRINO

ERA225 GRIGIONI, CARLO. "La tavola di Lattanzio da Forlì."
 Rassegna bibliografica dell'arte italiana 18 (1915):98-100.
 Agrees that inscription on the Madonna del fuoco, 1438,
 Capella della Canonica, Cathedral, Forlì, which identifies
 artist as Lattanzio da Forlì, is seventeenth-century and false.
 Attributes to Giovanni di Maestro Pedrino.

ERA226 GIOVANNI di MAESTRO PEDRINO depintore. Cronica del suo
 tempo. Edited by Gino Borghezio and Marco Vattasso. Studi
 e testi. Biblioteca apostolica vaticana, vols. 50 and 62.
 Rome: 1929 and 1934, pp. 564 and 525.
 Diary of Giovanni Merlini.

ERA227 PASINI, ADAMO. "Giovanni di Maestro Pedrino dipintore
 (Giovanni Merlini). Atti e memorie della reale Deputazione

di storia patria per le provincie di Romagna, 4th ser. 19
(1929):49-90, 1 b&w illus.
 Documents on the Madonna del fuoco and the life of the
artist.

ORIOLO, GIOVANNI DA

ERA228 CORBARA, ANTONIO. "Possibili pitture di Giovanni da
 Oriolo." Melozzo da Forlì 5 (October 1938):237-39, 4 b&w
 illus.
 Attributes fragments from the Life of St. Anthony in S.
 Antonio, Faenza, to Giovanni. Compares with the Portrait of
 Leonello d'Este in the Louvre.

PALMEZZANO, MARCO

ERA229 VASARI, GIORGIO. Le vite de' più eccellenti pittori,
 scultori ed architettori. . . . Annotated by Gaetano
 Milanesi. Vol. 6. Florence: Sansoni, 1973, pp. 335-36.
 Compilation of 1550 and 1568 editions. Reprint of 1906
 edition.
 List of works.

ERA230 C., G. Intorno a Marco Palmezzano da Forlì e ad alcuna suoi
 dipinti. Forli: Casali, 1844, 19 pp.
 Summary of works and description.

ERA231 CALZINI, EGIDIO. "Marco Palmezzano e le sue opere."
 Archivio storico dell'arte 7 (1894):185-200, 269-91, 335-58,
 455-75, 24 b&w illus.
 Catalog of works and summary of documents. Death date
 1538. Also early history of Forliese painting.

ERA232 GRIGONI, CARLO. "Documenti." Rassegna bibliografica
 dell'arte italiana 2 (1899):222-23.
 Three notarial acts: 25 December 1484, painting four
 figures for "domibus hospitalis" in Forlì; 16 September 1516,
 for money owed; 3 September 1523, for money owed for an ancona.

ERA233 B[ELTRAMI, LUCA]. "Corrieri artistici, Milano." Rassegna
 d'arte 1 (1901):157.
 Adds two additional works in Brera: Christ with Two
 Praying Angels and Madonna and Child with Saints. Provenance.

ERA234 GARNIER, GEORGES. "Tre dipinti del Palmezzano, inediti."
 Rassegna d'arte 1 (1901):104-5, 3 b&w illus.
 Additions to Calzini's list (ERA231). Annunciation, Lateran,
 Rome; Annunciation, Sala della Congregazione di Carità, Carpi;
 and a dispersed altarpiece, the central panel in the Palazzo
 arcivescovile, Ravenna, other parts in sacristy of the
 Mansionarii, Cathedral, Ravenna, and fragments in the Accademia
 di belle arte, Ravenna.

Artists

ERA235 GRIGONI, CARLO. "La famiglia di Marco Palmezzano."
 Rassegna bibliografica dell'arte italiana 4 (1901):114–28; 5
 (1902):177–204.
 Extensive reconstruction of the family of Palmezzano from
 notarial documents in Forlì. New documents concerning Marco
 including evidence of sojourn in Venice before 1515.

ERA236 FFOULKES, CONSTANCE JOCELYN. "Una tavola di Marco
 Palmezzano." Rassegna bibliografica dell'arte italiana 8
 (1905):90–91.
 Sale of half-length Madonna and Child with St. John in
 the collection of Lord Tweedmouth. Dated 1532. Traces
 provenance.

ERA237 FFOULKES, CONSTANCE JOCELYN. "Un quadro di Marco Palmezzano
 in una collezione privata inglese." Rassegna bibliografica
 dell'arte italiana 10 (1907):16–19.
 Crucifixion in the collection of Rev. Canon Raymond
 Pelly. Reads date as 1531 not 1480. Suggests it is the
 Crucifixion formerly in the collection of Giuseppe Vallardi,
 Milan.

ERA238 BRUNELLI, ENRICO. "Un'opera inedita del Palmezzano."
 L'arte 11 (1908):452–53, 1 b&w illus.
 Holy Family, Scialoja Collection, Rome.

ERA239 RICCI, CORRADO. "Per la storia della pittura forlivese."
 L'arte 14 (1911):80–92, 11 b&w illus.
 Discusses Palmezzano's Miracles of S. Giacomo in San
 Biagio, 6 illustrations.

ERA240 VENTURI, ADOLFO. Storia dell'arte italiana. Vol. 7, La
 pittura del quattrocento. Pt. 2. Milan: U. Hoepli,
 1913, pp. 64–85, 17 b&w illus.
 Biography. Attributions. Sees as follower of Melozzo
 who still retains much of the quattrocentesque qualities. Bib-
 liography. List of rejected attributions at the end.

ERA241 CROWE, J[OSEPH] A[RCHER], and G[IOVANNI] B[ATTISTA]
 CAVALCASELLE. "Melozzo and Palmezzano." In A History of
 Painting in Italy: Umbria, Florence and Siena, from the
 Second to the Sixteenth Century. Edited by Tancred
 Borenius. Vol. 5, Umbrian and Sienese Masters of the
 Fifteenth Century. London: John Murray, 1914, pp. 33–62,
 1 b&w illus.
 Attributions to Palmezzano. List of his works at end of
 chapter.

ERA242 GRIGIONI, CARLO. "Il testamento e la morte di Marco
 Palmezzano." Rassegna bibliografica dell'arte italiana 19
 (1916):129–30.
 Based on will, dates death of Marco between 29 March and
 25 May 1539.

ERA243 MOSCHETTI, ANDRE. "Un nuovo Christo crocifero di Marco
 Palmezzano." Dedalo 2 (1920):363-68, 3 b&w illus.
 Christ Bearing the Cross in the Ferretto Collection,
 Padua, attributed to Palmezzano between 1534 and 1536. Com-
 pares to versions in the Museo civico, Venice, and Palazzo
 Spada, Rome. Suggests influence of Francia.

ERA244 GALAZZI PALUZZI, CARLO. "Una tavola di Marco Palmezzano."
 Bollettino d'arte (1921):261-66, 5 b&w illus.
 Madonna di Loreto, altarpiece of the Church of the
 Madonna di Loreto in Rome attributed to Marco.

ERA245 MALAGUZZI VALERI, FRANCESCO. "Il restauro del quadro del
 Palmezzano nella parrochiale di S. Maria di Rontana
 (Bologna)." Bollettino d'arte, 2d ser. 6 (1926-27):567-71,
 1 b&w illus.
 Adoration of Magi in the main panel, Christ Preaching in
 the lunette. Signed and dated 1514.

ERA246 FIOCCO, GIUSEPPE. "Un affresco melozzesco nel battistero di
 Siena." Rivista d'arte 11 (1929):153-71, 5 b&w illus.
 Washing of the Feet in the baptistry in Siena attributed
 by documents to Pietro degli Oriuoli (sic), but comparison with
 Madonna and Child with Saints signed by Orioli in the Museo
 dell'opera, Siena, suggests this is incorrect. Attributes it
 instead to Palmezzano. Influence of Ansuino da Forlì.

ERA247 GRONAU, [GEORG]. "Palmezzano, Marco." In Thieme-Becker.
 Vol. 26. Leipzig: Seeman, 1932, pp. 181-83.

ERA248 ZOCCA, EMMA. "Appunti su Bartolommeo Montagna." L'arte 40
 (1937):183-91, 3 b&w illus.
 On basis of influence of Palmezzano on the art of
 Montagna hypothesizes a trip to Veneto for Palmezzano.

ERA249 GALLI, ROMEO. "La tavola di Dozza di Palmezzano." Melozzo
 da Forlì 7 (April 1939):335-37, 2 b&w illus.
 Restored Madonna and Child with SS. John the Baptist and
 Margaret in Dozza, Imolese parish church. Publishes document
 of 1492 for payments for the painting which verify the
 attribution.

ERA250 GRIGONI, CARLO. Marco Palmezzano, pittore forlivese: Nella
 vita, nelle opere, nell'arte. Faenza: Fratelli Lega, 1956,
 xv + 773 pp., 65 b&w illus.
 Very thorough monograph. Biography. Catalog of works
 and influence on his work. Bibliography with publication of
 previous authors' statements and opinions and all relevant
 Palmezzano documents.

ERA251 FORLÌ. PINACOTECA. Catalogo della mostra delle opere del
 Palmezzano in Romagna. Faenza: Fratelli Lega, 1957, 21
 pp., 42 b&w illus.

Artists

Illustrates entire exhibition. Evaluation of
Palmezzano's work. Detects decline after 1505 due to
greater participation of assistants.

ERA252 GOLFIERI, E[NNIO]. "Mostra di opere del Palmezzano per il V
centenario della nascità." Bollettino d'arte, 4th ser. 42
(1957):357-58, 2 b&w illus.
Review of exhibition and Grigoni's monograph (ERA250).
Agrees with Grigoni that Palmezzano not simply a slavish fol-
lower of Melozzo. Finds Venetian influences as well.

PARRASIO, ANGELO

ERA253 GOMBOSI, GEORG. "A Ferrarese Pupil of Piero della
Francesca." Burlington Magazine 62 (1933):66-78,
7 b&w illus.
Using the Belfiore studiolo as basis traces principal
influences and figures in fifteenth-century Ferrarese art.
Attributes Budapest Muses to Angelo Parrasio rather than Galasso.

ERA254 CLARK, KENNETH. "Letter." Burlington Magazine 62
(1933):143, 4 b&w illus.
Associates Muses in Budapest, attributed by Gombosi to
Angelo Parrasio, with engraved Tarrocchi figures.

RAIBOLINI, FRANCESCO (FRANCIA)

ERA255 VASARI, GIORGIO. Le vite de' più eccellenti pittori,
scultori ed architettori. . . . Annotated by Gaetano
Milanesi. Vol. 3. Florence: Sansoni, 1973, pp. 534-63.
Compilation of 1550 and 1568 editions. Reprint of 1906
edition.
Biography. Considerable annotation including attribu-
tions outside of Vasari, relationship with Raphael, and work of
his sons.

ERA256 MALVASIA, CARLO CESARE. Felsina pittrice: Vite de pittori
bolognesi. Vol. 1. Bologna: Erede di Domenico Barberi,
1678, pp. 38-51.
"Life of Francia." Cites Vasari as source. Includes
names of works and location. Letter of Raphael to Francia and
poem by Francia to Raphael.

ERA257 BALDINUCCI, FILIPPO. Notizie dei professori del disegno da
Cimabue in qua. Edited by F. Ranalli. Vol. 1. Florence:
U. Batelli & Co., 1845, pp. 598-601.
Identifies Francia as pupil of Zoppo. Cites Vasari as
source but accepts Malvasia as more trustworthy. Notes patrons
including court of Urbino. Says painting held in esteem in
Bologna before Francia.

ERA258 CALVI, JACOPO ALESSANDRO. Memorie della vita, e delle opere
 di Francesco Raibolini detto il Francia. Bologna: Salina,
 1812, 59 pp.
 Documents sixteenth-century sources on Francia.

ERA259 GOZZADINI, GIOVANNI. "Di una targa bentivolesca pitturata
 nel secolo XV." Atti e memorie della reale Deputazione di
 storia patria per le provincie Romagna 5 (1867):1-21, 1 b&w
 illus.
 Attributes a shield with Saint George on it in the Aria
 Collection, Bologna, to Francia.

ERA260 PANIZZI, ANTHONY. Chi era Francesco da Bologna? 2d ed.
 London: Case di Basil Montagu Pickering, 1873, 58 pp.
 Identifies inventor of Aldine cursive, called Francesco
 da Bologna in 1501, as Francia. Francia documents.

ERA261 VENTURI, ADOLFO. "Il Francia." Rassegna emiliana di
 storia, letturatura ed arte 1 (1888):5-12.
 Biographical data. Identifies Cossa as his teacher.
 Sees parallel with Costa.

ERA262 ORIOLI, EMILIO. "Sentenza arbitrale pronunciata da
 Francesco Francia." Archivio storico dell'arte 5
 (1892):133-35.
 Documents from 1482, 1503, and 1516. Also document con-
 cerning painter Alessandro Orazio.

ERA263 YRIARTE, CHARLES. "Isabelle d'Este et les artistes de son
 temps: Relations d'Isabelle avec Lorenzo Costa et Francia."
 Gazette des beaux arts, 3d ser. 15 (1896):330-46, 3 b&w
 illus.
 Correspondence between Isabella and her agents concerning
 portraits and decorations for her studiolo concerning Francia
 and Costa summarized.

ERA264 JACOBSEN, EMIL. "Lorenzo Costa und Francesco Francia."
 Jahrbuch der Königlich preussichen Kunstsammlungen 20
 (1899):159-73, 6 b&w illus.
 Consideration of the interaction between Costa and
 Francia. Does not consider Francia the teacher of Costa,
 though may have learned goldsmithing and die-cutting from
 Francia. General review of Francia's work.

ERA265 WILLIAMSON, GEORGE CHARLES. Francesco Raibolini Called
 Francia. London: G. Bell & Sons, 1901, 160 + xvi pp., 42
 b&w illus.
 Moralistic biography. Catalog of works including paint-
 ings and metalwork.

ERA266 CALZINI, EGIDIO. "Per un quadro di Francia." Rassegna
 bibliografica dell'arte italiana 8 (1905):4-7.

Artists

Presentation in the Pinacoteca malatestiana, Cesena, done
for Giovanni Bertuzzoli, Sta. Maria del Monte.

ERA267 COLASANTI, ARDUINO. "Una tavola di Francesco Francia."
Rassegna d'arte 5 (1905):188–89, 1 b&w illus.
Publishes St. Roch in private collection, Naples, with
inscription FRANCIA AVRIFABER MCCCCCII.

ERA268 GEREVICH, TIBERIO. "Francesco Francia nell'evoluzione della
pittura bolognese." Rassegna d'arte 8 (1908):121–23, 139–
42, 11 b&w illus.
Influence of Lippo Dalmasio on Francia. Overview of his
work. Considers Francia highpoint of Bolognese art. On p. 140
n. 1 lists minor artists working in Bologna in fifteenth
century, with sources.

ERA269 CROWE, J[OSEPH] A[RCHER], and G[IOVANNI] B[ATTISTA]
CAVALCASELLE. "Francesco Francia." In A History of Paint-
ing in North Italy. Edited by Tancred Borenius. Vol. 2.
London: John Murray, 1912, pp. 269–94, 2 b&w illus.
Biography. Apprenticeship to Costa. Early influence
of Perugino. Relationship to Raphael. Followers include
Aspertini and Viti.

ERA270 LIPPARINI, GIUSEPPE. Francesco Francia. Bergamo: Istituto
italiano d'arti grafiche, 1913, 135 pp., 106 b&w illus.
Biography. Attributions, also to Giacomo and Giulio
Francia. Characterizes as an eclectic and colorist. Notes
work as a sculptor.

ERA271 TALBOT JACKSON, MARGARET. "A Madonna by Francia." Art in
America 2 (1913–14):431–32, 1 b&w illus.
Attributes fragment of a Madonna and Child in the Academy
of Fine Arts, Philadelphia, to Francia.

ERA272 FORATTI, ALDO. "Note su Francesco Francia."
L'Archiginnasio 9 (1914):160–73, 1 b&w illus.
Publishes Francia documents of 1499 and 1515. Says was
not an architect. Disputes work as a sculptor. Agrees worked
as metalsmith and engraver. Gives several codices in the
Biblioteca comunale, Bologna, to Francia.

ERA273 VENTURI, ADOLFO. Storia dell'arte italiana. Vol. 7, La
pittura del quattrocento. Pt. 3. Milan: U. Hoepli,
1914, pp. 852–978, 134 b&w illus.
Equivalent of a monograph on Francia. Begins with auto-
graphed works and dates. Issue of influences and attributions.

ERA274 FRATI, LODOVICO. "Di alcuni amici del Francia." Atti e
memorie della reale Deputazione di storia patria per le
provincie di Romagna, 4th ser. 6 (1915–16):219–32.

Considers the humanistic circle around Francia and works
that he did of and for them. Poems dedicated to Francia and
mentioning his work.

ERA275 SIGHINOLFI, LINO. "Note biografiche intorno a Francesco
 Francia." Atti e memorie della reale Deputazione di storia
 patria per le provincie di Romagna, 4th ser. 6 (1915-16):
 135-53.
 Notarial documents on Francia and family. Inventory in
 1510 of study of Bartolommeo Bianchini. Includes five paint-
 ings by Francia: Portrait of Bianchini, Crucifixion, and three
 unknown.

ERA276 ZUCCHINI, GUIDO. "Per due autoritratti del Francia."
 L'Archiginnasio 10 (1915):209-12, 1 b&w illus.
 Distinguishes between Self-portrait reported by Oretti as
 in the collection of Marchese Valerio Boschi and the one sent to
 Raphael as two different works. Cites another portrait in
 collection of Conte d'Arache, Turin, noted 1846.

ERA277 GRONAU, [GEORG]. "Francia, Francesco." In Thieme-Becker.
 Vol. 12. Leipzig: Seeman, 1916, pp. 319-23.

ERA278 ZUCCHINI, GUIDO. "Ancora per gli autoritratti del Francia."
 L'Archiginnasio 11 (1916):255-57.
 Notes Self-Portrait (Man with a Ring) engraved by Faucci
 is the one from the Boschi Collection that eventually went to
 England. It is the same one incorrectly identified by Cook as
 a self-portrait of Baldassare Estense.

ERA279 COULSON JAMES, EDITH E. "A Portrait from the Boschi Collec-
 tion, Bologna." Burlington Magazine 30 (1917):73-78, 4 b&w
 illus.
 Cites manuscript in the Biblioteca comunale, Bologna,
 Memorie per la vita e delle opere artistiche de bolognese
 Francesco Raibolini detto il Francia raccolte da Gaetano
 Giordani in Bologna, noting an engraving by Carlo Faucci (1729-
 84) of Francia self-portrait. Identifies it with Man with a
 Ring from the Boschi Collection probably sold in 1858 to Vito
 Enei, and then from the Abdy Collection, London, 1911. Now in
 the Thyssen Collection, Lugano. Also notes second self-
 portrait described by Zucchini (ERA278).

ERA280 COULSON JAMES, EDITH E. "The Auto-ritratti of Francia."
 Art in America 8 (1919-20):167-72, 2 b&w illus.
 Portrait of a Man with a Ring, engraved by Faucci, iden-
 tified with the one in the Boschi Collection, Bologna, in the
 eighteenth century, which passed into the collection of Sir
 William Abdy, London. Now in the Thyssen Collection, Lugano.

ERA281 COULSON JAMES, EDITH E. "The Auto-ritratti of Francesco
 Francia?" Burlington Magazine 39 (1921):2 b&w illus.

Artists

Portrait of a Man, Musée, Angers, proposed as the same
sitter in the Boschi, Portrait of a Man with Ring. Traces
portrait in Angers to Campana Collection in Rome (1861). Says
it may be one sent by Francia to Raphael, 1508.

ERA282 VENTURI, ADOLFO. "Capolavori primitivi inediti del Francia
 a Vienna e del Costa a Reggio Emilia." L'arte 24
 (1921):185-88, 3 b&w illus.
 Madonna and Child in private collection, Vienna.

EA283 HADLEN, DETELEV von. "The Predella of Francia's Felicini
 Madonna." Burlington Magazine 51 (1927):113-14, 2 b&w
 illus.
 Baptism in collection of Albert Keller, New York, and
 Nativity in Art Gallery, Glasgow, part of predella of Felicini
 Madonna in Bologna. Third lost panel stigmatization of Saint
 Francis.

ERA284 BAXANDALL, MICHAEL, and ERNST H. GOMBRICH. "Beroaldus on
 Francia." Journal of the Warburg and Courtauld Institutes
 25 (1962):113-15, 2 b&w illus.
 Beroaldus text dates from ca. 1500. Fame of Francia
 among contemporaries.

ERA285 RAGGHIANTI, CARLO LODOVICO. "Il primo Francia." Bollettino
 annuale dei musei ferraresi 3 (1973):9-17, 8 b&w illus.
 Ferrarese influences on Francia in the earliest phase,
 1480-90, particularly influence of Ercole de' Roberti. Some
 reattributions.

ERA286 CAZORT, MIMI, and CATHERINE JOHNSON. Bolognese Drawings in
 North American Collections: 1500-1800. Ottawa: National
 Gallery of Canada, 1982, 303 pp., 124 b&w illus.
 Attributes Judith with the Head of Holofernes, Morgan
 Library to Francia. Ties to a drawing in the Louvre (Inv.
 5606). Possible connection with Raphael.

ERA287 VOLPE, CARLO. "Un quadro in cerca d'autore: L' 'Ignota'
 dell'Ambrosiana." In Scritti di storia dell'arte in onore
 di Federico Zeri. Milan: Electa, 1984, pp. 276-83, 4 b&w
 illus.
 Attributes Portrait of an Unknown Woman in the Ambrosiana
 not to Lorenzo Costa, because sees no influence of Roberti, nor
 to immediate circle of Leonardo, but rather to Francia. Dates
 ca. 1490-94. Identifies as a lady from Bentivoglio court in
 Bologna.

 ROBERTI, ERCOLE DE'

ERA288 VASARI, GIORGIO. Le vite de' più eccellenti pittori,
 scultori ed architettori. . . . Annotated by Gaetano
 Milanesi. Vol. 2. Florence: Sansoni, 1973, pp. 141-8.

Reprint of 1906 edition. Life of Roberti. Confusion of two figures, particularly in the footnotes. Description of the Garganelli Chapel, S. Piero, Bologna. Very positive evaluation for perspective and emotion.

ERA289 BARUFFALDI, GIROLAMO. Vite de' pittori e scultori ferraresi. Vol. 1. Ferrara: Domenico Taddei, 1844, pp. 132-48.
Life of "Ercole Grandi pittore, detto Ercole da Ferrara." Confusion over two Ercoles. Disagrees with Malvasia over city of origin. Says Costa his master. Dispute between Costa and Ercole over Garganelli Chapel. Publishes epitaph, content of which is disputed in the footnotes.

ERA290 BOSCHINI, GIUSEPPE. "Elegia latina in lode d'Ercole Grandi pittore Ferrarese scritta da Daniello Fini." In Memorie originali italiane risquardanti le belle arti. Edited by Michelangelo Gualandi. Bologna: Sassi nelle spaderie, 1844, pp. 67-69.
Sixteenth-century poetic elegy written by Daniello Fini before 1539. Original in Biblioteca comunale, Ferrara, Classe I, 358. Refers to Ercole particularly in regard to his painting of expressions and animals.

ERA291 VENTURI, ADOLFO. "Ercole Grandi." Archivio storico dell'arte 1 (188):193-201.
Distinguishes between "Ercole Grandi" and Ercole de' Roberti.

ERA292 VENTURI, ADOLFO. "Ercole de' Roberti fa cartoni per le nuove pitture della delizia di Belriguardo." Archivio storico dell'arte 2 (1889):85.
Publishes letter of 1493. Erroneously identifies patron as Alfonso I d'Este rather than Ercole I.

ERA293 VENTURI, ADOLFO. "Ercole de' Roberti." Archivio storico dell'arte 2 (1889):339-60, 12 b&w illus.
Attributions and documents.

ERA294 FRIZZONI, GUSTAVO. "Tre opere provenienti dall'antica scuola ferrarese nuovamente illustrate." Archivio storico dell'arte 7 (1894):177-84, 3 b&w illus.
Publication of Ercole de' Roberti, Pagan Sacrifice, in a private collection in Milan.

ERA295 RICCI, CORRADO. "La pala portuense d' Ercole Roberti." Rassegna d'arte 4 (1904):11-12, 4 b&w illus.
Madonna and Child Enthroned with SS. Anne and Elizabeth, St. Augustine and B. Pietro degli Onesti in the Brera. Done for the Church of Sta. Maria in Porto, near Ravenna. Came to Brera in 1911. Provenance. Payments to Ercole in 1481 indicate artist's movements.

Artists

ERA296 VENTURI, ADOLFO. "Due nuovi quadri di Ercole de' Roberti
 nel museo del Louvre." L'arte 5 (1905):178-79, 2 b&w illus.
 SS. Apollonia and Michael.

ERA297 VENTURI, ADOLFO. Storia dell'arte italiana. Vol. 7, La
 pittura del quattrocento. Pt. 3. Milan: U. Hoepli, 1914,
 pp. 656-712, 36 b&w illus.
 Documented works and biography. Some of the late attri-
 butions are too cinquecentesque for Roberti.

ERA298 GAMBA, CARLO. "Ercole ferrarese." Rassegna d'arte antica e
 moderna 2, no. 7 (1915):191-98, 10 b&w illus.
 Copy of Crucifixion from the Garganelli Chapel, Bologna,
 given to Pinacoteca, Bologna. Also relates Louvre no. 1677,
 Men Before a Portal, as another copy from the chapel. Dif-
 ference in two related to stylistic change in Ercole between
 1482-86. Shows parallel with Melozzo da Forlì. Attributes St.
 Sebastian, Pitti, to Ercole on the basis of physiognomy.

ERA299 FILIPPINI, FRANCESCO. "Ercole da Ferrara ed Ercole da
 Bologna." Bollettino d'arte 11 (1917):49-63, 5 b&w illus.
 Traces history of the confusion of two Ercole de' Roberti
 (Grandis). Error in publication of Venturi of document of 1505
 that does not mention Ercole de' Roberti, only Mo Ercole.

ERA300 ZUCCHINI, GUIDO. "Le vetrate di San Giovanni in Monte di
 Bologna." Bollettino d'arte 11 (1917): 3 b&w illus.
 Evangelist on facade of S. Giovanni in Monte, Bologna, to
 Ercole de' Roberti.

ERA301 ZUCCHINI, GUIDO. "La distruzione degli affreschi della
 Cappella Garganelli." L'arte 23 (1920):275-78, 2 b&w illus.
 Traces history of the frescoes. Deterioration already
 second half of the sixteenth century. Destroyed in 1606.
 Fragments eventually to Palazzo Tanari and then Academy in
 Bologna. Copies by Lorenzo Costa.

ERA302 GRONAU, [GEORG]. "Grandi, Ercole." In Thieme-Becker. Vol.
 14. Leipzig: Seeman, 1921, pp. 184-85.

ERA303 HOLMES, CHARLES. "A Lost Picture by Ercole de' Roberti."
 Burlington Magazine 50 (1927):171-72, 1 b&w illus.
 Identifies Death of the Virgin in St. Patrick's Church,
 Wapping, as a copy of the lost fresco by Ercole from the
 Garganelli Chapel, Bologna.

ERA304 DOBROKLONSKY, M. "Die Zeichnungensammlungen der Ermitage."
 Pantheon 2 (1928):475-82, 1 b&w illus.
 Identifies figures in drawing of six men by Ercole de'
 Roberti as Ercole I, Sigismondo and Alfonso d'Este, and cour-
 tiers. No direct evidence.

ERA305 DUSSLER, LUITPOLD. "A Rediscovered Picture by Ercole de'
 Roberti." Burlington Magazine 54 (1929):199, 2 b&w illus.
 Attributes Adoration of the Magi in collection of A.S.
 Drey, Munich, to Ercole, ca. 1499. Others had attributed to
 Costa.

ERA306 POPHAM, A[RTHUR] E. "Notes on Drawings: Ercole de'
 Roberti." Old Master Drawings 8 (1933):23-25, 2 b&w illus.
 Study of figures for a Christ carrying Cross in the
 Fitzroy Fenwick Collection. For the predella of the altarpiece
 of S. Giovanni in Monte, Bologna. Four drawings for predella
 survive.

ERA307 GRONAU, [GEORG]. "Roberti, Ercole de." In Thieme-Becker.
 Vol. 28. Leipzig: Seeman, 1934, pp. 426-7.

ERA308 BARGELLESI, GIACOMO. "Ercole di Ferrara." Rivista di
 Ferrara 2 (1934):399-413.
 Puts to rest notion of two "Ercoles" by publishing all of
 the relevant documents.

ERA309 BOECK, WILHELM. "Quattrocento Painting in the Kaiser
 Friedrich Museum." Burlington Magazine 64 (1934):29-35, 8
 b&w illus.
 In response to rearrangement of museum new and recon-
 firmed attributions. Attributes Race of Atalanta and Madonna
 and Child with Four Saints to circle of Ercole de' Roberti.

ERA310 BUSUIOCEANU, ALESSANDRO. "Dipinti sconosciuti di Ercole
 Roberti e della sua scuola." L'arte 40 (1937):161-82, 10 b&w
 illus.
 Two allegorical scenes in Sinia, Castello di Peles. Re-
 lates to Mantegna in style.

ERA311 BODMER, HEINRICH. "'Ercole Grandi' und Ercole de' Roberti."
 Pantheon 25 (1940):59-63, 6 b&w illus.
 Traces history of the myth of two "Ercoles" back to
 confusions in sixteenth century. Indisputedly one person.

ERA312 ORTOLANI, SERGIO. Cosmè Tura, Francesco del Cossa, Ercole
 de' Roberti. Milan: U. Hoepli, 1941, 225 pp., 200 b&w
 illus.
 General discussion of attributions to and style of
 Roberti on pp. 139-209.

ERA313 ZUCCHINI, GUIDO. "Un frammento degli affreschi di Ercole da
 Ferrara per la Cappella Garganelli." Proporzioni 1
 (1943):81-84, 1 b&w illus.
 Notes the survival of a head of a weeping woman, fragment
 from the Garganelli Chapel frescoes in the Villa Boschi, now in
 the Walters Gallery, Baltimore. Reconstructs how it might have
 come into Boschi Collection.

Artists

ERA314 GRONAU, HANS D. "Ercole Roberti's St. Jerome." Burlington
 Magazine 91 (1949):243-44, 4 b&w illus.
 Connects St. Jerome in collection of Sir Thomas Barlow,
 with Ercole's work in the period 1470-80. Relates to a drawing
 in Berlin from circle of Mantegna.

ERA315 ROTONDI, PASQUALE. "Un'ipotesi sui rapporti tra Luca
 Signorelli ed Ercole Roberti." In Studies in the History of
 Art Dedicated to William E. Suida on his Eightieth Birthday.
 London: Phaidon, 1959, pp. 110-15, 7 b&w illus.
 Eighteenth-century sources cite paintings by Ercole in
 Galli Chapel, SS. Innocenti, Urbino. Giovanni Santi mentions
 Ercole. Suggests Signorelli knew Ercole's work, derives sense
 of space and violent three-dimensional movement from Ercole.

ERA316 BALOGH, JOLANDA. "Ercole de' Roberti a Buda." Acta
 Historiae Artium Academiae Scientiarum Hungaricae 6
 (1959):277-81, 4 b&w illus.
 Trip of Ercole to Hungary and court of Matthew Corvinus.
 Evidence in sixteenth-century literary source, miniatures, and
 sculptural relief.

ERA317 SALMI, MARIO. Ercole de'Roberti. Milan: Silvana, 1960, 59
 pp., 52 b&w and 19 color illus.
 Introductory essay concentrating on style. Attributions.
 Bibliography.

ERA318 RUHMER, EBERHARD. "Erganzendes zur Zeichenkunst des Ercole
 de' Roberti." Pantheon 20 (1962):241-47, 19 b&w illus.
 Strong early stylistic affinity to Cossa. Identifies
 drawings in Rotterdam and Windsor by Roberti after Mantegna.
 Attributes five other drawings, including reattribution of St.
 Sebastian in Lehman Collection. Influence of Roberti on
 graphics.

ERA319 ZERI, FEDERICO. "Appunti per Ercole de' Roberti."
 Bollettino d'arte, 5th ser. 50 (1965):72-79, 13 b&w illus.
 Discusses following works: Christ before Pilate, minia-
 ture in Louvre; Argonaut series; Weeping Woman fragment in
 Baltimore; reconstructs predella with Eucharistic scenes
 from panels in London.

ERA320 MUNICH. STAATLICHE GRAPHISCHE SAMMLUNG. Italienische
 Zeichnungen 15-18. Jahrhundert. 4 May-6 August, 1967.
 Munich: Staatliches Graphische Sammlung, 1967, 91 pp., 79
 b&w illus.
 Catalog entry 66, plate 7, attributed to shop of Ercole
 de' Roberti. Reproduces lost part of Ercole's Crucifixion in
 the Garganelli Chapel, S. Petronio. Similar drawing in
 Budapest.

ERA321 MELLER, PETER. "Two Drawings of the Quattrocento in the
 Uffizi: A Study in the Stylistic Changes." Master Drawings
 12 (1974):261-79, 30 b&w illus.
 Reattributes Head of a Warrior, Uffizi, 151E, to circle
 of Ercole de' Roberti, possibly Antonio Manieri. Traces way
 motif that has origins in Mantegna was transmitted.

ERA322 RAGGHIANTI COLLOBI, LICIA. Il Libro de' disegni de Vasari.
 2 vols. Florence: Vallechi, 1974, 1:70; 2:plates 191-92.
 Publishes Woman or Monk Kneeling and Man in Long Hood
 from the Vasari's Libro de' disegni in Dusseldorf, Kunstmuseum,
 Inv. 3765.

ERA323 STOICHITÀ, VICTOR IERONIM. "Deux oeuvres ferrarises au
 Musée d'art de la Republique socialiste de Roumanie. I.
 'Qualche fabula antiqua et de bello significato.'" Revue
 roumaine d'histoire de l'art 15 (1978):19-52, 2 color and 23
 b&w illus.
 Identifies the subjects of the Good and Bad Auguries as
 antithetical subjects: Eros Protheurythmos (Ancient god of
 order and rhythmn) and Amor Dei (God of love). History of
 subjects.

ERA324 STOICHITÀ, VICTOR IERONIM. "Deux oeuvres ferrarises au
 Musée d'art de la Republique socialiste de Roumanie. II.
 'Zoane Francesco da Parma pictore egregio.'" Revue roumaine
 d'histoire de l'art 16 (1979):65-79, 21 b&w illus.
 Reattributes Amor Dei and Eros Protherythmos from Ercole
 de' Roberti to Giovan Francesco Maineri. Traces history of the
 attribution. Dates between 1495-1500.

RONDINELLI, NICOLÒ

ERA325 GRIGONI, CARLO. "Documenti." Rassegna bibliografica
 dell'arte italiana 12 (1909):163-67.
 Will of the wife of Nicolò Rondinelli, 1496. Other
 documents concerning minor artists working in Fano in the
 fifteenth century.

*ERA326 BORENIUS, TANCRED. "Notes on Nicolò Rondinelli." Felix
 Ravenna (1911):8-10, illus.
 Cited in Repetoire d'art et d'archeologie 11-15
 (1912):86, no. 1580. Attributes a Madonna and Child in Berlin,
 signed by Bellini to Rondinelli. Also Madonna and Child with
 the Baptist, Doria Gallery, Rome, signed by Bellini to
 Rondinelli.

ERA327 SIREN, OSWALD. "Two Pictures at the National Museum of
 Stockholm." Burlington Magazine 54 (1929):22-27, 1 b&w
 illus.
 Attributes Madonna and Child with SS. Lawrence and Andrew
 to Rondinelli, ca. 1500, after return from Venice.

Artists

ERA328 GRIGONI, CARLO. "Una 'Madonna' sconoscuita di Nicolò
 Rondinelli." Belvedere 8, no. 9 (1929):287-91, 2 b&w illus.
 Publishes Madonna and Child in the Ettore Casadei Collec-
 tion, Forlì. Suggests Rondinelli's wife as inspiration.

ERA329 BORENIUS, TANCRED. "Rondinello, Niccolò." In Thieme-
 Becker. Vol. 28. Leipzig: Seeman, 1934, pp. 570-1.

DE' RUSSI, FRANCO

ERA330 SERAFINI, ALBERTO. "Ricerche sulla miniatura umbra."
 L'arte 15 (1912):420-22, 2 b&w illus.
 Illustrates miniatures by Franco de' Russi.

ERA331 PERGOLA, PAOLO della. "Russi, Franco di Giovanni de'." In
 Thieme-Becker. Vol. 29. Leipzig: Seeman, 1935, p. 230.

ERA332 LEVI d'ANCONA, MIRELLA. "Contributi al problema di Franco
 dei Russi." Commentari 11 (1960):33-45, 4 b&w illus.
 New itinerary for Franco de' Russi, Ferrara to Venice to
 Urbino. New attributions. Graticolatio of Bernardo Bembo,
 British Museum, Add MS. 20916, and fragments in Wildenstein
 Collection, Paris.

ERA333 ALEXANDER, J[OHN] J.G. "A Manuscript of Petrach's Rime and
 Trionfi." Victoria and Albert Yearbook 2 (1970):27-40, 1
 color and 14 b&w illus.
 MS. L101-1947, in the Victoria and Albert Museum, by the
 Paduan scribe Sanvito. Attributes miniatures to Franco and a
 second hand.

ERA334 ADORISIO, ANTONIO. "Carlo Crivelli, Girolamo da Cremona e
 Franco de' Russi in incunaboli miniati della Biblioteca
 casanatense." Accademie e biblioteche d'Italia 40
 (1972):27-34, 8 b&w illus.
 Attributes Pliny, Natural History, incunabolo 1157,
 to Franco de' Russi rather than "Master of the Putti," and
 incunabolo 1143 to the "Master of the Putti."

TURA, COSMÈ

ERA335 BARUFFALDI, GIROLAMO. Vita di Cosimo Tura, pittore
 ferrarese del secolo XV. Bologna: Nobili (per nozze
 Boldrini), 1836, 39 pp.
 Brief descriptive biography, with notes by Giuseppe
 Petracci.

ERA336 BARUFFALDI, GIROLAMO. Vite de' pittori e scultori
 ferraresi. Vol. 1. Ferrara: Domenico Taddei, 1844,
 pp. 63-91.
 Life of Cosmè. Includes description of the Schifanoia
 frescoes at the end. Says Galasso master of Tura. Painted

life-sized Madonna over portal, and New Testament in Sacrati
Chapel in Sta. Maria degli Angeli, Ferrara. Says Tura respon-
sible for the Sala dei mesi.

ERA337 AVVENTI, FRANCESCO. Descrizione dei dipinti di Cosimo Turra
 [sic], ultimamente scoperti nel Palazzo Schifanoia in
 Ferrara nell'anno 1840. Bologna: Marsigli, 1840, 30 pp.
 Description of Sala dei mesi frescoes with attribution to
 Tura and assistants.

ERA338 VENTURI, ADOLFO. "Cosmè Tura e la Capella di Belriguardo."
 Il Buonarroti, 3d ser. (1885):55-63.
 Review of the documents concerning the decoration of the
 chapel in Belriguardo and reconstruction of the program of the
 paintings.

ERA339 VENTURI, ADOLFO. "Cosma Tura gennant Cosmè." Jahrbuch der
 Königlich preussichen Kunstsammlungen 9 (1888):3-33, 3 b&w
 illus.
 Biography and comprehensive documents.

ERA340 HARCK, FRITZ von. "Verzeichnis der Werke des Cosma Tura."
 Jahrbuch der Königlich preussichen Kunstsammlungen 9
 (1888):34-40.
 Catalogue raisonné including documented and described but
 lost works. Some provenance.

ERA341 VENTURI, ADOLFO. "Documenti." Archivio storico dell'arte 7
 (1894):52-53.
 Document of 1431 concerning Tura.

ERA342 VENTURI, ADOLFO. "L'arte emiliana (al Burlington Fine-Arts
 Club di Londra)." Archivio storico dell'arte 7 (1894):89-
 106, 9 b&w illus.
 Review of the exhibition at the Burlington Fine-Arts
 Club, including comments about Tura paintings in the exhibit.

ERA343 RICCI, CORRADO. "Tavole sparse di un polittico di Cosmè
 Tura." Rassegna d'arte 5 (1905):145-46.
 Reassembles polyptych from S. Luca in Borgo, Ferrara.
 Madonna and Child in Bergamo, St. Dominic in Uffizi, St.
 Sebastian in Berlin, and St. Anthony of Padua in Louvre.

ERA344 LAZZARI, ALFONSO. "Il 'Barco' di Lodovico Carbone." Atti e
 memorie della Deputazione ferrarese di storia patria 24
 (1913):1-44.
 Includes description of study at Belfiore and mention of
 Cosmè Tura (p. 34) within the poem.

ERA345 VENTURI, ADOLFO. Storia dell'arte italiana. Vol. 7, La
 pittura del quattrocento. Pt. 3. Milan: U. Hoepli, 1914,
 pp. 506-58, 37 b&w illus.

Artists

 Factual information and some documents in footnotes. Influences and attributions. Schifanoia discussed pp. 570-84. Tura influence in June, July, August, September, and section with horsemen.

ERA346 BORENIUS, TANCRED. "'The Crucifixion' by Cosimo Tura." Burlington Magazine 27 (1915):202-5, 1 b&w illus.
 Attributes small Crucifixion with the Virgin and St. John in the collection of Herbert Cook to Tura.

ERA347 VENTURI, ADOLFO. "Disegno di Cosmè Tura." L'arte 26 (1923):229, 1 b&w illus.
 Seated Bishop in the Bonnat Collection, Bayonne.

ERA348 VENTURI, ADOLFO. "Un raro disegno di Cosmè Tura." L'arte 31 (1928):254-55, 1 b&w illus.
 Samson and the Lion, Wauters Collection, Paris, sold in Amsterdam in June 1926.

ERA349 VENTURI, ADOLFO. "Un ritratto di Cosmè Tura." L'arte 33 (1930):283-84, 1 b&w illus.
 Portrait of a Man, now in New York, formerly in Matthiesen Gallery, Berlin.

ERA350 WESCHER, PAUL. "Buchminiaturen im Stil Cosimo Tura." Berliner Museen. Berichte aus den preussichen Kunstsammlungen. Beiblatt zum Jahrbuch der Königlich preussichen Kunstsammlungen 51 (1930):78-81, 4 b&w illus.
 On basis of style associates initial "N", Berlin, Kupferstichkabinett, 4493; "L" with St. Francis in Wildenstein, Paris; and "G" with Stigmatization of St. Francis, now Washington, National Gallery, with Tura shop. Also author portrait, possibly by Tura himself, from printed History of Troy, Berlin, 3789.

ERA351 GOMBOSI, [GEORG]. "Tura, Cosimo." In Thieme-Becker. Vol. 33. Leipzig: Seeman, 1939, pp. 480-83.

ERA352 HARTZSCH, OTTO. "Cosimo Tura." Pantheon 26 (1940):153-61, 11 b&w illus.
 Reconstructs the Pala Roverella. Discusses the iconography of the planets on the cathedral organ wings.

ERA353 ORTOLANI, SERGIO. Cosmè Tura, Francesco del Cossa, Ercole de' Roberti. Milan: U. Hoepli, 1941, 225 pp., 200 b&w illus.
 General discussion of Tura's style and attributions, pp. 5-82.

ERA354 SORRENTINO, A[NTONIO], and C[ESARE] GNUDI. "Restauro delle ante d'organo di Cosmè Tura della Cattedrale di Ferrara." Bollettino d'arte, 4th ser. 33 (1948):262-65.

Report of the restoration of the organ wings from the
cathedral of Ferrara by Cosmè Tura. Notes damage. Detailed
photographs.

ERA355 RIGHINI, GIULIO. "Cosimo Tura a San Giorgio." Atti e
 memorie della Deputazione di storia patria per l'Emilia e la
 Romagna. Sezione di Ferrara 4 (1946-49):89-110, 5 b&w
 illus.
 Discusses Pala Roverella and location of Tura's tomb.

ERA356 DAVIES, MARTIN. "Tura's 'Virgin and Child Enthroned' in the
 National Gallery." Burlington Magazine 94 (1952):168.
 Cleaning reveals fragments of inscription that verify
 notion that the panel is central portion of the Pala Roverella.

ERA357 NEPPI, ALBERTO. Cosmè Tura (Saggio critico). Milan:
 Gastaldi, 1953, 143 pp., 5 b&w illus.
 Brief survey of Ferrarese art during the times of
 Leonello and Borso d'Este. Biography of Tura. Attributions.
 Characteristics of his style.

ERA358 SALMI, MARIO. Cosmè Tura. Milan: Electa, 1957, 69 pp., 53
 b&w and 14 color illus.
 Discussion of Tura's work. Discusses impact on illumina-
 tion. Reconstructs Pala Roverella and Pala d'Argenta. Agrees
 with Gnudi (ERC127) that Tura responsible for planning out the
 Schifanoia frescoes. Brief bibliography.

ERA359 RUHMER, EBERHARD. Tura: Paintings and Drawings. London:
 Phaidon, 1958, 184 pp., 16 + 85 b&w and 3 color illus.
 Catalogue raisonné. Sees Tura's direct participation in
 the Schifanoia. Offers iconographic interpretation of cycle.
 Limited bibliography.

ERA360 CHASTEL, ANDRÉ. "Tura and the Secrets of Ferrara." Art
 News 62, no. 10 (1958-59):40-41, 62-63, 1 b&w illus.
 Reviews of Salmi (ERA358) and Ruhmer (ERA359). Doubts
 some of Salmi's attributions. Suggests should look further
 into the area of manuscript illumination and Tura's activities
 as a decorator. Also doubts Ruhmer's assertion of Tura's
 presence in the Schifanoia.

ERA361 BIANCONI, PIERO. Tutta la pitture di Cosmè Tura. Milan:
 Rizzoli, 1963, 76 pp., 95 b&w and 4 color illus.
 Pocket-sized catalogue raisonné, review of opinions, and
 selected bibliography. Illustrates all works.

ERA362 GUIDONI, ENRICO, and ANGELA MARINO. "Cosmus pictor."
 Storia dell'arte 1 (1969):388-416.
 Iconographic interpretation of the cathedral organ wings.
 Relates background to drainage of the swamps around Ferrara.

Artists

Astrological imagery related to restoration of cosmic harmony
through crusade against the Turks.

ERA363 BARGELLESI, GIACOMO. "Tura o Aleotti ad Argenta?" Atti e
memorie della Deputazione provinciale ferrarese di storia
patria, 3d ser. 11 (1972):161-70, 1 b&w illus.
Reattributes polyptych formerly in Argenta to Antonio
Aleotti rather than Tura.

ERA364 MOLAJOLI, ROSEMARIA, ed. L'opera completa di Cosmè Tura e i
grandi pittori ferraresi del suo tempo: Francesco Cossa e
Ercole de' Roberti. Classici dell'arte, no. 73. Milan:
Rizzoli, 1974, 104 pp., 164 b&w and 64 color illus.
Overview of criticism on each of the artists surveyed in
the book. Definition of the artistic culture in Ferrara.
Catalog of works and attributions for each. Palazzo Schifanoia
discussed on pp. 100-102.

ERA365 SGARBI, VITTORIO. "La cultura figurativa di Cosmè Tura e le
ante d'organo della Cattedrale di Ferrara." In La
Cattedrale di Ferrara. Accademia delle Scienze di Ferrara.
Ferrara: Belriguardo, 1982, pp. 503-14.
Stylistic analysis of organ wings. Argues against notion
of Tura as between medieval and Gothic. Sees him reflective of
general North Italian style seen in Carlo Crivelli, Zoppo, and
Schiavone.

ERA366 CIERI VIA, CLAUDIA. "Il tempio come 'Locus iustitiae': La
Pala Roverella di Cosmè Tura." In La corte e lo spazio:
Ferrara estense. Edited by Giuseppe Papagano and Amedeo
Quondam. Vol. 2. Rome: Bulzoni, 1982, pp. 577-91, illus.
in vol. 3.
Identifies themes related to the virtue of Justice in the
Pala Roverella, which are in turn related to Borso d'Este's
special identification with that virtue.

DEI VEGRI, SUOR CATERINA

ERA367 BARUFFALDI, GIROLAMO. Vite de' pittori e scultori
ferraresi. Vol. 2. Ferrara: Domenico Taddei, 1844,
pp. 387-88.
Very brief note about dei Vegri, records a prayerbook by
the miniaturist in the cathedral in Ferrara.

ERA368 RAGG, LAURA M. "Sister Caterina dei Vegri." In The Women
artists of Bologna. London: Methuen & Co., 1907, pp. 11-
164, 4 b&w illus.
Biography.

*ERA369 FILIPPINI, FRANCESCO. "Santa Caterina da Bologna pittrice."
Il Comune di Bologna 7, no. 7 (1928):43-47.
Cited in Lombardi, "I corali del Museo del Duomo," ERC103.

ERA370 MOSCHINI, VITTORIO. "Alcune sante attribuite a Caterina
 Vegri." Bollettino d'arte, 3d ser. 28 (1934):156-59, 5 b&w
 illus.
 Eight paired female saints in church of S. Giovanni in
 Bragora, Venice. Tempera on panel. Piece of paper attached to
 panels with attribution to Caterina dei Vegri. Questions at-
 tribution by comparison with St. Ursala, Pinacoteca, Bologna,
 which has an old inscription with Caterina's name and date of
 1452.

 ZAGANELLI DA COTIGNOLA, FRANCESCO AND BERNARDINO

ERA371 RICCI, CORRADO. "La 'Madonna della rose' dei Zaganelli da
 Cotignola nel Museo di Vicenza." L'arte 17 (1914):1-6, 1
 b&w illus.
 Attributes painting of Madonna della rose in Museo
 civico, Vicenza, to Francesco and Bernardino Zaganelli. Dis-
 tinguishes from pupil Girolamo Marchesi da Cotignola.

 ZOPPO, MARCO

ERA372 DAVARI, STEFANO. "Una lettera di Marco Zoppo." L'arte 2
 (1899):253.
 Letter dated 1462.

ERA373 LAZZARINI, VITTORIO. "Nuovi documenti su Mantegna,
 Squarcione, Marco Zoppo, Schiavone--Giovanni d'Alemagna e
 Antonio da Murano pittori negli Eremitani da Padova."
 Rassegna d'arte 6 (1906): facing 145.
 Reports finding documents in the notarial and judicial
 records in the archives in Padua concerning Squarcione and
 shop. Included is an act in which in 1455 Squarcione indicates
 that he wants to donate all of his goods, including drawings
 and other artist's materials to Marco Zoppo. Never carried
 out.

ERA374 CROWE, J[OSEPH] A[RCHER], and G[IOVANNI] B[ATTISTA]
 CAVALCASELLE. A History of Painting in North Italy. Edited
 by Tancred Borenius. Vol. 2. London: John Murray, 1912, pp.
 48-53, 1 b&w illus.
 Considers Zoppo pupil of Squarcione rather than Lippo
 Dalmasio, as Malvasia says. Attributions and stylistic analysis.

ERA375 WEINMEYER, KONRAD. "Eine Zeichnung des Marco Zoppo?"
 Monatshefte fur Künstwissenschaft 7 (1914):157, 2 b&w illus.
 Publishes series of studies of Madonna and Child and
 Madonna and Child with Saints in a Munich private collection.
 Dates ca. 1480.

ERA376 BORENIUS, TANCRED. "On a Dismembered Altarpiece by Marco
 Zoppo." Burlington Magazine 38 (1921):9-10, 3 b&w illus.

Publishes three half-length images of saints (Paul in
Oxford, Bishop Saint in the National Gallery, London, and Peter
in collection of Mr. Henry Harris) as all from unidentified
altarpiece by Zoppo.

ERA377 DODGSON, CAMPBELL. A Book of Drawings Formerly Attributed
 to Mantegna. London: British Museum, 1923, 16 pp.,
 26 illus.
 Facsimile of drawings in the Rosebery Codex, British
Museum.

ERA378 SUPINO, IGINO B. "Nuovi documenti su Marco Zoppo pittore."
 L'Archiginnasio 20, no. 3-4 (1925):128-32.
 Series of documents concerning commissions and legal
matters in Bologna between 1461 and 1478. Letter from Anziani
in Bologna to Doge in Venice proves that Zoppo died in Venice
in 1478.

ERA379 F. "A Pietà by Marco Zoppo." Bulletin of the Art Institute
 of Chicago 20, no. 4 (1926):55-56, 1 b&w illus.
 Turaesque Pietà in the Ryerson Collection, Chicago.

ERA380 FIOCCO, GIUSEPPE. "Felice Feliciano amico degli artisti."
 Archivio veneto tridentino 9 (1926):188-99.
 Letter of 1475 from Feliciano to Zoppo praising his
paintings and commenting on the artist's dogs.

ERA381 VENTURI, ADOLFO. "Due ali di Marco Zoppo a Dublino e
 Edimburgo." L'arte 30 (1927):62-63, 2 b&w illus.
 Wings of a triptych with SS. Mark and Augustine, and
Giovanni Battista and Giovanni Evangelista. Reattributes to
Zoppo from Giusto di Andrea.

ERA382 FIOCCO, GIUSEPPE. "Un libro di disegni di Marco Zoppo." In
 Miscellanea di storia dell'arte in onore di Igino Benevenuto
 Supino. Florence: L.S. Olschki, 1933, pp. 337-51, 10 b&w
 illus.
 Reconstructs part of a Zoppo sketchbook from fragments in
the Rosebery Codex, British Museum; Kunsthalle, Hamburg; and
the Biblioteca reale, Turin. Refers to engravings after the
drawings by Francesco Novelli.

ERA383 POPHAM, A[RTHUR] E. "Notes on Drawings: Marco Zoppo." Old
 Master Drawings 5 (1930):48-49, 1 b&w illus.
 Publishes Study of a Kneeling Saint in the British
Museum.

ERA384 MOSCHETTI, ANDREA. "Zoppo, Marco." In Thieme-Becker. Vol.
 36. Leipzig: Seeman, 1947, pp. 554-5.

ERA385 KUHNEL-KUNZE, IRENE. "Zum Werke des Marco de Rugeri gennant
 Lo Zoppo." Zeitschrift für Künstwissenschaft 1.3-4
 (1947):98-104, 7 b&w illus.

Publishes three Saints, Mary Magdalen, Catherine, and
Jerome, seen by Zanetti in a cloister near San Gregorio,
Venice, in 1771, as by Zoppo. Saint Jerome had cartellino in
hand with name "Rugeri" on it. Documents and biography.

ERA386 BERTINI, ALDO. "Disegni inediti nella Biblioteca reale di
 Torino: Marco Zoppo." La critica d'arte 8 (1950):501, 1
 b&w illus.
 Publishes verso of drawing in Biblioteca reale with two
studies of the Madonna and Child. Recto previously published
by Fiocco (ERA382).

ERA387 FIOCCO, GIUSEPPE. "Notes sur les dessins de Marco Zoppo."
 Gazette des beaux arts 53 (1954):221-30, 264-66, 5 b&w
 illus.
 Clarifies recent attributions. Importance of external
influences on Zoppo.

ERA388 NEWTON, STELLA PEARCE. "Costumi tedeschi e borgognoni nel
 libro di Marco Zoppo." Commentari 9, no. 3 (1958):155-60,
 10 b&w illus.
 Traces sources of costumes in Rosebery Codex to Federick
III's trip to Italy in early 1450s.

ERA389 BUCHOWIECKI, WALTER. "Zur Meisterfrage der Gonzaga-Cassoni
 in Klagenfurt." Alte und Moderne Kunst 54-55 (1962):15-20, 7
 b&w illus.
 Identifies the pieces in Klagenfurt with two coffers
ordered from Zoppo by Barbara Gonzaga in 1462.

ERA390 ARMSTRONG, LILIAN. "Two Notes on Drawings by Marco Zoppo."
 Pantheon 21 (1963):298-310, 11 b&w illus.
 Uffizi SS. Sebastian and Michael and Crucifixion by Zoppo
connected with Ferrarese sculpture. Suggests date of 1456 for
stopover in Ferrara by Zoppo en route to Venice. Influence of
Zoppo on Cossa, Tura, and Ercole de' Roberti. Reconstructs two
pages from Zoppo sketchbook.

ERA391 ARMSTRONG ANDERSON, LILIAN. "The Paintings and Drawings of
 Marco Zoppo" Ph.D. Dissertation, Columbia University, 1966,
 612 pp., numerous b&w illus.
 Catalogue raisonné published with very few revisions in
the Garland series (ERA396).

ERA392 RUHMER, EBERHARD. Marco Zoppo. Saggi e studi di storia
 dell'arte, vol. 9. Vincenza: Neri Pozza, 1966, 110 pp., 8
 color illus. and 188 b&w illus.
 Catalogue raisonné.

ERA393 MUNICH. STAATLICHE GRAPHISCHE SAMMLUNG. Italienische
 Zeichnungen 15-18. Jahrhundert. 4 May-6 August, 1967.

Artists

> Munich: Staatliches Graphische Sammlung, 1967, 91 pp., 79 b&w illus.
> Catalog entry 85, plate 5, six studies of the Virgin and Child, attributed to Zoppo. Part of dispersed "patternbook" with sheets in Braunschweig, Frankfurt, Hamburg, London, Paris, Turin, and Munich.

ERA394 ALEXANDER, JOHN G. "A Virgil Illuminated by Marco Zoppo." Burlington Magazine 111 (1969):514-16, 5 b&w illus.
 Assigns illuminations in Paris, B.N. Lat. 11309 to Zoppo on the basis of style. Accepted by Armstrong (ERA396).

ERA395 FORSTER, MICHAEL. "Zur gegenständlichen Deutung zweier Blätter aus dem Londoner 'Skizzenbuch' des Marco Zoppo." Wiener Jahrbuch für Kunstgeschichte 22 (1969):167-68, 4 b&w illus.
 Iconographic interpretation of two sheets with cavorting putti on sailed ship with wheels. Connects with Greek bacchic celebrations. Symbolic marriage procession. Suggests knowledge through source in Este library.

ERA396 ARMSTRONG, LILIAN. The Paintings and Drawings of Marco Zoppo. New York and London: Garland Publishing, 1976, ix + 589 pp., 242 b&w illus.
 Catalogue raisonné. Bibliography. Very slight revision of her dissertation (ERA391).

Liguria

GENERAL

LI1 RATTI, CARLO GIUSEPPE. <u>Descrizione</u> <u>delle</u> <u>pitture,</u> <u>scolture</u>
<u>e</u> <u>architetture</u> <u>che</u> <u>trovansi</u> <u>in</u> <u>alcune</u> <u>città,</u> <u>borghi</u> <u>e</u>
<u>castelli</u> <u>delle</u> <u>due</u> <u>riviere</u> <u>dello</u> <u>stato</u> <u>ligure</u>. Genoa;
Ivone Gravier, 1780, 256 pp.
 By city. Includes Savona, but not Genoa. Works by
Giovanni Mazone d'Alessandria, Ludovico Brea, Lorenzo Fasolo,
and Tucius de Andria.

*LI2 STAGLIENO, MARCELLO, and ANTONIO MERLI. <u>Sunto</u> <u>storico</u>
<u>cronologico</u> <u>delle</u> <u>arti</u> <u>del</u> <u>disegno</u> <u>e</u> <u>dei</u> <u>principali</u> <u>artisti</u>
<u>in</u> <u>Liguria</u>. Genova: Tip gazzetta dei tribunale, 1862,
46 pp.
 Cited in Cesare Manzoni, <u>Biografia</u> <u>italica:</u> Saggio
<u>bibliografica</u> <u>di</u> <u>opere</u> <u>italiane</u> <u>a</u> <u>stampe.</u> . . . Osnabruck:
Biblio Verlag, 1981, p. 181, no. 3068.

LI3 BELGRANO, LUIGI TOMMASO. "Rendiconti dei lavoro fatti dalla
Società ligure di storia patria negli anni accademici
MDXCCCLXII-MDCCCLXIV." <u>Atti</u> <u>della</u> <u>Società</u> <u>ligure</u> <u>di</u>
<u>storia</u> <u>patria</u> 3 (1864):cxxx-cxxxiv.
 Publishes 1619 inventory from the Church of San
Giambattista, Montalto, which lists two paintings by Ludovico
Brea, <u>St.</u> <u>George</u>, 1519, and unspecified, 1485. Letter from
Father Andrea Fossati, describing three paintings in the parish
church of Camporosso. One to Corrado d'Alemagna and two to
Ludovico Brea. Alessandro Wolf notes frescoes by by Manfredino
di Bosilio in parish church of Volpedo.

LI4 ALZIERI, FEDERICO. <u>Notizie</u> <u>dei</u> <u>professori</u> <u>dei</u> <u>disegno</u> <u>in</u>
<u>Liguria</u> <u>dalle</u> <u>origini</u> <u>al</u> <u>secolo</u> <u>XVI</u>. 3 vols. in 2. Genoa:
Sambolino, 1866-76, 445 and 563 pp.
 Vol. 1 shifts from Tuscan influence to Lombard, docu-
ments. Vol. 2 appendix with Nicesi artists including Brea
working in Liguria (1881). Vol. 3 includes miniaturists and

General

 intarsiatori. Vol. 2 extremely important for documentary
 information.

LI5 ROSSI, GIROLAMO. "Pittori piemontesi nella Liguria." Arte
 e storia 10 (1891):33-44.
 Documentary notices of a number of minor Piedmontese
 artists who work in Liguria, including Giovanni Battista
 Canavesio da Pinerolo.

LI6 BRES, GIUSEPPE. Notizie intorno ai pittori nicesi:
 Giovanni Mirallieti, Ludovico Brea e Bartolomeo Bensa in
 relazione all'opera di Federigo Alizeri. Genoa: Luigi
 Sambolino & Figlio, 1903, 28 pp.
 Corrects inscriptions in Alzieri, particularly panel in
 Lucerame and in the sacristy of the parish church in Val del
 Condamine. Miralheti dead by 1488. May be the master of
 Ludovico Brea.

LI7 BENSA, TOMASO. La peinture en Basse-Provence, à Nice et en
 Ligurie. Cannes: V. Guiglion, 1908, 178 pp., 1 b&w illus.
 Giovanni Canavesio da Pinerolo working in Nice and Liguria
 (pp. 63-8). Part 3 devoted to Ludovico Brea (pp. 73-134).
 Three periods: Nice, transition, and Genovese. Earliest in-
 fluence from Jean Miralheti. Worked in Umbria and Rome.

LI8 BRES, GIUSEPPE. Questioni d'arte regionale. Studio
 critico. Altre notizie inedite sui pittori nicesi. Nice:
 P. Lersch & A.N. Emanuel, 1911, 99 pp., b&w illus.
 Includes articles on Provençal painters working in Liguria
 including Miralheti (pp. 44-56), Ludovico Brea (pp. 57-64), and
 Giacomo Durandi (pp. 81-84). Also notices of Giovanni and
 Giacomo Canavesio.

LI9 CAGNOLA, GUIDO. "La mostra retrospettiva d'arte regionale a
 Nizza." Rassegna d'arte 12 (1912):81-87, 9 b&w illus.
 Review of exhibition in Nice. Traces work of fifteenth-
 century artists including Jean Miralheti, Giacomo de Carolis,
 and Giacomo Durandi. Special attention to the development of
 Ludovico Brea.

LI10 GROSSO, ORLANDO. "Per le fonti della storia dell'arte
 Liguria." In L'Italia e l'arte straniera: Atti del X
 Congresso internazionale di storia dell'arte in Roma-1912.
 Rome: 1922, pp. 507-8.
 Very short summary of the principal bibliographic sources
 on art in Liguria in historical order. Cites collections of
 archival notations by Marcello Staglieno in the Biblioteca
 Berio and Società di storia patria, Achille Neri, and Francesco
 Podestà.

LI11 VENTURI, ADOLFO. "La pittura in Liguria e nel Piemonte."
 In Storia dell'arte italiana. Vol. 7, La pittura del

quattrocento. Pt. 4. Milan: U. Hoepli, 1913, pp. 1097-
1103, 12 b&w illus.
 Brief sections with attributions and stylistic descrip-
tion of works by Durandi, Miralheti, Brea, Canavesio, Mazone,
and Gandolfino di Roreto.

LI12 BRES, GIUSEPPE. L'arte nella estrema Liguria occidentale.
 Notizie inedite. Nice: Commercio P. Lersh & A.N. Emanuel,
 1914, 92 pp., 30 b&w illus.
 Organized by town, lists works of art through to the
 seventeenth century. Mentions works with documents by Giovanni
 Canavesio and Giovanni da Montorfano.

LI13 BOREA, G. "Au Musée Massena à Nice: L'exposition des Brea,
 peintre Niçois des XVe et XVIe siècles. Musées de France:
 Bulletin 9 (June 1937):89-93, 4 b&w illus.
 Exhibition of the work of the Brea, particularly Ludovico,
 in the Massena Museum, Nice. Forty-eight panels in the exhibi-
 tion. Sketch of the work of Francesco Brea and Ludovico.
 Notes primarily Milanese influence in Ludovico's style. Re-
 views types of altarpieces, does not adjust style to frame.

LI14 GENOVA. PALAZZO REALE. Mostra della pittura antica in
 Liguria dal trecento al cinquecento. Catalogo. Edited by
 Antonio Morassi. Milan: Alfieri, 1946, 93 pp., 52 b&w
 illus.
 First part of two-part exhibition of works put in storage
 during the war. Not everything is illustrated. Brief biogra-
 phies and bibliography for artists. Imprint of Lombard,
 Flemish, and Venetian art on Ligurian art.

LI15 PODESTÀ, ATTILIO. "Pittura in Liguria dal trecento al
 cinquecento." Emporium 104 (1946):61-76, 13 b&w illus.
 Review of the exhibition in the Palazzo reale (LI14).
 Emphasizes influence of Sienese, Lombard, and Piedmontese art
 on fifteenth-century Ligurian art. Special mention of Brea,
 Foppa, Giovanni Mazone, Donato de' Bardi, and Carlo Braccesco.

LI16 CASTELNOVI, GIAN VITTORIO. "Dipinti antichi della Liguria
 intemelia." Rivista ingauna e intemelia 2 (1947):1-10, 13
 b&w illus.
 Review of exhibition held in the Museo Bicknell,
 Bordighera, 1946-47, thirteenth through the seventeenth
 centuries. Includes notice of works by Ludovico Brea and
 Stefano Adrechi.

LI17 LAMBOGLIA, NINO. "Affreschi e strutture medioevali del
 Palazzo vescovile di Albenga." Rivista ingauna e intemelia
 3 (1948):17-21, 3 b&w illus.
 Documents anonymous fresco with bishop's coat-of-arms,
 1476-78.

General

LI18 LAMBOGLIA, NINO. "Ancora sull'affresco del Palazzo
 vescovile di Albenga." Rivista ingauna e intemelia 3
 (1948):41.
 Documentation on anonymous fresco in Albenga. Cites
 Paneri, Sacro e vago giardinello della città e diocesi di
 Albenga, Vol. 1, pp. 160-61, for exact date of 1477. Another
 fresco of 1463.

LI19 Mostra di opere d'arte restaurate, Genoa, Maggio, 1956.
 Quaderni della Soprintendenza alle gallerie ed opere d'arte
 della Liguria 6 (1956):22-32.
 Includes works by Giovanni Canavesio, Giovanni Mazone,
 Luca Baudo da Novara, and Ludovico Brea. Bibliography.

LI20 TOURING CLUB ITALIANO. Guida d' Italia: Liguria. Milan:
 Touring Club italiano, 1967, 503 + 35 pp., 13 maps and 12
 city plans.
 Comprehensive guide to the region. Index by place and
 artist.

LI21 CASTELNOVI, GIAN VITTORIO. "Il quattro e il primo
 cinquecento." In La pittura a Genova e in Liguria dagli
 inizi al cinquecento. Edited by Colette Bozzo Dufour,
 Fiorella Caraceni Poleggi, Gian Vittorio Castelnovi et al.
 Genoa: SAGEP, 1970, pp. 77-179, 14 color and 53 b&w illus.
 General discussion of the development of art in Liguria,
 tracing Lombard influence. Biographies and lists of works by
 artists discussed. Index.

LI22 BARBERO, B[RUNO]. "Pittura nella Val Bormida di Millesimo
 tra quattro e cinquecento: Novità culturale 'imagerie
 populaire.'" Atti e memorie della Società savonese di
 storia patria 8 (1974):155-62, 6 b&w illus.
 Frescoes in parish churches.

LI23 DE NEGRI, TEOFILO OSSIAN. "La pittura tardogotica delle'
 'Alpi Liguria,' da Antonio Monregalese a Pietro Guidi."
 Bollettino ligustico per la storia e la cultura regionale 27
 (1975):79-102, 28 b&w illus.
 Overview of recent literature on development of popular
 art in region of Ligurian Alps. Publishes number of works by
 Antonio Monregalese including paintings in Bastia. Frescoes of
 Damned in Rezzo, 1515.

LI24 CASTELNUOVO, ENRICO. "Le Alpi, crocevia e punto d'incontro
 delle tendenze artistiche nel XV secolo." Richerche di
 storia dell'arte 9 (1978-79):5-12.
 Questions whether an Alpine culture and art exists.
 Finds one in fifteenth century manifest in coincidence of secu-
 lar and religious subjects throughout region. Sees Jacquerio
 as example of Alpine artists. Decline after fifteenth century.

CITIES

GENOA

General

LIC1 SOPRANI, RAFFAELE. Le vite de' pittori, scultori ed
 architetti genovesi e de' forestieri che in Genova operarono,
 con ritratti e col supplemento di Carlo Giuseppe Ratti. 2
 vols. Genova: Casamara, 1768, 483 and 395 pp.
 First edition published in Genoa in 1674. Includes
 chronologically arranged biographies with attributions.

LIC2 BALDINUCCI, FILIPPO. Notizie dei professori del disegno da
 Cimabue in qua. Vol. 2. Edited by F. Ranalli. Florence:
 U. Batelli & Co., 1846, pp. 122-23. Reprint. Florence:
 Eurografica, 1974.
 Artists in the city of Genoa. Mentions Antonio Semino,
 pupil of Ludovico Brea. Born in Bologna 1483.

LIC3 BELGRANO, LUIGI TOMMASO. "Di una tavola del secolo XV
 rappresentante la B. Vergine Annunziata." Atti della
 Società ligure di storia patria 4 (1866):275-84.
 Publishes Annunciation in Sta. Maria di Castello, Genoa,
 1442. Offers student of Nicolò da Voltri or Antonio Vivarini
 as possible artists. See Giovanni Mazone.

LIC4 STAGLIENO, MARCELLO. Appunti e documenti sopra diversi
 artisti poco o nulla conosciuti che operarono in Genova nel
 secolo XV. Genoa: R.I. de' Sordomuti, 1870, 65 pp.
 Publishes tax account documents for Domenico de Verno,
 Giovanni di Parigi, Donato and Buonforte di Pavia (Donato de'
 Bardi).

LIC5 GROSSO, ORLANDO. Genova nell'arte e nella storia. Milan:
 Alfieri & Lacroix, 1914, 180 pp. and numerous b&w illus.
 Historical overview of fifteenth-century art, pp. 65-75.

LIC6 CAPPELLINI, ANTONIO. Genova; Tesori d'arte patria. Note
 biografiche di pittori, scultori e architetti genovesi dal
 400 al 1900. Genoa: n.p., 1931, 120 pp.
 Collection of brief biographies and attributions.
 Entries for Nicolò da Voltri and Antonio Semino.

LIC7 MORASSI, ANTONIO. Capolavori della pittura a Genova. Milan
 and Florence: Electa, 1951, 105 pp., 105 b&w illus.
 Selection of works in Genoa based on exhibition Mostra
 della pittura antica in Ligura (1946) (LI14). Brief biogra-
 phies of the artists and attributions of the works discussed.

Cities

LIC8 FLORIANI, ANNA de. "Le miniature dei corali di Santa Maria
 di Castello a Genova." La Berio 15, no. 1 (1975):30-43, 11
 b&w illus.
 Includes one anonymous Ligurian Antiphonal of 1462.

LIC9 Del BRENNA, GIOVANNA ROSSA. "Arte della pittura nella città
 di Genova." La Berio 16, no. 1-3 (1976):5-28, 5-23, 5-29;
 17, no. 1-3 (1977):5-15, 5-25; 18, no. 1 (1978):5-27.
 Publishes Libro primo dell'arte della pittura nella città
 di Genova, statutes of the painter's guild in Genoa. Includes
 the rollbook of the guild. Original in Biblioteca Berio,
 Genoa, M.R. I, 2, 38, 168 fols.

LIC10 LONGHI, ROBERTO. "Progetti di lavoro di Roberti Longhi:
 'Genova pittrice.'" Paragone 349 (1979):3-25, 4 b&w illus.
 Edited notes of Roberto Longhi for a survey of painting
 in Genoa. Mentions Bonifacio Bembo, Carlo Braccesco, Donato
 de' Bardi, and Giovanni Mazone d'Alessandria. Notes on 1946
 Liguria exhibition.

 Guidebooks

LIC11 RATTI, CARLO GIUSEPPE. Istruzione di quanto può vedersi di
 più bello in Genova in pittura, scultura ed architettura.
 Genoa: Paolo & Adamo Scionico, 1766, xxviii + 402 pp.
 Guidebook. Indexed by monument. Massacre of Innocents
 in S. Agostino and Oginissanti in Sta. Maria di Castello by
 Ludovico Brea.

LIC12 ALZIERI, FEDERICO. Guida artistica per la città di Genova.
 3 vols. in 2. Genoa: Ferrando, 1846-47, 623 and 1358 pp.
 Index by church, but no artist index. Works by Brea,
 Bardi, and Mazone in the churches listed in vol. 2.

 SAVONA

LIC13 BELLORO, GIOVANNI TOMMASO. "Pittori che operavano in Savona
 tra 1340 e il 1540." Giornale ligustico di scienze, lettere
 ed arti 1 (1827):436-37.
 Brief checklist of artists in Savona, names only.

LIC14 TORTEROLI, TOMMASO. Monumenti di pittura, scultura e
 architettura della città di Savona. Savona: Giacomo
 Prudente Librajo, 1847, 380 pp.
 Depends heavily on Ratti (LI1). Identifies works by
 Ludovico Brea, Alberto da Lodi, Jacopo Marone de Alessandria
 (altarpiece in S. Giacomo) [error in reading; should be
 Mazone], Giovanni Mazone (Chapel of Sixtus IV), and Giovanni
 and Donato da Montorfano.

LIC15 CASTELNOVI, GIAN VITTORIA. "Restauri di opere d'arte nella
 Diocesi di Savona." Rivista ingauna e intemelia 7 (1952):
 14-19.

Madonna and Child with Saints and Donors by Tuccio
d'Andria, Duomo, Savona, 1487. Cited in Ratti (LI1).

ARTISTS

BREA, LUDOVICO

LIA1 ROSSI, GIROLAMO. "Il maestro del pittore Ludovico Brea."
Giornale ligustico di archeologia, storia e belle arti 21
(1896):326-28.
On the basis of an inscription on a panel of the Madonna
of the Miserecordia in Nice from 1488 names Giovanni Miralheti
(ac. 1426-88) as Ludovico's master. Also genealogy of Brea.

LIA2 BRES, GIUSEPPE. Notizie intorno ai pittori nicesi:
Giovanni Mirallieti, Ludovico Brea e Bartolomeo Bensa in
relazione all'opera di Federigo Alizeri. Genoa: Luigi
Sambolino & Figlio, 1903, 28 pp.
Corrects notes of Alzieri (LI4). Miralheti dead by 1488.
Possibly master of Brea. Documents concerning Miralheti.
Paintings by Ludovico in sacristy of the Miserecordia, Genova.

LIA3 BRES, GIUSEPPE. Brevi notizie inedite di alcuni pittori
nicesi. Nizza: G. Malvano, 1906, 31 pp.
Includes genealogical information and a few documents on
works of art by Ludovico Brea.

LIA4 "Brea, Ludovico." In Thieme-Becker. Vol. 4. Leipzig:
Seeman, 1910, pp. 557-58.

LIA5 BORENIUS, TANCRED. "An Annunciation by Ludovico Brea."
Burlington Magazine 40 (1922):292-97, 1 b&w illus.
Publishes Annunciation in the collection of Mr. Henry
Harris. Suggests contact between Foppa and Brea. Attributes
on basis of comparison with Lieuche polyptych.

LIA6 LABANDE, LEON HONORÉ. "Louis Brea." Gazette des beaux-
arts, 6th ser. 18 (1937):73-92, 9 b&w illus., 143-60, 9 b&w
illus.
Building on the information from exposition in 1912.
Includes minimal biographical and contractual information.
Traces travels from Taggio to Savona to Genoa. Influence of
Foppa. Attributions.

LIA7 LABANDE, LEON HONORÉ. Le Bres, peintres niçois des XVme et
XVIme siècles en Provence et en Ligurie. Nice: Editions
des amis du Musée Massena, 1937, 226 pp., 49 b&w illus.
Biographies and documents concerning the Brea family.
Works and attributions.

Artists

LIA8 CASTELNOVI, GIAN VITTORIO. "Un opera di Ludovico Brea
 recuperata: La S. Devota di Dolceacqua." Rivista ingauna e
 intemelia 4 (1949):8-11, 5 b&w illus.
 Connects polyptych in Dolceacqua with one ordered by
 Francesca Grimaldi, widow of Marquis of Dolceaqua in 1515.

LIA9 NALDINI, ANNA. "Contributo allo studio di Ludovico Brea."
 Arte antica e moderna 31-32 (1965):302-10, 12 b&w illus.
 Detects Lombard elements in his work. Attributes Presen-
 tation in Temple, Museé, Moulins, 1495-1500; Crucifixion,
 location unknown; and Martyrdom of St. Erasmo, parish church,
 Briga Marittima, 1510-15, to Brea.

LIA10 FLORIANI, ANNA DE. "Un dipinto genovese inedito di Ludovico
 Brea." Studi genuensi 9 (1972):94-100, 8 b&w illus.
 Virgin and Child with St. Anne in collection of B. Meli
 Lupi, Soragna, connects with documented work of 1513.

LIA11 BAUDI di VESME, ALESSANDRO. Schede Vesme: L'arte in
 Piemonte. Vol. 4. Turin: Società piemontese di
 archeologia e belle arti, 1982, pp. 1192-1212.
 Includes biography, checklist of works, documents and
 extracts of articles. Very important for information from pre-
 1925 works.

 FASOLO, LORENZO

LIA12 "Fasolo, Lorenzo." In Thieme-Becker. Vol. 11. Leipzig:
 Seeman, 1915, p. 285.

LIA13 BONZI, MARIO. "Il San Siro di Viganego." Il raccoglitore
 Ligure 2, no. 11 (1933):4, 1 b&w illus.
 Panel of San Siro by Lorenzo Fasolo with document, 1503.

LIA14 BONZI, MARIO. "Un dipinto della Pinacoteca di Savona." Il
 raccoglitore Ligure 4, no. 1-2 (1935):5, 1 b&w illus.
 Nativity by Lorenzo Fasolo in Pinacoteca civica, Savona,
 with chronology of his works from Alzieri (LI4).

LIA15 VARALDO, CARLO. "Nuovi documenti sull' attività ligure di
 Lorenzo Fasolo." Arte lombarda 49 (1978):80-82.
 Contract for a Maestà for Arte dei Berrettai of S.
 Agostino in Savona, 1508. Frescoes in church of N. Signora
 della Consolazione, Savona, and document concerning son,
 Bernardino.

 FIESCHI, SUOR TOMMASINA

LIA16 "Fiesco, Tommasina del." In Thieme-Becker. Vol. 11.
 Leipzig: Seeman, 1915, p. 547.

LIA17 UMILE da GENOVA, P. "Di Suor Tommasina Fieschi: Scrittice
 e pittrice." Il raccoglitore ligure 2, no. 12 (1933):9-10.
 Documents life of Dominican nun (1448-1533), pupil of
 Giovanni Mazone d'Alessandria.

SEMINO, ANTONIO

LIA18 BOSSI, MARIA GRAZIA. "Note su Antonio Semino." Commentari
 15 (1964):62-76, 14 b&w illus.
 Genovese artist active between 1485 and 1490. Works with
 Lorenzo Fasolo and his son, Andrea Semino.

Lombardy

L01 LOMAZZO, GIOVAN PAOLO. Tratto dell'arte della pittura.
 Milan: 1584. Reprint. Scritti sulle arti. Edited by
 Roberto Paolo Ciardi. Vol. 2. Florence; Centro Di, 1974,
 727 pp.
 Cites work of Bramantino, Zenale, Butinone, and Foppa.
 Includes index.

L02 LOMAZZO, GIOVAN PAOLO. Idea del tempio della pittura, nella
 quale egli discorre dell'origine e fondamento delle cose
 contenute nel suo trattato dell'arte della Pittura. Milan:
 1590. Reprint. Hildesheim: Georg Olms Verlagsbuchhandlung,
 1965, 168 pp.
 Praise of Foppa in perspective and human proportion,
 notes works in Milan. Zenale and Butinone as practitioners of
 perspective. Bramantino expert in human proportion. Also
 mentions Civerchio.

L03 MALVEZZI, LUIGI. Le glorie dell'arte lombarda, ossia
 illustrazione storica delle più belle opere dal 590 al 1850.
 Milan: Agnelli, 1882, xi + 302 pp.
 Chronological survey of Lombard art. Major break seen
 with coming of Leonardo. Discussion of the Monza frescoes by
 the Zavattari, Foppa, Leonardo and Michelino Besozzo, Bergognone,
 Butinone, Zenale, as well as others. Lombards working in
 Piedmont.

L04 FFOULKES, COSTANZA JOCELYN. "Le esposizione d'arte italiana
 a Londra." Archivio storico dell'arte 7 (1894):249-68.
 Special attention to Lombard artists including: Foppa,
 Bergognone, Ambrogio de Predis, and Bernardino dei Conti da
 Pavia.

L05 MALAGUZZI VALERI, FRANCESCO. "Nuovi documenti su pittori
 del XV secolo tratti dalle carte del periodo sforzesco."
 L'arte 3 (1900):144-46.

General

From Sforza archives letters concerning Bonifacio Bembo, Cristoforo da Cremona (Moretti?), Vincenzo Foppa, Leonardo Ponzoni da Cremona, and Zanetto Bugatto.

L06 MALAGUZZI VALERI, FRANCESCO. Pittori lombardi del quattrocento. Milan: L.F. Cogliati, 1902, 253 pp., 30 b&w illus.
 Critical history of fifteenth- and sixteenth-century Lombard painting. Issue of sources and influences. Some original documents. Includes index of artists discussed in the text. Special section on portraiture at the Milanese court.

L07 SUIDA, WILHELM. "Neue Studien zur Geschichte der lombardischen Malerei des XV. Jahrhunderts." Repertorium für Kunstwissenschaft 25 (1902):331-47, 1 b&w illus.
 Highly critical review of Malaguzzi-Valeri. In particular, sketches different relationship between Butinone and Zenale.

L08 MALAGUZZI VALERI, FRANCESCO. "Maestri minori lombardi." Rassegna d'arte 5 (1905):88-92, 10 b&w illus.
 Followers of Bergognone. Artists who follow the pre-Leonardesque trend in Lombardy characterized by the "angelic Christian sentimentality" of Bergognone. Include Ambrogio Bevilacqua and Agostino de Montebello. Illustrates frescoes in S. Michele, Pavia, 1491. See L012 for continuation.

L09 SANT'AMBROGIO, DIEGO. "Una pala d'altare lombarda della fine del XV secolo." Rassegna d'arte 7 (1907):96, 1 b&w illus.
 Madonna and Child with Saints and Donors triptych from Assiano. Bears inscription "Marci Longobardi et Joannis Auroni Canturensis Opus" probably identifying artists.

L010 SUIDA, WILHELM. "Über die behandlung der Lombardischen Kunst in B. Berensons North Italian Painters of the Renaissance." Monatshefte für Kunstwissenschaft 1 (1908):439-42.
 Highly critical of Berenson's characterization. Disputes his characterization as "prettiness." Suggests greater importance for Donato de' Bardi than Berenson has given. Revises lists for Foppa, Zenale, Butinone, and Boltraffio.

L011 SUIDA, WILHELM. "Studien zur Lombardischen Malerei des XV. Jahrhunderts." Monatshefte für Kunstwissenschaft 2 (1909):47-95, 19 b&w illus.
 Review of Lombard fifteenth-century painting. Disagrees with ffoulkes and Maiocchi's emphasis on Foppa as founder of Lombard style (LA175). Greater role for Donato de' Bardi. List of attributions with chronology for Foppa, Butinone, and Zenale. In conclusion disagrees that Foppa depends on Bellini, instead Donato. Sense of space may also be indigenous Lombard rather than Tuscan.

L012 MALAGUZZI VALERI, FRANCESCO. "Maestri minori lombardi del
 quattrocento." Rassegna d'arte 11 (1911):193-201, 19 b&w
 illus.
 Discusses the period before Leonardo with Foppa and
 Paduan influences as primary. Transitional figures including
 Zanetto Bugatto, Bonifacio and Benedetto Bembo, Giovanni Donato
 da Montorfano, and the Zenoni da Vaprio. See also L08.

L013 RICCI, CORRADO. Art in Northern Italy. London: William
 Heinemann, 1911, pp. 154-58 and 191, b&w illus.
 Section of general book on North Italian art including
 sections on Foppa, Butinone, Zenale, Bergognone, Boltraffio,
 Bevilacqua, and the Bembi. Bibliography.

L014 MALAGUZZI VALERI, FRANCESCO. "La pittura e la miniatura
 nella lombardia in una nuova pubblicazione." Rassegna
 d'arte 12 (1912):28-32, 12 b&w illus.
 Review of Toesca (L015). Adds works to Toesca's commen-
 taries. Says that the Torrechiara frescoes are by Francesco
 Tacconi and not a Brescian or Benedetto Bembo.

L015 TOESCA, PIETRO. La pittura e la miniatura nella Lombardia:
 Dai più antichi monumenti alla metà del quattrocento.
 Milan: U. Hoepli, 1912, 595 pp., 516 b&w illus.
 Later edition: Turin: Einaudi, 1966, 278 pp., 524 b&w
 illus.
 Crucial early study of the nature and contribution of
 Lombard art from beginnings through the mid-fifteenth century.
 Attempts to isolate out that which is uniquely Lombard. Bib-
 liography. Some documentation.

L016 MALAGUZZI VALERI, FRANCESCO. La corte di Lodovico il Moro.
 Vol. 3, Gli artisti lombardi. Milan: U. Hoepli, 1917, xii
 + 368 pp., 15 b&w plates and 490 b&w text illus.
 Divided into sections on portraitists and miniaturists.
 Some documentary information and specific works. Illustrations
 throughout all four volumes.

L017 ANCONA, PAOLO D'. "Antichi pittori lombardi." Dedalo 4
 (1923-4):361-80, 15 b&w illus.
 Review of exhibition at Circolo d'arte e d'alta cultura,
 Milan. First major exhibition since 1908. Distinguishes
 Lombard art from Tuscan (the former more emotional). Illus-
 trates works by Zavattari, Foppa, Butinone, Bergognone,
 Boltraffio, Bramantino, and Ambrogio de Predis.

L018 SALMI, MARIO. "Una mostra d'antica pittura lombarda."
 L'arte 26 (1923):149-60, 10 b&w illus.
 Review of exhibition of April 1923, in Milan.

General

LO19 WEIGELT, CURT H. "Lombardische Miniaturen im
 Kupferstichkabinett." Jahrbuch der Königlich preussichen
 Kunstsammlungen 44 (1923):23-52, 8 b&w illus.
 Traces development of Lombard miniaturists from four-
 teenth and fifteenth centuries. Mentions work by Belbello and
 the Master of the Vitae Imperatorum.

LO20 ZOEGE von MANTEUFFEL, KURT. Review of Francesco Malaguzzi
 Valeri, La Corte di Lodovico il Moro. Vol. 3, Gli artisti
 lombardi. Repertorium für Kunstwissenschaft 44 (1924):
 138-41.
 Critical review.

LO21 WITTGENS, FERNANDO. "Un ciclo di affreschi di caccia
 lombardi del quattrocento." Dedalo 13 (1933):65-83, 17 b&w
 illus.
 Discussion of the hunting cycle in the Casino Borromeo,
 Oreno. Considers the possibility of Moretti as the artist, but
 rejects in favor of circle of the Zavattari.

LO22 SCHENDEL, ARTHUR van. Le dessin en Lombardie jusqu'à la fin
 du XVe siècle. Brussels: Editions de la connaissance,
 1938, 154 pp., 91 b&w illus.
 Selected Lombard drawings by the Master of the Vitae
 Imperatorum, Foppa, Bergognone, Butinone, and Bramantino. Sec-
 tion of architectural drawings. Chapter on late Gothic empha-
 sizes work of Michelino da Besozzo.

LO23 TOESCA, ELENA BERTI. "Un romanzo illustrato del '400."
 L'arte 42 (1939):135-43, 9 b&w illus.
 Attributes illustrations in Italian Lancelot and Arthur-
 ian romances in Florence, Biblioteca nazionale, Pal. 556, to
 anonymous Lombard, mid-fifteenth century. Relates to circle of
 Zavattari. See also Bembo.

LO24 GRASSI, LUIGI. "Un quesito di pittura lombarda preleonardesca
 e il ritrovamento di una Pietà." L'arte 43 (1940):103-13, 6
 b&w illus.
 Discussion of place in Lombard art of anonymous Pietà in
 the Cernuschi Collection of Paris. References to Vincenzo
 Foppa, Bergognone, Bernardo Butinone, and Vincenzo Civerchio.

LO25 RAGGHIANTI, CARLO LUDOVICO. "Studi sulla pittura lombarda
 del '400." Critica d'arte 8 (1949):31-46, 288-300, figs.
 24-51, 210-25, b&w illus.
 Fresco cycle in Roccabianca, not French but Lombard.
 Links to glass painting in Cathedral of Milan, circle of
 Cristoforo Moretti, Nicolò da Varallo, and the so-called
 Maestro Gracile.

LO26 TOESCA, ILARIA. "Anonimi lombardi c. 1450: Un trittico a
 Vienna e un vetro dorato a Piacenza." Paragone 3 (1950):52-
 53, figs. 18-19.

Places triptych in the Diocesan Museum in Vienna, in circle of Cristoforo Moretti. Also Veronese influence.

L027 BARONI, CONSTANTINO, and SERGIO SAMEK-LUDOVICI. La pittura
 lombarda del quattrocento. Messina and Florence:
 G. D'Anna, 1952, 282 pp., 103 b&w illus.
 Chap. 2 a historiographic survey of the literature on
 Lombard art. Subsequent chapters deal with stylistic questions
 in regard to Giovannino de'Grassi, Michelino and Leonardo da
 Besozzo, the Zavattari, Belbello da Pavia, Cristoforo Moretti,
 the Bembi, Vincenzo Foppa, Bergognone, Butinone, and Zenale.

L028 BARONI, CONSTANTINO, and GIAN ALBERTO dell'ACQUA. Tesori
 d'arte in Lombardia. Milan: Treccani degli Alfieri, 1952,
 61 pp., 152 b&w and 24 color illus.
 Revision of catalog of show of Lombard art from 500 B.C.
 to 1800 held in Zurich in 1948-49. All works of art in Milan.
 Catalog entries include factual description, brief history of
 attributions, and short bibliography.

L029 BOLOGNA, FERDINANDO. "Un 'San Girolamo' lombardo del
 quattrocento." Paragone 49 (1954):45-50, 1 b&w illus.
 St. Jerome, Accademia Cararra, Bergamo, dates ca. 1460.
 Connects with Roger van der Weyden St. Jerome from Sforza
 triptych in Brussels, polyptych assigned to Carlo Braccesco by
 Longhi (LA107). Bologna relates to Zanetto Bugatto. Issue of links
 between Lombard and Northern art.

L030 D'OTRANGE, M.L. "Thirteen Tarot Cards from the Visconti-
 Sforza Set." Connoisseur 133 (1954):54-60, 11 b&w and 2
 color illus.
 Provenance and illustration of tarot cards, majority in
 New York private collection. Some by Antonio Cicognara. Ex-
 planation of tarot.

L031 PELLEGRIN, ELIZABETH. La Bibliothèque des Visconti et des
 Sforza ducs de Milan au XVe siècle. Paris: Centre national
 de la recherche scientifique, 1955, 494 pp.
 History of the library at Pavia and dispersion of the
 collection. Includes several fifteenth-century inventories.
 Traces manuscripts listed in inventories where possible. Also
 Visconti and Sforza manuscripts outside inventories. Descrip-
 tions of the manuscripts. Index of copists and illuminators.

L032 SALMI, MARIO. "La pittura e la miniatura gotiche." In
 Storia di Milano. Vol. 6, Il ducato visconteo: 1392-1450.
 Milan: Treccani, 1955, pp. 798-855, numerous b&w and color
 illus.
 Sections on the de Veris, Michelino, and Leonardo de
 Besozzo, the Sala di Giochi frescoes, Cristoforo Moretti,
 Bonifacio and Benedetto Bembo, Belbello, Giovanni d'Ugolino,
 Donato de Bardi, Paolo da Brescia, and the Master of the Vitae
 Imperatorum.

General

LO33 VILLA, GEMMA. "Gli affreschi di S. Maria Annunciata a
 Brunello di Varese." Arte lombarda 2 (1956):168-75, 10 b&w
 illus.
 Gives Last Judgment, Sta. Maria Annunciata to the circle
 of Vincenzo Foppa, late fifteenth century.

LO34 WITTGENS, FERNANDA. "La pittura lombarda nella seconda metà
 del quattrocento." In Storia di Milano. Vol. 7, L'eta
 sforzesca: 1450-1500. Milan: Treccani, 1955, pp. 747-836,
 numerous b&w and color illus.
 Section on painting includes Foppa, Braccesco, Butinone,
 Zenale, and Bergognone. Miniaturists include Giovanni Pietro
 Birago, Cristoforo de Predis, and Girolamo da Cremona. Stained
 glass includes Cristoforo de' Mottis, Nicolò da Varallo, and
 Foppa.

LO35 BOLOGNA, FERDINANDO. "Una Madonna lombarda del quattrocento."
 Paragone 93 (1957):3-11, 9 b&w illus.
 Discussion of Madonna and Child, Cagnola Collection,
 Gazzada, connects with SS. John the Baptist, Ambrose, Jerome,
 Christopher, and Lawrence in Buenos Aires. Dates ca. 1460-70.
 Lombard ties with northern European painting (e.g., Zanetto to
 Brussels and France). St. Jerome, Accademia Carrara, Bergamo,
 and frescoes in Genoa, Sta. Maria di Castello evidence of ties.

LO36 GENGARO, MARIA LUISA. "Breve percorso tra gli anonimi
 lombardi del quattrocento." Arte lombarda 3 (1957):71-83,
 20 b&w illus.
 Considers number of problems in fifteenth-century Lombard
 art. Connection of early Lombard art with Northern Inter-
 national style, particularly in regard to Michelino da Besozzo
 and Bonifacio Bembo. Also Bembo shop as conduit of Venetian
 and Tuscan influences. Traces shop in various anonymous
 Milanese frescoes from third-quarter fifteenth century.

LO37 MAZZINI, FRANCO. "Pittori del tre e quattrocento alla mostra
 'Arte lombarda dai Visconti agli Sforza.'" Arte lombarda 3,
 no. 1 (1957):83-89, 7 b&w illus.
 Summary review of exhibition in Milan (LO43). Illus-
 trates work of Butinone, Michelino da Besozzo, Foppa,
 Braccesco, and Bergognone. Attributes Pala Bottigella to
 Foppa.

LO38 TEA, EVA. "I due volti del quattrocento pittorico lombardo."
 Arte lombarda 3 (1957):45-50, 4 b&w illus.
 Identifies two strains, medieval and humanistic, in the
 fifteenth-century style of Lombardy, with special attention to
 the art of Bergognone.

LO39 ZERI, FEDERICO. "Un'agguinto al problema della 'Madonna'
 Cagnola." Paragone 93 (1957):11-16, 1 b&w illus.
 Connects SS. George and Gregory the Great in Toledo,
 Ohio, with the Master of the Cagnola Madonna.

LO40 BRIZIO, ANNA MARIA. "La mostra d'arte lombarda, 'Dai
 Visconti agli Sforza.'" Bollettino d'arte, 4th ser. 43
 (1958):356-60, 4 b&w illus.
 Review of the exhibition (LO43). Questions some attribu-
 tions (e.g., paintings to Bramante-Bramantino).

LO41 LONGHI, ROBERTO. "Aspetti del'antica arte lombarda."
 Paragone 101 (1958):3-25, b&w illus.
 On basis of "Mostra d'arte lombarda dai Visconti agli
 Sforza (LO43)," reevaluates origins and achievements of Lombard
 artists, particularly influence of Michelino de Besozzo into
 1460s in art of Zavattari and Leonardo de Besozzo. Later
 continuation of Lombard tendencies towards ornament and
 narration.

LO42 MATALON, STELLA, and FRANCO MAZZINI. Affreschi del trecento
 e quattrocento in Lombardia. Introduction by Gian Alberto
 dell'Acqua. Milan: Edizione del milione, 1958, 81 pp., 133
 b&w illus.
 Includes an index and bibliography. Fresco cycles in
 major cities like Milan, Pavia, and Lodi, and more obscure
 locales: Angera, Crevenna, and Albizzate. Casa Borromeo hunt-
 ing cycle in Oreno to an anonymous Lombard circle of Giovanni
 Zenone da Vaprio.

LO43 MILAN. PALAZZO REALE. Arte lombarda dai Visconti agli
 Sforza. April-June, 1958. Introduction by Roberto Longhi.
 Milan: Silvana, 1958, 183 + xli pp., 208 b&w and 9 color
 illus.
 Catalog of wide-ranging exhibition of fifteenth-century
 Lombard art. Illustrates all of the works in exhibition.
 Bibliography. Entries on all of the artists in exhibition.
 Attributions.

LO44 PODESTÀ, ATTILIO. "Arte lombarda dai Visconti ai Sforza."
 Emporium 127 (1958):243-53.
 Review of the exhibition (LO43).

LO45 RUSSOLI, FRANCO. "Des Visconti aux Sforza." L'oeil 39
 (March 1958):18-25, 6 b&w and 2 color illus.
 Review of the 1958 exhibition (LO43). Emphasizes Lombard
 opposition to Tuscan rationality in favor of emotion and appeal
 to the senses. Illustrates works by Bonifacio Bembo, Butinone,
 Zenale, Foppa, and Bergognone.

LO46 TERNI de GREGORY, WINIFRED. Pittura artigiana lombarda del
 rinascimento. Milan: Cassa di risparmio delle provincie
 lombarde, [1958], 191 pp., 12 color and 43 b&w illus.
 Publishes a number of provincial Lombard paintings, par-
 ticularly ceiling decorations.

General

LO47 ZERI, FEDERICO. "Due esercitazioni lombarde." Paragone 103
 (1958):66-71, 3 b&w illus.
 Two panels in the Kress Collection, Houston, Texas.
 Suida connected with name of Fermo da Caravaggio; dates panels
 1475-85. Reconstructs Lombard polyptych with St. George,
 Cremona, ca. 1480.

LO48 ACQUA, GIAN ALBERTO dell'. Arte lombarda dei Visconti agli
 Sforza. Milan: Silvana, 1959, 96 pp., 164 b&w and 48 color
 illus.
 Briefer version of the catalog for the 1958 exhibition
 (LO43). Question of the nature of Lombard style. Attributions
 to Bramantino, Foppa, Donato de' Bardi, and others.

LO49 MAZZINI, FRANCO. "Contributi alla pittura lombarda tardo-
 gotica." In Studies in the History of Art Dedicated to
 William E. Suida on His Eightieth Birthday. London:
 Phaidon, 1959, pp. 86-89, 7 b&w illus.
 Attribution of frescoes in parish church, Silvano Pietro
 (Pavia), to Michelino de Besozzo and Cristoforo Moretti. Mid-
 fifteenth century.

LO50 OTTINO della CHIESA, ANGELA. Pittura lombarda del '400.
 Bergamo: Istituto italiano d'arti grafiche, 1959, 104 pp.,
 62 color illus.
 Begins with overview of Lombard art and contrast with
 Florentine. Individual sections on artists in conjunction with
 illustration. Suggests possible identification of the Master
 of the Giochi Borromeo as Giovanni Zenone da Vaprio.

LO51 SUIDA, WILLIAM [WILHELM]. "Epilogo alla 'Mostra d'arte
 lombarda dai Visconti agli Sforza." Arte lombarda 4
 (1959):82-90, 7 b&w illus.
 Questions a number of attributions in the exhibition
 (LO43) including ones to Dopnato de' Bardi, Benedetto Bembo,
 the Master of the Cicogna-Mazzini Panel, and Butinone.

LO52 MEISS, MILLARD. "An Early Lombard Altarpiece." Arte antica
 e moderna 19 (1961):125-33, 11 b&w illus.
 Altarpiece with Virgin and Child with Eight Saints to the
 Master of the De natura rerum, circle of Belbello and Michelino
 de Besozzo.

LO53 PRIJATELIJ, KRUNO. "Due pittori lombardi del quattrocento
 dalmata." Arte lombarda 7 (1962):148.
 Documents activity of Giovanni Pietro da Milano and
 Girolamo da Milano in Dalmatia.

LO54 PUPPI, LIONELLO. "Pitture lombarde del quattrocento." Arte
 lombarda 7 (1962):49-59, 17 b&w illus.
 Attributions to Bonifacio Bembo, Butinone, Bergognone,
 and Civerchio.

L055 MAZZINI, FRANCO. "Problemi pittorici bramanteschi."
 Bollettino d'arte, 4th ser. 49 (1964):327-42, 22 b&w illus.
 Facade decorations from Casa Angelini, Bergamo, late
fifteenth century, follower of Butinone and Zenale. Cappella
del Battista, S. Pitro in Gessate, Milano, to Giovanni Donato
da Montorfano and Bramante.

L056 FENYO, IVAN. North Italian Drawings from the Collection of
 the Budapest Museum of Fine Arts. New York: Orchard House,
 1965, 176 + xxxi pp., 175 b&w illus.
 Plates 1-3 are Lombard, early fifteenth-century, Hunting
Adventure, and a page of Animal Figures.

L057 MATALON, STELLA. "Ricuperi e restauri lodigiani."
 Bollettino d'arte, 5th ser. 51 (1966):183-86, 9 b&w illus.
 Frescoes in the Church of S. Francesco, Lodi, Madonna and
Child with Saints, 1430-80. History of restorations. Circle
of de Veris, Cristoforo Moretti, and the Zavattari.

L058 CASTELFRANCHI VEGAS, LIANA. Gli affreschi quattrocenteschi
 del Castello di Masagno. Milan: Bramante, 1967, 17 pp., 39
 b&w and color illus.
 Provincial frescoes in the Castello di Masagno related in
style to Borromeo frescoes from Oreno and in the Palazzo
Borromeo, Milan. Aristocratic games and virtues and vices.
Draws parallel with the style of Master of the Vitae
Imperatorum.

L059 SCIOLLA, GIANNI CARLO. "Contributi per la storia della
 pittura lombarda nella seconda metà del quattrocento." Arte
 lombarda 12, no. 1 (1967):49-54, 9 b&w illus.
 Three brief attributional studies. SS. Agnese and
Giovanni Battista in Cologne to Bergognone. Five glass panels
in Zurich to Pavese artist, end of the fifteenth century. Five
Apostles in Milan to Master of San Primo, ca. 1495.

L060 ZANINI, WALTER. "La diffusion de la peinture ferraraise en
 Lombardie dans la seconde moitié du XVe siècle." Gazette
 des beaux-arts, 6th ser. 69 (1967):307-18, 14 b&w illus.
 Sketches exchanges between Ferrara and Milan because of
ties between Este and Sforza. Flow of influence of Tura, Cossa
and Roberti north to Lombardy, seen in Zenale, Butinone, Nicolò
da Varallo, Birago, and Bramantino.

L061 LEVI d'ANCONA, MIRELLA. The Wildenstein Collection of Illu-
 minations: The Lombard School. Florence: Olschki, 1970,
 179 pp., 17 b&w and 28 color illus.
 Begins with overview of development of Lombard book illu-
mination through mid-sixteenth century. Entries for individual
works include biography, traditional attributions, characteris-
tics of style, list of works, and bibliography. Works by
Master of the Vitae Imperatorum, Belbello, Girolamo da Cremona,

General

Master of <u>Budapest</u> <u>Antiphonary</u>, Ambrogio da Cermenate, Bartolomeo
de' Rigossi da Gallarate, and school of Birago.

LO62 TOURING CLUB ITALIANO. <u>Guida</u> <u>d'</u> <u>Italia</u>: <u>Lombardia</u> <u>(eccetto</u>
<u>Milano</u> <u>e</u> <u>Laghi</u>). Milan: Touring Club italiano, 1970, 756 +
56 pp., 9 maps and 10 city plans.
 Comprehensive guide to the region. Index by artist and
location.

LO63 PIROVANO, CARLO. <u>La</u> <u>pittura</u> <u>in</u> <u>Lombardia</u>. Milan: Electa,
1973, 203 pp., 208 b&w and color illus.
 General survey of the development of Lombard painting
from medieval through modern. Fifteenth-century painting,
pp. 48-102.

LO64 RUGGIERI, UGO. <u>Maestri</u> <u>lombardi</u> <u>e</u> <u>lombardo-veneti</u> <u>del</u>
<u>rinascimento</u>. Biblioteca di disegni, vol. 1. Florence:
Istituto Alinari, 1976, 33 pp., 40 color plates.
 Includes drawings by Bernardino Zenale, a study for a
polyptych by Bramantino, and a study from the circle of
Boltraffio.

LO65 SNOW-SMITH, JOANNES INLOES. "Pasquier Le Moyne's Account of
the Works of Art in Piedmont and Lombardy (1515)." Ph.D.
Dissertation, University of California at Los Angeles, 1977,
498 pp., 56 b&w illus. and tables.
 Publishes Pasquier Le Moyné, <u>Le</u> <u>couronnement</u> <u>du</u> <u>roy</u>
<u>François</u> <u>premier</u> <u>de</u> <u>ce</u> <u>nom</u> (Paris: Gilles Couteau, 1520), with
translation of narrative section. Account of campaign of 1515
into Italy with mention of works of art along the way. Cursory
description of frescoes in the castello, the Certosa and S.
Giacomo in Pavia, stable decorations in Milan, and Giovanni
Donato da Montorfano's <u>Crucifixion</u> and Leonardo <u>Last</u> <u>Supper</u> in
Sta. Maria delle Grazie.

LO66 PIROVANO, CARLO. "Ambiente e paesaggio nella pittura
preleonardesca." In <u>Lombardia</u>; <u>Il</u> <u>territorio</u>, <u>l'ambiente</u>,
<u>il</u> <u>paesaggio</u>. Edited by Carlo Pirovano. Milan: Electa,
1981, pp. 163-234, 116 b&w and color illus.
 Essay dedicated to landscape backgrounds in Lombard paint-
ing primarily in the fourteenth and fifteenth centuries. Asserts
contrast with the Florentine. Lombard more particularistic,
less abstract. Influence of social structure and ties with
North interlaced with aesthetic issues.

LO67 CASTELFRANCHI VEGAS, LIANA. "'Retracto del naturale':
Considerazioni sulla ritrattistica lombarda degli anni fra
quattrocento e cinquecento." <u>Paragone</u> 34, nos. 401-3
(1938):64-69, 6 b&w illus.
 Mania for portraiture at end of century a combination of
courtly taste and Northern influence. Discusses evolution of
Lombard portraiture beginning with Zanetto. Illustrates two

portraits attributed to Foppa in Rijksmuseum, Amsterdam, and Poldi-Pezzoli. Also publishes two drawn male profiles in the Accademia Carrara, Bergamo, nos. 1955 and 1998. Concludes with Leonardo's influence on Ambrogio de Predis and Boltraffio.

CITIES

BERGAMO

General

LC1 TASSI, FRANCESCO MARIA. Vite de' pittori, scultori e architetti bergameschi. 2 vols. Milan: Labor, 1970, 252 and 241 pp.
 Vol. 2: Mazzini, Franco, ed. Saggio biobibliografico: Edizioni critiche dei manoscritti "Indice delle Chiese della Citta [di Bergamo] e Borghi" di F.M. Tassi, "Memorie di alcuni quadri esistenti nelle chiese del Territorio di Bergamo" di F.M. Tassi, "Catalogo dei libri del conte F.M. Tassi," 21 Lettere di F.M. Tassi a G. Carrara, "Pittori bergameschi" di G. Beltramelli, postille di G. Lochis e A. Piccinelli alle "Vite" di F.M. Tassi--Scelte critiche dai manoscritti "Memorie raccolta per servire alla storia dei pittori etc." di F.M. Tassi e suoi corrispondenti, "Guinte," "Notizie" e "Memorie" di G. Carrara-- Indice analitico generale.
 First edition of the Vite: Bergamo: 1793.
 Includes index. Artists are arranged chronologically. Very few minor fifteenth-century artists, Pasino di Villa, Giacomo de Balsamo, Giorgio, Guido, Defendente, and Bernardo da San Pellegrino. Also Zenale biography. Includes documents.

LC2 PESENTI, PIETRO. Bergamo. Italia artistica, 57. Bergamo: Istituto italiano d'artigrafiche, 1910, 138 pp., 138 b&w and 1 color illus.
 Historical survey that treats art works in chronological order. Work of Bergognone in Chiesa di Sto. Spirito.

Guidebooks

LC3 PASTA, ANDREA. Le pitture notabili di Bergamo che sono esposte alla vista del pubblico. Bergamo: Locatelli, 1775, 168 pp. Reprint. Bologna: Forni, 1976.
 Arranged by building. Index at end alphabetically by artist. No fifteenth-century artists in list.

LC4 MINISTERO DELL'EDUCAZIONE NAZIONALE. DIREZIONE GENERALE ANTICHITÀ E BELLE ARTI. Provincia di Bergamo. Inventario degli oggetti d'arte d'Italia, vol. 1. Rome: Libreria dello stato, 1931, 500 pp., numerous b&w illus.
 Survey of works of art arranged alphabetically by city. Index of artists at end. Attributions. Bibliography. Most works illustrated.

Cities

Collections and Museums

LC5 JACOBSEN, EMIL. "Die Galerie Lochis zu Bergamo." Repertorium
 für Kunstwissenschaft 19 (1896):249-68.
 Catalog of contents with attributions. Works by
 Butinone, Bernardino Zenale, Bernardino dei Conti, Boltraffio,
 Tura, Ambrogio Bergognone (Fossano), and Vincenzo Foppa.

LC6 MORASSI, ANTONIO. La Galleria Carrara a Bergamo. Rome:
 Libreria dello stato, 1934, 93 pp., 106 illus.
 Summary catalog of the collection.

LC7 ROSSI, FRANCESCO, and ROSANNA PACCANELLI. Accademia Carrara,
 Bergamo. Catalogo dei dipinti. Bergamo: Grafica Gutenberg
 editrice, 1979, 459 pp., illus.
 Catalog of collection arranged chronologically and by
 school. Illustrates all of the works catalogued. Bembo,
 Bergognone, Baldassare Estense, and others.

BRESCIA

General

LC8 FENAROLI, D. STEFANO. Dizionario degli artisti bresciani.
 Brescia: Pavoni, 1887, 317 pp. Reprint. Bologna: Forni,
 1971.
 Short biographies. Alphabetically arranged. Includes
 information on Alessandro Ardesio, Apollino da Calvisiano,
 Pietro da Cemmo, Vincenzo Foppa, and Giovanni da Marone (Mazone).

LC9 UGOLETTI, ANTONIO. Brescia. Italia artistica, 50.
 Bergamo: Istituto italiano d'artigrafiche, 1909, 152 pp.,
 160 b&w illus.
 Guide to the arts in Brescia. Painting, including manu-
 script illumination, pp. 79-90. Works by Foppa, Antonio
 Promis, Pietro da Cemmo, Civerchio, and others discussed.

LC10 PONTE, PIERO da. "Brevissimi cenni di alcuni de' più
 antichi pittori bresciani." In L'Italia e l'arte straniera:
 Atti del X Congresso internazionale di storia dell'arte in
 Roma--1912. Rome: 1922, pp. 512-21.
 Bibliographic references to works about Brescian art.
 Includes significant information about manuscript sources in
 the Biblioteca Queriniana. Brief section includes references
 to Foppa.

LC11 CARBONI, GIOVANNI BATTISTA. Notizie istoriche delli
 pittori, scultori ed architetti bresciani a cura di Camillo
 Boselli. Brescia: "Commentarii dell'Ateneo di Brescia,"
 1962, pp. xiii + 97.
 Publication of manuscript in the Biblioteca Archiginnasio,
 Bologna, B. 97, XIV. Mainly seventeenth century and later.

One brief notice concerning Vincenzo Foppa and reproduction of his tombstone.

LC12 BOSELLI, CAMILLO. "Spunti nel quattrocento pittorico bresciano." Arte lombarda 8, no. 2 (1963):104–11, 12 b&w illus.
General discussion of fifteenth-century painting in Brescia. Notices particularly about Giovanni da Marone (Mazone). Anonymous fresco fragments in Pinacoteca Tosio-Martinego.

LC13 PANAZZA, GAETANO. "La pittura nella prima metà del quattrocento." In Storia di Brescia. Vol. 2. Brescia: Morcelliana, 1963, pp. 891–928, numerous b&w and color illus.
Artists in the Broletto and Castello, 1408–21, including Gentile da Fabriano. Work of Giovanni Bembo (S. Francesco d'Assisi, Brescia), Andrea and Bonifacio major force. Also sees Venetian influences, Jacopo Bellini and Antonio Vivarini. Votive frescoes and Lombard influences. Master Paroto identified from archives. Section on Paolo (identifies as Paolo da Brescia) and Bartolommeo da Caylina.

LC14 PANAZZA, GAETANO. "La pittura nella seconda metà del quattrocento." In Storia di Brescia. Vol. 2. Brescia; Morcelliana, 1963, pp. 949–1006, numerous b&w and color illus.
Begins with Giovanni Pietro da Cemmo in Brescia and various provincial churches, influence of Mantegna and Foppa. Work of Vincenzo Civerchio; Antonio and Matteo Zamara, Gloria dei santi, Nembro, 1490; and Girolamo da Brescia in Florence.

Guidebooks

LC15 AVEROLDO, GIUL'ANTONIO. Le scelte pitture di Brescia additate al forestiere. Brescia: Gian-Maria Rizzardi, 1700, xvi + 292 + viii pp.
Itinerary guide. Cites works by Foppa on pp. 23, 44, 205, 223. Alphabetical artist index at the back.

LC16 CARBONI, GIOVANNI BATTISTA. Le pitture e sculture di Brescia che sono esposte al pubblico con un appendice di alcune private gallerie. Brescia: Bossini, 1760, 196 pp. Reprint. Bologna: Forni, 1977.
Arranged by church and collection with alphabetical artist index at the back. Notes works by Foppa and Bonifacio Bembo.

LC17 ZAMBONI, BALDASSARE. Memorie intorno alle pubbliche fabbriche più insigni della città di Brescia. Brescia: Pietro Vescovi, 1777–8, iv + 163 pp., 12 plans.
Includes documentation of frescoes by Vincenzo Foppa in the Palazzo della ragione, 1489–90, pp. 32–34.

Cities

LC18 MINISTERIO DELL'EDUCAZIONE NAZIONALE. DIREZIONE GENERALE
 ANTICHITÀ E BELLE ARTI. Brescia: Catalogo delle cose
 d'arte e d'antichità. Edited by Antonio Morassi. Rome:
 Libreria dello stato, 1939, 549 pp., 344 b&w illus.
 Description of works of art in Brescia and vicinity.
 State of conservation. History of the works. Illustrations.
 Bibliography. Artist index.

 Collections and Museums

LC19 PANAZZA, GAETANO. La Pinacoteca e i musei di Brescia.
 Bergamo: Istituto italiano d'arti grafiche, 1968, 239 pp.,
 numerous b&w illus.
 History of the Pinacoteca Tosio-Martinego, pp. 96-159.
 Selected illustrations of works including pieces by Birago,
 Jacopo Filippo Medici called l'Argenta, and Foppa.

 CREMONA

 General

LC20 LAMO, ALESSANDRO. Discorso di Alessandro Lamo intorno alla
 scoltura e pittura . . . fatte dall' eccellentissimo e nobile
 M. Bernardino Campo. Cremona: Pietro Ricchini, 1774,
 109 pp.
 Notes work of Antonio della Corna, and Bonifacio and
 Gianfrancesco Bembo.

LC21 ZAIST, GIOVANNI BATTISTA. Notizie istoriche de' pittori,
 scultori ed architetti cremonesei. 2 vols. in 1. Cremona:
 Pietro Ricchini, 1774, 262 and 176 pp.
 Includes information on Cristoforo Moretti, Onorata
 Rodiani, Antonio della Corna, Alessandro Pampurino, Antonio
 Cicognara, and Bonifacio and Gianfrancesco Bembo. Records
 inscriptions and locations of works.

LC22 SORESINA VIDONI, BARTOLOMMEO de. La pittura cremonese.
 Milan: Società tipografica de' classici italiani, 1824, 142
 pp. Reprint. Bologna: A. Forni, 1978.
 Begins with a brief history of Cremonesi painting from
 Lomazzo (L01-2), Vasari, Zaist (LC20) and other sources. Bio-
 graphical section with graphic illustration and discussion of
 Presentation in the Temple by Bonifacio Bembo. Entire work
 concludes with "Table of Cremonese Artists" with notices about
 Antonio da Ferrari da Pavia, Antonio della Corna, Antonio
 Cigonara, the Tacconi, Alessandro Pampurino, and others.

LC23 GRASSELLI, GIUSEPPE. Abecedario biografico dei pittori,
 scultori ed architetti cremonesi. Cremona: Co' Torchj
 d'Omobone Manini, 1827, 291 pp.
 Main source for alphabetically arranged biographies is
 Zaist (LC20). Publishes some documents. Index.

LC24　ODORICI, FEDERIGO.　"Dello spirito di associazione di alcune
　　　città Lombarde nel medio evo."　Archivio storico italiano,
　　　n.s. 11, no. 1 (1860):73-108.
　　　　　Includes the statutes of the painter's guild (University)
　　of Cremona from 1475.

LC25　SCHWEITZER, EUGENIO.　"La scuola pittorica cremonese."
　　　L'arte 3 (1900):41-71, 1 b&w illus.
　　　　　Brief review of "L'esposizione d'arte sacre" in Cremona,
　　including information on Boccaccio Boccaccino, Francesco and
　　Filippo Tacconi, Antonio Cicognara, and Gianfrancesco Bembo.

LC26　LONATI, GUIDO.　"Cremonesi a Brescia nel secolo XV."
　　　Bollettino storico cremonese 5 (1935):157-72.
　　　　　Documentary survey of Cremonese artists including Bembi
　　working in Brescia from 1415 to 1495.

LC27　DAINOTTI, V.　"I corali della Cattedrale di Cremona,"
　　　Accademie e biblioteche d'Italia 13 (1938):26-44, 6 b&w
　　　illus.
　　　　　Publishes twenty-five choral books, most from second-half
　　of fifteenth century, when change in breviary led to new books.
　　Information from colophons and endpages.　Two principal minia-
　　turists Giovanni di Gadio and Antonio Cicognara.　Also mentions
　　works by Cristoforo de Predis and influence of Girolamo da
　　Cremona.

LC28　GREGORI, MINA.　"Contributi all conscenza della miniatura
　　　cremonese nella mostra d'antiche pitture dal XIV al XIX
　　　secolo."　Annali della Biblioteca governativa e libreria
　　　civica di Cremona 1 (1948):57f, 5 b&w illus.
　　　　　General comments on the choirbooks, which are compared
　　with other works.　Special mention of Cicognara.

LC29　PUERARI, ALFREDO.　"I corali del Duomo di Cremona e la
　　　miniatura cremonese nel quattrocento.　Parte I.　Orientamenti
　　　della pittura e della miniatura a Cremona nell'ultimo
　　　trentennio del '400."　Annali della Biblioteca governativa e
　　　libreria civica di Cremona 8, no. 1 (1955):5-31, 31 b&w
　　　illus.
　　　　　Overview of artists working in last third of fifteenth
　　century in Cremona.　Ties with Ferrarese school.　Mentions
　　Benedetto Bembo, Francesco and Filippo Tacconi, Girolamo da
　　Cremona, Antonio della Corna, Cicognara, Cemmo, Mazzola, and
　　Platina.

LC30　ZANONI, FELICE.　"I corali del Duomo di Cremona e la
　　　miniatura cremonese nel quattrocento.　Parte II.　Catalogo
　　　descrittivo."　Annali della Biblioteca governativa e
　　　libreria civica di Cremona 8, no. 2 (1955):i-cviii, 15 b&w
　　　illus.

Cities

General catalog of the choral books. Includes index at
end by artist and subject. Very useful.

LC31 BOMBELLI, ANDREA. I pittori cremonesi dal 1400 ad oggi.
Milan: Ceschina, 1957, 300 pp., 129 b&w illus.
 Brief biographies and bibliographies on Giovanni,
Bartolomeo and Silvestro Bombelli, don Nebridio Marchi, and
Vincenzo Civerchio.

Guidebooks

LC32 CAMPO, ANTONIO. Cremona fedelissima città et nobilissima
colonia de romani rappresentata in disegno col suo contado
et illustrata d'una breve historia delle cose più notabili
appartenenti ad essa. Cremona: n.p., 1585, unpaged.
 On p. liii, a list of the famous artists who had worked
in Cremona, including Cristoforo Moretti, Bonifacio and Gian
Francesco Bembo, and Jacopo Pampurino.

LC33 AGLIO, GIUSEPPE. Le pitture e le sculture della città di
Crema. Cremona: G. Feraboli, 1794, 198 pp.
 Arranged by church. Includes attributions, descriptions
of works visible, and inscriptions. Difficult to use because
there is no index.

Collections and Museums

LC34 PUERARI, ALFREDO. La Pinacoteca di Cremona. Florence:
Sansoni, 1951, 295 pp., 309 b&w and 4 color illus.
 Guide by rooms. With first mention of artist includes a
biography and, for individual works, attributions and compari-
sons. Works by Bonifacio and Benedetto Bembo, Agnolo degli
Erri, Luca and Antonio della Corna, Francesco Bianchi Ferrari,
and others.

LC35 CREMONA. MUSEO CIVICO 'ALA PONZONE.' Catalogo raccolta
artistiche. Edited by Alfredo Puerari. Cremona: Libreria
del convegno, 1976, 13 color and 106 b&w illus.
 Catalog of the collection exclusive of paintings. In-
cludes miniatures by Baldassare Colderadi, Birago, Cicognara,
Pampurino, Lorenzo Fodri, and don Nebridio Marchi.

MANTUA

LC36 CADIOLI, GIOVANNI. Descrizione delle pitture sculture ed
architecture che si osservano nella città Mantova e ne` suoi
contorni. Mantua: Per l'erede di A. Pazzoni, 1763, 136 pp.
Reprint. Bologna: A. Forni, 1974.
 Guide to Mantua, organized for a walking tour. Gives
some attributions for paintings, e.g., chapel in S. Agnese with
altarpiece by Lorenzo Costa (p. 40), the paintings of Mantegna

in San Andrea (pp. 53–55) and Sta. Maria della Vittoria (p.
56), and Francia in Sant'Orsola (pp. 73–74). No artist index.

LC37 CODDÈ, PASQUALE, and L[UIGI] CODDÈ. Memorie biografiche
 poste in forma di dizionario dei pittori, scultori, ed
 architetti ed incisori mantovani per la più parte finora
 sconosciuti. Mantua: Negretti, 1837, xxiii + 175 pp.
 Reprint. Bologna: A. Forni, 1967.
 Brief alphabetical biographies of Mantuan artists.
 Fifteenth-century entries include Antonio del Bolognino,
 Giovanni de' Russi, and Giovan Francesco Maineri.

LC38 ARCO, CARLO D'. Delle arti e degli artefici di Mantova:
 Notizie raccolte ed illustrate con disegni e con documenti.
 2 vols. Mantua: Agazzi, 1857–59, 126 pp., 59 b&w illus.,
 and 308 pp., 2 leaves of signature facsimiles. Reprint.
 Bologna: A. Forni, 1975.
 Vol. 1 includes some information on Michele da Pavia
 working in Mantua painting image of three consols. Also no-
 tices of Crivelli and de' Russi. Work and influence of Costa.
 In vol. 2 letters and documents in chronological order. Only
 minor artists like Antonio Bolognino. Considerable documenta-
 tion on Mantegna.

LC39 LUZIO, ALESSANDRO. La gallerie dei Gonzaga venduta
 all'Inghilterra nel 1627–28. Rome: Bardi, 1974, vi +
 342 pp.
 First edition: Milan: 1913.
 Includes documents concerning work of Lorenzo Costa and
 Francia for Isabella d'Este in studiolo and for portraits.

LC40 MINISTERO DELL'EDUCAZIONE NAZIONALE. DIREZIONE GENERALE
 ANTICHITÀ E BELLE ARTI. Provincia di Mantova. Inventario
 degli oggetti d'arte d' Italia, vol. 6. Rome: Libreria
 dello stato, 1931, 197 pp., numerous b&w illus.
 Inventory of works of art (painting, sculpture, minor
 arts) throughout area of Mantua. Arranged alphabetically by
 city. Artist index. Includes attributions for the works and
 bibliography.

LC41 PERINA, CHIARA. "Dall'inizio del secolo XV alla metà del
 XVI." In Mantova: Le arti. Vol. 2, pt. 1. Mantua:
 Istituto Carlo d'Arco per la storia di Mantova, 1961, pp.
 237–500.
 Sees lack of unity in Mantuan art before 1400. Heraldic
 taste dominant. Chap. 1: Late Gothic. Supplanting of Belbello
 da Pavia by Girolamo da Cremona and Michele da Pavia. Chap. 2:
 Mantegna. Chap. 3: Second half of fifteenth century. Fres-
 coes in Sta. Maria dei Voti and S. Francesco. Influence of
 Mantegna on Francesco Mantegna. Lombards working in Mantua.
 Miniaturists including Giraldi and Girolamo. Chap. 4: Patron-
 age of Isabella d'Este. Works by Costa, Roberti, Baldassare
 Estense, and Giovan Francesco Maineri.

Cities

MILAN

General

LC42 VITALE, SALVATORE. Theatrum Triumphale Mediolanesis Urbii
Magnalium. Milan: Jo. Baptista & Giulio Cesare Malatesta,
[1642], 3 parts, 323 pp.
 In pt. 1, pp. 30-31, alphabetical list of "pictores
memorabiles" with short description of why famous. Minia-
turists on p. 33.

LC43 ALBUZZI, ANTONIO FRANCESCO. "Memorie per servire alla
storia de' pittori, scultori e architetti milanese (18th
century)." L'arte 51 (1948-51):1-14; 52 (1952):15-52; 54
(1954): 53-74; 55 (1955):75-122. Reprint. Milan: Stucchi,
1956, viii + 124 pp.
 Includes notices of Vincenzo Foppa, Cristoforo Moretti,
Vincenzo Civerchio, Stefano Scotto, Giacobino de' Mottis,
Ambrogio Fossano, Ambrogio and Filippo Bevilacqua, Ambrogio
Bergognone, Macrino d'Alba, Giovanni Donato Montorfano, and
Giovanni Antonio Boltraffio.

LC44 ROSIMINI, CARLO de'. Dell'istoria di Milano. Vol. 4.
Milan: Manini & Rivolta, 1820, 528 pp.
 Documents concerning the decorations in the Sala verde,
Saletta, and Camera della torre in the Castello sforzesco in
Pavia in 1469. Estimated by Costantino da Vaprio and Bonifacio
Bembo.

LC45 CALVI, GIROLAMO LUIGI. Notizie sulla vita e sulle opere dei
principali architetti, scultori e pittori che fiorirono in
Milan durante il governo dei Visconti e degli Sforza. 3
vols. Milan: Ronchetti, 1859-69, 163, 283, and 111 pp.
Reprint. Bologna: A. Forni, 1975.
 Brief biographies of artists working in Milan based on
Albuzzi (LC43). Vol. 1 includes Michelino and Stefano da
Pandino. Vol. 2 includes Bramantino, Foppa, Bonifacio Bembo,
Costantino Zenone da Vaprio, Butinone, Zenale, Zanetto Bugatto,
Cristoforo de' Mottis, Civerchio, Bernardino de' Rossi,
Bevilacqua, Bergognone, and a "Trozo da Monza." Vol. 3 ex-
clusively devoted to Leonardo.

LC46 MONGERI, GIUSEPPE. L'arte in Milano. Milan: Società
cooperative fra tipografia, 1872, 546 pp.
 Organized like a guide to major artistic monuments in
Milan, but considers the works in chronological order.

LC47 "Creditori della duchessa Bianca Maria Sforza." Archivio
storico lombardo 3 (1876):534-42.
 Documents concerning Zanetto Bugatto and Costantino
Zenone da Vaprio from a book of creditors, dating shortly after
1469. Also letters concerning Zanetto's work as portraitist.

LC48 CAFFI, MICHELE. "Di alcuni maestri di arte nel secolo XV in
 Milano poco noti o male indicati." Archivio storico
 lombardo 5 (1878):82-96.
 Archival documents concerning Bonifacio Bembo, Giovanni
 Donato Montorfano, and Paulino da Montorfano.

LC49 CAFFI, MICHELE. "Di altri antichi pittori milanese poco
 noti." Archivio storico lombardo 8 (1881):54-60.
 Documents concerning Zanetto Bugatto, Bonifacio Bembo,
 Gregorio Zavattari, and Giacomino Vismara, and Costantino
 Zenone in the Chapel of the Madonna, Caravaggio.

LC50 PORRO, GIULO. "Nozze di Beatrice d'Este e di Anna Sforza."
 Archivio storico lombardo 9 (1882):483-534.
 Publishes the documents summoning artists to decorate the
 Sala della balla for the weddings, pp. 497-98.

LC51 MONGERI, GIUSEPPE. "L'arte del minio nel ducato di Milano
 dal secolo XIII al XVI. Appunti tratti dalle memorie
 postume del marchese Gerolamo d'Adda." Archivio storico
 lombardo 12 (1885):330-56, 528-57, 759-96, 1 b&w illus.
 Important documentary source on art of manuscript illumi-
 nation. Attempt at comprehensive survey of illuminated manu-
 scripts dispersed from Visconti-Sforza library ca. 1500 by
 Ascanio Sforza. Index of miniaturists.

LC52 VENTURI, ADOLFO. "Relazioni artistiche tra le corti di
 Milano e Ferrara nel secolo XV." Archivio storico lombardo
 12 (1885):225-80.
 Exchange of artists between Milan and Ferrara. Particu-
 larly portraitist Baldassare Estense (da Reggio); anonymous
 youth placed in Tura shop by duke of Milan; Boccaccino's trip
 to Ferrara 1497. Original documents in the footnotes.

LC53 "Pittori sforzeschi." Archivio storico lombardo, 2d ser. 9
 (1892):995-96.
 Various legal documents concerning Giacomino da Vaprio,
 Bonifacio Bembo (citizenship in Milan, 23 April 1474) and other
 minor artists. Spoglie from a number of different sources.

LC54 MOTTA, EMILIO. "L'università dei pittori milanesi nel 1481
 con altri documenti d'arte nel quattrocento." Archivio
 storico lombardo, 3d ser. 3 (1896):408-31.
 Roll of the painters' guild in 1481, found in the
 Archivio notarile, Milan, protocols of Benino Cairati recorded
 in codici of marchese Vercellino Maria Visconti, Triviluziani
 1817, f. 213.

LC55 MALAGUZZI VALERI, FRANCESCO. Milano. 2 vols. Bergamo:
 Istituto italiano d'arti grafiche, 1906, 170 pp. and 155 b&w
 illus., and 162 pp. and 140 b&w illus.

Cities

Historically organized overview of art in Milan.
Visconti and early Sforza are covered in vol. 1, pp. 97-170,
with specific discussion of Foppa, Zenale, Bramantino et al.
Period of Ludovico il Moro, pp. 9-38, Boltraffio, and influence
of Leonardo.

LC56 ADY, CECILIA M. A History of Milan Under the Sforza.
London: Methuen & Co., 1907, 351 pp., 20 b&w illus.
Chap. 12 concerned with art (pp. 273-89). Very cursory.

LC57 BISCARO, GEROLAMO. "Le imbreviature del notaio Bonforte
Gira e la Chiesa di Santa Maria di San Satiro." Archivio
storico lombardo, 4th ser. 13-14 (1910):105-30.
Includes documents relating to decoration of Casa Landi
with Agostino dei Fonduti doing decorative work outside (con-
tract 18 February 1484). Ambrogio de Predis guarantor for work
in Casa Landi. Document for altarpiece by Boltraffio, 1502.

LC58 CROWE, J[OSEPH] A[RCHER], and G[IOVANNI] B[ATTISTA]
CAVALCASELLE. "The Milanese." In A History of Painting in
North Italy. Edited by Tancred Borenius. Vol. 2. London:
John Murray, 1912, pp. 316-408, 6 b&w illus.
Includes sections specifically on Foppa, Bramantino,
Butinone and Zenale, and Ambrogio Bergognone. Footnotes par-
ticularly useful for earlier opinions and sources.

LC59 BISCARO, GEROLAMO. "Note di storia dell'arte e della
coltura a Milano dai libri mastri Borromeo (1427-78)."
Archivio storico lombardo, 5th ser. 1 (1914):71-108.
Rich documentary source from Borromeo account books.
Gives decorations in Casa Borromeo to Michelino da Besozzo on
the basis of rates of pay. Payments for other fresco cycles,
portraits, and religious commissions.

LC60 CUST, LIONEL. "The Frescoes in the Casa Borromeo at Milan."
Burlington Magazine 33 (1918):8-14, 5 b&w illus.
Publishes illustrations from the Sala dei giochi in the
Casa Borromeo. Attributes them to Pisanello or circle at mid-
century. Compares with costume drawings in Chantilly and
Bayonne with the figures in the Sala.

LC61 PECCHAI, PIO. "Pittori del quattrocento che lavorarono per
conto dell'Ospedale maggiore di Milano." Archivio storico
lombardo, 5th ser. 6 (1919):490-93.
Notices from the Mastri dell'archivio. Includes payments
to Gottardo Scotto, Baldassare Estense, Giacomino da Vaprio,
Incontro Luppi, Pietro da Velate, Francesco da Vaprio, and
Ambrogio Bevilacqua as well as others.

LC62 BELTRAMI, LUCA. Notizie e ricordi di opere d'arte del
secolo XV nella Chiesa di S. Pietro in Gessate di Milano.
Milan: Nozze Beltrami-Gavazzi, 1932, 32 pp.

Publishes documents from the notarial records of Giovanni
Antonio Bianchi concerning the painting of the Grifo Chapel.
Initial commission 1487 to Trozo da Lodi, shifted to Foppa,
1489, actually painted by Zenale and Butinone. Subject is life
of Saint Ambrose.

LC63 AGOSTINI, PIER GIUSEPPE. "L'antica chiesetta di S. Siro a
 Milano e i suoi affreschi." Arte cristiana 49 (1961):247-
 52, 11 b&w illus.
 Oratory rebuilt in 1456. Frescoes in apse. Central apse
 Christ with Evangelist symbols after 1460, below Crucified
 Christ with Madonna and Saints, last quarter fifteenth century.
 Arch medallions dated 1468.

LC64 OTTINO della CHIESA, ANGELA. San Maurizio al Monastero
 maggiore. Milan: 1962, 382 pp., 159 color and b&w illus.
 Monograph on the Church of S. Maurizio, Milan. Includes
 section on the participation of Boltraffio, Zenale, and influ-
 ence of Foppa in the decoration of the church.

LC65 DORIA, ANTONELLA. "I corali quattrocenteschi miniati di S.
 Stefano in Brolo." Arte lombarda 61, no. 1 (1982):81-92, 23
 b&w illus.
 Extensive discussion of three manuscripts in Archivio
 della curia, Milan: Ingresso ambrosiano, Antifornario
 domenicale, and Liber offitiorum dominicalium. Dates 1424-44
 on basis of patron.

LC66 STEFANI, LETIZIA. "I codici miniati quattrocenteschi di S.
 Maria Incoronata." Arte lombarda 61, no. 1 (1982):65-80, 17
 b&w illus.
 Reproduces a number of miniatures from codices originally
 from Sta. Maria Incoronata, Milan. Relates to contemporary
 fifteenth-century Lombard art.

 Guidebooks

LC67 SANT'AGOSTINO, AGOSTINO. L'immortalità e gloria del
 pennello overo catalogo delle pitture insigni che stanno
 esposto al pubblico nella città di Milano. Milan: Federico
 Agnelli, 1671, 106 pp. Reprint. Marco Bona Castelloti, ed.
 Milan: Il Polifilo, 1980.
 In reprint, notes on other attributions, current loca-
 tions of works, index by artist in the back. Original organ-
 ized by zone. Works by Bembo, Bergognone, Boltraffio,
 Bramantino, Ambrogio de Preda, Foppa, Macrino d'Alba,
 Michelino, and Zenale.

LC68 BIFFI, GIUSEPPE. Pitture, scolture et ordine d'architettura
 enarte co' suoi autori. . . . Biblioteca braidese, MS.
 braidese AD 11.35., 18th century, 96 fols.

Cites earlier sources for descriptions. Works by
Bramantino, Zenale, and Foppa.

LC69 TORRE, CARLO. Il ritratto di Milano. Milan: Gl'Agnelli,
 1714, viii + 393 pp.
 Includes an index. Mentions works by Foppa, Zoppo,
 Bramantino, Civerchio, and Carlo Francesco Orsini.

LC70 LATUADA, SERVILIANO. Descrizione di Milano. 5 vols.
 Milan: Cairoli, 1737-38, 336, 348, 338, 459, and 448 pp.
 Reprint. Milan: Cisalpino-Goliardica, 1972.
 Organized by "porte" and then by church. Map in vol. 1.
 No index.

LC71 BASCAPÈ, GIACOMO C. I palazzi della vecchia Milano. Milan:
 U. Hoepli, 1945, 371 pp., 400 b&w illus.
 Popular survey of Milanese palaces and their history.
 Palazzo Borromeo, pp. 140-43. Index.

LC72 TOURING CLUB ITALIANO. Guida d' Italia: Milano e Laghi.
 Milan: Touring Club italiano, 1967, 624 + 42 pp., 17 maps
 and 11 city plans.
 Comprehensive guide to the city and region. Index by
 artist and location.

 Collections and Museums

LC73 MALAGUZZI VALERI, FRANCESCO. "La collezione Sipriot a
 Brera." Rassegna d'arte 4 (1904):6-10, 12 b&w illus.
 Private collection of Casimiro Sipriot given to the
 Brera, includes an Ecce Homo by Bergognone, a St. Francis
 Receiving the Stigmata from the circle of Bergognone, a Dead
 Christ from the circle of Bramantino.

LC74 WITTGENS, FERNANDA. "Alcune opere della collezione Cologna
 in Milano." L'arte 32 (1929):210-22, 15 b&w illus.
 Attributes polyptych with Life of the Virgin to Gottardo
 Scotto and Madonna and Child with Saints to Antonio Cicgonara.

LC75 MORASSI, ANTONIO. Il Museo Poldi-Pezzoli in Milano. Rome:
 Libreria dello stato, 1932, 60 pp., 75 b&w illus.
 Summary guide to the collection.

LC76 MILAN. R. PINACOTECA DI BRERA. Catalogo. Edited by Ettore
 Modigliani. Milan: Presso la R. Pinacoteca di Brera, 1935,
 195 pp., 48 b&w illus.
 Brief biographies for the artists. Provenance of works.
 Objects by Bramantino, Foppa, Bergognone, Butinone, Marcino
 d'Alba, Bevilacqua, Boltraffio, Bernardino dei Conti, and
 Ambrogio de Predis.

LC77 MORASSI, ANTONIO. La regia Pinacoteca di Brera. Rome: Libreria dello stato, 1942, 104 pp., 125 b&w illus.
 Summary guide to the collection by room. Index of artists alphabetically with accession number and room.

LC78 OITTINO della CHIESA, ANGELA. Brera. Novara: Istituto geografico de Agostino, 1953, 156 pp., 30 color and numerous b&w illus.
 Selected works from the collection in chronological order. Evolutionary vision of Lombard art. Works by Bonifacio Bembo, Foppa, Bergognone, Butinone, Cossa, Ercole de' Roberti, Costa, Francia, Boltraffio, and Bramantino.

LC79 MILAN. PINACOTECA POLDI-PEZZOLI. La Pinacoteca Poldi-Pezzoli. Edited by Franco Russoli. Preface by Bernard Berenson. Historical notes by Guido Gregorietti. Milan: Electa, 1955, 297 pp., 41 color and 138 b&w illus.
 History of the collection. Brief catalog entries for all holdings. History of attributions at the end. Works by Foppa, Bergognone, Francia, Bernardino dei Conti, Boltraffio, Luca Baudo, Gottardo Scotto, Tura, Palmezzano, and Cristoforo Moretti.

LC80 N. d. R. "Collezioni private a Milano e in Italia. Le pitture più antiche della Collezione Aldo Crespi." Acropoli 1 (1960-61):228-34, 3 color illus.
 Publishes Madonna and Child with Angels by Foppa, ca. 1488-90, and Resurrection and Lamentation by Butinone.

LC81 MILAN. PINACOTECA AMBROSIANA. La Pinacoteca ambrosiana. Edited by Antonia Falchetti. Fontes ambrosiani, 42. Milan: Neri Pozza, 1969, 330 pp., 244 b&w and 8 color illus.
 Catalog of all of the paintings. History of the collection. Bibliography for the works. Provenance. Works by Bergognone, Zenale, Bramantino, and Ambrogio de Predis.

LC82 MELZI d'ERIL, GIULIO. La Galleria Melzi e il collezionismo milanese del tardo settecento. Milan: Virgilio, 1973, 201 pp., 29 b&w illus.
 History of formation of the Melzi Collection in the eighteenth century. Catalog of the collection's works and their present location. Previous inventories. Works by Ambrogio de Predis, Bramantino, Bergognone, and Zenale.

LC83 MILAN. BIBLIOTECA TRIVULZIANA. Miniatura lombarde della Biblioteca trivulziana. Milan: Ripartizione cultura, 1973, 149 pp., 48 b&w and 28 color illus.
 Selection of holdings presented by category: fragments and loose miniatures; sacred, literary, and historical texts; chorals; and diplomatic and legal documents.

Cities

LC84 MILAN. BIBLIOTECA TRIVULZIANA. Miniatura italiane della
 Biblioteca trivulziana. Milan: Comune ripartizione
 cultura, 1974, pp. 157.
 Organized by school. Emilian pp. 45-77, with 10 color
 and 19 b&w illus. Roman Missal, Cod. 2165, Martino di Giorgio
 d'Alemagna da Modena and manner of Giraldi, and Caius
 Sallustius, Cod. 694, by Giraldi.

LC85 MILAN. MUSEO POLDI-PEZZOLI. Dipinti. Edited by Mauro
 Natali. Milan: Electa, 1982, 563 pp., 517 b&w and color
 illus.
 Catalog of all of the paintings. In entries bibliogra-
 phy, major dates of the artist, condition of the work, and
 attributional history. Works by Tura, Boltraffio, Bergognone,
 Luca Baudo, Foppa, Gottardo Scotto, and Donato de' Bardi.
 Index.

 Monuments

 Castello

LC86 CANETTA, CARLO. "Vicende edilizie del Castello di Milano
 sotto il dominio sforzesco." Archivio storico lombardo 10
 (1883):357-80.
 Documents concerning decorations within the castello
 including information about Bonifacio Bembo, Zanetto, and
 Costantino Zenone da Vaprio in the chapel and the Sala verde.

LC87 BELTRAMI, LUCA. Il Castello di Milano sotto il dominio dei
 Visconti e Sforza, 1368-1535. Milan: U. Hoepli, 1894, 739
 pp., 179 engraving and 5 b&w illus. and plans.
 Extensive documentation concerning decorative programs
 for the castello. Bonifacio Bembo, Costantino Zenone da
 Vaprio, and Zanetto Bugatto as painters at court. Contracts
 and letters.

LC88 BELLONI, GIAN GUIDO. Il Castello sforzesco di Milano.
 Milan: Bramante editrice, 1966, 74 pp., 40 color and 235
 b&w illus.
 History of the castello with summary overview of the
 collection housed there. Selected works illustrated including
 Bonifacio and Benedetto Bembo, Nicolò da Varallo, Foppa, Donato
 Montorfano, Bramantino, Butinone, Boltraffio, Bergognone, and
 Baldassare Estense.

 Cathedral

LC89 MILAN. DUOMO. Annali della fabbrica del Duomo di Milano
 dall'origine fino al present. 4 vols. Milan: G. Brigola,
 1877-85, 316 pp., 317 pp., 321 pp., and 340 pp.
 Appendici. 2 vols. Milan: G. Brigola, 1883-5, 324 pp.
 and 316 pp.

Indice general. Milan: Tipografia sociale, E. Reggiani,
1885.
Documentation of work on the Cathedral of Milan from the
fourteenth century on, payments, contracts, deliberations,
documents for the fifteenth century in vol. 1-3 and the appen-
dices. In vol. 2 of the appendix includes a list of all of the
painters who worked in the cathedral.

LC90 MONNERET de VILLARD, UGO. Le vetrate del Duomo di Milano:
Ricerche storiche. 3 vols. Milan: Alfieri & Lacroix,
1918, 1:223 pp.; 2:plates 1-100; 3:plates 101-90.
Documentary and visual resource for the stained glass
windows and workers in the Cathedral of Milan. Summary of
documents concerning Stefano Pandino, Cristoforo and Agostino
de' Mottis, Nicolò da Varallo, Francesco Zavattari, and others.
Artist index.

LC91 PIRINA, CATERINA GILLI. "Franceschino Zavattari, Stefano da
Pandino, Maffiolo da Cremona, 'magistri a vitriatis' e la
vetrata della 'raza' nel Duomo milanese." Arte antica e
moderna 33 (1966):25-44, 13 b&w illus.
Four windows in the cathedral, two Apocalypse and two New
Testament, first two decades of fifteenth century. Documents.
Brief biography on each artist.

LC92 ARLSAN, EDOARDO. Le pitture del Duomo di Milano. Milan:
Ceschina, 1960, 125 pp., 6 color and 195 b&w illus.
Six fifteenth-century works by anonymous Lombard artists,
influence of Michelino da Besozzo.

PAVIA

General

LC93 BREVENTANO, STEFANO. Istoria delle antichità, nobilità e
delle cose notabili della città di Pavia. Pavia: Hieronimo
Bartholdi, 1570. Reprint. Bologna: A. Forni, 1972, 224 pp.
Includes descriptions of the decorations in the Castello
sforzesco in Pavia (pp. 7r-v), paintings destroyed in 1527.

LC94 ROBOLINI, GIUSEPPE. Notizie appartenenti alla storia della
sua patria (Pavia). Vol. 6. Pavia: Fusi & Co., 1838.
Includes survey of artists working in the Certosa, pp.
152-57 and "Serie cronologica dei pittori ed altri artisti
Pavesi" from the second half of fifteenth century and early
sixteenth century, pp. 179-90.

LC95 CAROTTI, GIULIO. "Gli affreschi dell'Oratorio dell'antico
Collegio fondato dal cardinale Branda Castiglioni in Pavia."
Archivio storico dell'arte, 2d ser. 3 (1897):249-75, 12 b&w
illus.

Cities

Assigns the frescoes to the circle of Vincenzo Foppa from the 1470s.

LC96 NATALI, G[IULIO]. "Saggio d'un 'Abecedario artistico pavese.'" Bollettino della Società pavese di storia patria 7 (1907):340-48.
 Very brief biographies, alphabetically arranged through "B." Includes Donato and Boniforte de' Bardi (says there are two Donatos), Luchino Belbello da Pavia, and Laura Bossi.

LC97 SANGIULIANI, A. CAVAGNA. "La Chiesa di Sant'Agata in Monte a Pavia." Bollettino della Società pavese di storia patria 7 (1907):56-68, 4 b&w illus.
 Draws attention to frescoes in choir of church and their condition. Discusses attribution to Bernardino de' Rossi and Butinone. No conclusions.

LC98 SORIGA, RENATO. "Per le fonti della storia dell'arte in Pavia." In L'Italia e l'arte straniera: Atti del X Congresso internazionale di storia dell'arte in Roma--1912. Rome: 1922, p. 509.
 Brief bibliography of archivistic studies of art in Pavia from the mid-nineteenth century until the early twentieth century.

LC99 SORIGA, RENATO. Pavia e la Certosa. Italia artistica, 88. Bergamo: Istituto italiano d'artigrafiche, 1926, 135 pp., 166 b&w illus.
 Historically arranged guide to Pavia. Fifteenth century, pp. 56-87. The Certosa is discussed on pp. 113-35. Special attention to Bergognone.

LC100 MAIOCCHI, RODOLFO. Codice diplomatico-artistico di Pavia dall'anno 1330 all'anno 1550. 2 vols. Pavia: Tip. già Cooperativa di B. Bianchi, 1937-49, 380 and 208 pp.
 Rich documentary source on Pavese art. Vol. 1 covers 1330-1492. Vol. 2 from 1492-1505.

LC101 MORANI, DARIO. Dizionario dei pittori pavesi. Milan: Alfieri & Lacroix, 1948, 140 pp., b&w illus.
 Dictionary arranged alphabetically. Cursory notices about the artists. Selected bibliography at end.

LC102 ARSLAN, EDOARDO. "Commento a un affresco pavese." Critica d'arte, 3d ser. 8 (1949):276-87, 4 b&w illus.
 Discussion of Christ with Twelve Apostles, dated 1491, from San Primo, Pavia. Says actually non-Lombard, 1450-60. Discusses Tuscan and Venetian influences on Lombard fifteenth-century art. Questions attribution of Louvre Annunciation to Carlo Braccesco.

LC103 PANAZZA, GAETANO. "Vetrate pavesi." Critica d'arte, 4th
 ser. 2 (1955):252-55, illus. 197-201.
 Discussion of the windows in Sta. Maria del Carmine and
 S. Lanfranco in Pavia. Relates to the work of Vincenzo Foppa.

LC104 ROMANINI, ANGIOLA MARIA. "Un nuovo complesso di tavoletto
 da soffitto quattrocentesche ritrovate a Pavia." Arte
 lombarda 4 (1957):58-66, 6 b&w illus.
 Panels from the ceiling of the Ospedale di San Matteo by
 an anonymous Lombard artist, between 1449 and 1471.

LC105 BOTTARI, STEFANO. "Un'aggiunta al Maestro della
 Resurrezione della Cappella del Collegio Castiglioni in
 Pavia." Arte antica e moderna (1963):321-22, 1 b&w illus.
 Gives Last Supper in private collection to the "Master of
 the Resurrection." Identifies Master as Antonio da Pavia
 rather than Bonifacio Bembo.

LC106 CIPRIANI, RENATA. Indice del codice diplomatico-artistico
 di Pavia. Milan: Istituto lombardo di scienze e lettere,
 1966, 68 pp.
 Artist index to Maiocchi (LC100).

 Collections and Museums

LC107 BICCHI, UGO. "Postille al catalogo della civica Pinacoteca
 di Pavia." Arte lombarda 6, no. 1 (1961):117-19.
 Supplements 1957 catalog published by Alfieri and LaCroix.
 Makes attributions to Civerchio and Francesco Marmitta.

LC108 PAVIA. PINACOTECA MALASPINA. Catalogo. Pavia: Comune di
 Pavia, 1981, 249 pp., 16 color and numerous b&w illus.
 Guide to the museum. Painting pp. 108-222. Illustrates
 every painting in collection. Works by Foppa, Bartolomeo degli
 Erri, Butinone, Boltraffio, Bevilacqua, and others.
 Bibliography.

 Monuments

 Castello

LC109 CAFFI, MICHELE. "Il Castello di Pavia." Archivio storico
 lombardo 3 (1876):543-59.
 Cites documents for the decorations of the castello for
 the marriage of Galeazzo Maria Sforza and Bona da Savoy, 1468;
 others referring to Bonifacio Bembo from 1457 and 1470;
 Bonifacio Bembo, Vincenzo Foppa, Zanetto Bugatto, Constantino
 Zenone da Vaprio in the chapel, 1474-76; competitive bidding of
 Johanne Pietro da Corte.

LC110 MAGENTA, CARLO. I Visconti e gli Sforza nel Castello di
 Pavia. 2 vols. Milan: U. Hoepli, 1883.

Cities

History of the construction and decoration of the castello. Includes documents.

Certosa

LC111 "Memorie inedite della Certosa di Pavia." Archivio storico lombardo 6 (1879):134-46.
Documents from the records of Matteo Valerio (1604-45) concerning Bergognone, Jacopo de' Mottis, and Bernardino de' Rossi.

LC112 MAGENTA, CARLO. La Certosa di Pavia. Milan: Fratelli Bocca, 1897, 488 + lxxxi pp., 60 heliotype illus.
Traces history of the Certosa from foundation, including documents concerning construction and decoration. Work of Bergognone and others.

LC113 MOTTA, EMILIO. "Documenti d'arte per la Certosa di Pavia." Archivio storico lombardo, 4th ser. 1 (1904):177-80.
Nicolò da Varallo and Antonio da Pandino painting windows for the Certosa in 1477.

LC114 MORASSI, ANTONIO. La Certosa di Pavia. Rome: Libreria dello stato, 1938, 92 pp., 96 illus.
Brief, popular guide to the Certosa.

LC115 ANGELINI, CESARE, ed. La Certosa di Pavia. Architecture: Maria Grazia Albertini Ottolenghi. Sculpture; Rossana Bossaglia. Painting: Franco Renzo Pesenti. Milan: Cassa di risparmio delle provincie lombarde, 1982, 604 pp., 543 illus. in b&w and color.
Index by artists. Section on painting pp. 83-113. Cites documents for the decorations with footnotes. Attributions, particularly for the designs of the stained glass windows.

ARTISTS

ARALDI, ALESSANDRO

LA1 RICCI, CORRADO. "Alessandro e Josafat Araldi." Rassegna d'arte 3 (1903):133-37, 5 b&w illus.
Factual and documentary summary of lives. Traces known works.

LA2 RICCI, CORRADO. "Araldi, Alessandro." In Thieme-Becker. Vol. 2. Leipzig: Seeman, 1908, pp. 54-55.

LA3 GHIDIGLIA QUINTAVALLE, AUGUSTA. "Alessandro Araldi." Rivista del istituto di archeologia e storia dell'arte, n.s. 8 (1958):292-333, 46 b&w illus.

Monographic study of Araldi with major emphasis on work in Parma. Includes listing of documents, later citations, and attributional history along with own opinions.

LA4 GHIDIGLIA QUINTAVALLE, AUGUSTA. "Araldi, Alessandro." In *Dizionario biografico italiano*. Vol. 3. Rome: Istituto della enciclopedia italiana, 1961, pp. 711-13.
Biographical information. Attributions. Bibliography.

LA5 ZANICHELLI, GIUSEPPE Z. *Iconologia della camera di Alessandro Araldi di San Paolo in Parma*. Parma: University of Parma, Centro studi e archivio della communicazione, 1979, 179 pp., 48 b&w illus.
Iconographic study of the apartments of the abbess of San Paolo, Benedictine nunnery. Date 1514. Theme of spiritual and temporal voyages to ultimate victory of salvation.

BALSEMO, JACOPO DA

LA6 CORTESI, LUIGI, and GABRIELE MANDEL. *Jacopo da Balsemo miniatore (c. 1425-1503)*. Bergamo: Monumenta bergomensia, 1972, 71 pp., 181 color and 231 b&w illus. and text figs.
Catalogue raisonné with bibliography.

BARDI, DONATO AND BONIFORTE DE'

LA7 SUIDA, WILHELM. "Bardi, Boniforte Conte de'." In Thieme-Becker. Vol. 2. Leipzig: Seeman, 1908, p. 486.

LA8 SUIDA, WILHELM. "Bardi, Donato Conte de'." In Thieme-Becker. Vol. 2. Leipzig: Seeman, 1908, p. 486.

LA9 BOSSAGLIA, ROSSANA. "Bardi, Boniforte Conte de'." In *Dizionario biografico italiano*. Vol. 6. Rome: Istituto della enciclopedia italiana, 1963, pp. 286-87.
Minimal biographical notices from documents. Bibliography.

LA10 BOSSAGLIA, ROSANNA. "Bardi, Donato." In *Dizionario biografico italiano*. Vol. 6. Rome: Istituto della enciclopedia italiana, 1963, pp. 296-97.
Biographical facts. Attributions. Bibliography.

LA11 ZERI, FEDERICO. "Agguinte a Donato de' Bardi." In *Diari di lavoro 2*. Turin: Einaudi, 1976, pp. 47-50, 6 b&w illus.
Attributes *St. John the Baptist*, shown at Helikon Gallery, London, 1974; and *SS. Sebastian and Ambrose*, Cicogna Mazzoni Collection, Milan, to Bardi. Notes Flemish influence.

BAUDO, LUCA DA NOVARA

LA12 SALMI, MARIO. "Luca Baudo da Novara." *Bollettino d'arte*, 2d ser. 5 (1925-26):502-12, 8 b&w illus.

Chronology, attributions, and documents (1491-1510).
Reconstructs personality and oeuvre based on signed and dated
works. Sees Lombard with Venetian and Flemish influences.
Reattributes Adoration in Savona previously given to Signorelli.

LA13 CASTELNOVI, GIAN VITTORIO. "Baudo, Luca." In Dizionario
 biografico italiano. Vol. 7. Rome: Istituto della
 enciclopedia italiana, 1965, pp. 289-91.
 Biographical facts. Attributions. Bibliography.

BELBELLO DA PAVIA, LUCHINO

LA14 PACCHIONI, GUGLIELMO. "Belbello da Pavia e Gerolamo da
 Cremona, miniatori: Un prezioso messale gonzaghesco del
 secolo XV." L'arte 18 (1915):241-52, 343-72, 31 b&w illus.
 Assigns Missal in Mantua and chorale in Siena to Belbello
 and Gerolamo.

LA15 ZERI, FEDERICO. "Belbello da Pavia: Un Salterio."
 Paragone 3 (1950):50-52, 3 b&w illus.
 Attributes Psalter in British Museum, Add. MS. 15114, to
 Belbello. Notes connection with work of Giovanni da Modena.

LA16 SALMI, MARIO. "Contributo a Belbello da Pavia." In
 Miscellanea Giovanni Galbiati. Vol. 2. Fontes ambrosiani,
 vol. 26. Milan: U. Hoepli, 1951, pp. 321-28,
 15 b&w illus.
 Attributes Antiphonal in the Uffizi (cor. 9) to Belbello
 and shop. On iconography of saints dates 1444-50. Traces
 possible influence of Lorenzo Monaco in Belbello's work.

LA17 SAMEK-LUDOVICI, SERGIO. "Belbello da Pavia." Bollettino
 d'arte 38 (1953):211-24, 15 b&w illus.
 Overview of his work. Checklist of miniatures in Landau-
 Finlay Psalter, Bible of Nicolò III, and Missal of Barbara of
 Brandenburg.

LA18 SAMEK-LUDOVICI, SERGIO. Miniature di Belbello da Pavia
 dalla Bibbia vaticana e dal messale Gonzaga di Mantova.
 Milan: Aldo Martello, 1954, 70 pp., 26 color illus.
 Includes documents concerning Belbello and relates his
 work to Lombard and French environment. Mainly useful for
 tipped-in color plates.

LA19 RANDALL, LILIAN V. "Un saint Jerome du XVe s." Vie des
 arts 33 (1963-64):18-19, 1 color illus.
 Attributes the painting of Saint Jerome in his study
 removing a thorn from the paw of a lion to Belbello. No nota-
 tion of where the original is located.

LA20 CIPRIANI, R[ENATA]. "Belbello, Luchino." In Dizionario
 biografico italiano. Vol. 7. Rome: Istituto della
 enciclopedia italiana, 1965, pp. 546-47.
 Biography, attributions, and bibliography.

LA21 GENGARO, MARIA LUISA. "Contributo a Belbello da Pavia. In
 memoria di Guglielmo Pacchioni." Arte lombarda 15, no. 1
 (1970):45-48, 2 b&w illus.
 Attributes two images of Sallust from MS. I. 113 Sup,
 Biblioteca ambrosiana, Milan, to Belbello. Suggests some ad-
 justment to the classical subject matter in rendering.

LA22 MEISS, MILLARD, and EDITH KIRSCH. The Visconti Hours. New
 York: George Braziller, 1972, 262 pp., numerous color illus.
 Color facsimile of the Visconti Hours in the Biblioteca
 nazionale, Florence. Brief introduction. Section on Belbello
 pp. 26-28. Description of life and principal works. Style.
 Provenance of work.

LA23 CADEI, ANTONIO. Belbello, miniatore lombardo: Artisti del
 libro alla corte dei Visconti. Studi di storia dell'arte 6.
 Rome: Bulzoni, 1976, 217 pp., 102 b&w illus.
 Begins with origins of Belbello and evolution. Compari-
 sons with Giovanni di Grassi, Master of De natura deorum, and
 Girolamo da Cremona.

LA24 PADOVANI, SERENA. "Su Belbello da Pavia e sul 'Minatore di
 San Michele a Murano.'" Paragone 339 (1978):24-34, 22 b&w
 illus.
 Positive review of Cadei (LA23). Style and works of the
 "Master of San Michele a Murano," called "Genesis Master" by
 Cadei.

LA25 KIRSCH, EDITH WEISBORD. "The Visconti Hours: The Patronage
 of Giangaleazzo Visconti and the Contribution of Giovannino
 dei Grassi." Ph.D. Dissertation, Princeton University, 1981,
 2 vols., 344 pp., 303 b&w illus.
 Primarily concerned with Giovannino but does briefly
 discuss Belbello in the Visconti Hours and in Missal, Smith-
 Lesouef 22, Bibliothèque nationale, Paris.

BEMBO, BENEDETTO AND BONIFACIO

LA26 LANCETTI, VINCENZO. Biografia cremonese. Vol. 2. Milan:
 Tip. di Commercio al Bocchetto, 1820, pp. 156-60. Reprint.
 Bologna: A. Forni, 1970.
 Biographies of Bonifacio and Giovanni Francesco Bembo.

LA27 MALAGUZZI-VALERI, FRANCESCO. "Bonifacio e Benedetto Bembo."
 In Pittori lombardi del quattrocento. Milan: L.F.
 Cogliati, 1902, 253 pp.

Artists

 Biographical information and sorting out of works by the
various members of Bembo family.

LA28 MALAGUZZI-VALERI, FRANCESCO. "Bembo, Benedetto." In
 Thieme-Becker. Vol. 3. Leipzig: Seeman, 1909, p. 283.

LA29 MALAGUZZI-VALERI, FRANCISCO. "Bembo, Bonifacio." In
 Thieme-Becker. Vol. 3. Leipzig: Seeman, 1909, p. 283.

LA30 SALMI, MARIO. "Un nuovo Benedetto Bembo." Dedalo 7
 (1926):43-50, 7 b&w illus.
 Fragment of Flight into Egypt discovered in San Michele,
 Cremona. Dates it after 1462.

LA31 BONETTI, CARLO. "I Bembi pittori cremonesi (1375-1527)."
 Bollettino storico cremonese 1 (1931):7-35, 2 b&w illus.
 Documents from notarial archives in Cremona concerning
 Bembo family. Genealogy of the family. Illustrations of work
 Benedetto.

LA32 WITTGENS, FERNANDA. "Note e aggiunte a Bonifacio Bembo."
 Rivista d'arte 18 (1936):346-66, 15 b&w illus.
 Considers art of Belbello da Pavia as root for Bonifacio
 Bembo.

LA33 RASMO, NICOLÒ. "Il codice palatino 556 e le sue
 illustrazioni." Rivista d'arte 21 (1939):245-81,
 22 b&w illus.
 Attributes drawings in Biblioteca vaticana, Palatino 556,
 to Bembo. Publishes cycle of ceiling panels for Meli family
 palace, Cremona, ca. 1447, divided between Cremona, Trento, and
 Torcello.

LA34 PUERARI, ALFREDO. "Gli affreschi scoperti nella Chiesa
 della SS. Trinità a Cremona." Bollettino storico cremonese
 10 (1940):74-80.
 Uncovering frescoes previously hidden by the altarpieces
 in SS. Trinità. Saints and Virgin Enthroned attributed to
 Benedetto Bembo. Frescoes in cells of the campanile and sac-
 risty, Saints and Dormition, dated 1475, attributed to
 Bonifacio and Benedetto Bembo.

LA35 BOTTARI, STEFANO. "I tarocchi di Castello Ursino e
 l'origine di Bonifacio Bembo." Emporium 114 (1951):110-24,
 16 b&w illus.
 Connects fifteen tarot cards in the Museo civico,
 Catania, with Bonifacio Bembo illuminations in Palatina 556.
 Dates 1446-53 shop of Bembo. Strong parallels with work of
 Zavattari and Leonardo de Besozzo.

LA36 ZERI, FEDERICO. "Due santi di Bonifacio Bembo." Paragone
 17 (1951):32-35, 2 b&w illus.

Attributes SS. Alessio and Giuliano in Brera to Bembo, ca. 1450.

LA37 SALMI, MARIO. "Nota su Bonifacio Bembo." Commentari 4 (1953):7-15, 19 b&w illus.
Attributes Este genealogy in Biblioteca estense, alpha L.5.16, to Bonifacio Bembo, late 1460s. Development of his art from the tarot cards and Palatina 556. Removes Sforza profiles in Brera from Bembo.

LA38 FERRI, GABRIELLA. "Bonifacio Bembo." Dissertation, Università di studi di Pavia, Facoltà di lettere e filosofia, 1954-55, 244 & xvii pp.
Historiographic essay on critical appraisal of Bembo. Biography. Catalogue raisonné of his works. Bibliography.

LA39 FERRARI, MARIA LUISA, and MINA GREGORI. "I corali del Duomo di Cremona e la miniatura cremonese del quattrocento. Parte III. Il codice XI e i codici XII, XIV e XV." Annali della Biblioteca governativa e libreria civica di Cremona 8, no.3 (1955):1-23, 22 b&w illus.
Assigns Chorale XI to circle of Bonifacio Bembo on the basis of style.

LA40 WITTGENS, FERNANDA. "Un dipinto ignoto di Bonifacio Bembo nel Museo di Worcester." Arte lombarda 2 (1956):69-71, 5 b&w illus.
Madonna and Child with Musical Angels, attribution particularly based on color.

LA41 LONGHI, ROBERTO. "Una cornice per Bonifacio Bembo." Paragone 87 (1957):3-13, 2 b&w illus.
Notes paucity of Lombard altarpieces from thirteenth to fifteenth centuries. Suggests painters mainly working on sculptural complexes and windows. Discusses Prophet from cloister of Sta. Maria di Castello, Genoa, and Life of Saint Benedetto in the library in Mantua. Relates to the work of Bembo. Also Acton Triptych by Bembo.

LA42 VOLTINI, FRANCO. "Tre tavolette da soffitto di Bonifacio Bembo." Paragone 87 (1957):54-56, 3 b&w illus.
Identifies three figures in arches in the Museo del seminario, Cremona, from Monastero della Colomba, as by Bonifacio Bembo. Dates ca. 1460-67.

LA43 FERRARI, MARIALUISA. "Considerazioni bembesche ai margini di una 'lettura.'" Paragone 97 (1958):67-70, 3 b&w illus.
Connects a frescoed altarpiece in the parish church of Carpenedolo (Brescia) and two altarpieces in a private collection to the circle of Andrea Bembo.

Artists

LA44 FERRARI, MARIALUISA. "Il 'salterio' riminese di Bonifacio
 Bembo." Paragone 111 (1959):40-45, 3 b&w illus.
 Publishes chorale in Biblioteca Gambalunga, Rimini.
 Pluteo corali II, attributes to Bembo.

LA45 PUPPI, LIONELLO. "A proposito di Bonifacio Bembo e della
 sua bottega." Arte lombarda 4, no. 2 (1959):245-52, 15 b&w
 illus.
 Discusses dependency of the "Master of the Tarocchi of
 Castello Ursino" on Bonifacio Bembo.

LA46 QUINTAVALLE, ARTURO CARLO. "Un ciclo di affreschi di
 Bonifacio Bembo." Critica d'arte 8 (1961):45-56, 8 b&w
 illus.
 Assigns cycle of frescoes in the chapel in the Castello
 di Monticelli d'Ongina to Bonifacio. Patron is Carlo
 Pallavicino. Related to paintings in Museo civico, Cremona,
 and Cappella Cavalcabò, S. Agostino, Cremona. Dates them
 to around 1455.

LA47 PESENTI, FRANCO RENZO. "Per una nuova interpretazione di
 Bonifacio Bembo." Arte antica e moderna 21 (1963):319-21, 5
 b&w illus.
 Attributes Resurrection in the chapel of the Collegio
 Castiglioni to Bonifacio. Living nearby ca. 1475.

LA48 QUINTAVALLE, ARTURO CARLO. "Problemi bembeschi a Monticelli
 d'Ongina." Arte antica e moderna 21 (1963):36-45, 21 b&w
 and 1 color illus.
 Attempts to define roles of Bonifacio and Benedetto in
 the chapel in the Castello di Monticelli d'Ongina.

LA49 CONSOLI, GIUSEPPE. "Un ciclo affreschi (forse di Bonifacio
 Bembo) finora ignorata." Arte lombarda 10, no. 1
 (1965):156-58, 7 b&w illus.
 Fresco fragments at Quarto Oggiaro (Milan).

LA50 PESENTI, FRANCO RENZO. "Per la discussione su Bonifacio
 Bembo." Arte lombarda 10, no. 2 (1965):67-9, 6 b&w illus.
 Suggests two quite different personalities, one Gothic
 other Renaissance in the works assigned to Bembo. Need to
 reconsider attributions like angels in the vaulting of the
 chapel in the castello, Milan, and Este genealogy in Vatican.
 Renaissance personality more reasonable.

LA51 MOAKLEY, GERTRUDE. The Tarot Cards Painted by Bonifacio
 Bembo for the Visconti-Sforza Family. New York: New York
 Public Library, 1966, 124 pp., 77 b&w illus.
 Illustrates all of the cards. Dates ca. 1450. History
 of the pack. History and meaning of tarot. Six cards by
 circle of Antonio Cicognara or by Butinone or Zenale.

LA52 LONGHI, ROBERTO. "'Me Pinxit': Le restituzione di un trittico d'arte cremonese circa il 1460 (Bonifacio Bembo)." In <u>Opere complete</u>. Vol. 2, <u>"Me Pinxit"</u> e <u>quesiti</u> <u>caravaggeschi</u> 1928-34. Florence: Sansoni, 1968, pp. 79-87, 10 b&w and 2 color illus.
 First published in 1928. Reconstruction of polyptych attributed to Bonifacio.

LA53 SAMEK-LUDOVICI, SERGIO, and ITALO CALVINO. <u>Tarocchi:</u> <u>Il</u> <u>mazzo</u> <u>visconteo</u> <u>di</u> <u>Bergamo</u> <u>e</u> <u>New</u> <u>York</u>. Parma: F.M. Ricci, 1969, 165 pp., 63 plates.
 Facsimile of the tarocchi and history of their interpretation. Attributes the <u>Visconti</u> <u>Tarot</u> to Bonifacio Bembo.

LA54 FERRARI, MARIA LUISA. "Corollari bembeschi." <u>Paragone</u> 253 (1971):54-69, 14 b&w illus.
 Discusses "Renaissance qualities" of Benedetto and Bonifacio, reconfirms Gothic and neo-Gothic tendencies. Publishes <u>Christ</u> <u>with</u> <u>Symbols</u> <u>of</u> <u>Passion</u>, <u>Annunciation</u>, and Saints in private collection.

LA55 GHIDIGLIA QUINTAVALLE, AUGUSTA. "Gli affreschi di Bonifacio Bembo a Monticelli d'Ongina." <u>Bollettino</u> <u>storico</u> <u>piacentino</u> 68, no. 2 (1973):128-33, 3 b&w illus.
 Restoration of two chapels in the Rocca dei Pallavicino commissioned by the bishop Carlo Pallavicino. One story of hermit saints, the other dedicated to San Bassiano and with the life and passion of Christ. Differentiates character of Bonifacio from Benedetto.

LA56 WITHOFT, BRUCIA. "A Saint Michael by Bonifacio Bembo." <u>Arte</u> <u>lombarda</u> 19 (1974):43-50, 12 b&w illus.
 <u>St.</u> <u>Michael</u>, in Boston Museum of Fine Arts, acquired in 1970. Shows parallels in details with the work of Gentile da Fabriano.

LA57 SUMMER, LUCIANO. "Considerazioni topografiche sugli affeschi della Camera d'oro a Torchiara." <u>Parma</u> <u>nell'arte</u> 11, no. 1 (1979):51-64, 1 b&w illus. and 3 plans.
 Traces various opinions of how itinerary of Bianca Pellegrini d'Arluno is depicted on vaults of Camera d'oro. Depictions of the various castles. Benedetto Bembo ca. 1462. Bibliography.

LA58 ROTONDI TERMINIELLO, GIOVANNA. "Bottega di Bonifacio Bembo (1460-1470 circa). Undici tavolette da soffitto." <u>Galleria</u> <u>nazionale</u> <u>di</u> <u>Palazzo</u> <u>Spinola.</u> <u>Interventi</u> <u>di</u> <u>restauro</u> 2 (1980):25-29, 11 b&w illus.
 Series of eleven profile bust-length heads from ceiling decoration in the castello, Portofino (Genoa). Description and measurements. Comparison with three young men, seminary, Cremona (see LA42).

Artists

LA59 ALGERI, GIULIANA. "Gli Zavattari e Bonifacio Bembo." In
 Gli Zavattari: Una famiglia di pittori e la cultura
 tardogotica in Lombardia. Genoa: De Luca editore, 1981,
 pp. 59-94, 45 b&w illus.
 Suggests new chronology for the three packs of tarot
 cards in New Haven, Milan (Brera), New York, and Bergamo.
 Suggests larger role for Francesco Zavattari rather than
 Bonifacio Bembo. Also gives illustrations in Codex palatino
 556, Florence, Biblioteca nazionale, to Francesco Zavattari.

 BESOZZO, MICHELINO and LEONARDO DA (MOLINARI)

LA60 MANNUCCI, GIOVANNI. "Un Michelino da Besozzo nella
 Pinacoteca di Siena." Rassegna d'arte senese 1 (1905):90-
 91, 1 b&w illus.
 Mystic Marriage of St. Catherine with SS. John the
 Baptist and Anthony Abbot in the Galleria nazionale, Siena.
 Signed Michelino fecit.

LA61 MALAGUZZI VALERI, FRANCESCO. "Besozzo, Leonardo di
 Molinari." In Thieme-Becker. Vol. 3. Leipzig: Seeman,
 1909, pp. 532-33.

LA62 MALAGUZZI VALERI, FRANCESCO. "Besozzo, Michelino di
 Molinari." In Thieme-Becker. Vol. 3. Leipzig: Seeman,
 1909, p. 233.

LA63 TOESCA, PIETRO. "Le miniature dell'elogio funebre di Gian
 Galeazzo Visconti." Rassegna d'arte 10 (1910):156-58, 4 b&w
 illus.
 Locates in the circle of Michelino.

LA64 ZAPPA, GIULIO. "Milan da Besozzo, miniatore." L'arte 13
 (1910):443-49, 4 b&w illus.
 Identifies miniatures in Paris, B.N. MS. lat. 5888, as by
 Michelino.

LA65 van MARLE, RAIMOND. "Un quadro di Michelino da Besozzo.
 Due miniature di Nicolò da Bologna." Cronache d'arte
 (1927):398-404, 4 b&w illus.
 Publishes Marriage of the Virgin in collection of
 Maitland F. Griggs, New York.

LA66 PAECHT, OTTO. "Early Italian Nature Studies and the Early
 Calendar Landscape." Journal of the Warburg and Courtauld
 Institutes 13 (1950):13-47, 34 b&w illus.
 Discusses Michelino's nature studies and place in his
 work. Cites passage in Uberto Decembrio's De republica, where
 Michelino is praised for naturalism.

LA67 SULZBERGER, S[UZANNE]. "Michelino da Besozzo et les
 relations entre l'enluminure italienne et l'art eyckian."
 Scriptorium 6 (1952):276-78, 2 b&w illus.
 Draws parallel between illumination in Funeral Elegy of
 Giangaleazzo Visconti by Pietro da Casteletto (Paris, B.N. MS.
 lat. 5888) and illumination of the Virgo inter virgines from
 the Très riches heures of Jean, Duke of Berry, destroyed. Sees
 former as source for latter.

LA68 BICCHI, UGO. "Un ciclo di affreschi attribuibili a Leonardo
 de Besozzo in una chiesa di Casatenovo." Arte lombarda 1
 (1955):51-7, 12 b&w illus.
 Cycle of frescoes in the apse of Sta. Margherita,
 Casatenovo, given to Leonardo. Dated 1463. Hypothesizes a
 trip north from Naples to do cycle. Suggests sympathy with
 Tuscan art, particularly Masolino.

LA69 MAZZINI, FRANCO. "Un affresco inedito e il primo tempo di
 Michelino da Besozzo." Arte lombarda 1 (1955):40-50, 9 b&w
 and 2 color illus.
 Crucifixion, church of S. Salvatore sopra Crevenna (Erba)
 attributed to Michelino on the basis of style. Considers among
 earliest work, 1385-90. Shows influence of French art.

LA70 BICCHI, UGO. "Contributo allo conoscenza di Michelino da
 Besozzo." Bolletino della Società pavese di storia patria,
 n.s. 8 (1956):187-90, 2 b&w illus.
 Attributes Aesop images in the Rocca d'Angera from the
 Palazzo Borromeo and the Liberal Arts in the Museo civico,
 Pavia, to Michelino, ca. 1430-35.

LA71 SCHILLING, R. "Ein Gebetbuch des Michelino da Besozzo."
 Münchner Jahrbuch der bildenden Kunst 8 (1957):65-80, 14 b&w
 illus.
 Attributes prayerbook in the library of Dr. Martin
 Bodmer, Genf-Colognay, West Germany, now in the Morgan Library,
 to Michelino.

LA72 SCHELLER, R.W. "'Uomini famosi.'" Bulletin van het
 Rijksmuseum 10 (1962):56-67, 5 b&w illus.
 Eight sheets from the Morris Collection copied from the
 Codex Crespi in Milan. Unknown Lombard master circle of
 Michelino. Illustrates the "uomini famosi."

LA73 PIRINA, CATERINA GILLI. "Michelino da Besozzo and the
 Vecchioni of the Stained-glass Window of S. Giulitta."
 Burlington Magazine 111 (1969):64-70, 8 b&w illus.
 After cleaning, on basis of style, gives prophets from
 Chapel of S. Giulitta, Cathedral, Milan, to Michelino. Pub-
 lishes payments to Michelino and other designers of stained
 glass for the cathedral between 1423-25.

Artists

LA74 SELLIN, DAVID. "Michelino da Besozzo." Ph.D. Dissertation,
 University of Pennsylvania, 1969, 330 pp., 130 b&w illus.
 Seeks to define work of Michelino by concentrating on
 known works of art, spheres of activity, and patronage. Three
 periods of activity: Milan, Venice, and Pavia. Discovery of
 frescoes in Carmine, Pavia.

LA75 CASTELFRANCHI VEGAS, LIANA. "Il libro d'oro Bodmer di
 Michelino da Besozzo e i rapporti tra miniatura francese e
 miniatura lombarda agli inizi del quattrocento." In Études
 d'art français offertes à Charles Sterling. Paris: Presses
 universitaires de France, 1975, pp. 91-103, 11 b&w illus.
 Evaluative description of Bodmer Hours, Pierpont Morgan,
 MS. 449. Dates ca. 1405. Hypothesizes that Michelino worked
 as a miniaturist only between 1395 and 1415. Exchanges between
 Lombardy and France. Parallels with Boucicaut Master.

LA76 CIRILLO MASTROCINQUE, ADELAIDE. "Leonardo da Besozzo e
 Sergiani Caracciolo in S. Giovanni a Carbonara." Napoli
 nobilissima 17, no. 2 (1978):41-49, 6 b&w illus.
 History of the Chapel of Sergiani Caracciolo in S.
 Giovanni a Carbonara, Naples. Activity of Leonardo da Besozzo
 in Naples and in the chapel, Nativity of Virgin and Coronation.
 Analysis of costume, dates between 1435-50, after death of
 Sergiani.

LA77 EISLER, COLIN. The Prayer Book of Michelino da Besozzo.
 New York: George Braziller, 1981, 27 pp., and 182 color
 illus.
 Facsimile of prayerbook in the Pierpont Morgan Library
 (M449) with introductory essay and summary bibliography. Brief
 discussion of work of Michelino and patronage in introduction.

BEVILACQUA, GIOVANNI AMBROGIO

LA78 MALAGUZZI VALERI, FRANCESCO. "Gio. Ambrogio Bevilacqua."
 In Pittori lombardi del quattrocento. Milan: L.F.
 Cogliati, 1902, pp. 163-168, 1 b&w illus.
 Chronological consideration of Bevilacqua's oeuvre.

LA79 PAULI, G[USTAV]. "Bevilacqua, Giovanni Ambrogio." In
 Thieme-Becker. Vol. 3. Leipzig: Seeman, 1909, p. 559-60.

LA80 BELLINI, ANGELO. "La pala del Bevilacqua in S. Vito a Somma
 Lombardo." Rassegna d'arte 12 (1912):14-16, 1 b&w illus.
 Madonna and Child with Two Saints, before 1500. Donor is
 Battista Visconti.

LA81 MAZZINI, FRANCO. "Bevilacqua, Giovanni Antonio." In
 Dizionario biografico italiano. Vol. 9. Rome: Istituto
 della enciclopedia italiana, 1967, pp. 793-94.
 Biographical facts. Attributions. Bibliography.

LA82 VERTOVA, LUISA. "A Dismembered Altar-piece and a Forgotten
 Master--I & II." Burlington Magazine 111 (1969):70-79,
 112-21, 25 b&w illus.
 Reconstructs altarpiece from fragments of Saints in
 Waddesdon Manor Collection and Museum, Luxembourg, and Madonna
 and Child Enthroned in Museum, Dijon. Dates altarpiece to
 1484-91. Traces career and oeuvre of Bevilacqua, and histor-
 ical fortune.

BINASCO, FRANCESCO

LA83 WESCHER, PAUL. "Francesco Binasco, Miniaturmaler der
 Sforza." Jahrbuch der Berliner Museen 2 (1960):75-91, 11
 b&w illus.
 Identifies Binasco as the illuminator of the Paolo e
 Daria (78 C 27) in Dahlem, Kupferstichkabinett. Also mentions
 Antonio da Monza (Corradino) and Pietro Birago.

LA84 WESCHER, PAUL. "Binasco, Francesco." In Dizionario
 biografico italiano. Vol. 10. Rome: Istituto della
 enciclopedia italiana, 1968, pp. 487-9.
 Summary of work for Lodovico il Moro and Ippolito d'Este.
 Notes dispersal of Binasco's miniatures in the nineteenth cen-
 tury. Bibliography.

BIRAGO, GIOVANNI PIETRO DA

LA85 MALAGUZZI VALERI, FRANCESCO. "Birago, Giampietrino." In
 Thieme-Becker. Vol. 4. Leipzig: Seeman, 1910, p. 46.

LA86 CALABI, EMMA. "Giovanni Pietro da Birago e i corali miniati
 dell'antica Cattedrale di Bresica." Critica d'arte 3
 (1938):144-51, 7 b&w illus.
 Sixteen chorals from the cathedral, now in the Pinacoteca
 Tosio-Martinego, Brescia, three (22, 23, and 25) bearing
 Birago's signature. Paduan and Ferrarese influence. Second
 hand more provincial. Dismisses Birago as miniaturist of Libro
 d'oro of Bona da Savoy.

LA87 HORODYSKI, BOGDAN. "Birago, miniaturiste des Sforza."
 Scriptorium 10 (1956):251-55, 2 b&w illus.
 Publishes illuminated frontispiece from printed Sforziade
 in the National Library, Warsaw. Work signed "Presbiter
 Joannes Petrus Biragus fecit." Lists thirteen other works
 assignable to Birago. Two other versions of frontispiece image
 affected by political considerations.

LA88 BERTINI, ALDO. "Un'ipotesi sull'attività pittorica di
 Giovanni Pietro Birago." In Arte in Europa: Scritta di
 storia dell' arte in onore di Edoardo Arslan. Vol. 1.
 Milan: n.p., 1966, pp. 471-74, 4 b&w illus.

Artists

Attributes two paintings: mythological scene formerly in
Finarte, Milan, and Meeting of Aeneas and Dido, Museo Borgogna,
Vercelli, to Birago. Compares with Vatican Grammatica. Gives
illuminations in the Grammatica normally assigned to Cristoforo
de Predis to Birago.

BOLTRAFFIO, GIOVANNI ANTONIO

LA89 CAROTTI, C. "La Galleria di Brera in Milano. G.A.
 Boltraffio [a proposto dell'acquisto della tavola dei due
 devoti]." Gallerie nazionale italiane 4 (1899):298-331.
 First real monograph on Boltraffio. Description of
works, locations, and attributions.

LA90 FABRICZY, KARL von. "Boltraffios h. Barbara im Berliner
 Museum." Repertorium für Kunstwissenschaft 28 (1905):539.
 Provenance of the St. Barbara.

LA91 MALAGUZZI VALERI, FRANCESCO. "Per la storia artistica della
 Chiese di San Satiro in Milano." Archivio storico lombardo,
 4th ser. 3 (1906):140-51.
 Contract for the Altar of St. Barbara, San Satiro, 1502.

LA92 PAULI, G[USTAV]. "Boltraffio, Giovanni, Antonio." In
 Thieme-Becker. Vol. 4. Leipzig: Seeman, 1910, pp. 256-58.

LA93 BOCK, FRANZ. "Leonardofragen." Repertorium für
 Kunstwissenschaft 39 (1916):153-65.
 Sorting out the difference between Leonardo and
Boltraffio particularly as it appears in the Cracow Woman with
an Ermine. Also defines relationship with Ambrogio de Predis.
Mentions Pala sforzesca.

LA94 SCHEGEL, LISA de. "Arte retrospettiva di alcuni dipinti di
 Giovanni Antonio Boltraffio." Emporium 46 (1917):197-205, 7
 b&w illus.
 Examines works by Boltraffio in non-Italian collections:
Portrait of Francesco Melzi, Bern; Portrait of a Boy,
Chatsworth; St. Barbara, Berlin.

LA95 HOLMES, Sir CHARLES. "Leonardo and Boltraffio." Burlington
 Magazine 39 (1921):107-8, 2 b&w illus.
 Attributes La belle ferronière in the Louvre to Leonardo,
not Boltraffio, by comparing it to Boltraffio's Portrait of a
Youth in collection of Sir Philip Sasson.

LA96 HEVESY, ANDRÉ de. "Boltraffio." Pantheon 18 (1936):323-29,
 7 b&w illus.
 General overview of works with illustrations.

LA97 VENTURI, ADOLFO. Leonardo da Vinci e la sua scuola.
 Novara: Istituto geografico de Agostini, 1941, p. xxix,
 plates 73-84.

Traces influence first from Zenale and Foppa and then Leonardo in Boltraffio's work.

LA98 COGLIATI ARANO, LUISA. "Boltraffio, Giovanni Antonio." In Dizionario biografico italiano. Vol. 11. Rome: Istituto della enciclopedia italiana, 1969, pp. 360-62.
 Biographical facts. Attributions. Bibliography.

LA99 RAMA, ELENA. "Un tentativo di rilettura della ritrattistica di Boltraffio fra quattrocento e cinquecento." Arte lombarda 64 (1983):79-92, 9 b&w illus.
 Documents relating to Boltraffio's legal affairs from Milanese archives. Two poems dedicated to Boltraffio. Relationship of Milanese courtly literature to his portraits. Identifies portrait at Chatsworth as ideal portrait of poet Girolamo Casio.

BONASCIA, BARTOLOMMEO

LA100 VENTURI, ADOLFO. "Bonascia, Bartolomeo." In Thieme-Becker. Vol. 4. Leipzig: Seeman, 1910, pp. 272-3.

LA101 RUHMER, EBERHARD. "Bartolommeo Bonascia ein Nachfolger des Piero della Francesca in Modena." Münchener Jahrbuch der bildenden Kunst, 3d ser. 5 (1954):89-101, 11 b&w illus.
 Catalog of works attributable to Bonascia using Pietà, 1485, in Galleria estense as touchstone. Strong influence of Piero della Francesca, but generally true in Modena. Attributes Pestapepe in Forlì to Bonascia, not Melozzo.

LA102 RUHMER, EBERHARD. "Bonascia, Bartolommeo." In Dizionario biografico italiani. Vol. 11. Rome: Istituto della enciclopedia italiana, 1969, pp. 588-90.
 Biographical facts. Attributions. Bibliography.

BOSSI, LAURA DE'

LA103 "Una miniatrice Pavese." Archivio storico lombardo, 2d ser. 9 (1892):217.
 Manuscript of Jacopo da Voragine, Golden Legend, dated 30 April 1485, in Archivio capitolare, Fiorenzola. Bossi nun in Sta. Maria di Giosafat, Pavia.

LA104 NATALI, G[IULIO]. Bossi, Laura de'." In Thieme-Becker. Vol. 4. Leipzig: Seeman, 1910, p. 407.

BRACCESCO, CARLO

LA105 "Braccesco, Carlo." In Thieme-Becker. Vol. 4. Leipzig: Seeman, 1910, p. 499.

Artists

LA106 BAUDI di VESME, ALESSANDRO. "Un polittico di Carlo Braccesco
 a Montegrazie." Bollettino d'arte 6 (1912):9-12.
 Twenty-panel polyptych signed "Carolus Mediolanensis
 pinxit" 1478. Review of what is known of Braccesco.

LA107 LONGHI, ROBERTO. Carlo Braccesco. Milan: Castello
 sforzesco, 1942, unpaged, 42 b&w and 1 color illus.
 Unfolds the personality and style of Braccesco. Docu-
 ments contained in the footnotes.

LA108 NICHOLSON, BENEDICT. Review of Roberto Longhi's Carlo
 Braccesco. Burlington Magazine 88 (1946):259-60, 1 b&w
 illus.
 Questions Longhi's (LA107) attribution of Montegrazie
 Altarpiece to Braccesco. Publishes St. Andrew with Cross,
 whereabouts unknown, as Braccesco.

LA109 CASTELNOVI, GIAN VITTORIO. "Un affresco del Braccesco."
 Emporium 57 (1951):163-72, 10 b&w illus.
 Attributes fresco in Sta. Maria di Castello, Genoa, with
 Christ, Virgin, and Saints to Braccesco. Dates ca. 1480.

LA110 ZERI, FEDERICO. "Two Contributions to Lombard Quattrocento
 Painting." Burlington Magazine 97 (1955):74-77, 6 b&w
 illus.
 Reconstructs the rest of the St. Andrew Altarpiece by
 Braccesco by publishing a St. Peter and a St. Paul formerly in
 a private collection in Lucca. Dates altarpiece to between
 1480-90.

LA111 ARSLAN, EDOARDO. "Il 'Maestro dell' Annunciazione del
 Louvre' e Carlo Braccesco." In Scritti sulla storia d'arte
 in onore di Mario Salmi. Vol. 2. Rome: De Luca editore,
 1962, pp. 439-50, 8 b&w illus.
 Comparison of signed Montegrazie Altarpiece and Louvre
 Annunciation suggests two different hands, only share fact that
 both done in Liguria, second half of fifteenth century. Master
 of the Louvre Annunciation possibly one of two artists named
 Francesco da Pavia.

LA112 COGLIATI ARANO, LUISA. "Braccesco, Carlo." In Dizionario
 biografico italiano. Vol. 13. Rome: Istituto della
 enciclopedia italiana, 1971, pp. 601-2.
 Biographical facts. Attributions. Bibliography.

BUTINONE, BERNARDO

LA113 CAFFI, MICHELE. "Zenale e Butinone. A proposito della pala
 di San Martino in Treviglio." Arte e storia 6 (1887):
 218-20.
 Early documentation on both artists and reference to
 other works by them.

LA114 MELANI, ALFREDO. "La grande pala nel San Martino di
 Treviglio." Arte e storia 6 (1887):188-89.
 Description of the altarpiece to clarify relative roles
 of Zenale and Butinone.

LA115 MALAGUZZI VALERI, FRANCESCO. "Bernardino Butinone e
 Bernardo Zenale." In Pittori lombardi del quattrocento.
 Milan: L.F. Cogliati, 1902, pp. 3-58, 23 b&w illus.
 Distinction between Butinone and Zenale. Sources not in
 Leonardo but in the North.

LA116 SEIDLITZ, WALDEMAR von. "Zenale e Butinone." L'arte 6
 (1903):31-36, 2 b&w illus.
 Reaction to Malaguzzi Valeri (LA115) attributions.
 Attributes Adoration in Ambrosiana, Milan, to Butinone.

LA117 COOK, HERBERT. "Notes on the Early Milanese Painters
 Butinone and Zenale." Burlington Magazine 4 (1904):84-94,
 179-85, 12 b&w illus.; 5 (1905):199-210, 8 b&w illus.
 General survey of documentation and biography of Butinone
 and Zenale. Differentiates between two artists. Attributions.

LA118 MALAGUZZI VALERI, FRANCESCO. "Un trittico di Butinone nella
 Pinacoteca comunale di Milano." Rassegna d'arte 4
 (1904):38-39, 1 b&w illus.
 Acquisition of triptych with thirteen scenes from the
 life of Christ by the Pinacoteca of the Castello sforzesca.
 Provenance. Attributes to Butinone, middle period ca. 1485.
 Miniature scale and quality. Note on Zenale as well. Too
 early for Leonardo influence.

LA119 SEIDLITZ, WALDEMAR von. "Butinone, Bernardino." In Thieme-
 Becker. Vol. 5. Leipzig: Seeman, 1911, pp. 300-302.

LA120 MALAGUZZI VALERI, FRANCESCO. "Nuovi affreschi lombarde del
 quattrocento." Rassegna d'arte 14 (1914):155-62, 13 b&w
 illus.
 Attributes Chapel of the Organ, Cathedral, Treviglio to
 Butinone. Dates pre-S. Pietro in Gessate, ca. 1485.

LA121 SALMI, MARIO. "Il trittico del Butinone nella Pinacoteca di
 Brera." Archivio storico lombardo, 6th ser. 2 (1925):
 154-58.
 Tries to establish date, 1484. Question of which way
 influence ran between Foppa and Butinone. Connects with paint-
 ing in the Carmine described by Fornari and Calvi (LC45).

LA122 SALMI, MARIO. "Bernardino Butinone." Dedalo 10
 (1929-30):336-61, 395-426, 51 b&w illus.
 Traces the evolution of Butinone's style. Influence
 flows from Mantegna to Foppa to Northern painting to his part-
 nership with Zenale. Compares also to works by Gottardo Scotto.

Artists

LA123 BERTINI, ALDO. "Disegni inediti nella Biblioteca reale in
Torino. 'Pittore lombardo prossimo al Butinone.'" La
critica d'arte 9 (1950):503, 1 b&w illus.
Adoration of the Child attributed to Butinone.

LA124 ZERI, FEDERICO. "Two Contributions to Lombard Quattrocento
Painting." Burlington Magazine 97 (1955):74-77, 6 b&w
illus.
Attributes Last Judgement in New York private collection
to Butinone, not Sienese artist Benvenuto di Giovanni, on basis
of style and comparison with Life of Christ polyptych in the
Brera.

LA125 LASAREFF, VICTOR. "Una nuova Madonna lombarda e alcuni
problemi del primo leonardismo a Milano." Arte lombarda 9
(1964):83-96, 6 b&w illus.
Publishes Madonna, school of Butinone, in Moscow.

LA126 MAZZINI, F[RANCO]. "Butinone, Bernardino." In Dizionario
biografico italiano. Vol. 15. Rome: Istituto della
enciclopedia italiana, 1972, pp. 609-12.
Biography, history of attributions, and bibliography.

CASTELLO, FRANCESCO DA

LA127 NEUWIRTH, JOSEPH. "Italienische Bilderhandschriften in
osterreichischen Klosterbibliotheken." Repertorium für
Kunstwissenschaft 9 (1886):383-409.
Codex 89, Library, Benedictine Abbey, Lambach, Austria.
Signed by Francesco da Castello da Milan for Provost Dominicus
Kálmánczay.

LA128 BERNATH, M[ORTON] H. "Castello, Francesco da." In Thieme-
Becker. Vol. 6. Leipzig: Seeman, 1912, pp. 150-51.

*LA129 HOFFMANN, EDITH. "Franciscus de Castello és szerepe a budai
könyvfestö mühelyben." Magyar Müvészet 9 (1933):42-46.
Disputes identification of Francesco da Castello with
Francesco da Concorezzo. Cited in Csapodi (LA133).

LA130 WITTGENS, FERNANDA. "Francesco da Castello." La
bibliofilia 39 (1937):273-82, 6 b&w illus.
Defines style of Francesco by examining Breviarium
Hungaricum to try to locate other works. Finds parallels in
style with Cristoforo de Predis, fusion of Lombard and Flemish
elements. More plastic than de Predis. Attributes breviary in
Liechtenstein Library, Vienna; missal in the treasury of the
Cathedral of Agram; and a codex in the Beatty Collection in
London. Influence of Castello in series of codices from court
of Matthew Corvinus. Lists works and their locations.

LA131 BERKOVITS, ILONA. Illuminated Manuscripts in Hungary: XI–
 XVI Centuries. New York and Washington: Praeger, 1969, 110
 pp., 47 b&w and 45 color illus. outside text.
 Discusses Francesco da Castello and the Kálmáncsehi
 Breviary, Budapest, pp. 65–72. Francesco went to Hungary from
 Ferrara late 1470s. Influenced art in Buda through late 1480s.

LA132 DANEU LATTANZI, ANGELA. "Di alcuni miniatori lombardi della
 seconda metà del secolo XV. I––Riesaminato Francesco da
 Castello." Commentari 23 (1972):225–60, 37 b&w illus.
 Bibliography. Summary of manuscript ascriptions and
 stylistic characteristics. Uses Boston Antiphonal (MS. Med.
 120), 1474, as center of discussion. From Ferrarese to more
 Foppesque. Influence of Cristoforo de Predis.

LA133 CSAPODI-GÀRDONYI, KLARA. "Francesco da Castello." In
 Dizionario biografico italiano. Vol. 21. Rome: Istituto
 della enciclopedia italiana, 1978, pp. 794–95.
 Biographical facts. Attributions. Bibliography.

CAYLINA, BARTOLOMEO

LA134 MAZZINI, FRANCO. "Caylina, Bartolomeo." In Dizionario
 biografico italiano. Vol. 23. Rome: Istituto della
 enciclopedia italiana, 1979, pp. 162–63.
 Brother of Paolo Caylina. Publishes few documentary
 facts concerning Bartolomeo. Brief bibliography.

CAYLINA, PAOLA (DA BRESCIA)

LA135 "Caylina, Paolo." In Thieme-Becker. Vol. 5. Leipzig:
 Seeman, 1911, p. 240.

LA136 SEMENZATO, CAMILLO. "Un polittico di Paolo da Brescia."
 Arte veneta 9 (1955):24–28, 8 b&w illus.
 Polyptych in Galleria Sabauda, Turin, recognized as
 touchstone for work of Paolo da Brescia. Sees Lombard Gothic
 elements in main image and Tuscan in the medallions in the
 pinnacles. Two prints and sheet of drawings with same compo-
 sition as pinnacles.

LA137 PANAZZA, GAETANO. "Un'opera nuova di Paolo da Brescia." In
 Studi di storia dell'arte in onore di Antonio Morassi.
 Venice: Alfieri, 1971, pp. 50–57, 13 b&w illus.
 Frescoes in S. Giovanni Evangelista, Brescia, signed and
 dated 1486.

LA138 MAZZINI, FRANCO. "Caylina, Paolo." In Dizionario
 biografico italiano. Vol. 23. Rome: Istituto della
 enciclopedia italiana, 1979, pp. 163–64.

Artists

Summary of works. Bibliography. Sees artist as having
mixed Venetian and Lombard characteristics. Influence of
Zavattari, Cristoforo Moretti, and Antonio Vivarini.

CEMMO, GIOVANNI PIETRO DA

LA139 MALAGUZZI VALERI, FRANCESCO. "Nuovi affreschi lombarde del
 quattrocento." Rassegna d'arte 14 (1914):155-62, 13 b&w
 illus.
 Frescoes in the Church of the Annunciation in Borno,
 signed and dated 1475 by Giovanni Pietro da Cemmo.

LA140 "Giovanni Pietro da Cemmo." In Thieme-Becker. Vol. 14.
 Leipzig: Seeman, 1921, p. 139.

LA141 BARNI, SANDRA. "I da Cemmo, pittori di Val Camonica."
 Archivio storico lombardo, 8th ser. 2 (1950):280-303, 2 b&w
 illus.
 Documents and attributions concerning family of the da
 Cemmo. Surname dei Grechi or Grecho. Differentiates hands.
 Girardo and brother Paroto. Giovanni Pietro and Pietro.
 Pietro, a member of the Umilati, receives greatest attention.
 Frescoes in S. Rocco, Baoglino; Sta. Maria Annunziata, Bienno;
 and Sta. Maria, Esine.

LA142 PUERARI, ALFREDO. "Gli affreschi cremonesi di Giovanni
 Pietro da Cemmo." Bollettino d'arte 37 (1952):220-30, 16
 illus.
 Attributing frescoes in Cappella del Sacramento, S.
 Agostino, Cremona, and Palazzo Fodri to Cemmo. Antonio della
 Corna also working in Fordri. Reminders of Bembo and influence
 of Bramante. Dating through comparisons with an Augustinian
 antiphonal of 1498.

LA143 FERRARI, MARIA LUISA. Giovanni Pietro da Cemmo: Fatti di
 pittura bresciana del quattrocento. Milan: Ceschina, 1956,
 146 pp., 4 color illus. out of text, 132 b&w illus.
 out of text.
 Catalogue raisonné. Bibliography.

LA144 VERGA, CORRADO. "Ricupero di un ciclo di affreschi nel
 refettorio dell'ex convento degli agostiniani a Crema."
 Arte lombarda 3, no. 1 (1958):90-92, 3 b&w illus.
 Reaffirms attribution of recently restored cycle (Last
 Supper, Saints, and Augustinian Bishops) as by Giovanni Pietro
 da Cemmo.

LA145 MULAZZANI, GERMANO. L'antica pieve di Pisogne: Affreschi
 in Valcamonica fra medio evo e rinascimento (Giovan Pietro
 da Cemmo). N.p.: Il Carol, 1972, 79 pp., 52 illus.
 Church restored in 1488. Three sections of frescoes:
 Interior of facade, Triumph of Death, Cemmo; presbytery, Life

of the Virgin, dated before 1498, influenced by Bramante; and
Plague Saints along the nave.

CIVERCHIO, VINCENZO DA CREMA

LA146 CAFFI, MICHELE. "Di Vincenzo Civerchio da Crema, pittore,
 architectto, intagliatore del secolo XV – XVI, notizie,
 documenti." Archivio storico italiano, 4th ser. 11
 (1883):329–52.
 Documents from 1500 to 1544 concerning Civerchio. Sec-
 ondary sources about commissions and biography. Earliest work
 dates 1493.

LA147 BERNATH, M[ORTON] H. "Civerchio, Vincenzo." In Thieme-
 Becker. Vol. 7. Leipzig: Seeman, 1912, pp. 20–22.

LA148 ANSALDI, GIULIO R. "Un nuovo Civerchio." L'arte 39
 (1936):183–85, 2 b&w illus.
 Attributes Franciscan Saint Reading in the Finardi Col-
 lection, Rome, to Civerchio. Compares with Franciscan Saint in
 Bergamo.

DELLA CORNA, ANTONIO

LA149 BONETTI, CARLO. "Due opere sconosciute di Antonio de la
 Corna, pittore cremonese (1481)." Archivio storico
 lombardo, 4th ser. 20 (1913):477–78.
 Document of 4 February 1481, for an ancona and pala for
 the Altar of the Flagellants of Cistello in St. Michael,
 Cremona, from the protocols of Policlets de la Corna in the
 Archivio notarile, Cremona. Already painted a St. Hippolito
 for same church.

LA150 SALMI, MARIO. "Una mostra di antica pittura lombarda."
 L'arte 26 (1923):149–60, 10 b&w illus.
 Review of exhibition. Includes extensive excursus on the
 art of Antonio della Corna.

LA151 BOLOGNA, FERDINANDO. "The Cremonese Ceiling from via
 Belvedere." Burlington Magazine 96 (1954):166–71, 15 b&w
 illus.
 Grisaille ceiling decorations (Apollo and the Muses with
 busts of Emperors) in the Victoria and Albert formerly given to
 Altobello Melone attributed to Antonio della Corna. Influence
 of Bramantino on late works. Della Corna literature in
 footnote.

LA152 VOLTINI, FRANCO. "Antonio della Corna ad Asola." Paragone
 97 (1958):9–22, 9 b&w illus.
 Reattributes polyptych in Cathedral, Asola, to della
 Corna. Others had given to Girolamo da Cremona.

Artists

LA153 ZERI, FEDERICO. "Studies on Italian Paintings. II. Panels
 of the Passion of Christ by Antonio della Corna." Journal
 of the Walters Art Gallery 29-30 (1966-67):48-67, 15 b&w
 illus.
 Cycle of small panels of Passion of Christ by Antonio
 della Corna, some formerly in Spiridon Collection, Rome. Sees
 influence of Girolamo da Cremona.

CORRADINI, ANTONIO DA MONZA

LA154 VENTURI, ADOLFO. "Il pontificale di Antonio da Monza nella
 Biblioteca vaticana." L'arte 1 (1898):154-64, 13 b&w illus.
 Gives Ottoboniano latino, no. 501, to the author of the
 Libro d'oro of Bona da Savoy.

LA155 VENTURI, ADOLFO. "Ancora Antonio da Monza miniatore."
 L'arte 2 (1899):114, 2 b&w illus.
 Two fragments in the Uffizi.

LA156 P.K. "Antonio da Monza." In Thieme-Becker. Vol. 2.
 Leipzig: Seeman, 1908, pp. 1-2.

LA157 RATTI, A. "Frate Antonio da Monza Incisore?" Rassegna
 d'arte 12 (1912):133-39, 16 b&w illus.
 Questions Hill's attribution of engravings to Antonio.

LA158 CUTOLO, A[LESSANDRO]. L' "Officium parvulum beatae Mariae
 Virginis" donato da Ludovico il Moro a Carlo VIII re di
 Francia. Milan: U. Hoepli, 1947, 52 pp., illus.
 Gives the Officium to "pseudo Antonio da Monza."

LA159 BROWN, DAVID ALAN. "The London 'Madonna of the Rocks' in
 Light of Two Milanese Adaptations." In Collaboration in
 Italian Renaissance Art. Edited by Wendy Stedman Sheard and
 John Paoletti. New Haven and London: Yale University
 Press, 1978, pp. 167-68, 8 b&w illus.
 Reference to illustration by Antonio Corradini (da Monza)
 in relation to the Madonna of the Rocks.

CRIVELLI, TADDEO

LA160 FRATI, LODOVICO. "Di Taddeo Crivelli e di un graduale da
 lui miniato, giudicato erroneamente perduto." Rivista delle
 biblioteche e degli archivi 8 (1897):1-5.
 Identifies Graduale VI della Pentecoste in Bologna, San
 Petronio, as work considered lost by Malaguzzi Valeri. Says
 left Bologna in 1476, not dead.

LA161 MALAGUZZI VALERI, FRANCESCO. "Ancora di Taddeo Crivelli e
 di un graduale erroneamente attribuitogli." Rivista delle
 biblioteche e degli archivi 8 (1897):94-95.

Disagrees with Frati's attribution. Attributes Graduale
VI to Martino da Modena, initial attribution. Reasserts
Crivelli's death in 1476.

LA162 BAER, L[EO]. "Crivelli, Taddeo." In Thieme-Becker. Vol.
 8. Leipzig: Seeman, 1913, pp. 134-36.

LA163 FRATI, LODOVICO. "Miniatori bolognese del quattrocento."
 L'arte 22 (1919):121-23.
 Cites document of 1476 concerning Crivelli for an Offices
 of the Virgin for Brumino de' Bianchi in Bologna.

LA164 BERTONI, GIULIO. Il maggiore miniatore della Bibbia di
 Borso d'Este: Taddeo Crivelli. Modena: Orlandini, 1925,
 73 pp, 10 b&w illus.
 Numerous documents concerning the Bible of Borso, as well
 as extracts from the account book of Taddeo.

FEDELI, MATTEO DE'

LA165 "Fedeli, Matteo de'." In Thieme-Becker. Vol. 11. Leipzig:
 Seeman, 1915, p. 334.

LA166 ZERI, FEDERICO. "Matteo de' Fedeli." Paragone 34, no. 401-
 3 (1983):60-63, 4 b&w illus.
 On basis of comparison with Madonna and Child with
 Angels, signed and dated 1491, in Milanese private collection,
 attributes St. Christopher, Christ Church, Oxford, and
 Crucifixion, Museo di Castelvecchio, Verona, to Matteo. Draws
 parallel with Ercole de' Roberti. Notes ties with Ferrarese
 court.

FOPPA, VINCENZO

LA167 COZZANDA, LEONARDO. Vago e curioso ristretto profano e
 sacro dell'historia bresciana. Brescia: Giov. Maria
 Rizzardi, 1694, 264 pp.
 Chap. 63 is Pittori. Mentions Foppa and lists works in
 Brescia. Buried in Brescia in San Barnaba.

LA168 VASARI, GIORGIO. Le vite de' più eccellenti pittori,
 scultori ed architettori. . . . Edited by Guglielmo della
 Valle. 6th ed. Vol. 3. Siena; Pazzini Carli & Co., 1791,
 pp. 233-34.
 Notes by Venanzio de Pagave in the life of Filarete
 describing two paintings by Foppa in SS. Annunziata, Spedale,
 Milan, illustrating the foundation of the Spedale.

LA169 CAFFI, MICHELE. "Vincenzo Foppa da Brescia: Pittore ed
 architetto." Archivio storico lombardo 5 (1878):96-106.

Artists

Summary of documents. Maestà for Sta. Maria delle Grazie
in Monza, 1465. Prophets in great cloister in Certosa, Pavia,
1465. Catalog of paintings.

LA170 CAROTTI, GIULIO. "La gran pala del Foppa nell'Oratorio di
 Santa Maria di Castello in Savona." Archivio storico
 dell'arte 8 (1895):449-65, 11 b&w illus.
 Identifies polyptych in oratory of Sta. Maria di Castello
 as "Maestà" in 1489 letter. Polyptych moved to Sta. Maria di
 Castello in 1600.

LA171 JACOBSEN, EMIL. "Die Gemälde der Einheimischen Malerschule
 in Brescia." Jahrbuch der Königlich preussichen
 Kunstsammlungen 17 (1896):19-42, 2 b&w illus.
 Traces development of Brescian painting from Foppa to the
 mid-sixteenth century. Surveys works of Foppa, Vincenzo
 Civerchio, and Floriano Ferramola.

LA172 FFOULKES, CONSTANCE JOCELYN. "Cenni su Vincenzo Foppa."
 Rassegna d'arte 2 (1902):168-73, 5 b&w illus.
 Proving that Pietà in Berlin is one described by Marcello
 Oretti as being in Chapel of S. Agostino, S. Pietro in Gessate,
 Milan. Dates ca. 1495. Payment to Vincenzo in 1495 shows
 still alive. Traces painting from seventeenth century into
 Berlin.

LA173 FFOULKES, CONSTANCE JOCELYN. "Notes on Two Pictures
 Ascribed to Vincenzo Foppa." Repertorium für
 Kunstwissenschaft 25 (1902):65-81.
 Identifies Pietà from S. Pietro in Gessate, Milan, as
 panel in Paris. Bibliography in footnotes.

LA174 FFOULKES, CONSTANCE JOCELYN. "Vincenzo Foppa e la famiglia
 Caylina di Brescia." Rassegna d'arte 2 (1902):3-5, 1 b&w
 illus.
 Documents concerning the family of Foppa's wife. Proves
 that her family came from Brescia. Land transactions. Does
 not consider Paolo da Brescia same as Paolo Caylina because no
 evidence of Foppesque influence in Turin polyptych.

LA175 FFOULKES, CONSTANCE JOCELYN, and RODOLFO MAIOCCHI. Vincenzo
 Foppa of Brescia, Founder of the Lombard School: His Life
 and Work. 2 vols. London and New York: John Lane, 1909,
 421 pp., 90 b&w illus.
 Catalogue raisonné and biography. Very rich source of
 documents and bibliography. First great monograph on Foppa.

LA176 FRIZZONI, GUSTAVO. "Vincenzo Foppa, pittore." L'arte 12
 (1909):249-60, 7 b&w illus.
 Links Foppa to Antonio Brea and Ambrogio Fossano.

LA177 MALAGUZZI VALERI, FRANCESCO. "Il Foppa in una recente
 pubblicazione." Rassegna d'arte 9 (1909):84-88, 6 b&w
 illus.
 Critical review of ffoulkes and Maiocchi (LA175).

LA178 PAULI, G[USTAV]. "Foppa, Vincenzo." In Thieme-Becker.
 Vol. 12. Leipzig: Seeman, 1916, pp. 195-7.

LA179 SUIDA, WILHELM. "Two Unknown Pictures by Vincenzo Foppa."
 Burlington Magazine 45 (1924):210-15, 2 b&w illus.
 Full-length standing figures of SS. John the Baptist and
 Dominic in Vienese private collection. Conjectures part of
 altarpiece for Spinola family chapel, S. Domenico, Genoa, ca.
 1470.

LA180 HENNIKER-HEATON, RAYMOND. "The Holy Family, Vincenzo
 Foppa." Bulletin of the Worcester Art Museum 16
 (July 1925):32-34, 1 b&w illus.
 Describes Holy Family in Worcester as illustrative of
 Foppa's artistic character.

LA181 VENTURI, ADOLFO. "Anconetta di Vincenzo Foppa." L'arte 37
 (1934):77, 1 b&w illus.
 Madonna and Child with the Averoldi blason on the back in
 collection of G. Langhi, Milan.

LA182 PARKER, K[ENNETH] T. "Justice of Trajan." Old Master
 Drawings 13 (1938):6-8, 1 b&w illus.
 Publishes Justice of Trajan in the Ashmolean, Oxford.
 Related to print by Giovanni Maria da Brescia. Connects to
 Medici bank decorations, late 1460s.

LA183 MORASSI, ANTONIO. "Pittori bresciani del rinascimento:
 Vincenzo Foppa." Emporium 89 (1939):348-58, 11 b&w illus.
 In response to a Mostra della pittura bresciana del
 rinascimento, evaluates status of Foppa in Lombardy and Liguria.
 Does not see Paduan roots, compares Ovetari and Portinari
 chapels, sees rather local Lombard origins. History of works.
 Qualities of his style.

LA184 WITTGENS, FERNANDA. Vincenzo Foppa. Milan: Alimicare
 Pizzi, 1949, 130 pp., 10 color and 105 b&w illus.
 Published after Maiocchi and ffoulkes (LA175). States
 greater concern with the works and style than documents. Dis-
 putes some attributions. Two principal phases with break at
 Portinari Chapel.

LA185 WATERHOUSE, E[LLIS] K. "The Fresco by Foppa in the Wallace
 Collection." Burlington Magazine 92 (1950):177, 1 b&w
 illus.
 Identifies the subject of the fresco as Cicero reading in
 contrast to Wittgens (LA184) identification of the subject as a
 boy reading Cicero.

Artists

LA186 BOTTARI, STEFANO. "Una tavola di Vincenzo Foppa."
 Commentari 2 (1951):201-2, 1 b&w illus.
 Publishes Madonna and Child with the Baptist and Angels
 in the Gargallo Collection, Siracusa. Dates 1488-90.

LA187 MAZZINI, FRANCO. "Il restauro degli affreschi del Foppa
 nella Cappella Portinari in S. Eustorgio." Bollettino
 d'arte, 4th ser. 36 (1951):271-77, 12 b&w illus.
 Report on the restorations of the frescoes in the
 Portinari Chapel with historical review of previous resto-
 rations since seventeenth century. Emphasis on color qualities
 of the frescoes.

LA188 SANDBERG-VAVALA, EVELYN. "Vincenzo Foppa." Burlington
 Magazine 93 (1951):134-35.
 Review of Wittgens's Vincenzo Foppa (LA184).

LA189 WITTGENS, FERNANDA. "Restauri e scoperte nel territorio
 della Lombardia." Bollettino d'arte, 4th ser. 37 (1952):72-
 77, 3 b&w illus.
 Reports restoration of the Pala Mercanti, Pinacoteca
 Tosio-Martinengo, Brescia.

LA190 RAGGHIANTI, CARLO LUDOVICO. "Il Foppa e le vetriere del
 Duomo di Milano." Critica d'arte, n.s. 1 (1954):520-43, 32
 b&w illus.
 Criticizes attributions of Monneret de Villard (LC90).
 Gives cartoons for the New Testament cycle to Foppa. Gives
 some windows to Master "Gracile," Cristoforo de' Mottis, and
 Nicolò da Varallo.

LA191 PANAZZA, GAETANO. "Vetrate pavesi." Critica d'arte, n.s. 2
 (1955):252-55, 6 b&w illus.
 Attributes window in Sta. Maria del Carmine, Pavia, to
 Foppa. Dates on basis of identity of donor to 1482-89. At-
 tributes three occuli in S. Lanfranco, Pavia, to Bernardino
 Lanzani.

LA192 RAGGHIANTI, CARLO LUDOVICO. "Postilla foppesca." Critica
 d'arte, n.s. 2 (1955):285-92, 11 b&w illus.
 Reevaluates the question of role of Foppa in the Milan
 Cathedral windows after criticisms by Samek-Ludovici. Retains
 earlier opinions.

LA193 TESTORI, GIOVANNI. "Un 'San Sebastiano' del Foppa."
 Paragone 87 (1957):56-59, 1 b&w illus.
 Dates St. Sebastian in a private collection to ca. 1470,
 draws a parallel with St. Jerome, Academia Carrara, Bergamo.

LA194 ROTONDI, PASQUALE. Vincenzo Foppa in Santa Maria di
 Castello a Savona. Genoa: Soprintendenza alle gallerie ed
 opere d'arte della Liguria, 1958, 45 pp., 52 illus.

Small monograph on painting. Particular attention to
relationship between paintings in the polyptych and sculptures
that decorated it.

LA195 ARSLAN, EDOARDO. "Foppa, Vincenzo." In Encyclopedia of
 World Art. Vol. 5. New York, London and Toronto: McGraw
 Hill, 1961, cols. 508-10, 1 color and 7 b&w illus.
 Account of stylistic development. Attributions.
 Bibliography.

LA196 ARSLAN, EDOARDO. "Vincenzo Foppa." In La storia di
 Brescia. Brescia: Morcelliana, 1963, pp. 929-48, numerous
 b&w and color illus.
 Biography of Foppa. Considers 1462 as crucial year in
 which reputation established. Maturity from 1467 to 1489.
 From return to Brescia in 1489 to 1515-16, year of his death,
 last section. Sees influence of Venetian contacts. Extensive
 bibliography.

LA197 TORRITI, PIETRO. "Contributo a Vincenzo Foppa." Arte
 lombarda 8, no. 2 (1963):112-13, 1 color illus.
 Dead Christ with Angel in a Milanese private collection
 to Foppa, dates 1460-70.

LA198 PANAZZA, GAETANO. "Dipinti bresciani inedite del
 rinascimento." In Scritti sulla storia d'arte in onore di
 Mario Salmi. Vol. 2. Rome: De Luca editore, 1969, pp.
 429-38, 8 b&w illus.
 Attributes Madonna and Child, Chiesa della Purità di
 Maria Vergine, Brescia, to Vincenzo Foppa. Suggests Johnson
 Madonna possibly copy of the Brescia work.

LA199 DALAI EMILIANI, MARISA. "Per la prospettiva 'padana':
 Foppa rivisitato." Arte lombarda 16 (1971):117-36, 24 b&w
 illus.
 Through nineteenth century, Foppa characterized as master
 of perspective. Twentieth century (Wittgens, Longhi), idea
 changed. Tests Foppa's use of mathematical perspective in
 selected works. Finds selective use. More flexible than
 Tuscans. Filarete as possible source of knowledge of
 perspective.

LA200 SALMI, MARIO. "Masaccio e Vincenzo Foppa." Commentari 25
 (1974):24-28, 4 b&w illus.
 Demonstrates dependence of Adoration of Magi, Sta. Maria
 di Castello, Genoa, by Foppa, on Adoration of Magi from Pisa
 Polyptych by Masaccio.

LA201 FRANGI, GIUSEPPE. Foppa: Lo stendardo di Orzinuovi.
 Brescia: Grafo edizioni, 1977, 53 pp., 13 b&w and 7 color
 illus.

Artists

Small monograph on the <u>Standard</u> <u>of</u> <u>Orzinuovi</u> in the
Brescia Museum. Documents, style in relation to Foppa's other
works and Lombard painting. History of the object.

LA202 BERNSTEIN, JoANNE GITLIN. "Science and Eschatology in the
 Portinari Chapel." <u>Arte</u> <u>lombarda</u> 60 (1981):33-40, 7 b&w
 illus.
 Relates bands of color in the dome of Portinari Chapel to
Aristotelean notions of gradation of light as transmitted by
Oresme, and to rainbow. Rainbow as allegorical image of bea-
tific vision.

LA203 SCOTTI, GIUSEPPINA. "Alcune ipotesi di lettura per gli
 affreschi della Capella Portinari alla luce degli scritti di
 S. Antonino vescovo di Firenze." <u>Arte</u> <u>lombarda</u> 64
 (1983):65-78, 15 b&w illus.
 Visual roots of <u>Annunciation</u> in Masolino and examples
from the Veneto, the <u>Assumption</u> in Paduan and Lombard examples.
Iconography of the Portinari Chapel as a whole and <u>Annunciation</u>
and <u>Assumption</u> in particular linked to <u>Summa</u> of S. Antonino.

FOSSANO, AMBROGIO DA (BERGOGNONE)

LA204 BELTRAMI, LUCA. "L'Incoronazione della Vergine dipinta da
 Ambrogio Fossano, detto il Bergognone nell'abside della
 basilica di San Simpliciano in Milano." <u>Archivio</u> <u>storico</u>
 <u>dell'arte</u> 6 (1893):25-31, 4 b&w illus.
 Primarily condition report with statement about need for
restoration.

LA205 GRUYER, GUSTAVE. "Une fresque du Borgognone dans l'Eglise
 de San-Simpliciano à Milan." <u>Gazette</u> <u>des</u> <u>beaux-arts</u>, 3d
 ser. 9 (1893):484-91, 3 line drawings.
 Examination of <u>Coronation</u> <u>of</u> <u>the</u> <u>Virgin</u> and description.
Compares with the <u>Coronation</u> in Sta. Maria della Consolazione,
Ferrara, which he attributes to Mazzolino. Dates Bergognone to
first quarter of sixteenth century.

LA206 BELTRAMI, LUCA. <u>Ambrogio</u> <u>Fossano,</u> <u>detto</u> <u>il</u> <u>Bergognone</u>.
 Milan: Tip. Lombardi, 1895, 139 pp.
 Short, factual monograph. Attributions.

LA207 BELTRAMI, LUCA. "Ambrogio Fossano, detto il Bergognone."
 <u>Emporium</u> 1 (1895):339-45, 6 b&w illus.
 First period, 1488-94, richest and most brilliant. Work
in the Certosa. Middle period, 1494-1514, new interest in
perspective. Return to Certosa 1514-22, fusion of color.
Preference for religious subject matter and treatment.

LA208 FABRICZY, KARL von. "Ein Bild von Ambrogio Borgognone."
 <u>Repertorium</u> <u>für</u> <u>Kunstwissenschaft</u> 18 (1895):325-26.

Summary of article by Diego Sant'Ambrogio reporting dis-
covery of Baptism of Christ signed and dated (Ambrosius de
Fossano, 1506) in sacristy of parish church at Melegnano.

LA209 LOESER, CHARLES. "La collection Beckerath au cabinet des
 estampes de Berlin." Gazette des beaux-arts, 3d ser. 29
 (1903):47-59, 6 b&w illus.
 Illustrates a drawing of the Coronation of the Virgin,
lunette format, which he relates to the S. Simpliciano, Milan,
Coronation. Also publishes drawing of a kneeling man by
Bramantino.

LA210 ANGELINI, LUIGI. "Di una Vergine del Bergognone in Burligo
 (Bergamo)." Rassegna d'arte 7 (1907):76-77, 1 b&w illus.
 Panel painting of standing Virgin with standing Christ
Child. Dates 1500-15.

LA211 FFOULKES, CONSTANCE JOCELYN, and RODOLFO MAIOCCHI. "Intorno
 al pittore Ambrogio Bergognone." L'arte 12 (1909):203-4.
 Suggests that there are two painters who appear under the
name Ambrogio Bergognone: Ambrogio di Stefano di Milano
(Fossano) and Ambrogio di Giorgio, pavese.

LA212 SANT'AMBROGIO, DIEGO. "Una tavola del Borgognone in Liguria
 nella Chiesa di San Francesco di Recco." Arte e storia 28
 (1909):236-42, 1 b&w illus.
 A panel with the Crucifixion including the Virgin, St.
John, and the Magdalen. Dated 1506.

LA213 ZAPPA, GIULIO. "Nota sul Bergognone." L'arte 12 (1909):51-
 62, 108-118, 6 b&w illus.
 Discussion of the stylistic development of Bergognone,
four periods with different influences.

LA214 MALAGUZZI VALERI, FRANCESCO. "Borgognone, Ambrogio di
 Stefano." In Thieme-Becker. Vol. 4. Leipzig: Seeman,
 1910, pp. 358-60.

LA215 CAGNOLA, GUIDO. "Note intorno a quadri italiani in una
 galleria tedesca." Rassegna d'arte 13 (1913):1-4, 1 b&w
 illus.
 Collection Raczynski, Posen, includes a SS. Christopher
and George with the Virgin triptych by Ambrogio da Fossano.

LA216 CAGNOLA, GUIDO. "Intorno al Bergognone." Rassegna d'arte
 14 (1914):217-22, 8 b&w illus.
 Tracing work of Bergognone in various museums and
collections.

LA217 CALDERARA-BRUCHI, ANTONIA. "Ambrogio Bergognone et les
 peintres primitifs de Lombardie." La Revue de l'art ancien
 et moderne 27 (1920):27-36, 104-14, 9 b&w illus.

Artists

Sketches in history of fifteenth-century Lombard painting
beginning with Michelino and Zavattari. Defines Foppa as typ-
ical of school, large masses, simple poses, perspective con-
struction. Carried to pupils/follower Butinone, Zenale, and
Civerchio. Bergognone as culmination and synthesis. Emphasis
on Pavia.

LA218 BURROUGHS, BRYSON. "The Assumption of the Virgin by
 Bergognone." Bulletin of the Metropolitan Museum of Art 22
 (1927):144-46, 2 b&w illus.
 Brief sketch of provenance. Dates ca. 1520-22. Apostles
 in the frame from earlier altarpiece.

LA219 MORASSI, ANTONIO. "Un affresco di Ambrogio e alcune opere
 di Bernardino Bergognone." Bollettino d'arte, 2d ser. 10
 (1930-31):448-60, 12 b&w illus.
 Christ in the Winepress, Church of the Incornata, Milan,
 first decade of the sixteenth century. Notes about iconography
 of the image.

LA220 APRÀ, NIETTA. Ambrogio da Fossano detto il Bergognone.
 Milan: G.G. Gorlich, 1945, 91 pp., 90 b&w illus.
 Summary text with a small bibliography and numerous il-
 lustrations. Confluence of Northern and Paduan tendencies in
 Bergognone.

LA221 SANDBERG-VAVALA, EVELYN. "Ambrogio Bergognone in a Recent
 Publication." Burlington Magazine 89 (1947):305-9, 4 b&w
 illus.
 Brief critical review of Aprà (LA220) leads to author's
 own evaluation of Bergognone's work. Suggests abilities as a
 landscape painter evident in his backgrounds.

LA222 MAZZINI, FRANCO. Bergognone. Milan: Scuola editrice,
 1948, 122 pp., 14 b&w illus.
 Monograph. Biography and attributions.

LA223 GENGARO, MARIA LUISA. "Un precedente del Bergognone,
 Leonardo de Ponzoni." Arte lombarda 1 (1955):72-75, 5 b&w
 illus.
 Gives fresco of the Madonna in the Palazzo Borromeo to
 Leonardo de Ponzoni and relates his work to Bergognone's.
 Other frescoes in the palazzo to Cristoforo Moretti and
 Michelino.

LA224 PORACCHIA, JOLANDA. "I tempi stilistici del Bergognone."
 Arte lombarda 1 (1955):76-89, 14 b&w illus.
 Observations concerning influences on Bergognone. Par-
 ticular attention to color, light, and atmosphere. Relation-
 ship to Foppa, sees more influence from world of miniaturists.

Artists

LA225 MAZZINI, FRANCO. "Restauri di affreschi in Lombardia con
 notizia di opere poco note." Bollettino d'arte, 4th ser. 41
 (1956):182-89, 2 b&w illus.
 Notice of the restoration of Bergognone fresco of Funeral
 of S. Ambrose, Chapel of St. Martin, S. Pietro in Gessate,
 Milan.

LA226 MAZZINI, FRANCO. "Agguinte al Bergognone." Paragone 87
 (1957):59-62, 2 b&w illus.
 From ca. 1480, Christ with Two Angels, in the Museo del
 Castello, Milan; and SS. Peter and John the Baptist, Suida
 Collection, New York.

*LA227 BRAMBILLA, ANTONIO. La sacrestia di S. Maria della Passione
 ed il ciclo pittorico del Bergognone. Milan: Unione
 tipografica, 1959, 6 pp., 21 plates.
 Cited in Bibliografica del libro d'arte italiano.
 Vol. 2., pt 2. Rome: Carlo Bestetti edizioni d'arte, 1952-62,
 p. 259.

LA228 PORACCHIA, JOLANDA. Il Bergognone (Ambrogio da Fossano)
 1455 c.-1523. Milan: Edizioni del milione, 1963, 39 pp.,
 47 b&w and 3 color illus.
 Small monograph. Biographical data and stylistic devel-
 opment. Influence of Leonardo emphasized.

*LA229 VALSECCHI, MARCO. Il Bergognone a S. Simpliciano: Con una
 nota sui restauri a curi di Franco Mazzini. Milan: Cassa
 di risparmio, 1964, 55 pp., 14 color and 4 b&w illus.
 Cited in Repetoire d'art e archéologie, n.s. 2 (1966):222,
 no. 4811.

*LA230 MAZZINI, FRANCO, ANTONIO BRAMBILLA, and PININ BARCILON. Un
 capolavoro lombardo quasi ignorati: Il trittico di S. Maria
 di Crescenzago e il suo recente restauro. Milan: Lions
 Club, 1966, 4 pp., illus.
 Cited in Repetoire d'art e archéologie, n.s. 4 (1968):310,
 no. 6782. Attributes the triptych to Bergognone.

LA231 GILBERT, CREIGHTON. "Two composition drawings by
 Bergognone." Master Drawings 6 (1968):3-20, 6 b&w illus.
 St. Augustine liberating the prisoners of Pavia
 (Sarasota, Ringling Museum) and St. Augustine enrolling in the
 University of Carthage (New York, collection of Janos Scholz).

LA232 BORA, GIULIO. "Due secoli d'arte a Milano: La pittura in
 Santa Maria della Passione." In Santa Maria della Passione
 e il Conservatorio Giuseppe Verdi a Milano. Fontes
 ambrosiana, vol. 66. Milan: Silvana, 1981, pp. 82-162, 30
 b&w illus. and color illus.
 Bergognone frescoes in the Sala capitolare, depicting
 Christ with the Apostles, Church Fathers, and Saints. Geometric

relationship of the paintings to the space. Details in the
illustrations.

LA233 SANNAZZARO, GIOVANNI BATTISTA. "Alcune precisazioni sul
 'Battesimo di Cristo' del Bergognone a Melegnano." Arte
 lombarda 60 (1981):114-17, 6 b&w illus.
 Precise reading of inscription on the Baptism in
 Melegnano. Dated 1506. History of the painting in the seven-
 teenth and eighteenth centuries. Documents restoration in 1903.

LA234 SHELL, JANICE. "Two documents for Bergognone's Melegnano
 Altarpiece." Archivio lombardo 64 (1983):99-103.
 Contract for the Melagnano Altarpiece, 1505, details the
 contents. Receipt for payment for the altarpiece out of the
 legacies of Pietro and Ludovico Osnago.

GALOPINI, GIACOMO

LA235 PORTIOLI, ATTILIO. "Giacomo Galopini, prete e miniatore
 mantovano del secolo XV." Archivio storico lombardo, 3d
 ser. 6 (1899):330-47.
 Documents concerning illuminations from 1416 to 1431.

GAZIS, LUDOVICO DE

LA236 SUIDA, WILLIAM [WILHELM]. "Il Graduale di Ludovico De
 Gazis, Cremonese." Arte lombarda 4, no. 2 (1959):253-60, 9
 b&w and 6 color illus.
 Signed and dated (1489) Graduale in the collection of
 H.P. Kraus, New York, by otherwise unknown artist. Relates to
 Cremonese art in third quarter of fifteenth century.

GIOVANNI D'UGOLINO DA MILANO

LA237 VITALI ROSATI, URIELE. "Il messale di Giovanni di Maestro
 Ugolino miniatore milanese." L'arte 13 (1910):469-72, 2 b&w
 illus.
 Publishes missal in cathedral treasury in Fermo. Done
 for the bishop of Fermo. Description of the illuminations.

LA238 "Giovanni di Ugolino da Milano." In Thieme-Becker. Vol.
 14. Leipzig: Seeman, 1921, p. 146.

GIROLAMO DA CREMONA

LA239 BERENSON, BERNARD. "An Altarpiece by Girolamo da Cremona."
 In The Study and Criticism of Italian Art. 2d ser. London:
 Bell & Sons, 1902, pp. 97-110, 5 b&w illus. Reprint.
 Berenson, Bernard. Rudiments of Connoisseurship. New York:
 Schocken, 1962, pp. 97-111.
 Through Morellian analysis attributes altarpiece with
 Christ, Four Saints, and a Donor, Cathedral, Viterbo, to
 Girolamo.

LA240 BERENSON, BERNHARD. "Una nuova pittura di Girolamo da
 Cremona." Rassegna d'arte 7 (1907):33-35, 4 b&w illus.
 Nativity in the Jarves Collection, New Haven, and Poppea
 and St. Peter in the Regiate Priory, collection of Lady Henry
 of Somerset.

LA241 CAGNOLA, GUIDO. "Un altra natività di Girolamo da Cremona."
 Rassegna d'arte 7 (1907):78, 1 b&w illus.
 Nativity in the shop of the Fratelli Grandi, Milan.

LA242 PACCHIONI, GUGLIELMO. "Belbello da Pavia e Girolamo da
 Cremona, miniatori: Un prezioso messale gonzaghesco del
 secolo XV." L'arte 18 (1915):241-52, 343-72, 31 b&w illus.
 Discussion of miniatures in the Missal of Barbara of
 Brandenburg in Mantua and choral in Siena.

LA243 BERENSON, BERNARD. "A Cassone-Front in Le Havre by Girolamo
 da Cremona." In Essays in the Study of Sienese Painting.
 New York: F. Fairchild Sherman, 1918, pp. 52-56, 3 b&w
 illus.
 Attributes cassone-front with the Rape of Helen in Le
 Harve to Girolamo da Cremona.

LA244 TOESCA, PIETRO. "Un dipinto di Girolamo Cremona." Rassegna
 d'arte 18 (1918):141-43, 3 b&w illus.
 Attributes Annunciation, Accademia dei belle arti, Siena,
 to Girolamo.

LA245 BAER, L[EO]. "Girolamo da Cremona." In Thieme-Becker.
 Vol. 14. Leipzig: Seeman, 1921, pp. 184-85.

LA246 SALMI, MARIO. "Girolamo da Cremona miniatore e pittore."
 Bollettino d'arte, 2d ser. 2 (1922-23):385-404, 26 b&w
 illus., 461-78, 21 b&w illus.
 Biography, works, and chronology. Sienese influence.
 Attributes Hercules scenes in Palazzo Venezia, Rome, to Girolamo.

LA247 FOGOLARI, GINO. "Le più antiche pitture di Girolamo da
 Cremona." Dedalo 5 (1924-5):67-85, 15 b&w illus.
 Polyptych in the Church of Sant'Andrea, Asola, as earli-
 est work by Girolamo. Twenty-seven panels. Dates between
 1460-70.

LA248 BOECK, WILHELM. "Quattrocento Painting in the Kaiser
 Friedrich Museum." Burlington Magazine 64 (1934):29-35,
 8 b&w illus.
 In response to rearrangement of museum new and recon-
 firmed attributions including attribution of Healing of a Lame
 Man to Girolamo da Cremona.

LA249 ZERI, FEDERICO. "Una pala d'altare di Girolamo da Cremona."
 Bollettino d'arte, 4th ser. 35 (1950):35-42, 10 b&w illus.

Artists

Attributes <u>Madonna</u> <u>and</u> <u>Child</u> <u>with</u> <u>SS.</u> <u>Benedict</u> <u>and</u>
<u>Francesca</u> <u>Romana</u> from sacristy of Sta. Maria Nova, Rome, to
Girolamo. Dates ca. 1472, for Benedictines in Monteoliveto or
Siena, then sent to Rome.

LA250 LEVI d'ANCONA, MIRELLA. "A Baptism of Constantine by
 Girolamo da Cremona." In <u>Essays</u> <u>in</u> <u>the</u> <u>History</u> <u>of</u> <u>Art</u>
 <u>Presented</u> <u>to</u> <u>Karl</u> <u>Lehman</u>. New York: New York University
 Press, 1964, pp. 74-86, 5 b&w illus.
 Publishing illumination in Wildenstein Collection, Paris.

LA251 LEVI d'ANCONA, MIRELLA. "Postille a Girolamo da Cremona."
 In <u>Studi</u> <u>di</u> <u>bibliografica</u> <u>e</u> <u>di</u> <u>storia</u> <u>in</u> <u>onore</u> <u>di</u> <u>Tammaro</u> de
 <u>Marinis</u>. Vol. 3. Verona: Stamperia Valdonega, 1964, pp.
 45-50, 13 b&w illus.
 Discusses <u>Baptism</u> <u>of</u> <u>Constantine</u> by Girolamo. Dates
 1451. Documents work of Girolamo in Siena and Monteoliveto
 Maggiore.

LA252 ADORISIO, ANTONIO. "Carlo Crivelli, Girolamo da Cremona e
 Franco de' Russi in incunaboli miniati della Biblioteca
 Casanatense." <u>Accademie</u> <u>e</u> <u>biblioteche</u> <u>d'Italia</u> 40
 (1972):27-34, 9 b&w illus.
 Attribution of Livy, <u>Historiae</u> <u>Romanae</u>, to Girolamo.
 Sees influence of Donatello and Mantegna in Veneto.

LA253 FURLAN, CATERINA. "I 'Trionfi' della collezione Kress: Una
 proposta attributiva e divagazione sul tema." <u>Arte</u> <u>veneta</u>
 27 (1973):81-90, 21 b&w illus.
 Attributes the miniatures to Girolamo da Cremona.

LA254 RIGHETTI, MARINA. "Indagine su Girolamo da Cremona." <u>Arte</u>
 <u>lombarda</u> 41 (1974):32-42, 18 b&w illus.
 Influence of Girolamo on contemporaries. Hypothesizes
 participation in <u>Bible</u> <u>of</u> <u>Borso</u> d'Este. Attributes miniatures
 previously given to Marco dell'Avogaro. Also attributes <u>Adora-</u>
 <u>tion</u> <u>of</u> <u>Magi</u> and <u>Trumpeting</u> <u>Angel</u> in Piccolomini Library,
 Siena, to Girolamo.

IPPOLITA MASTER

LA255 HUBARY, ILONA. "Eine Humanistenhandschrift aus der
 'Biblioteca Sforza' in der Landesbibliotek Coburg."
 <u>Jahrbuch</u> <u>Coburger</u> <u>Landesstiften</u> (1961):27-32, 1 color
 and 4 b&w illus.
 Eight miniatures in the <u>Bucolics</u> of Bonino Mombrizio
 attributed to the <u>Ippolita</u> Master.

MAINERI, CARLO

LA256 ODERICO, GASPARO LUIGI. "Osservazioni sopra alcuni codici
 della libreria di G. Filippo Durazzo." <u>Giornale</u> <u>ligustico</u>

di archeologia, storia e belle arti 7-8 (1880):2-27, 44-64,
95-120, 142-56, 180-94, 236-47, 273-88, 299-330, 331-62.
 Codex 7 (pp. 56-57) a Psalter, signed and dated 1472, by
Carlo Maineri, sacerdote cremonese. Describes other fifteenth-
century and earlier codices by anonymous artists.

LA257 "Miniatori lombardi." Archivio storico lombardo, 3d ser. 1
 (1894):501-2.
 Mentions Carlo Maineri among miniaturists.

MASTER OF THE PALA SFORZESCA

LA258 MALAGUZZI VALERI, FRANCESCO. "Il Maestro della Pala
 sforzesca." Rassegna d'arte 5 (1905):44-48, 6 b&w illus.
 Rejects identification of Zenale as Master. Attributes
 drawings in British Museum and Ambrosiana, and Madonna and
 Child with St. Rocco and a Donor, Collection Cora, Turin, to
 Master.

LA259 JACOBSEN, EMIL. "Un quadro e un disegno del Maestro della
 Pala sforzesca." Rassegna d'arte 10 (1910):53-55, 2 b&w
 illus.
 Attributes a Holy Family in Seminario, Venice, and a
 drawing of a head in the Borghese, Rome, to the Master of the
 Pala sforzesca.

LA260 SALMI, MARIO. "Nuove attribuzione al Maestro della Pala
 sforzesca." Cronache d'arte (1927):388-97, 7 b&w illus.
 Attributes five small oval panels with Apostles in the
 Museo di Castello, Milan. Identifies Master as Jacopo de'
 Mottis.

LA261 SUIDA, WILHELM. Leonardo und sein Kreis. Munich:
 F. Bruckmann, 1929, 327 pp., 192 b&w illus.
 Catalog of works attributed to Master of the Pala
 sforzesca, pp. 283-84.

LA262 "Meister der Pala sforzesca." In Thieme-Becker. Vol. 37.
 Leipzig: Seeman, 1950, p. 262.

LA263 BINAGHI OLIVARI, MARIA TERESA. "Il ciclo di Annone
 Brianza." In Il Maestro della Pala sforzesca. Quaderni di
 Brera, no. 4. Florence: Centro Di, 1978, pp. 25-30, 26 b&w
 illus.
 Attributes the cycle of frescoes, Crucifixion with
 Virgin, St. John the Evangelist, and SS. George and Ambrose, in
 the presbytery of the Church of St. George in Annone Brianza
 (Como) to the Master. Influence of Bramante and Leonardo.
 Work in turn influencing Marco d'Oggiono.

LA264 COLLURA, DOMENICO. "Richerche sull'armatura del San Giorgio
 ad Annone Brianza." In Il Maestro della Pala sforzesca.

Artists

Quaderni di Brera, no. 4. Florence: Centro Di, 1978, pp. 31-32, 1 b&w illus.
Armor tied to Italian models between 1490 and 1510, with some small anachronisms.

LA265 GREGORI, MINA. "Per un 'San Gerolamo' dell' Accademia Carrara in Bergamo." In Essays presented to Myron Gilmore. Edited by S. Bertelli and G. Ramakus. Vol. 2. Florence: La nuova Italia editrice, 1978, pp. 207-12, 7 b&w illus.
By stylistic comparison with other works given to the Master attributes a St. Jerome, Accademia Carrara, Bergamo, to the Master of the Pala sforzesca. Suggests it is among earliest works, before the Pala. Contemporary with Foppa and Bergognone.

LA266 ROMANO, GIOVANNI. "La Pala sforzesca." In Il Maestro della Pala sforzesca. Quaderni di Brera, no. 4. Florence: Centro Di, 1978, pp. 7-23, 25 b&w illus.
Sketch of the courtly environment of Lodovico il Moro within which the pala was produced. Rejects Ambrogio de Predis as the Master. Notes work as superficial reaction to the values of Leonardo and Bramante but still fundamentally "old-fashioned." In notes mention of Marco Longobardi, Master of San Rocco a Pallanza, and Ludovico de Donati.

LA267 MULAZZANI, GERMANO. "Un aggiunta al 'Maestro della Pala sforzesca.'" Arte lombarda 51 (1979):22-23, 2 b&w illus.
Attributes Madonna and Child Enthroned in the apse of Church of Sta. Maria delle Grazie, Monasterolo di Inzago (Milano), to the Master of the Pala sforzesca.

MASTER OF THE VITAE IMPERATORUM

LA268 STONES, ALISON. "An Italian Miniature in the Gambier-Parry Collection." Burlington Magazine 111 (1969):7-12, 7 b&w illus.
"C" from Olivetan choirbook in the G-P Collection and "D" and "L" from an Olivetan choirbook in the Pierpont Morgan Library (M558B/A) on basis of style in the circle of the Master of the Vitae Imperatorum. Bibliography. Checklist of works by Master and circle.

LA269 TOESCA, ILARIA. "In margine al 'Maestro delle Vitae Imperatorum.'" Paragone 237 (1969):73-76, 12 b&w illus.
Additions to the catalog of works cited by Alison Stones.

MEDICI DA CREMA, GIOVAN PIETRO

LA270 LEVI d'ANCONA, MIRELLA. "A Masterpiece by Giovan Pietro Medici da Crema in the Wildenstein Collection." Commentari, n.s. 22 (1971):164-71, 6 b&w illus.
Annunciation and Nativity in the Wildenstein Collection in Paris.

LA271 HAHNLOSER, H[ANS] R. "Johannes Petrus de Medicis, Crema.
 Graduale eines verschollenen lombardischen Miniators." In
 Festschrist Arnold Geering. Bern and Stuttgart: Francke,
 1972, pp. 159-65, 7 b&w illus.
 Nativity of Christ from Graduale in the collection of
 J.B. Conant, New York, ca. 1490.

 MONTORFANO, GIOVANNI DONATA DA

LA272 BELTRAMI, LUCA. "Donato Montorfano e la collaborazione di
 Leonardo nella 'Crocefissione' del refettorio di S. Maria
 delle Grazie." Rassegna d'arte 21 (1921):217-32, 11 b&w
 illus.
 Evaluation of contribution of Leonardo. Concludes possi-
 ble minimal intervention of Leonardo in donor and page.

LA273 SALMI, MARIO. "Gli affreschi scoperti in Sta. Maria delle
 Grazie a Milano." Bollettino d'arte, 2d ser. 8 (1928):3-13,
 8 b&w illus.
 Story of SS. Catherine of Alexandria and Catherine of
 Siena in the Cappella Bolla. Fourth-quarter of fifteenth cen-
 tury with temporary break in the decorations ca. 1490. History
 of Bolla family.

LA274 MAZZINI, FRANCO. "Restauri di affreschi in Lombardia con
 notizia di opere poco note." Bollettino d'arte, 4th ser. 41
 (1956):182-9.
 Restoration of the Crucifixion in refectory of Sta. Maria
 delle Grazie, Milan, by Montorfano, and decorative frieze with
 heads of Benedictines by Bernardino de' Rossi.

LA275 REBERSCHAK, SANDRA. "Contributo alla conoscenza del
 Montorfano." Critica d'arte 38 (1960):126-48, 27 b&w illus.
 Work of Montorfano and Nicolò da Varallo in S. Pietro in
 Gessate, Sta. Maria delle Grazie, and Chiesa della Rosa, Milan.
 Attributes Saints from Chiesa della Rosa, now Ambrosiana, to
 Montorfano.

LA276 VERTOVA, LUISA. "A Dismembered Altar-piece and a Forgotten
 Master--I & II." Burlington Magazine 111 (1969):70-79, 112-
 21, 25 b&w illus.
 Primarily Bevilacqua, but gives Obiano Altar in Cappella
 di S. Antonio, S. Pietro in Gessate, Milan, and Cappella della
 Vergine e S. Giuseppe, S. Pietro in Gessate, to Montorfano.

 MORETTI, CRISTOFORO

LA277 CAFFI, MICHELE. "Arte e dolori." Archivio storico lombardo
 6 (1879):565-75.
 Loss of paintings of Casale Monferrato. Letter of
 Moretti to Galeazzo-Maria Sforza, 1474, and other documents
 from 1450s and 1460s.

Artists

LA278 MALAGUZZI VALERI, FRANCESCO. "Cristoforo Moretti e
 l'influsso di Pisanello nella scuoli lombarda." In <u>Pittori</u>
 <u>lombardi</u> <u>del</u> <u>quattrocento</u>. Milan: L.F. Cogliati, 1902, pp.
 79-94.
 Discusses Moretti in context of influence of Pisanello.
 Also refers to Michelino da Besozzo and Zavattari vis-à-vis
 ambient in which Moretti working.

LA279 LONGHI, ROBERTO. "'Me Pinxit': I resti del polittico di
 Cristoforo Moretti già in Sant'Aquilino di Milano." In
 <u>Opera</u> <u>Complete</u>. Vol. 2, <u>"Me</u> <u>Pinxit"</u> <u>e</u> <u>quesiti</u>
 <u>caravaggeschi:</u> <u>1928-34</u>. Florence: Sansoni, 1968,
 pp. 75-79, 5 b&w illus.
 Originally published in 1928. Defines character of
 Moretti and reconstructs dispersed polyptych from
 Sant'Aquilino.

LA280 "Moretti, Cristoforo." In Thieme-Becker. Vol. 25.
 Leipzig: Seeman, 1931, p. 142.

LA281 DEGENHART, BERNHARD. "Eine Lombardische Kreuzigung."
 <u>Propozioni</u> 3 (1950):65-68, 22 b&w illus.
 Attributes <u>Crucifixion</u>, formerly in Berlin, and <u>Titus</u>
 <u>Livius</u> in the Vatican to Cristoforo Moretti. Places in circle
 of Belbello and Michelino.

LA282 GENGARO, MARIA LUISA. "Aggiunte per la storia della pittura
 lombarda del secolo XV." <u>Bollettino</u> <u>d'arte</u>, 4th ser. 39
 (1954):296-305, 16 b&w illus.
 Frescoes in the Casa Borromeo. History of monuments.
 Connects through the Borromeo accounts with Michelino da Besozzo
 and Cristoforo Moretti.

 MOTTIS, AGOSTINO AND CRISTOFORO DE'

LA283 SALMI, MARIO. "Maestri lombardi del quattrocento: Agostino
 de' Mottis." <u>Bollettino</u> <u>d'arte</u>, 2d ser. 8 (1928):193-201, 8
 b&w illus.
 Son of Cristoforo de' Mottis, worked in Pavia in the
 Certosa on stained glass, and in S. Pietro in Gessate, Milan.
 Archaistic style. Circle of Foppa, Zenale, and Butinone.

LA284 "Motti, Cristoforo." In Thieme-Becker. Vol. 25. Leipzig:
 Seeman, 1931, pp. 196-97.

LA285 PIRINA, CATERINA GILLI. "Precisazioni su Cristoforo de'
 Mottis." <u>Arte</u> <u>in</u> <u>Europa:</u> <u>Scritti</u> <u>di</u> <u>storia</u> <u>dell'arte</u> <u>in</u>
 <u>onore</u> <u>di</u> <u>Edoardo</u> <u>Arslan</u>. Vol. 1. Milan: n.p., 1966, pp.
 407-30, 3 b&w illus.
 Consideration based on documentation, style, and icon-
 ography as to what part Mottis played in the S. Giovanni

Evangelista window, Milan Cathedral, and what part by the Frate
Gesuati. Rejects notion of Master Gracile.

FRATE NEBRIDIO

LA286 LEVI d'ANCONA, MIRELLA. "Frate Nebridio. Il maestro del
messale Mainardi." Arte lombarda 7, no. 2 (1963):87-92, 4
b&w illus.
Describes oeuvre of Frate Nebridio using the signed min-
iature in the Museo civico, Bologna, as touchstone. Close to
Belbello. Attributes Breviary in Oxford and Breviary in the
Brera, Milan.

LA287 BANDERA, SANDRA. "Persistenza tardogotiche a Cremona:
Frate Nebridio e altri episodi." Paragone 323 (1977):34-72,
32 b&w illus.
Background of patronage in Cremona in mid-fifteenth cen-
tury. Continuation of courtly taste in Lombard region, influ-
ence of Sforza. Attributions to Frate Nebridio.

PONZONI, LEONARDO DE

LA288 "Ponzoni, Leonardo." In Thieme-Becker. Vol. 27. Leipzig:
Seeman, 1933, p. 255.

LA289 GENGARO, MARIA LUISA. "Un precedente del Bergognone,
Leonardo de Ponzoni." Arte lombarda 1 (1955):72-75, 5 b&w
illus.
Attributes the Madonna fresco in the Palazzo Borromeo to
Leonardo de Ponzoni and relates his work to Bergognone's.

PREDIS, AMBROGIO DE

LA290 BODE, WILHELM von. "Ein Bildnis der zweiten Gemälin
Kaiser Maximilians, Bianca Maria Sforza, von Ambrogio de
Predis." Jahrbuch der Königlich preussichen Kunstsammlungen
10 (1889):71-79, 3 b&w illus.
Identifies a profile portrait in a private collection in
Berlin as by Ambrogio by drawing parallels with one in the
Ambrosiana. Notes the monogram of Ambrogio on portrait in the
Salting Collection, London.

LA291 MOTTA, EMILIO. "Ambrogio Preda e Leonardo da Vinci."
Archivio storico lombardo, 2d ser. 10 (1893):972-96.
Documents concerning Ambrogio's activity in Germany in
late 1490s.

LA292 HEWETT, A. EDITH. "A Newly Discovered Portrait by Ambrogio
de Predis." Burlington Magazine 10 (1906-7):308-14, 3 b&w
illus.
Portrait of Lucrezia Crivelli(?) in the collection of the
Earl of Roden.

Artists

LA293 SUIDA, WILHELM. "Ambrogio da Preda und Leonardo da Vinci."
 Jahrbuch der Kunsthistorischen Sammlungen des allerhöchsten
 Kaiserhauses 26 (1906):1-48, 23 b&w illus.
 Begins with review of the literature and attributions,
 particularly question of relationship to Pala sforzesca, the
 London Madonna of the Rocks, and various drawings. Relation-
 ship to Zenale and Bernardino dei Conti. Factual biography.
 Attributions also to Boltraffio and Antonio da Monza.

LA294 MATHER, FRANK JEWETT. "A Portrait of Bianca Maria Sforza."
 Burlington Magazine 11 (1907):130-31, 1 b&w illus.
 Profile portrait of Bianca Maria in the Widener Collec-
 tion, formerly in the Lippman Collection in Berlin. Jewelry
 typically Milanese. Dates to ca. 1493, time of marriage to
 Emperor Maximillan. Notes another later portrait of Bianca by
 Bernardino dei Conti in the collection of Countess Arconati-
 Visconti, Paris.

LA295 BISCARO, GEROLAMO. "La commissione della 'Vergine delle
 rocce,' a Leonardo da Vinci, secondo i documenti originali
 (25 Aprile 1483)." Archivio storico lombardo, 4th ser. 13-
 14 (1910):125-61.
 Includes text of an appeal to the duke of Milan for
 additional funds for the Madonna of the Rocks.

LA296 BODE, WILHELM von. "Leonardos Bildnis der jungen Dame mit
 dem Hermelin aus dem Czartoryski-Museum in Krakau und die
 Jugendbilder des Kunstlers." Jahrbuch der Königlich
 preussichen Kunstsammlungen 36 (1915):189-207, 11 b&w illus.
 Includes discussion of the work of Ambrogio, attributes
 the Pala sforzesca to Ambrogio (pp. 190-94).

LA297 SUIDA, WILHELM. "Predis, Ambrogio de." In Thieme-Becker.
 Vol. 27. Leipzig: Seeman, 1933, pp. 368-70.

LA298 DOUGLAS, ROBERT LANGTON. "Ambrogio de' Predis--A Portrait
 of a Lady." Art in America 34 (1946):5-7, 1 b&w illus.
 Profile portrait from Dreyfuss Collection. Suggests
 early work. Possibly portrait of Lucia Marliani, countess of
 Melzo.

LA299 WEISS, ROBERTO. "Giovanni Ambrogio Preda in Rome." Journal
 of the Warburg and Courtauld Institutes 21 (1958):297.
 Publishes document that places Giovanni Ambrogio in Rome
 in July 1491. In document calls himself illuminator.

LA300 SUIDA, WILHELM. "Giovanni Ambrogio De Predis (sic)
 miniatore." Arte lombarda 4, no. 1 (1959):67-73, 9 b&w and
 9 color illus.
 Notes Borromeo documents show Ambrogio miniaturist. At-
 tributes illuminations in an Hours of the Virgin, collection of

H.P. Kraus, New York, MS. 45, to Ambrogio. Checklist of minia-
tures. Also attributes two other illuminations and a drawing
in Venice.

LA301 TOESCA, ELENA BERTI. "Un San Giovannino discusso e
 dimenticato." In Studies in the History of Art Dedicated to
 William E. Suida on His Eightieth Birthday. London:
 Phaidon, 1959, pp. 144-45, 1 b&w illus.
 Profile half-length image of the young Saint John the
 Baptist in the Louvre attributed to circle of Ambrogio. Pre-
 viously attributed to Bianchi Ferrari by Venturi and Piero di
 Cosimo by Berenson.

PREDIS, CRISTOFORO DE

LA302 Il libro d'oro Borromeo alla Biblioteca ambrosiana: Miniato
 da Cristoforo Preda--Secolo XV. Edited by Luca Beltrami.
 Milan: U. Hoepli, 1896, 70 pp., 40 heliotype illus.
 On basis of style and the imprese dates the work between
 1476 and 1487. Suggests done for marriage of Giberto Borromeo
 to Maddalena di Brandenburg. Comparison to codex in Turin of
 1476 dates after that work. Summary of oeuvre.

LA303 "Cristoforo Preda il celebre miniature della corte ducale
 sforzesca era milanese e sordomuto." La bibliofilia
 (1911):313-18, 2 b&w illus.
 On the basis of the signatures of Cristoforo identifies
 him as Milanese and deaf and dumb.

LA304 BAER, LEO. "Predis, Cristoforo de." In Thieme-Becker.
 Vol. 27. Leipzig: Seeman, 1933, p. 370.

LA305 WITTGENS, FERNANDA. "Cristoforo de Predis." La bibliofilia
 36 (1934):341-70, 23 b&w illus.
 Attributes illuminations in a Commentary on the Bible by
 Nicolas Lira, Ambrosiana B 40 INF (owned by Federico Fregoso),
 f. 1486, to Cristoforo. Comparison with other works by artist.
 Sees roots in Belbello. Compares to Francesco da Castello.
 Sees Northern influence.

LA306 JACOBSEN, MICHAEL A. "A Sforza Miniature by Cristoforo da
 Preda." Burlington Magazine 116 (1974):91-96, 4 b&w illus.
 Miniature in the Wallace Collection (M342). Connects
 iconography with the War of the Public Weal and dates to ca.
 1510.

ROSSI, BERNARDINO DE'

LA307 DAVARI, STEFANO. "Documenti du Bernardino de' Rossi,
 pittore pavese." L'arte 2 (1899):501-2.
 Documents of 1485, 1493, and 1512.

Artists

LA308 SUIDA, WILHELM. "Rossi, Bernardino de." In Thieme-Becker.
 Vol. 29. Leipzig: Seeman, 1935, pp. 53-4.

 SUARDI, BARTOLOMEO (known as BRAMANTINO)

LA309 PAGAVE, VENANZIO de. Intorno la vita di Bramante e
 Bramantino (Bartolomeo Suardi). Milan, Biblioteca
 ambrosiana, S. 157 sup., "Vita di Bartolomeo Suardi detto il
 Bramantino," ff. 103-114v., 18th century.
 Early compilation of material on Bramantino from docu-
 ments and sixteenth- through eighteenth-century sources.

LA310 VASARI, GIORGIO. Le vite de' più eccellenti pittori,
 scultori ed architettori. . . . Edited by Guglielmo della
 Valle. 6th ed. Vol. 5. Siena: Pazzini Carli & Co., 1792,
 pp. 157-64.
 In the life of Bramante includes a life of Bramantino by
 Venanzio de Pagave. Distinguishes between Agostino Bramantino
 and Bartolomeo Suardi. Attributions to Bramantino. Publishes
 documents of 1513 (Cistercians in Rome) and 1536 (marriage of
 daughter). Also includes notes concerning Zenale.

LA311 FABRICZY, KARL von. "Ein Gemälde Bramantino's."
 Repertorium für Kunstwissenschaft 22 (1899):251-52.
 Summary of article by Diego Sant'Ambrogio from
 Perserveranza, 1898. Painting in Sta. Maria della Passione,
 Milan, grisaille of Sacrifice of Abraham.

LA312 KOOP, A.J., and HERBERT COOK. "The Bramantino Portraits
 from San Martino di Guznago." Burlington Magazine 8
 (1905-6):135-41, 6 b&w illus.
 Disputes the ascription of these portraits, which are in
 the Metropolitan Museum of Art in New York, to Bramantino.

LA313 SUIDA, WILHELM. "Die Jugendwerke des Bartolomeo Suardi
 gennant Bramantino." Jahrbuch der Kunsthistorischen
 Sammlungen des allerhöchsten Kaiserhauses 25 (1905):1-71, 57
 b&w illus.
 Pt. 1: Factual data, sources and comments from sixteenth
 through nineteenth centuries. Pt. 2: Stylistic development of
 Bramantino through 1500. Sets birth date late 1460s. Adora-
 tion of Christ Child in Ambrosiana touchstone. Stylistic in-
 fluences Butinone, G.A. Amadeo, and Ercole de' Roberti. After
 late 1480s influence of Bramante. Pt. 3: Activity in Milan
 1500-1508. Transmitter of principles of Leonardo. Triviluzio
 tapestries; S. Bartolomeo, Bergamo; choir stalls; and frescoes
 in Sta. Maria delle Grazie. List of extant, lost, and falsely
 attributed works.

LA314 SUIDA, WILHELM. "Die Spätwerke des Bartolomeo Suardi
 gennant Bramantino." Jahrbuch der Kunsthistorischen
 Sammlungen des allerhöchsten Kaiserhauses 26 (1906-7):293-
 372, 75 b&w illus.

Begins by assessing Leonardo's impact on Milanese paint-
ing. Notes Bramantino as alternative. Pt. 1: Bramantino in
Rome 1508-9. Nothing certain on which to base work in Rome
except visual impact of antiquities. Dismisses Mongeri's at-
tribution of Ruins of Rome in the Ambrosiana as being by
Bramantino. Only certain dates after 1509. Assumes very short
stay in Rome. Pt. 2: 1513 back in Lombardy, work for the
Cistercians in Rome; 1518-19 working on the Trivulzio funeral
chapel S. Nazarro, Milan; 1525 document from the Sforza. Chron-
ology of works. Publishes section in Lomazzo that reproduces
Bramantino's art theory. Pt. 3: Impact on later artists
including Luini and Gaudenzio Ferrari.

LA315 VASARI, GIORGIO. Le vite de' più eccellenti pittori,
 scultori ed architettori. . . . Annotated by Gaetano
 Milanesi. Vol. 6. Florence: Sansoni, 1973, pp. 511-13,
 527-32.
 Reprint of 1906 edition. Biography of Bramantino in
 Milanesi's commentary on the lives of Girolamo da Carpi and
 Garofalo. Notes work in Milan. Confusion of artist working in
 Vatican in mid-fifteenth century. Cites his abilities at fore-
 shortening. Collection of drawings of architectural monments
 in Lombardy.

LA316 SUIDA, WILHELM. "Bramantino." In Thieme-Becker. Vol. 4.
 Leipzig: Seeman, 1910, pp. 519-21.

LA317 FRY, ROGER E. "Bramantino." Burlington Magazine 23
 (1913):317, 1 b&w illus.
 Publishes Madonna lactans by Bramantino in the collection
 of P.M. Turner. Influence of Mantegna.

LA318 FIOCCO, GIUSEPPE. "Il periodo romano di Bartolomeo Suardi
 detto il Bramantino." L'arte 17 (1914):24-40, 13 b&w illus.
 Bramantino seen linked to older Lombard tradition, Foppa,
 as opposed to Leonardesque. Five phases beginning 1500. Roman
 phase 1508-13. Catalog of attributions and school by place.

LA319 FRIZZONI, GUSTAVO. "Intorno al Bramantino e alle sue
 presunte relazioni col Luini." Rassegna d'arte antica e
 moderna 2, no. 7 (1915):147-55, 10 b&w illus.
 Adheres to Suida's chronology (LA313-14), but disputes
 Fiocco's longer stay in Rome. Presents some unpublished works
 that he attributes to Bramantino (LA318). Says altarpiece in
 Paris, Musée Jacquemart André, dates to Roman period. Two
 Madonna and Child compositions. Lucretia in Johnson Collec-
 tion, Philadelphia. Says that Luini completely responsible for
 the Pelucca frescoes.

LA320 BORENIUS, TANCRED. "'The Adoration of the Magi' by
 Bramantino." Burlington Magazine 29 (1916):141, 1 b&w
 illus.

Artists

 Publishes <u>Adoration</u> in the National Gallery, London,
formerly in the collection of Sir Henry Layard. Agrees with
Suida (LA313) on pre-1500 date.

LA321 VENTURI, ADOLFO. "Il Bramantino. Il centro della volta
 nella stanza vaticana della Segnatura. Il Cristo di
 Chiarvalle." <u>L'arte</u> 27 (1924):181-86, 3 b&w illus.
 Agrees with Longhi that <u>Argo</u> in the castello, Milan, is
by Bramantino. Attributes vault of Carafa Chapel, S. Domenico
Maggiore, Naples; center of vault of Stanza della Segnatura,
Vatican; and <u>Christ at the Column</u>, Chiaravalle, to Bramantino.

LA322 VENTURI, ADOLFO. "Scelta di rari disegni nei Musei
 d'Europa." <u>L'arte</u> 29 (1926):1-18, 17 b&w illus.
 Publishes three drawings attributed to Bramantino. <u>Sacri-</u>
<u>fice</u> in collection of Gathorne Hoordy, London; <u>Seated Male Nude</u>
<u>with Young Boy</u> in Accademia, Venice; and <u>Hercules and Caucus</u> in
collection of Prince Franz von Waddburg, Wolfegg.

LA323 SUIDA, WILHELM. "Bramantino: Erorterungen un zusatze."
 <u>Der Cicerone</u> 20 (1928):549-56, 8 b&w illus.
 Disagrees with Fiocco's (LA318) and Venturi's (LA321)
attribution of Prophets in S. Domenico Maggiore, Naples, to
Bramantino. Attributes eight small panels of Saints in private
collection, Rome; <u>St. Sebastian</u>, Palazzo Aldobrandini, Rome
(possibly 1508); and drawings in Accademia, Venice, of standing
figure; and Louvre, <u>Lamentation</u> and preparation for an altar-
piece to Bramantino.

LA324 VENTURI, ADOLFO. "Capolavoro del Bramantino." <u>L'arte</u> 31
 (1928):11-12, 1 b&w illus.
 Attributes <u>St. Sebastian</u> in private collection, Rome, to
Bramantino. Not terribly likely.

LA325 GABRIELLI, MARIAROSA. "Aggiunte a Bramantino." <u>Bollettino</u>
 <u>d'arte</u> 3, no. 27 (1933-34):561-72, 12 b&w illus.
 Suggests birthdate of ca. 1470. Dates <u>Argo</u> 1498 because
of location and tie to Lodovico il Moro. Still accepts Proph-
ets from Carafa Chapel as Bramantino, dates to beginning of
sixteenth century. Publishes <u>Ecce Homo</u> in Trivulzio Collec-
tion, Milan; <u>Portrait of a Youth</u>, private collection, Rome; and
<u>Adoration of Christ Child</u>, private collection, Amsterdam. Last
shows influence of Leonardo in shepherd.

LA326 SUIDA, WILHELM. "Die Trivulzio-Sammlung im Castello
 Sforzesco in Mailand." <u>Pantheon</u> 17 (1936):55-63, 87-92, 21
 b&w illus.
 Publishes works by Foppa, Ambrogio de Predis, and
Bramantino in Trivulzio Collection. Reasserts that the Twelve
Months tapestries woven by Benedetto da Milano for Gian Giacomo
Trivulzio after cartoons by Bramantino, 1501 terminus post
quem.

LA327 BUSUIOCEANU, ALESSANDRO. "Una nuova Pietà del Bramantino."
 Rivista d'arte 20 (1938):147-57, 4 b&w illus.
 Pietà in the Royal Palace, Bucharest. Dates 1510-18.

LA328 POPE-HENNESSEY, JOHN. "Recent Research." Burlington
 Magazine 76 (1940):31, 1 b&w illus.
 In review of article by Morassi in Emporium, states that
 paintings from Castello di S. Martino split between the Victoria
 and Albert Museum and the Metropolitan Museum, New York, are
 not by Bramantino but by Ferramola.

LA329 RAGGHIANTI, CARLO LUDOVICO. "Sul metodo nello studio dei
 disegni." Le arti 3 (1940):9-19, 6 b&w illus.
 In criticism of Degenhart's method of identifying
 artist's styles by geographically determined schools, Ragghianti
 illustrates single artists using various styles, including
 three drawings by Bramantino: Fainting Virgin, Budapest (not
 very likely); Madonna and Child, Uffizi; and Standing Saint,
 Venice. Argues in favor of personal history of artist with
 recognition of impact of work of other artists rather than
 absolute abstract developmental system. Sees early impact of
 Ercole de' Roberti on Bramantino.

LA330 SUIDA, GUGLIELMO [WILHELM]. "Bramante pittore ed il
 Bramantino." Proporzioni 3 (1950):164-69, 5 b&w illus.
 Notes new documents on Bramantino from Milanese archives.
 Birth before 1465, dead by 1530. Discusses the instruments in
 the Adoration of the Christ Child in the Ambrosiana. Publishes
 Madonna and Child in own collection and design for a fountain
 in the Louvre for the sanctuary of Sta. Maria delle Fontana,
 Milan, 1509f.

LA331 SUIDA, WILHELM. Bramante pittore ed il Bramantino. Milano:
 Ceschina, 1953, 448 pp., 253 b&w illus.
 Biographies and attributions of two artists, sorting out
 what is by each. Updates his articles of 1905-7 and subsequent
 publications (LA313-14).

LA332 GENGARO, MARIA LUISA. "Problem critici: Il Bramantino."
 Acme 7, no. 2 (1954):217-91.
 Catalog of documented and attributed works with bibliog-
 raphy on each of the works. Biographical data. Influences on
 Bramantino, including Donatello. Successive phases of
 Bramantino's works. Tries to define what are the authentic
 limits of Bramantino's art.

LA333 GENGARO, MARIA LUISA. "Problem di metodo per la storia
 dell'arte: Il Bramantino." Arte lombarda 1 (1955):112-33,
 17 b&w illus.
 Considering details in works of Bramantino as illustra-
 tive of his general architectonic approach, his sense of meas-
 ure. Catalog of works with attributional history and very
 complete bibliography.

Artists

LA334 LONGHI, ROBERTO. Review of Wilhelm Suida's Bramante pittore
 e il Bramantino. Paragone 63 (1955):57-61.
 Disagrees with Suida attributions (LA331) (e.g., Argo in
 Castello sforzesco, Milan). Says two trips to Rome for
 Bramantino.

LA335 MAZZINI, FRANCO. "Il restauro del cosidetto 'Trittico di S.
 Michele' di Bramantino." Bollettino d'arte 42 (1957):83-87,
 4 b&w illus.
 Proves that painting in the Ambrosiana was not originally
 a triptych, error of later restoration. Also shows that early
 in the execution of the painting composition changed through
 the adding of the angels.

LA336 GILARDONI, VIRGILIO. "Le sinopie del Bramantino in Sta.
 Maria delle Grazie di Bellinzona e le compagnie vaganti di
 pittori lombardi della fine del quattro e dei primi decenni
 del cinquencento." In Studies in the History of Art Dedi-
 cated to William E. Suida on His Eightieth Birthday.
 London: Phaidon, 1959, pp. 218-25, 9 b&w illus.
 Attributes sinopie in Chapel of S. Bernardino in the
 Church of Sta. Maria delle Grazie, Bellinzona, to Bramantino.
 Early in career. Connects Francesco Trivulzio with Bellinzona.
 Lombard influence (Bergognone, Foppa, and Nicolò da Varallo) in
 adjacent frescoes.

LA337 GENGARO, MARIA LUISA. "Ancora a proposito del Bramantino."
 Arte lombarda 7, no. 2 (1962):70-72, 3 b&w illus.
 Attributes Mystic Marriage of St. Catherine in private
 Milanese collection to Bramantino.

LA338 VALSECCHI, MARCO. Gli arazzi dei mesi del Bramantino.
 Milan: Cassa di risparmio delle provincie lombarde, 1968,
 218 pp., 85 color and 40 b&w illus.
 History of tapestry weaving in Renaissance Italy. Dates
 tapestries of the months done for Trivulzio to between 1501 and
 1509 by documents and stemme. History of the attribution to
 Bramantino. Iconography and stylistic analysis. Comments on
 Bramantino's architectural work in Trivulzio Mausoleum.

LA339 MULAZZANI, GERMANO. "Per Bramantino: L' 'Uomo di dolori'
 della Collezione Thyssen." Commentari 23 (1972):282-87, 2
 b&w illus.
 Relates iconography of the Uomo di dolori to sermons of
 Aelred of Rievaulx. Dates work to late 1480s, printing of the
 Imitation of Christ. Dependence of image on Bramante's Christ
 at the Column.

LA340 MULAZZANI, GERMANO. "Bramantino's 'Crucifixion': Iconog-
 raphy, Date and Commissioning." Burlington Magazine 116
 (1974):727-34, 4 b&w illus.

Relates the iconography to the sermons of Aelred of
Rievaulx. Painting motivated by opening phase of Council of
Pisa, therefore dates ca. 1510.

*LA341 MULAZZANI, GERMANO. "La 'Madonna Trivulzio' di Bramantino."
 Bollettino dell'Associazione degli amici Brera (1974):34-38,
 2 illus.
 Cited in Repetoire d'art et d'archéologie, n.s. 11, no. 4
 (1975):139, no. 3551. Identifies the donor as Gian Giacomo
 Trivulzio.

LA342 ACQUA, GIAN ALBERTO dell', and GERMANO MULAZZANI. L'opera
 completa di Bramantino e Bramante pittore. Milan: Rizzoli,
 1978, 104 pp., 87 b&w and 64 color illus.
 Begins with characterization of style, summary of crit-
 ical comments, and evaluations. Catalog. Selected bibliography.

LA343 FORTI GRAZZINI, NELLO. Gli arazzi dei mesi Trivulzio: Il
 committente, l'iconografia. Milan: Ripartizione cultura e
 spettacolo, 1982, 79 pp., 28 b&w illus.
 Biographical information about the patron of the tapes-
 tries, Gian Giacomo Trivulzio. Discussion of the iconography,
 particularly the astrological tradition. Disputes notion that
 Bramantino designs in the Ambrosiana can be seen as directly
 linked to the tapestries.

TACCONI, FRANCESCO

LA344 BONETTI, CARLO. "Un opera sconosciuta di Francesco Tacconi."
 Archivio storico lombardo, 4th ser. 9 (1908):181-84.
 Documents concerning commission for Lion of St. Mark on
 the tower in the Piazza del Duomo, Cremona, 1500, from the
 registers of the comune.

DE VERIS, FRANCESCO

LA345 GREGORI, MINA. "A proposito dei De Veris." Paragone 87
 (1957):43-45, 1 b&w illus.
 Angels in a tabernacle of Sta. Maria in Campomorto (Pavia)
 surrounding stone tabernacle to Francesco de Veris and son
 Filippo who did Last Judgement, Sta. Maria delle Ghirli,
 Campione, 1400.

ZANETTO BUGATTO

LA346 "Creditori della duchessa Bianca Maria Sforza." Archivio
 storico lombardo 3 (1876):534-42.
 Documents on Zanetto from Book of Creditors dating ca.
 1469. Letters concerning his work as a portraitist.

LA347 MALAGUZZI VALERI, FRANCESCO. "Zanetto Bugatto e i
 rittrattisti della corte di Francesco di Galeazzo Maria

Artists

Sforza." In Pittori lombardi del quattrocento. Milan:
L.F. Cogliati, 1902, pp. 123-50.
Art of portraiture at Sforza court with attention to
Zanetto and Flemish influence.

LA348 DIMIER, L[OUIS]. "Encore Zanetto Bugatto." La chronique
des arts, no. 39 (1904):320-21.
Publishes letters from ducal papers in Milan concerning
Zanetto dated 1460 and 1468.

LA349 DURRIERI, PAUL. "Achat par le roi de France Louis XI d'un
tableau di peintre milanais Zanetto Bugatto." La chronique
des arts, no. 28 (1904):231-32.
Document showing that Zanetto was at the court of France
1468. King of France purchased portraits of Francesco and
Galeazzo Maria Sforza.

LA350 REINACH, SALOMON. "Rogier de Tournai et Zanetto Bugatto."
La chronique des arts, no. 27 (1904):226.
Republication of letter of Duchess Bianca Sforza to Roger
of Tournai accompanying Zanetto to Brussels, 7 May 1463.

LA351 SEIDLITZ, WALDEMAR von. "Encore Zanetto Bugatti." La
chronique des arts, no. 4 (1905):27.
Citation of works by Zanetto cited by Calvi (LC45).

LA352 MALAGUZZI VALERI, FRANCESCO. "Ancora di Zanetto Bugatto de'
suoi soci." Rassegna d'arte 12 (1912):48.
Attributes triptych in Casorate to Bugatto, though possi-
bly Leonardo de Ponzoni.

LA353 PIERCE, CATHERINE W. "The Sforza Triptych." Art Studies 6
(1928):38-45, 4 b&w illus.
Discusses Sforza triptych in Brussels. Says donors are
not Milanese Sforza but rather Pesaro branch. Attributes not
to Zanetto but rather to Roger van der Weyden.

LA354 ARRIGONI, PAOLO. "Zanetto Bugatto." In Thieme-Becker.
Vol. 37. Leipzig: Seeman, 1947, p. 406.

LA355 WESCHER, PAUL. "Zanetto Bugatto e Roger van der Weyden."
Art Quarterly 25 (1962):209-13.
Relates Bergamo St. Jerome by Bugatto to Detroit St.
Jerome by Roger van der Weyden.

LA356 CONSOLI, GIUSEPPE. "Una nuova traccia per Zanetto Bugatti."
Arte lombarda 12 (1967):150-51, 3 b&w illus.
Publishes three fifteenth-century fresco fragments from
Church of Sta. Maria 'intes vineas,' Vigevano. Madonna and
Child by Leonardo Ponzoni. Attributes other fragments to
Bonifacio Bembo and Bugatto. Relates Bugatto to previously
misinterpreted document of 1472.

LA357 FRANCO FIORIO, MARIA TERESA. "Bugatti, Zanetto." In
 Dizionario biografico italiani. Vol. 15. Rome: Istituto
 della enciclopedia italiana, 1972, pp. 14-15.
 Biographical facts. Attributions. Bibliography.

LA358 CASTELFRANCHI VEGAS, LIANA. "Una Madonna fiamminga intorno
 al 1460 e il problema della Madonna Cagnola." Paragone 32,
 no. 381 (1981):3-9, 6 b&w illus.
 Draws parallel with a Madonna and Child, private collec-
 tion, Genoa, circle of Petrus Christus, and Madonna Cagnola.
 Attributes Madonna Cagnola to anonymous Lombard, ca. 1460-70.

LA359 STERLING, CHARLES. "À la recerche des oeuvres de Zanetto
 Bugatto: Une nouvelle piste." In Scritti di storia
 dell'arte in onore di Federico Zeri. Milan: Electa, 1984,
 pp. 163-78, 17 b&w illus.
 Begins by reviewing literature, emphasizing contacts with
 Roger van der Weyden. In identifying work should look for
 portraits and religious, with Flemish and Lombard characteris-
 tics. Reviews attributions. Does not accept Cagnola Madonna.
 Two new attributions: Portrait of Man of the Contarini Family,
 Museum, Chateauroux; and a Virgin with the Symbols of the
 Passion, private collection, Paris.

ZAVATTARI

LA360 ARRIGONI, PAOLO. "Zavattari." In Thieme-Becker. Vol. 36.
 Leipzig: Seeman, 1947, p. 420.

LA361 LONGHI, ROBERTO. "Per un polittico lombardo di Castel
 Sant'Angelo." Paragone 87 (1957):45-47, 3 b&w illus.
 Reconstructs seven-part polyptych from Castel Sant'Angelo.
 Two new panels in Florentine private collection. Assigns to
 the circle of the Zavattari.

LA362 CASTELFRANCHI VEGAS, LIANA. La leggenda di Teodolinda negli
 affreschi degli Zavattari. Milan: Sidera, 1964, 217 pp.,
 87 color illus.
 Privately printed for the Rotary Club of Monza. Sty-
 listic discussion of the Monza frescoes of 1444. Also the
 iconography.

LA363 NEGRI, RENATA. Gli Zavattari: La Cappella di Teodolinda.
 Milan: Fratelli Fabbri, 1965, 72 pp., 22 color and 32 b&w
 illus.
 Primarily important for illustrations of the chapel,
 Cathedral, Monza.

LA364 ALGERI, GIULIANA. Gli Zavattari: Una famiglia di pittori
 e la cultura tardogotica in Lombardia. Genoa: De Luca
 editore, 1981, 104 pp., 94 b&w illus.

Artists

 First chapter documents on the members of the family. Second chapter concerned with Chapel of Teodolinda and definition of individual styles. Third chapter is relationship with Bonifacio Bembo.

ZENALE, BERNARDO

LA365 MELANI, ALFREDO. "La grande pala nel San Martino di Treviglio." Arte e storia 6 (1887):188–89.
 Description of the altarpiece to clarify relative roles of Zenale and Butinone.

LA366 CAFFI, MICHELE. "Zenale e Butinone. A proposito della pala di San Martino in Treviglio." Arte e storia 6 (1887): 218–20.
 Early documentation on both artists and reference to other works by them.

LA367 MALAGUZZI VALERI, FRANCESCO. "Bernardino Butinone e Bernardo Zenale." In Pittori lombardi del quattrocento. Milan: L.F. Cogliati, 1902, pp. 59–78, 3 b&w illus.
 Distinction between Butinone and Zenale. Sources of style not with Leonardo but in the North.

LA368 SEIDLITZ, WALDEMAR von. "Zenale e Butinone." L'arte 6 (1903):31–36, 2 b&w illus.
 Reaction to Malaguzzi Valeri attributions. Attributes Adoration in Ambrosiana collection to Butinone.

LA369 COOK, HERBERT. "Notes on the Early Milanese Painters Butinone and Zenale." Burlington Magazine 4 (1904):84–94, 179–85, 12 b&w illus.; 5 (1905):199–210, 8 b&w illus.
 General survey of documentation and biography of Butinone and Zenale. Differentiates between two artists. Attributions.

LA370 MALAGUZZI VALERI, FRANCESCO. "Un documento e un quadro attribuito a Zenale." Rassegna d'arte 5 (1905):175, 1 b&w illus.
 Virgin and Child with SS. Jerome and Ambrose, S. Ambrogio, Milan. Publishes payment to Zenale from 1494 for altarpiece for Oratory of the Passion. Altarpiece seen there by Michele Caffi in nineteenth century. Suggests that Zenale received commission but gave to assistant to execute.

LA371 VASARI, GIORGIO. Le vite de' più eccellenti pittori, scultori ed architettori. . . . Annotated by Gaetano Milanesi. Vol. 3. Florence: Sansoni, 1973, pp. 151–52.
 Reprint of 1906 edition. Brief biographical information on Zenale and Butinone in notes on pp. 151–52. Based in part on Tassi.

LA372 SANDBERG-VAVALA, EVELYN. "The Reintegration of the Artistic
 Personality of Bernardo Zenale." Art in America 17
 (1928-29):199-222, 16 b&w illus.
 General catalog of works includes attribution of Madonna
 and Child, Museo civico, Verona; Virgin and Child in storage,
 Brera; and San Ambrogio Triptych to Zenale.

LA373 SUIDA, WILHELM. "Bernardo Zenale: Addenda et Corrigenda."
 Art in America 31 (1943):5-21, 11 b&w illus.
 Removes San Ambrogio Triptych from Zenale. Discusses
 work in four periods. Publishes documents. Reconstructs
 Ognissanti Altarpiece, a triptych with the Virgin and Apostles,
 Saints and Donors done for St. Anne, Milan. Contribution of
 Butinone.

LA374 ARRIGONI, PAOLO. "Zenale, Bernardo." In Thieme-Becker.
 Vol. 36. Leipzig: Seeman, 1947, pp. 456-7.

LA375 VILLA, GEMMA. "Precisazioni sullo Zenale." Commentari 6
 (1955):27-30, 5 b&w illus.
 Strongly critical of Suida both in chronology and charac-
 terization of Zenale. Retains San Ambrogio Triptych as Zenale.
 Notes importance of Bramante for Lombard painting.

LA376 ASTRUA, PAOLA LOIACONO. "Uno Zenale a Padova." In Per
 Maria Cionini Visani: Scritti amici. Turin: G. Canale,
 1977, pp. 43-47, 2 b&w illus.
 Attributes Three Weeping Angels in the Museo civico,
 Padua, to Zenale through parallels with Pietà in Musée Massena,
 Nice. Dates to very end of fifteenth or early sixteenth century.

LA377 GROSSELLI, ZELIA. "Alcuni documenti inediti su Bernardino
 Zenale." Arte lombarda 60 (1981):106-11.
 Twelve documents from 1479 to 1513 from the Archivio
 notarile, Milan. Nothing specifically relating to art.

LA378 CARLEVARO, GIOVANNA. "Materiale per lo studio di Bernardo
 Zenale." Arte lombarda 63 (1982-83):1-126, 81 b&w illus.
 Critical history. Catalogue raisonné. Bibliography.

LA379 MILAN. MUSEO POLDI PEZZOLI. Catalogue. Zenale e Leonardo:
 Tradizione e rinnovamento della pittura Lombarda. Exhibi-
 tion 4 December 1982-28 February 1983. Milan: Electa,
 1982, 310 pp., numerous b&w and color illus.
 Catalog of 1982 exhibition that tried to define the
 nature of indigenous Lombard style before Leonardo. Thorough
 catalog entries for Butinone, Bevilacqua, and Zenale. Signifi-
 cant essays. Documents on Zenale. Extensive bibliography.

Artists

ZENONE, GIOVANNI, COSTANTINO, and AGOSTINO DA VAPRIO

LA379A MALAGUZZI VALERI, FRANCESCO. "I Zenoni da Vaprio." In
 Pittori lombardi del quattrocento. Milan: L.F. Cogliati,
 1902, pp. 189-202.
 Publishes a number of letters concerning the work of
 Costantino Zenone da Vaprio and a few scattered notices of his
 brother Agostino, and cousin, Gabriele. No illustrations.

LA380 ARRIGONI, PAOLO. "Vapri." In Thieme-Becker. Vol. 34.
 Leipzig: Seeman, 1940, pp. 106-7.

LA381 CIPRIANI, RENATA. "Giovanni da Vaprio." Paragone 87
 (1957):47-50, 2 b&w illus.
 Connects Giovanni with the Borromeo. Suggests payment of
 1446 for the Diploma Borromeo in the Biblioteca Trivulziana,
 Milan. Relates also Sala dei giochi in the Casa Borromeo.
 Attributes frontispiece in Vitae diversorum principum, Vat.
 lat. 1903, to Giovanni.

Piedmont

GENERAL

P1 VERNAZZA, GIUSEPPE. Scheda ed estratti dai conti dei
 tesorieri relativi agli artisti piemontesi dal 1200 al 1700.
 Turin, Biblioteca reale, MS. Vernazza 43, 18th century, ff.
 25-54.
 Spoglie from the Turinese archives by Vernazza. Scant
 fifteenth-century notices, particularly on ff. 32-35. List of
 artist on f. 249r-v.

P2 VALLE, GUGLIELMO della. "Notizie dell'artefici Piemontesi."
 In Le vite de' più eccellenti pittori, scultori ed
 architettori. . . ., by Giorgio Vasari. Vol. 10. Siena:
 Pazzini Carli & Co., 1793, pp. 5-17.
 Overview of Piedmontese art mentions Gandolfino, Boniforte
 degli Oldoni, Ludovico Brea, and Macrino d'Alba. Attempt to
 redress bias of Vasari.

P3 GAMBA, FRANCESCO. "Abbadia di S. Antonio di Ranverso e
 Defendente de Ferrari da Chivasso." Atti della Società
 piemontese di archeologia e belle arti per la provincia di
 Torino 1 (1875):119-72.
 Establishing Piedmontese artistic tradition to Defendente,
 publishes earlier frescoes as well as those at Ranverso.

P4 VARNI, SANTO. "Della Pieve di Gavi." Giornale ligustico di
 archeologia, storia e belle arti 2 (1875):355-67.
 Describes paintings in the parish church including a large
 Madonna and Child that he compares with work of Manfredino de
 Bosilio.

P5 No entry.

P6 CHIECHO, G[IAN] C[ESARE]. "Opere artische medio-evali in
 Piemonte." Arte e storia 3 (1884):410-11.
 Cites fresco cycles in Casalese Cantina, Monregalese, and
 the parish churches in Ciglie, Belvedere, and San Bernardo a
 Piozzo.

General

P7 CHIECHO, G[IAN] C[ESARE]. "L'arte nell'alto Piemonte." Arte
 e storia 6 (1887):276-85.
 A somewhat chauvinistic vision of the value of the art of
 northern Piedmont, with notations on frescoes in a variety of
 provincial locations.

P8 ANCONA, PAOLO D'. "Gli affreschi del Castello di Manta nel
 Saluzzese." L'arte 8 (1905):94-106, 184-98, 17 b&w illus.
 Dates to end of fourteenth century but also discusses
 related fifteenth-century decorative ensembles. First part
 Nine Heroes and Heroines, source in the Chevalier errant.
 Second part, the Fountain of Youth frescoes, related to French
 illuminated text of the Chevalier.

P9 ROVERE, LORENZO. "I fondatori della scuola pittorica
 piemontese." Rassegna bibliografica d'arte italiana 14
 (1911):137-46; 15 (1912):45-56.
 Critical review of Weber (P10). Particularly critical of
 Weber's lack of depth and inattention to the provincial cycles
 from the first half of the century. Disagrees with attribu-
 tions, particularly creation of a "Master of Savigliano" whom
 Rovere maintains is Gandolfino.

P10 WEBER, SIEGFRIED. Die Begrunder der Piemonteser Malerschule
 im XV. und zu Beginn des XVI. Jahrhunderts: Zur
 Kunstgeschichte des Auslandes. Vol. 9. Strassburg: Heitz,
 1911, 124 pp., 11 b&w illus.
 Early, not totally successful attempt to give an overview
 of the development of art in Piedmont in the fifteenth century.
 Does not give much new in the way of archival material. Some
 new attributions, particularly to Spanzotti. First chapter
 primarily Canavesio. Second chapter devoted to Spanzotti and
 Eusebio Ferrari. Third deals with Macrino d'Alba.

P11 VENTURI, ADOLFO. "La pitture in Liguria e nel Piemonte." In
 La storia dell'arte italiana. Vol. 7, La pittura del
 quattrocento. Pt. 4. Milan: Hoepli, 1913, pp. 1096-1153,
 22 b&w illus.
 Attributions and stylistic descriptions of works by
 Canavesio, Mazone, Gandolfino di Roreto, Macrino d'Alba, and
 Spanzotti.

P12 MANDACH, CONRAD de. "De la peinture Savoyarde au XVe siècle
 et plus spécialemente des fresques d'Abondance." Gazette
 des beaux-arts, 4th ser. 10 (1914):103-30, 17 b&w illus.
 Brief review of the history of the House of Savoy. In-
 fluence of Franco-Flemish painting and manuscript illumination.
 Examination of the frescoes in the cloister of the Abbey of
 Abondance in Haute-Savoy, ca. 1480, life of the Virgin and
 infancy of Christ. Finds parallels with Fenis, Valle d'Aosta,
 and iconographic parallels with Piedmont, particularly Spanzotti

at Ivrea. Linked to Lombard school. Attributes them to Nicolas Robert.

P13 TOESCA, PIETRO. "Antichi affreschi piemontesi. La chiesa della missione a Villafranca Piemonte." Atti della Società piemontese di archeologia e belle arti per la provincia di Torino 8 (1917):52-64, 6 b&w illus.
Compares the iconography of the Virtues and Vices in the cycle to French examples. Relates the paintings to Manta. Passion cycle.

P14 BAUDI di VESME, ALESSANDRO. "Per le fonti della storia dell'arte piemontese." In L'Italia e l'arte straniera: Atti del X Congresso internazionale di storia dell'arte in Roma-- 1912. Rome: 1922, pp. 501-6.
Very useful bibliographic summary on Piedmontese art, with brief commentaries when the entry is ambiguous. Includes notices concerning the principal archival sources.

P15 CIACCIO, LISETTA MOTTA. "La pittura del rinascimento nel Piemonte e i suoi rapporti con l'arte straniera." In L'Italia e l'arte straniera: Atti del X Congresso internazionale di storia dell'arte in Roma--1912. Rome: 1922, pp. 276-80, 20 b&w illus.
Notes parallels in the treatment of subsidiary figures and format between Northern paintings of Passion and life of Christ and Piedmontese examples. Also iconographic and stylistic similarities. Influence from north to south via miniatures and panels. Considers geographic location. Notes also Spanish influence.

P16 FULCHERI, MICHELANGELO. "L'arte del medioevo e del rinascimento nelle regione cuneesi." Miscellanea cuneese. Biblioteca della Società subalpina 111 (1930):97-119.
General discussion with references to Saluzzese Gothic frescoes and renovations of Macrino, Defendente, and Giovanni Canavesio.

P17 ROMERIO, GIULIO. "L'arte in Valsesia avanti il cinquecento." Miscellanea Valsesiana. Biblioteca della Società subalpina 123 (1931):169-214, 11 b&w illus.
Section on painting, pp. 209-13. No specific attributions before Gaudenzio Ferrari. Does mention sites.

P18 GABRIELLI, NOEMI. "Le pitture della Capella di S. Margherita nel santuario di Crea." Bollettino storico-bibliografico subalpino 36 (1934):429-51, 22 b&w illus.
Sees the influence of the Lombard artists Cristoforo Moretti and Benedetto Bembo.

General

P19 CAVALLARI-MURAT, AUGUSTO. "Considerazione sulla pittura
 piemontese verso la metà del secolo XV." Bollettino storico-
 bibliografico subalpino 38 (1936):43-79, 14 b&w illus.
 Reviews the literature on the major artistic influences
 on painting in Piedmont and Savona in the fifteenth century.
 Reevaluates as having an independent existence, in addition to
 contacts with Lombardy. Discusses the Vercellese school.
 Bibliography.

P20 CAVALLARI-MURAT, AUGUSTO. "Due affrschi piemontesi." Atti
 della Società piemontese di archeologia e belle arti per la
 provincia di Torino 15 (1936):299-309, 4 b&w illus.
 Relates Madonna delle Grazie, Coazze, to fifteenth-
 century international style.

P21 VACCHETTA, GIOVANNI. "Ricerche su opere d'arte del secolo
 XV in Cavallermaggiore e dintorni." Atti della Società
 piemontese di archeologia e belle arti per la provincia di
 Torino 15 (1936):49-77, 30 b&w illus.
 Illustrating provincial cycles and panels. Work by
 Giorgio Turcotto in Motta Chapel, S. Giovanni, Monasterolo,
 1478-79. Other attributions to same artist and other minor and
 anonymous artists.

P22 GABIANI, NICCOLA. "Un soffitto quattrocento in Moncavalo
 Monferrato." Atti della Società piemontese di archeologia e
 belle arti per la provincia di Torino 16 (1937):92-93.
 Reports discovery and restoration of the ceiling.

P23 GABRIELLI, NOEMI. "La mostra del gotico e del rinascimenti
 in Piemonte." Rivista di storia, arte, archeologia.
 Bollettino della sezione di Alessandria della reale
 Deputazione subalpina di storia patria 47 (1938):508-27, 23
 b&w illus.
 Review of the exhibition of Piedmontese art in Turin
 (P25). Discusses works by Gian Martino Spanzotti, Macrino
 d'Alba, and Gandolfino di Roreto.

P24 REINERS, HERBERT. "Die Ausstellung Piemonteser Kunst der
 Gotik und Renaissance." Pantheon 23 (1939):171-75, 6 b&w
 illus.
 Review of exhibition in the Palazzo Carignano (P25).
 Sees continuation of Gothic tendencies through the late fif-
 teenth century.

P25 TURIN. PALAZZO CARIGNANO. Mostra d'arte a Palazzo
 Carignano. 2a 1939: Gotico e rinascimento in Piemonte:
 Catalogo. Edited by Vittorio Viale. Turin: Rotocalco
 Dagino/ Città di Torino, 1939, 294 pp., 382 b&w illus.
 Fundamental exhibition. Biography and main works for
 each artist discussed. Sketch of main problems associated with
 artist. Spanzotti in mainstream of Piedmontese art rather than

Foppa or French as sources. Relates to Jacquerio, Giovanni
Beltramo da Pinerolo, work in Manta and Fenis. Opposes notion
of Piedmontese as derivative.

P26 BRIZIO, ANNA MARIA. La pittura in Piemonte dall'età romanica
 al cinquecento. Turin: G.B. Paravia & Co., 1942, 268 pp.,
 54 b&w illus.
 First chapter devoted to general historiographic survey
 of Piedmontese art. Subsequent chapters on Jacquerio,
 Spanzotti, Macrino d'Alba, Gandolfino di Roreto, and the
 Vercellese school. Catalog of works and bibliography.

P27 VIALE, VITTORIO. "Opere sconosciute o inedite di pittore
 piemontesi del principio del XVI secolo." Bollettino della
 Società piemontese di archeologia e belle arti, n.s. 1
 (1947):52-60, 4 b&w illus.
 Publishes work in private collections in Turin (Totino)
 by Macrino d'Alba and Spanzotti.

P28 GABRIELLI, NOEMI. "Segnalazione di antiche pitture in
 Piemonte." Bollettino della Società piemontese di
 archeologia e belle arti, n.s. 4-5 (1950-51):182-87, 1 b&w
 illus.
 Circle of Spanzotti fresco in parish church, Ozzano,
 Monferrato.

P29 CARITÀ, ROBERTO. "Ipotesi sul primo cinquecento piemontese."
 Bollettino d'arte, 4th ser. 40 (1955):237-43, 6 b&w illus.
 Discusses relationship between Spanzotti and Defendente
 Ferrari. Attributes Disputà in Turin to Monogrammist AVF,
 Antonio Valle(?).

P30 BRESSY, M[ARIO]. Il quattrocento a la Manta nell'arte. Vol.
 1. Quaderni d'arte e storia del Piemonte sudoccidentale.
 Saluzzo: G. Richard, 1956, 10 pp., 6 b&w illus.
 Fifteenth-century frescoes in Sta. Maria del Monastero
 and chapel of the Castello della Manta, ca. 1427. Dates other
 frescoes in Manta simply to mid-fifteenth century.

P31 CARITÀ, ROBERTO. "La pittura nel ducato di Amedeo VIII: Il
 Maestro del Duomo di Chieri." Bollettino d'arte, 4th ser. 41
 (1956):200-206, 15 b&w illus.
 Attributes frescoes in Sta. Giustina, Sezzadio, to "Mas-
 ter of the Duomo di Chieri." Proposes independent identity of
 style in the duchy of Amedeo VIII. See Jacquerio for first
 part of article.

P32 GABRIELLI, NOEMI. "La pittura in Valsesia prima di
 Gaudenzio." In Catalogo. Mostra di Gaudenzio Ferrari.
 Vercelli: Museo Borgogna, 1956, pp. 63-67, 4 b&w illus.

General

Dynasties of dei Merli and dei Cagnoli in Valsesia pro-
ducing local frescoes in Varallo. Two threads of influence,
Lombard and Piedmontese (Jacquerio).

P33 BERNARDI, MARZIANO. Tre monumenti pittorici del Piemonte
antico. Turin: Istituto bancario San Paolo di Torino, 1957,
105 pp., 28 color and 12 b&w illus.
Illustration and brief analysis of Giacomo Jacquerio,
Passion cycle in sacristy of Abbey of S. Antonio, Ranverso;
secular decorations in the Castello della Manta; and Spanzotti,
Life and Passion of Christ in Monastery of S. Bernardino presso
Ivrea.

P34 AMERIO, ROSALBA. "Affreschi quattrocenteschi inediti nel
cuneese." Bollettino della Società piemontese di archeologia
e belle arti, n.s. 12-13 (1958-59):30-33, 3 b&w illus.
Fresco cycle in Scarnafigi. Attributes to circle of
Giovanni Beltramo da Pinerolo.

P35 GABRIELLI, NOEMI. "Alcune pitture del quattrocento." In
Arquata e la vie dell'Oltregiogo. Edited by Carlo Ceschi,
Teofilo de Negri, and Noemi Gabrielli. Turin: ILTE, 1959,
pp. 249-70, 5 b&w and 12 color illus.
Publishes following works: polyptych by Manfredino de
Bosilio for Gavi, 1478; frescoes in Novi Ligure by same; paint-
ings by Franceschino de Bosilio in Pozzolo Formigano; and works
by Gandolfino di Roreto. Bibliography. Work as mixture of art
from Piedmont, Lombardy, and Liguria.

P36 FERRI, PIETRO. "La Cappella di San Pantaleone a Oro di
Boccioleto." In Atti e memorie del terzo congresso piemontese
di antichità ed arte: Congresso di Varallo Sesia. Turin:
Società piemontese di archeologia e belle arti, 1960, pp. 13-
17, 4 b&w illus.
Series of anonymous religious scenes including Christ
with the Evangelists, SS. Francis, Peter, Pontifice, and
Christopher; Coronation of the Virgin; and a Pietà. Dated
1476.

P37 GABRIELLI, NOEMI. "Gli affreschi di San Giovanni al Monte."
In Atti e memorie del terzo congresso piemontese di antichità
ed arte: Congresso di Varallo Sesia. Turin: Società
piemontese di archeologia e belle arti, 1960, pp. 9-12.
Some of the frescoes are mid-fifteenth century from the
circle of the Zavattari and Giovanni dei Campi. Date 1457
visible. Other frescoes moved from Chapel of the Pietà of
Quarona, 1494.

P38 AMERIO, ROSALBA. "Affreschi quattrocenteschi a Rocca
Canavese." Arte lombarda 6 (1961):15-19, 6 b&w illus.
Fresco fragments from late fifteenth century in presbytery
of Chiesa Confraternita di Croce. Vaults: four Evangelists

and four Church Fathers, Angels and the Lamb. Walls: Pietà, twelve Apostles, St. John the Baptist and Saints, and other figures. Lombard influence.

P39 MALLÈ, LUIGI. Le arti figurative in Piemonte dalle origini al periodo romantico. Turin: F. Casanova & Co., 1961, 496 pp., 9 color and 324 b&w illus.
　　　　Reprint: Le arti figurative in Piemonte dalle origini al periodo romantico. Vol. 1, Dalla preistoria al cinquecento. Turin: RIV-SKF, 1972–73, 228 pp., 12 color and 644 b&w illus. Text same as first edition, new illustrations.
　　　　English translation: Figurative Art in Piedmont. 2 vols. Turin: RIV-SKF, 1972–75, 12 color and 644 b&w illus.
　　　　Painting is discussed in two parts. Pp. 99–118 concern the late Gothic period, which includes the work of Jacquerio, Aimone Duce, Spanzotti, and Macrino d'Alba. Pp. 161–98 concern primarily the sixteenth century, but also have some comments about the work of Macrino and Spanzotti.

P40 TOURING CLUB ITALIANO. Guida d' Italia: Piemonte (eccetto Torino e Valle d'Aosta). Milan: Touring Club italiano, 1961, 832 pp., 19 maps and 16 city plans.
　　　　Comprehensive guide to the region. Index by place and artist.

P41 GASCO, PIERO, RENZO BONGIOVANNI, and GERONIMO RAINERI. Antichi affreschi del Monregalese. Cuneo: Tip. AGA di Serofino Borello, 1965, xix + 80 pp., 156 b&w and color illus.
　　　　Collection of details from fresco cycles from thirty-nine smaller churches in region near to and in Mondovì. Important visual and descriptive source for these numerous provincial cycles.

P42 SCIOLLA, GIANNI CARLO. "Gli affreschi quattrocenteschi nell'abbazia di Sannazzaro Sesia (Novara)." Bollettino d'arte, 5th ser. 51 (1966):152–54, 10 b&w illus.
　　　　Life of St. Benedict by "Master of Sannazzaro." Circle of Cremonese artists ca. 1460–70.

P43 BIROLLI, ZENO. "Il formarsi di un dialetto pittorico nella regione ligure-piemontese." Bollettino della Società piemontese di archeologia e belle arti, n.s. 20 (1966):115–25, 12 b&w illus.
　　　　Relationship between political boundaries of two provinces and the art of Piedmont in second half of the fifteenth century. Change from courtly style of first half of the century to Franco-Italian under Amedeo VIII.

P44 MALLÈ, LUIGI. "Il 'Maestro degli Apostoli' a Prascorsano." In Studi di storia dell'arte in onore di Vittorio Viale. Edited by Association internationale des critiques d'art. Sezione italiana. Turin: Fratelli Pozzo, 1967, pp. 9–17.

General

> Frescoes in cemetery chapel in Prascorsano, third-quarter
> of fifteenth century. Uses as a means of discussing Lombard
> and Provençal roots of art of Spanzotti.

P45 DEBIAGGI. CASIMIRO. Dizionario degli artisti valsesiani dal
 secolo XIV al XX. Varallo: Società per la conservazione
 delle opere d'arte e dei monumenti in Valesia, 1968.
 Alphabetical with chronological listing at back. Bib-
 liography. Entries for Nicolò da varallo and Filippo Ragni.

P46 DEBIAGGI, CASMIRIO. "La chiesa parrocchiale di Doccio in
 Valsesia ed i suoi ritrovamenti quattrocenteschi." Bollettino
 della Società piemontese di archeologia e belle arti, n.s. 22
 (1968):103-9, 3 b&w illus.
 Discovery of fifteenth-century St. George and the
 Dragon and St. Christopher frescoes.

P47 GRIVA, LUIGA. "Affreschi quattrocenteschi a Piossasco."
 Bollettino della Società piemontese di archeologia e belle
 arti, n.s. 22 (1968):110-12, 2 b&w illus.
 Frescoes in the Chapel of St. Elizabeth in the Church of
 the Confraternity of the Name of Jesus in the Piossasco.

P48 SCHIFFO, CARLO. "La chiesetta di San Ponzio in Marsaglia."
 Bollettino della Società per gli studi storici, archeologici
 ed artistici della provincia di Cuneo 59 (1968):91-93.
 Frescoes from the fifteenth century in provincial church
 of St. Anthony Abbot. Also frescoes ca. 1500 of SS. Thadeus,
 Simon, and Thomas.

P49 RAINERI, GERONIMO. "Gli affrsechi della Chiesa di Santa Maria
 Maddalena a Cerisola e la pittura murale del '400 in
 Piemonte." Bollettino della Società per gli studi storici,
 archeologici ed artistici della provincia di Cuneo 63
 (1970):125-27.
 Document of 1461 linking Segurano Cigna to frescoes in
 Sta. Maria Maddalena in Cerisola. Artist also worked at
 Prunetto. Ties with art of Antonio Monregalese. Both
 Provençal influence. Cult of Magdalen strong in Provence.
 Brief list of other artists working in the region.

P50 CARBONERI, NINO. Antologia artistica del Monregalese. Turin:
 Istituto bancario San Paolo di Torino, 1971, 154 pp. numerous
 b&w and color illus.
 Not limited to fifteenth century. Cycles in San
 Fiorenzo, Bastia Mondovi, and Chapel of San Magno, Borgo Santa
 Croce, Mondovi Piazza. Miniatures pp. 28-31. Characterizes
 Monregalese painting as combination of vernacular, Provençal,
 and Lombard.

P51 ROSSETTI, BREZZI, ELENA. "Momenti di pittura piemontese
 Avigliana--S. Maurizio Canavese." Bollettino della Società

piemontese di archeologia e belle arti, n.s. 25-26 (1971-72):
35-53, 7 b&w illus.
 Frescoes in the Church of S. Pietro in Avigliana. Some
first quarter of fifteenth century, Annunciation and Nativity.
Lombard and French influences.

P52 GABRIELLI, NOEMI. Arte nell'antica Marchesato di Saluzzo.
 Turin: Istituto bancario San Paolo di Torino, 1973, 260 pp.,
 numerous b&w and color illus.
 Pimarily a picture book with introductory essay concerned
with overview of art in region. Bibliography. Sections on
Manta; Jacquerio; Casa Cavasso, Sala di Giustizia; and "Master
of Elva."

P53 RAINERI, GERONIMO. "Appunti d'arte del '400 a Chiusa Pesio."
 Bollettino della Società per gli studi storici, archeologici
 ed artistici della provincia di Cuneo 69 (1973):29-30, 3 b&w
 illus.
 Fresco on facade of palace showing the Trinity, mid-
century. Draws parallels with those in San Bernardo alle
Forche de Mondovi and the Chapel of San Bernardo in Vicoforte.
Associates with Segurano Cigna. Notes other frescoes in Chiusa
Pesio.

P54 PICCAT, MARCO. "La raffigurazione delle sibille nel Saluzzese
 e nelle zone circostanti." Bollettino della Società per gli
 studi storici, archeologici ed artistici della provincia di
 Cuneo 77 (1977):19-46, 11 b&w illus.
 Summary of sybilline cycles in the region of Saluzzo.
Earliest 1450-60, Brossaco. Reproduces inscriptions. Varying
numbers of sybils and prophets. Ties to the popular drama.

P55 ROSSETTI BREZZI, ELENA. "Intorno ad uno sconosciuto polittico
 Monregalese." Studi piemontesi 6, no. 1 (1977):133-34, 4 b&w
 illus.
 Lost polyptych with Saint Francis, Crucifixion, Annuncia-
tion, and Saints dated to ca. 1450. Includes some archaisms
that refer back to earlier in the century.

P56 PICCAT, MARCO. "Antiche inscrizione in volgare: I cartigli
 delle chiese di Santo Stefano e di San Sebastiano di Busca."
 Bollettino della Società per gli studi storici, archeologici
 ed artistici della provincia di Cuneo 78 (1978):5-13, 8 b&w
 illus.
 Study of the inscriptions in vernacular appearing in the
frescoes by Tommaso and Matteo Biazaci, ca. 1470-80. St.
Stefano includes only one cartello in vernacular, San
Sebastiano all in vulgar. Bibliography on Biazaci.

P57 AA.VV. Guida breve al patrimonio artistico delle provincie
 piemontesi. Turin: Ministerio per i beni culturali e

General

ambientali. Sovrintendenza per i beni artistici e storici del Piemonte, 1979, 112 + v pp., 48 b&w illus.

Articles with bibliography on each of the main centers; Alessandria: Carla Spantigati; Asti: Claudio Bertolotto; Cuneo: Giovanna Galante Garrone and Mario Leone; Novara: Giovanni Romano; Turin: Michela di Marcco; Vercelli: Paola Astrua and Giovanni Romano.

P58 PICCAT, MARCO. "Una nuova acquizione iconografica all'intero del quattrocentesco ciclo della Cappella di S. Giorgio a Villar San Costanzo." Bollettino della Società per gli studi storici, archeologici ed artistici della provincia di Cuneo 82 (1980):107-12, 2 illus.

Anonymous Saint in St. George Chapel in Villar San Costanza identified as San Quentin by motif of two nails. Another example of Saint at La Manta. Popular cult in the region.

P59 PEROTTI, MARIO. Cinque secoli di pittura nel Piemonte cispadano antico: Prolegomeni per una storia dell'arte in provincia di Cuneo. Cuneo: L'Arciere, 1981, 243 pp., 178 b&w and color illus. including maps.

Section on quattrocento broken down by school, Saluzzese and Monregalese. Particularly useful iconographic comparisons and maps that trace itineraries of artists including Tommaso and Matteo Biazaci, Giovanni Canavesio, Pietro da Saluzzo, and Giovanni Mazzucco. Artist index.

P60 BAUDI di VESME, ALESSANDRO. Schede Vesme: L'arte in Piemonte. Vol. 4. Turin: Società piemontese di archeologia e belle arti, 1982, xxvii + 7 + 605 pp.

Collection of the notes of Baudi di Vesme on Ligurian and Piedmontese art. Introduction by Cavallari-Murat indicates sources. First section devoted to artists, listed alphabetically. Includes documents and extracts from articles pre-1905. Second section lists of paintings in collections, museums, and churches in Liguria and Piedmont. An indispensible source of information.

P61 NATALE, MAURO. "Una schede piemontese: 1435." In Scritti di storia dell'arte in onore di Federico Zeri. Milan: Electa, 1984, pp. 81-92, 15 b&w illus.

On the basis of a signed (Maestro Guglielmo) and dated (1435) polyptych in a private collection in Italy identifies Piedmontese artist, also called Master of Pecetto. Sets into context of Donato de Bardi and Nicolò da Voltri. Establishes ouevre including Crucifixion, Chapel of the Baptistry, Cathedral, Chieri.

CITIES

ALESSANDRIA

PC1 GIORGI, GIOVANNI ANTONIO de. <u>Notizie sui celebri pittori e
su altri artisti alessandrini</u>. Alessandria: Tip di Luigi
Capriolo, 1836, 103 pp. Reprint. Bologna: A. Forni, 1977.
 Only fifteenth-century artists are Giovanni Mazone,
Galeotto Nebeà, and Jacopo Marone (actually misreading for
Giovanni Mazone).

PC2 GABRIELI, NOEMI. "Monumenti della pittura nella provincia
di Alessandria dal secolo X alla fine del secolo XV." <u>Rivista
di storia, arte, archeologia per la provincia di Alessandria</u>
44 (1935):109-56, 47 b&w illus.
 Discusses works by Giovanni Mazone da Alessandria
(p. 129) and Manfredino and Franceschino de Bosilio (pp. 140-
47). Also includes a discussion of the hunting and games
frescoes in the Casa Zoppi, Cassine.

CASALE MONFERRATO

PC3 MINORI, TOMASO de'. "Vestigi d'arte francescana a Casale
Monferrato." <u>Rivista di storia, arte, archeologia per la
provincia di Alessandria</u> 42 (1933):617-35, 4 b&w illus.
 Attributes paintings in Casale to Gandolfino di Roreto
(Gandolfino d'Asti), Spanzotti, and Eusebio Ferrari.

PC4 GABRIELLI, NOEMI. "L'arte a Casale Monferrato dal XI al
XVIII secolo." <u>Seguito alla Biblioteca della Società
storica subalpina della reale Deputazione subalpina di
storia patria</u> 157 (1935):1-199, 283 b&w illus.
 General survey of the development of art in Casale
Monferrato. Includes a discussion of the paintings of the
marchesi of Monferrato in the palace of Anna d'Alençon, via
Alessandria 15. Biographies.

PC5 VIALE FERRERO, MERCEDES. <u>Ritratto di Casale</u>. Turin:
Istituto bancario San Paolo di Torino, 1966, 190 pp., 35
color and numerous b&w illus.
 Section on art. Roots of Spanzotti and works, pp. 28-46.
Discusses Cristoforo Moretti, Gandolfino di Roreto, and Macrino
d'Alba as well. Paintings in Casale Monferrato and Crea.
Bibliography.

PC6 ROMANO, GIOVANNI. <u>Casalesi del cinquecento: L'avvento
del manierismo in una città padana</u>. Turin: Einaudi, 1970,
132 pp., 92 b&w illus.
 Primarily concerned with the sixteenth century, but chap.
1 includes inventory of works in the region of Casale with
special attention to Macrino d'Alba and their shops.

Cities

NOVARA

PC7 BIANCHINI, FRANCESCO ANTONIO. Le cose rimarchevoli della
 città di Novara. 2 vols. in 1. Novara: Girolamo Miglio,
 1828, 338 and 194 pp. Reprint. Bologna: A. Forni, 1974.
 Historical survey of city followed by guidebook. Only
 fifteenth-century entry is painting by Giovanni dei Campi in
 Chiesa degli Ognissanti.

PC8 GIOLLI, RAFFAELLO. "Appunti d'arte Novarese. Nell'Abbadia
 di S. Nazaro alla Costa." Rassegna d'arte 8 (1908):67-69, 4
 b&w illus.
 Four figures of Franciscan saints. One anonymous. SS.
 Anthony of Padua and Alberto Sarsthiano signed and dated 1474
 by Giovanni Antonio dei Merli. Thomas da Novara signed by
 Tommaso dei Cagnoli.

PC9 Novara e il suo territorio. Novara: Banca popolare di
 Novara, 1952, 1039 pp., numerous b&w and color illus.
 Section on fifteenth-century art pp. 570-78. Discusses
 impact and art of Nicolò da Varallo, Cristoforo Moretti,
 Bonifacio Bembo, Zavattari, Giovanni dei Campi, and others.
 Influence of patron.

PC10 L'arte nel novarese: Affreschi novaresi del quattrocento.
 Novara: Società storica novarese, 1977, 77 pp., 68 b&w and
 color illus.
 Introductory essay with brief history of the region.
 Sees cavalresque and provincial styles mixing. Influence of
 Vercellese painters. Illustrates and discusses works by dei
 Cagnoli, Merli, de Bosis, and dei Campi in the provinces of
 Novara and Valsesia. Bibliography.

PINEROLO

PC11 BERNARDI, JACOPO. "Antichi pittori di Pinerolo." Arte e
 storia 10 (1891):49-50.
 Brief documentary notices of some minor Piedmontese
 painters including Joanne de Francino de Pinerolo (1416).

PC12 BERTEA, ERNESTO. Ricerche sulle pitture e sui pittori nel
 pinerolese. Pinerolo: Tip. Società, 1897, 69 pp.
 Reprint. Bologna: A. Forni, 1984.
 General overview of art in Pinerolo and vicinity from the
 fourteenth through the sixteenth centuries. Particularly use-
 ful for its description of the frescoes in the Castello
 d'Acaja, and for documentation on Giovanni Canavesio. Also
 includes a description of anonymous paintings found in Pinerolo
 and surrounding communities like Roletto, Frossasco, Volvera,
 and Cercenasco.

TURIN

General

PC13 RONDOLINO, FERDINANDO. "La pittura torinese nel medioevo."
 Atti della Società piemontese di archeologia e belle arti
 per la provincia di Torino 7 (1897):206-35.
 Second half of the article concerned with fifteenth cen-
 tury. Documents on Giacomo and Matteo Jacquerio. Notice also
 of Aimone Duce, Cristoforo Moretti, Amedeo Albini, Spanzotti,
 and others.

PC14 TOESCA, PIETRO. Torino. Italia artistica, 62. Bergamo:
 Istituto italiano d'arti grafiche, 1911, 148 pp., 180 b&w
 illus.
 Chap. 3 devoted to fifteenth century. Historical over-
 view of art in Turin. Discusses Spanzotti and Macrino d'Alba.
 In manuscript illumination discerns Ferrarese influence.

PC15 TOURING CLUB ITALIANO. Guida d' Italia: Torino e Valle
 d'Aosta. Milan: Touring Club italiano, 1975, 407 pp., 8
 maps and 8 city plans.
 Comprehensive guide to the city. Index by monument and
 artist.

Collections and Museums

PC16 MALLÈ, LUIGI. Museo civico di Torino: I dipinti del Museo
 d'arte antica. Catalogo. Turin: Museo civico d'arte
 antica, 1963, 200 pp., 326 b&w and 24 color illus.
 Introductory history of the collection. Not all objects
 are illustrated. Alphabetical catalog, brief biographies of
 artists, description of objects, provenance, and bibliography.

PC17 BERNARDI, MARZIANO. The Sabauda Gallery of Turin. Turin:
 ERI, 1968, 258 pp., 59 color and 69 b&w illus.
 General history and overview of the collection. Selected
 pictures illustrated in color with expanded commentary includ-
 ing works by Ercole de' Roberti, Nicolò da Varallo, Macrino
 d'Alba, and Spanzotti.

PC18 GABRIELLI, NOEMI. Galleria Sabauda: Maestri italiani.
 Turin: ILTE, 1971, 394 pp., 192 b&w and color illus.
 Entries on Macrino d'Alba, Ambrogio de Predis, Spanzotti,
 Gandolfino di Roreto, Nicolò da Varallo, and Giovanni
 Canavesio. Include statement on conservation, provenance,
 and specific bibliography. Index and general bibliography.

VALLE d'AOSTA

PC19 LeCLERE, TRISTAN. "Un protecteur de l'art français dans la
 Vallée d'Aoste." Gazette des beaux-arts, 3d ser. 37
 (1907):132-54, 17 b&w illus.

Cities

 History of the Challant. Emphasis on the chateaux of
Georges de Challant, including Montalto, Fenis, and Issogne.
Illustrates images from Issogne. Says painter is Lyonnais.
Also notes Lyonnais miniaturists working for Challant.

PC20 MINISTERO DELL'EDUCAZIONE NAZIONALE. DIREZIONE GENERALE
 ANTICHITÀ E BELLE ARTI. Catalogo delle cose d'arte e di
 antichità d'Italia. Vol. 1, Aosta. Edited by Pietro
 Toesca. 1st ser. Rome: E. Calzone, 1911, 153 pp., numer-
 ous b&w illus.
 Description of principal works, state of conservation,
history of attribution and provenance, bibliography, artist
index.

PC21 BOSON, GIUSTINO. Il Castello di Fenis. Novara: Istituto
 geografico De Agostino, 1958, 55 pp., 27 b&w and 12 color
 illus.
 Guide to the castle. History of the Challant. Building
history. Description of the decorations. Record of the in-
scriptions. Dates most of the frescoes to shortly before 1400.
Plan of the castle. Inventories of furniture from sixteenth
century.

PC22 GABRIELLI, NOEMI. Rappresentazioni sacre e profane nel
 Castello di Issogne e la pittura nella Valle d'Aosta fine
 dell '400. Turin: Industria libraria tipografica editrice,
 1959, 191 pp., 87 b&w and 53 color illus., 2 plans.
 Profusely illustrated discussion of cycles of frescoes in
Castello of Issogne and churches in Valle d'Aosta. Full de-
scription, chapters on dating, iconography, and general nature
of late fifteenth- and early sixteenth-century Piedmontese art.

PC23 BARBIERI, GINO. "Il mondo borghese rinascimentale negli
 affreschi del Castello di Issogne." Economia e storia 17
 (1970):584-99, 8 b&w illus.
 Discusses the frescoes depicting the various occupations
in the antechamber at Issogne. Links it to the rise of the
bourgeois in the Valle d'Aosta and Georges de Challant's roots.
Raises issue of the sources of the funds for building the
Castello of Issogne.

PC24 GRISERI, ANDREINA. Affreschi nel Castello di Issogne.
 Pesaro: Cassa di risparmio di Pesaro, 1972, 39 pp., 26
 color illus. and 27 b&w illus.
 Genealogy and character of Georges de Challant. Frescoes
in the castle dating between 1496-1506. Courtly character of
Sala baroniale, influence of libri d'oro. Judgment of Paris
done in honor of wedding of Filberto di Challant, 1501. In-
fluence of Venetian woodcuts. Also discusses Missal of Giorgio
di Challant, Turin, private collection, 1499; Missal,
Collegiata di Oreo, Aosta.

PC25 TOURING CLUB ITALIANO. Guida d' Italia: Torino e Valle
 d'Aosta). Milan: Touring Club italiano, 1975, 407 pp., 8
 maps and 8 city plans.
 Comprehensive guide to the region. Index by location and
 artist.

PC26 ORLANDONI, BRUNO, and DOMENICO PROLA. Il Castello di Fenis.
 Aosta: Museumci editore, 1982, 382 pp. with 427 b&w illus.
 and 16 color plates.
 Discussion of architecture and painting. Considers con-
 ception of space. Attribution to Giacomo Jacquerio and school.
 Comparison with Ranverso. Pt. 3 specifically on frescoes,
 considers style, cultural environment, and authorship. French
 influence.

VERCELLI

PC27 COLOMBO, GIUSEPPE. Documenti e notizie intorno gli artisti
 vercellesi. Vercelli: Giudetti, 1883, 502 pp.
 Organized by period. First chapter is art in Vercelli
 from sixth century through Gaudenzio. Includes documents on
 the Oldoni, Cristoforo Moretti, and several minor masters.
 Spanzotti mentioned in section on Sodoma, pp. 421-83.

PC28 MINISTERO DELL'EDUCAZIONE NAZIONALE. DIREZIONE GENERALE
 ANTICHITÀ E BELLE ARTI. Catalogo delle cose d'arte e di
 antichità d'Italia. Vol. 8, Vercelli. Edited by Anna Maria
 Brizio. Rome: Libreria dello stato, 1935, 216 pp., numer-
 ous b&w illus.
 Description of principal works, state of conservation,
 history of attribution, provenance, and bibliography. Artist
 index at back.

PC29 TURIN. MUSEO BORGOGNA. Opera d'arte a Vercelli e nella sua
 provincia: Recuperi e restauri: 1968-76. Catalogo della
 mostra. Edited by Franco Mazzini et al. Turin: Museo
 Borgogna, 1976, 276 pp., 34 b&w and 4 color illus.
 Works from the circle of Spanzotti, Tomaso Cagnola,
 Bramantino, and Bergognone. List of works restored.
 Bibliography.

ARTISTS

ALBINI, AMEDEO

PA1 DE. "Albini, Amedeo." In Thieme-Becker. Vol. 1. Leipzig:
 Seeman, 1907, p. 228.

PA2 VERGANO, LUDOVICO. "Un nuovo documento sul pittore Amedeo
 Albini." Rivista di storia, arte, archeologia per le
 provincie di Alessandria e Asti 63 (1954):73-74.

Artists

Contract of 7 March 1475, for lost painting for the
Certosa of Asti.

ANTONIO MONREGALESE

PA3 RAINERI, GERONIMO. "Antonio Monregalese." Bollettino della
 Società per gli studi storici, archeologici ed artistici
 della provincia di Cuneo 61 (1969):3-8, 19 b&w illus.
 Frescoes of Antonio Monregalese in the Chiesa della
 Montata in Molini di Triora, numerous illustrations. Signed
 and dated 1435. List of attributions and chronology. Influ-
 ence of Avignon.

PA4 RAINERI, GERONIMO. "Gli affreschi di S. Maurizio a
 Castelnuovo di Ceva." Bollettino della Società per gli studi
 storici, archeologici ed artistici della provincia di Cuneo
 70 (1974):47-48, 20 b&w illus.
 Frescoes in the presbytry of what is now the cemetery
 chapel of S. Maurizio, formerly Castle Chapel, in Castelnuovo
 di Ceva. Dated 10 October 1459, Fathers of the Church, Cruci-
 fixion, St. Maurice. Parallels with other regional frescoes.
 Attributes to Antonio Monregalese through comparison with Molini
 di Triora cycle of 1435.

PA5 DE NEGRI, TEOFILO OSSIAN. "La pittura tardogotica delle
 'Alpi Liguri," da Antonio Monregalese e Pietro Guidi."
 Bollettino ligustico per la storia e la cultura regionale 27
 (1975):79-102, 28 b&w illus.
 Overview of recent literature on the development of "pop-
 ular art" in the Ligurian art. Frescoes by Antonio Monregalese
 in Bastia, ca. 1472.

PA6 RAINERI, GERONIMO. Antonio da Monregalese--Santa Croce--S.
 Bernardo delle Forche. Mondovi: Autorotto, 1976, 144 pp.,
 22 b&w and color illus.
 Overview of works by Antonio and two "popular" fresco
 cycles in region of Mondovi.

PA7 RAINERI, GERONIMO. "Le cappelle di S. Croce a Mondovi e di
 S. Abbondio a Bologna." Bollettino della Società per gli
 studi storici, archeologici ed artistici della provincia di
 Cuneo 82 (1980):99-106, 4 b&w illus.
 Shows iconographic parallels between S. Abbondio Chapel
 in San Petronio, Bologna, by Giovanni da Milano, ca. 1420, and
 "armed cross" in S. Croce, Mondovi Piazza, ca. 1450-60 by
 Antonio Monregalese. Refutes notion of the art of the western
 portions of Liguria as provincial. Orientation toward Provence.

BARBAGELATA, GIOVANNI

PA8 CASTELNOVI, GIAN VITTORIO. "Giovanni Barbagelata."
 Bollettino d'arte, 4th ser. 36 (1951):211-24, 18 b&w illus.

Uses St. Ambrose Polyptych in parish church, Varazze, 1500, as touchstone for reconstructing oeuvre of Barbagelata. Publishes documnts 1484-1508 from Alzieri, vol. 2 (LI4). Sees as closer to indigenous Ligurian art, Giovanni Mazone and Luca Baudo, than Foppa.

BIAZACI, MATTEO AND TOMMASO

PA9 ACQUARONE, MARIA PINA. "Tommaso e Matteo Biazaci a Montegrazie e Piani di Imperia." In Argomenti di storia dell'arte. Edited by Corrado Maltese. Genoa: Università di Genova, 1980, pp. 75-96, 11 b&w illus.
 Publishes frescoes in Nostra Signora delle Grazie, Montegrazia, signed and dated 1483. Last Judgment, Paradise, Purgatory, Hell, Virtues and Vices. Medieval in character. Sta. Maria Assunta, Piani di Imperia, signed and dated 1488. Life of the Virgin, Apostles, and Sibyls. Influence of Jacopo da Voragine and popular religion on both.

BOSILIO, MANFREDINO AND FRANCESCHINO DE

PA10 VARNI, SANTO. "Di una tavola di Franceschino da Castelnuovo Scrivia." Giornale ligustico di archeologia, storia e belle arti 1 (1874):93-95.
 Madonna and Child with Saint, half-length Christ above in the Church of Sta. Trinità, Pozzuolo-Formigaro, dated 1507. Relates to earlier works in Pieve di Novi, 1474, and Gavi, 1478.

PA11 TEDDE, GIORGIO STARA. "La Pieve di Volpedo e i pittori Manfredino e Franceschino Basilio [sic]." Iulia Dertona 45 (March 1915):3-55, 3 b&w illus.
 History of Volpedo. Frescoes in Romanesque parish church. Three campaigns. First in the first half fifteenth century. Second attributed to Manfredino by comparison with Rivalta Scrivia. Dates second half fifteenth century. Third, attributed to Franceschino, dated 1502. Notes other works by both artists. Information about other Tortonese artists.

CANAVESIO, GIOVANNI

PA12 "Canavesio, Giovanni." In Thieme-Becker. Vol. 5. Leipzig: Seeman, 1911, p. 490.

PA13 BIROLLI, ZENO. "Due documenti inediti sull'attivita del pittore Giovanni Canavesio." Arte lombarda 9, no. 1 (1964):163-64.
 Two notarial documents from 1472 indicate work in Albenga as well as Pinerolo and Nice.

PA14 BREZZI, ELENA. "Precisazioni sull'opera di Giovanni Canavesio: Revisione critiche." Bollettino della Società

Artists

 piemontese di archeologia e belle arti, n.s. 18 (1964):35–
56, 17 b&w illus.
 Traces development. Says work adapted to public. Finds
influence of Brea and the French.

PA15 ROSSETTI BREZZI, ELENA. "Aggiunte al catalogo di Giovanni
 Canavesio." Bollettino della Società piemontese di
 archeologia e belle arti, n.s. 19 (1965):97–101, 2 b&w
 illus.
 In Loggia comunale, Albenga, Crucifixion and four stemme.

PA16 ROSSETTI BREZZI, ELENA. "Due nuovi frammenti canavesiani."
 Bollettino storico-bibliografico subalpino 68 (1970):636–41,
 3 b&w illus.
 Attributes two unpublished fragments, Martyrdom of St.
Christopher in an unknown collection and upper portion of panel
with SS. Sebastian and James, Courtauld Institute, London.
Both 1449–1500.

PA17 ROMANO, GIOVANNI. "Canavesio, Giovanni." In Dizionario
 biografico italiano. Vol. 17. Rome: Istituto della
 enciclopedia italiana, 1974, pp. 729–31.
 Biographical facts. Attributions. Bibliography. Eval-
uates work as retaining the integrity of local style.

PA18 ROTONDI TERMINIELLO, GIOVANNA. "Giovanni Canavesio (notizie
 dal 1450 al 1500). Polittico con S. Domenico fra i quattro
 dottori della Chiesa." Galleria nazionale di Palazzo
 Spinola. Interventi di restauro 2 (1980):30–35, 4 b&w
 illus.
 Polyptych with S. Domenico among the Four Church Doctors
and Madonna and Child with four half-length Saints above from
Dominican church, Taggia (Imperia). Originally in Reghezza
Chapel, ca. 1472. History of attribution to Canavesio.

DUCE, AIMONE

PA19 GABRIELLI, NOEMI. "Aimone Duce pittore a Villafranca
 Sabauda." In Studies in the History of Art Dedicated to
 William E. Suida on His Eightieth Birthday. London:
 Phaidon, 1959, pp. 81–85, 5 b&w illus.
 Signed cycle of wall paintings. Annunciation, Deposi-
tion, and two Saints on one wall. Virtues and Vices and five
Saints on the other, in the Oratorio delle Missioni, Villafranca
Sabauda. Dates before 1474.

GANDOLFINO DI RORETO

PA20 WEBER, SIEGFRIED. "Gandolfino d'Asti." In Thieme-Becker.
 Vol. 13. Leipzig: Seeman, 1920, pp. 155–56.

PA21 MASINI, LEONARDA. "Gandolfino di Roreto, pittore di Asti."
 Atti della Società piemontese di archeologia e belle arti 10
 (1926):197-215.
 Compares with work of Macrino. Gandolfino more provin-
 cial but ties with indigenous style of Liguria. Combination of
 Provençal and Lombard influence. Attributes Polytych,
 Savigliano, and Mystic Marriage of St. Catherine, Alba, to
 Gandolfino.

GIACOMO DA IVREA

PA22 LANGE, AUGUSTA. "Notizia sulla vita di Giacomo da Ivrea."
 Bollettino della Società piemontese di archeologia e belle
 arti, n.s. 22 (1968):98-102, 4 b&w illus.
 Listing of works with dates and documents.

JACQUERIO, GIACOMO GIOVANNI AND MATTEO

PA23 BERTEA, CARLO. "Gli affreschi di Giacomo Jacquerio nella
 Chiesa dell'Abbazia di Sant'Antonio di Ranverso." Atti
 della Società piemontese di archeologia e belle arti per la
 provincia di Torino 8 (1917):194-207, 11 b&w illus.
 Passion cycle and Saints and Prophets in the presbytry,
 Sant'Antonio, Ranverso, signed by Giacomo Jacquerio. Paintings
 in the oratory to another hand.

PA24 RONDOLINO, FERDINANDO. "Il Castello di Torino." Atti della
 Società piemontese di archeologia e belle arti per la
 provincia di Torino 13 (1932):1-55.
 Brief mention of decorations for a banquet by Giovanni
 Jacquerio in 1475.

PA25 CARITÀ, ROBERTO. "La pittura nel ducato di Amedeo VIII:
 Revisione di Giacomo Jacquerio." Bollettino d'arte, 4th
 ser. 41 (1956):109-27, 22 b&w illus.
 General overview of dating and attributions. Concentrat-
 ing on the Ranverso frescoes.

PA26 GARDET, CLEMENT. "De la peinture dans les états de Savoie
 au XVe siècle. L'école de Jacquerio et les fresques de
 Saint-Gervais de Genève et de l'Abbaye d'Abondance en
 Chablais." Genava 11 (1963):407-31, 10 b&w illus.
 Agrees with hypothesis that frescoes date from end of
 fourteenth to the middle of fifteenth centuries. Comparisons
 with work of Giacomo Jacquerio puts work in atelier. Attention
 particularly to the borders, coats-of-arms, iconography, and
 style.

PA27 CAVALLARI-MURAT, ALESSANDRO. "Un affresco jacqueriano a
 Lanzo Torinese." Bollettino della Società piemontese di
 archeologia e belle arti, n.s. 19 (1965):93-97, 4 b&w illus.
 Madonna and Child with the Baptist.

Artists

PA28 GRISERI, ANDREINA. Jacquerio e il realismo gotico in Piemonte. Turin: Pozzo, 1966, 164 pp., 48 figs., 134 b&w illus.
Fundamental discussion of Piedmontese Gothic and the role of the Jacquerio. Bibliography.

PA29 TURIN. PALAZZO MADAMA. Giacomo Jacquerio e il gotico internazionale. Edited by Enrico Castelnuovo and Giovanni Romana. Turin: Palazzo Madama, 1979, 478 pp., numerous illus.
Catalog of exhibition evaluating place of Jacquerio in the development of late Gothic art. Definition of International style.

PA30 CASTELNUOVO, ENRICO. "Postlogium Jacquerianum." Revue de l'art 52 (1981):41-46, 8 b&w illus.
Defines place of Jacquerio in the culture and broader patronage of the House of Savoy. Removes from isolation.

MACRINO D'ALBA

PA31 PIACENZA, GIUSEPPE. Notizie di Macrino pittore di Alba. Alba: Del Pila, 1770, 8 pp.
Publishes sixteenth- through eighteenth-century sources on Macrino including Paolo Cerrato, Irico, and Ferragatta.

PA32 FLERES, UGO. "Macrino d'Alba." Le gallerie nazionale italiane 3 (1895-96):66-99, 2 b&w illus.
Reconstruction of dispersed works of Macrino.

PA33 CIACCIO, LISETTA. "Macrino d'Alba: Derivazione artistica." Rassegna d'arte 6 (1906):145-53, 21 b&w illus.
Describes Umbrian influence on Macrino, particularly Pinturicchio.

PA34 MILANO, EUCLIDE. "Macrino de Alladio: Appunti e notizie." Arte e storia 27 (1908):86-90.
New attributions.

PA35 ROSSI, GIROLAMO BATTISTA. "Macrino de Alladio." Burlington Magazine 15 (1909):113-14, 2 b&w illus.
Suggests that portrait in collection of Alexander Imbert, Rome, with inscription "Macrini manu post fata vivam, 1499," is self-portrait. Compares to another self-portrait in collection of Alfeo Chiaffrino, Bra. Basic biography. References to Alladio family archives in the hospital in Alba.

PA36 MILANO, EUCLIDE. "Macrino d'Alba e il suo ambiente." Arte e storia 29 (1910):353-66, 2 b&w illus.
A discussion of the geographical and intellectual ambient within which Macrino worked.

PA37 CARMICHAEL, MONTGOMERY. "A Portrait of Macrino d'Alba by
 Himself." Burlington Magazine 21 (1915):53.
 Suggests that Self-portrait published by Rossi (PA35)
 actually the portrait of a relative of Macrino. Notes inclu-
 sion of the white Maltese Cross that indicates the sitter is a
 Knight Commander of the Order of St. John of Jerusalem.

PA38 MARANGONI, GUIDO. "Macrino d'Alba." Emporium 47 (1918):22-
 37, 14 b&w illus.
 Early history of Piedmontese art, very cursory. Identi-
 fies Macrino as transformer of the Vercellese style. Sees nu-
 merous influences including the Lombards and Bellini.

PA39 BAUDI di VESME, ALESSANDRO. "La famiglia del pittore
 Macrino d'Alba." Bollettino della Società piemontese di
 archeologia e belle arti 6 (1922):9-14.
 Documents the family back to 1427. Includes genealogy.
 Surname de Alladio. Taken from research of Vernazza.

PA40 WEBER, SEIGFRIED. "Macrino d'Alba." In Thieme-Becker.
 Vol. 23. Leipzig: Seeman, 1929, pp. 523-25.
 Thorough entry divided into sections on signed and dated
 works, signed works, attributed works, and doubtful attribu-
 tions. Bibliography.

PA41 VIALE, VITTORIO. "Vetro ad oro con ritratto di Anna
 d'Alençon, Marchesa di Monferrato." Bollettino storico-
 bibliografico subalpino, n.s. 8, no. 44 (1942):48-51, 3 b&w
 illus.
 Assigns a painted portrait of Anna d'Alençon to Macrino
 d'Alba.

PA42 PIANA, GIOVANNI ORESTE della. Macrino d'Alba. Maestri
 della val Padana, 1. Como: Cairoli, 1962, 131 pp., 29
 color and 10 b&w illus.
 Biography. No real clue as to teacher, birth, or death
 date. Special attention to Stigmatization of St. Francis,
 Turin; triptych, Philadelphia; and portraits. Catalog.
 Bibliography.

PA43 VIGLIENO-COSSALINO, FERDINANCO. "Contributo a Macrino
 d'Alba." Critica d'arte 73 (1965):27-41, 10 b&w illus.
 Identifies portraits of Guglielmo VII di Monferrato and
 Anna d'Alençon in Museum of Sanctuary of Crea Monferrato as
 part of altarpiece dated 1503, in same museum.

PA44 BAUDE di VESME, ALESSANDRO. "Macrino d'Alba." In Schede
 Vesme: L'arte in Piemonte. Vol. 4. Turin: Società
 piemontese di archeologia e belle arti, 1982, pp. 1450-67.
 Entry includes summaries and transcriptions of known
 documents, extracts from articles, list of attributions, and

Artists

genealogy of the family. Important early source for entries
pre-1925.

MAZONE GIOVANNI

PA45 CAFFI, MICHELE. "Giovanni Mazone (sic) (da Alessandria)."
 Archivio storico lombardo 2 (1875):433-35.
 Discusses a number of documents relating to Mazone's
 work.

PA46 VARNI, SANTO. "Chi sia l'autore della Tavola
 dell'Annunziata nella Chiesa di Santa Maria di Castello in
 Genova? Documento inedito." Giornale ligustico di
 archeologia, storia e belle arti 2 (1875):82-84.
 Contract of 1497 for Annunciation between Mazone and
 Giacomo Marchione.

PA47 GASPAROLO, FRANCESCO. "Per la storia del quadro del Mazone
 nella Pinacoteca di Alessandria." Rivista di storia, arte,
 archeologia per la provincia di Alessandria 32 (1923):228-
 34, 1 b&w illus.
 Brief history of how Mazone polyptych came into the
 collection of Pinacoteca, Alessandria.

PA48 "Mazone, Giovanni." In Thieme-Becker. Vol. 24. Leipzig:
 Seeman, 1930, p. 302.

PA49 BONZI, MARIO. "Un'anconetta della bottega di Giovanni
 Mazone." Il raccoglitore Ligure 3, no. 6 (1934):6, 1 b&w
 illus.
 Publishes St. Francis Receiving the Stigmata in the
 Palazzo Bianco, Genoa, as circle of Mazone.

PA50 BARNAUD, GERMAINE. "Un retable de Giovanni Massone
 d'Alexandre au Musée d'Alençon." Revue du Louvre 13
 (1963):137-42, 5 b&w illus.
 Rereading signature on a triptych with a Noli Me Tangere
 of 1477 leads to attribute work to Mazone. Work from San
 Giacomo, Savona. Described by Vivant Denon in September 1810.
 Corrects error of attribution to "Jacopo Marone." Proves no
 such artist, misreading of Giovanni Mazone.

PA51 FOLLI, A.M. "Giovanni Mazzone (sic), pittore genovese del
 quattrocento." Studi genuensi 8 (1970-71):163-90, 20 b&w
 illus.
 Active between 1433-1511. Contacts and influences.

PA52 MIGLIORINI, MAURIZIA. "Appunti sugli affreschi del Convento
 di Santa Maria di Castello a Genova." In Argomenti di
 storia dell'arte. Edited by Corrado Maltese. Genoa:
 Università di Genova, 1980, pp. 49-63, 16 b&w illus.

Three sets of mid-fifteenth-century frescoes in loggia of second cloister. Reattributes three Dominican Saints from Northern Giusto di Ravensburg to Giovanni Mazone.

PA53 TASSINARI, MAGDA. "Osservazioni su Giovanni Mazone." In Argomenti di storia dell'arte. Edited by Corrado Maltese. Genoa: Università di Genova, 1980, pp. 65-74, 8 b&w illus.
Traces confusion with "Jacopo Marone." Biography. Also shows a sculptor. History of attributions. Discusses Nativity, Crucifixion, Annunciation in Savona. Sees some Paduan influence from collaborators.

PA54 BAUDE di VESME, ALESSANDRO. "Mazzone (sic), Giovanni." In Schede Vesme: L'arte in Piemonte. Vol. 4. Turin: Società piemontese di archeologia e belle arti, 1982, pp. 1473-91.
Entry includes summaries and transcriptions of known documents, extracts from articles, list of attributions, and genealogy of Mazone. Important early source for entries pre-1925.

NICOLÒ DA VARALLO

PA55 "Nicolò da Varallo." In Thieme-Becker. Vol. 25. Leipzig: Seeman, 1931, p. 440.

PA56 SCIOLLA, GIANNI CARLO. "Ipotesi per Nicolò da Varallo--I & II." Critica d'arte 78 (1966):27-36; 79 (1966):29-39, 26 b&w illus.
Reexamining and reevaluating oeuvre after cleaning of windows of S. Giovanni Damasceno, Cathedral, Milan. Sees Foppa parallels in the designs in 1480s. Cremonese, Benedetto Bembo, influence 1465-70. Discusses relationship to Cristoforo de' Motti.

PA57 SCIOLLA, GIANNI CARLO. "Probabili affreschi di Nicolò da Varallo nel Museo nazionale di Budapest." Bollettino della Società piemontese di archeologia e belle arti, n.s. 20 (1966):126-30, 14 b&w illus.
Connects series of Prophets in Budapest with Cappella delle Grazie in Varallo, last quarter of fifteenth century.

SIMONDI, BERNARDINO

PA58 ROSSI, GIROLAMO. "Un pittore piemontese in Provenza nel XV secolo." Arte e storia 23 (1904):59-61.
Publishes testament of Saluzzese artist Bernardino Simondi, 12 March 1498. Document of particular interest for the description of types of drawings and cartoons passed on to apprentices and collaborators.

Artists

SPANZOTTI, GIOVANNI MARTINO

PA59 BAUDI di VESME, ALESSANDRO. "Martino Spanzotti, Maestro del
 Sodoma." Archivio storico dell'arte 2 (1889):421-23.
 Republishing of documents concerning Spanzotti.

PA60 CIACCIO, LISETTA. "Gian Martino Spanzotti da Casale,
 pittore, fiorito fra il 1481 ed il 1524." L'arte 4
 (1904):441-56, 15 b&w illus.
 Particular discussion of Ivrea cycle as touchstone of
 work.

PA61 BAUDI di VESME, ALESSANDRO. "Nuove informazione intorno al
 pittore Martino Spanzotti." Atti della Società piemontese
 di archeologia e belle arti per la provincia di Torino 9
 (1918-20):1-25, 6 b&w illus.
 Additional documentation discovered after the Archivio
 article of 1889 (P59), including dating of Tana Triptych to
 1488 and letter to Duke Carlo II of 1507.

PA62 COOK, HERBERT. "A Note on Spanzotti, the Master of Sodoma."
 Burlington Magazine 33 (1918):208-9, 2 b&w illus.
 Attributes Madonna and Child enthroned with Angels in the
 Cook Collection, formerly attributed to Foppa school by ffoulkes
 (LA175), to Spanzotti.

PA63 PACCHIONI, GUGLIELMO. "Alcuni dipinti inediti di Giovanni
 Martino Spanzotti." L'arte 33 (1930):16-29, 4 b&w illus.
 Triptych and Adoration of the Magi in Turin, Pinacoteca
 reale.

PA64 GABRIELLI, NOEMI. "Spanzotti, Giovanni Martino." In
 Thieme-Becker. Vol. 31. Leipzig: Seeman, 1937,
 pp. 332-34.
 Thorough entry including attributions and brief documenta-
 tion. Bibliography.

PA65 MALLÈ, LUIGI. "La pittura piemontese tra '400 e '500.
 Nuovi ritrovamenti e un vecchio problema. Martino Spanzotti
 e Defendente Ferrari." Bollettino della Società piemontese
 di archeologia e belle arti, n.s. 5-6 (1952-53):76-131, 19
 b&w illus.
 Questions attributions between Spanzotti and Defendente.
 Includes a summary of the literature. Relationship of
 Spanzotti's art to Northern European. Also detects Ferrarese
 influence.

PA66 RODOLFO, GIACOMO. "Lettera autografa di Gian Martino
 Spanzotti riguardante un'ancona da lui dipinti nel 1509 per
 la chiesa parrocchiale di Carmagnola." Bollettino della
 Società piemontese di archeologia e belle arti, n.s. 5-6
 (1952-53):132-38.

Demonstrates that panel painting now lost, which was to
be topped by a Pietà, was finished by September 1509. Pub-
lishes other documents associated with this painting.

PA67 GREGORI, MINA. "Due opere dello Spanzotti." Paragone 49
 (1954):50-54, 2 b&w illus.
 Publishes two compositions of Madonna and Child with
 Angels, one formerly in the von Tucher Collection, Vienna, the
 other in the Mayer van der Bergh Museum, Antwerp.

PA68 MALLÈ, LUIGI. "Aggiunte a Giovanni Martino Spanzotti: Un
 Martirio di S. Sebastiano." Bollettino della Società
 piemontese di archeologia e belle arti, n.s. 12-13
 (1958-59):34-37, 3 b&w illus.
 Predella panel in the Museo civico, Turin.

PA69 TESTORI, GIOVANNI. G. Martino Spanzotti: Gli affreschi di
 Ivrea. Ivrea: Centro culturale Olivetti, 1958, unpaged, 75
 b&w and color illus.
 Brief history of the church. Summary documentation of
 Spanzotti. Assumes Lombard training for Spanzotti. Apprecia-
 tion of the frescoes.

PA70 BERTINI, ALDO. "Un'aggiunta a una predella di Spanzotti nel
 Museo civico di Torino." In Studi di storia dell'arte in
 onore di Vittorio Viale. Edited by Association
 internationale des critiques d'art. Sezione italiana.
 Turin: Fratelli Pozzo, 1967, pp. 18-21.
 Saint Sebastian Destroying Idols in Rome tied to predella
 of Martyrdom of Saint Sebastian in Turin. Assigns Lives of SS.
 Crispino e Crispiniano in Cathedral, Turin, to Spanzotti with
 assistance of Defendente.

PA71 GABRIELLI, NOEMI. "Aggiunte Spanzottiane." Bollettino
 della Società piemontese di archeologia e belle arti, n.s.
 21 (1967):111-12, 3 b&w illus.
 Madonna and Child with Donor, parish church, Torrione.
 Discusses Ferrarese influence on Spanzotti.

PA72 MALLÈ, LUIGI. Spanzotti, Defendente, Giovenone: Nuovi
 studi. Turin: Editrice Impronta, 1971, 433 pp., 67 b&w
 illus.
 Chap. 1 reconstruction of career and stylistic develop-
 ment of Spanzotti, pp. 7-37. Chap. 2 evaluation of Spanzotti's
 impact on art ca. 1500-1510. Short bibliography.

PA73 BERTINI, ALDO C. Review of Malle's Spanzotti, Defendente,
 Giovenone. Commentari, n.s. 24, no. 3 (1973):244-46.
 Summary review of Mallè (PA71).

PA74 ROMANO, GIOVANNI. "La fortune critique de Martino Spanzotti
 a Ivrée." Congrès archéologique de France 129 (1971-appear-
 ing in 1978):194-201, 1 b&w illus.

Artists

 Traces attributions and dating history of the cycle and Spanzotti in general. Dates the cycle later than usual on basis of inclusion of St. Antonino, 1523.

PA75 BAUDE di VESME, ALESSANDRO. "Spanzotti." In <u>Schede</u> <u>Vesme:</u> <u>L'arte</u> <u>in</u> <u>Piemonte</u>. Vol. 4. Turin: Società piemontese di archeologia e belle arti, 1982, pp. 1595-1612.

 Entry includes summaries and transcriptions of known documents, extracts from articles, list of attributions, and genealogy of the family. Important for early source since entries pre-1925.

Index of Artists

Index of Authors